EARLY PRINTS

THE PRINT COLLECTION
OF THE ROYAL LIBRARY OF BELGIUM

Early Prints

Jan Van der Stock

HARVEY MILLER PUBLISHERS

HARVEY MILLER PUBLISHERS
An Imprint of Brepols Publishers
London / Turnhout

British Library Cataloguing in Publication Data
A catalogue record for this book
is available from the British Library
ISBN 1-872501-29-X

Origination and lay-out by Grafikon, Oostkamp, Belgium
Printed by Ter Roye, Oostkamp, Belgium
Bound by Scheerders van Kerchove, Sint-Niklaas, Belgium

Foreword

IT IS, for many reasons, both an honor and a pleasure for me to present you with this catalogue of early prints in the Royal Library of Belgium.

In the nineteenth century, the nationalistic spirit of the young Belgian nation led to the purchase of numerous prints by great masters in order to build up a concrete past for the new nation. Today, those who are familiar with the current budgetary restrictions of this federal institution would cry out in despair if they knew how their nineteenth-century predecessors spent huge sums at auctions. But that is of no help now. As head librarian, I am proud of our treasures from the past and would like to publicize the outstanding work of my predecessors.

This publication fits in with the continuing concern at the library regarding how its collections can be made better known. All too often, it is assumed that the compiling of professional inventories, cataloguing, and making archival, library, and museum collections more accessible, are not true scholarly endeavors. And yet, just the opposite is true, as such work requires an extensive and specialized knowledge of history, art history, and the professional literature for a wide range of subjects.

It is a credit to such an internationally respected art historian as Professor Jan Van der Stock that he perceived the full significance of this operation. Thus, I would like to thank him warmly for his efforts. In addition, the Print Room has taken advantage of this opportunity to mount the prints described in this work on acid free supports. Indeed, this, too, has become an ever-greater concern at the library during the past decade; for while conservation and preservation are often unobtrusive activities, they remain extremely important for the future.

The catalogue that follows takes you to the world of artists from long ago, to the free, independent spirit of the young Belgian nation of the nineteenth century, and to the enthusiastic search of a young researcher of today.

Pierre Cockshaw, head librarian

Contents

Foreword . 5

Acknowledgements . 9

Introduction to the catalogue . 11

The formation of the collection . 18

I. Anonymous woodcuts, metal cuts and white-line prints 25

II. Northern engravings of the fifteenth century . 59

III. Nielli . 127

IV. Early Italian engravings . 137

Bibliography . 155

Concordances . 167

Indices . 175

Illustrations and plates . 185

Early Prints in the Royal Library of Belgium
Jan Van der Stock

Acknowledgements

The Print Room of the Royal Library of Belgium currently possesses roughly 700,000 independent prints, including a few hundred 'early' woodcuts and engravings from the fifteenth and early sixteenth centuries, which make up one of the most important parts of the collection.[1] In the course of time, only a small portion of these has been recorded in a systematic catalogue. One-and-a-half centuries ago, in 1857, the head curator Louis Alvin catalogued the Library's noteworthy collection of Italian niello prints.[2] Thirty-five years later, in 1892, Max Lehrs, then head of the Dresden Print Room, published the first and only inventory of the collection of fifteenth-century northern engravings in the Royal Library's Print Room.[3] As for the two other parts of the collection included in this book, namely the early woodcuts and the early Italian prints, this is the very first time that each has been examined as a group. Consequently, the exceptionally rich collection of 'early' prints in the Royal Library of Belgium has remained essentially unknown to many thus far. This catalogue is a first step in making the collection better known.

The completion of this project required a great deal of energy and perseverance on my part. The work was not always easy and my self-confidence was tested severely more than once. Fortunately, many people assisted and encouraged me. First and foremost, I would like to thank the head curator of the Library, Pierre Cockshaw. I am also extremely grateful for the much needed support, encouragement and numerous suggestions I received from my many good friends and colleagues at the Royal Library: Bernard Bousmanne, Willy Vanderpijpen, François De Callataÿ, Bart Op De Beeck, Wim De Vos, Claudine Lemaire, Ann Kelders, Raphael De Smedt, Herman Mulder, Erwin Pairon, Hossam Elkhadem and Lieve Watteeuw. Elly Cockx-Indestege deserves a special word of thanks, for she read my manuscript carefully, with the knowledgeable perspective of a book historian. In such an undertaking as this, her feedback was absolutely essential, although I could not incorporate all of her suggestions. The errors and shortcomings in this book are mine alone. I would also like to thank Annette Pavet and Nancy Demartin, two colleagues from the Print Room, for their practical assistance and for the pleasant working environment. The Print Department's conservator, Gérard De Smaele, mounted all of the 'early' prints in the Print Room on acid-free supports. Most were still affixed to acidic cardboard from the first half of the twentieth century. Last but not least, I would like to thank Karen Bowen, who translated my text.

The King Baudouin Foundation (Belgium) honoured this project with the prize 'Beurs buiten categorie/Parcours hors-pistes 2001'. Hopefully, this award will contribute to the recognition and systematic preservation of the extremely rich, but generally little-known collection of prints at the Royal Library of Belgium.

J.V.d.S., Leuven, 29.09.2002

Introduction to the catalogue

This publication comprises virtually all of the independent prints preserved in the various collections that make up the Royal Library of Belgium. I have endeavoured to make the catalogue as complete as possible. Consequently, it contains not only the independent prints from the Print Room but also, for example, the numerous prints that were used to illustrate manuscripts and are thus preserved in the Manuscript Department. Similarly, the prints that are part of the Rare Books Division have been included here as well.

Nevertheless, true completeness is impossible to achieve. First, it is impossible to define precisely which prints should be included in the catalogue and which should not. In other words, it is not always evident when a print should be classified as 'early'. Thus, it is necessary to clarify how prints were selected and arranged in the catalogue. Second, a number of prints have undoubtedly gone undetected. Most of the 'early' independent prints in the Print Room are kept separately in a collection called the *réserve*. This collection also comprises a selection of works by such artists as Albrecht Dürer, the Wierix brothers, Rembrandt, Anthony van Dyck, James Ensor, and various other woodcutters, engravers, and etchers, where the prints in question had been deemed 'exceptionally precious' for reasons that are not always evident now. And yet, during my search through the approximately 700,000 'ordinary' prints that remain, I found numerous 'early' and extremely precious works that, for unclear reasons, had yet to be included in the *réserve*. Similarly, a systematic examination of the Print Room inventory, which has been kept since 1857, resulted in many unexpected finds. For example, I was consequently able to link numerous engravings with their original nineteenth-century inventory numbers, which many regarded as lost. This in turn enabled me to re-establish the provenance (albeit often limited) of many prints.

In this book, I have discussed the prints in four general groups.[4] In order to insure consistency in interpretation, these have been organised according to certain standard groupings that are recognised internationally and are, consequently, communicable. Due to the special character of the collection, however, occasional minor deviations had to be accommodated within each grouping.

Group 1: Anonymous woodcuts, metal cuts and white-line prints of the fifteenth and early sixteenth centuries (n° 001 - n° 150)

First and foremost, there are the 'anonymous woodcuts' (n° 001 - n° 130) and the 'metal cuts and white-line prints' (n° 131- n° 150) from the fifteenth and early sixteenth centuries. In contrast with the engravings, most of these are unique. I based the selection and the organisation of this group upon the system used by Wilhelm Ludwig Schreiber in his *Handbuch der Holz- und Metallschnitte des XV Jahrhunderts*, 8 vols., Leipzig, 1926-30. Every

'early' woodcut or metal cut has a 'Schreiber number'. This consists of the letters 'Schr.', followed by a roman numeral (from I to VI), which refers to the relevant volume of Schreiber's work, and then the number Schreiber used to identify the print.

Schreiber justifiably distinguishes between woodcuts and metal cuts. Within these two categories, he organised the prints according to an iconographic system that was already common in the nineteenth century. This system begins with the Old and New Testament, after which come the devotional images, then male and female saints and, last of all, those prints with profane subjects. Within this iconographical framework, Schreiber has additional sub-divisions, made according to the various presentations of a certain subject. These are then ranged by the size of the print, from largest to smallest. Several decades separate the publication of the first edition of Schreiber's catalogue (*Manuel de l'amateur de la gravure sur bois et sur métal au XVe siècle*, 5 vols., Berlin and Leipzig, 1891-1911) and the German edition *(Handbuch....)*, cited above. Thus, Schreiber was able to incorporate numerous additions and corrections in the later publication. He inserted these between the old series of numbers. By the time the last volume of the *Handbuch* appeared in 1930, Schreiber had amassed a great deal of new information, once again. In addition, numerous corrections had to be made. These additions and corrections were included in volume VIII. Finally, he added a second supplement to the same volume. In 1930, Schreiber planned an entirely new volume to his catalogue of independent prints (volume IX), but this was never completed. Since then, other authors who have published information on an unknown 'early' woodcut or metal cut, have assigned that print a fictive Schreiber number in the equally fictive volume IX. I have continued this practice, with the risk that some numbers may overlap with others. This number is intended to place the print more precisely and logically in the catalogue as a whole. I have noted it in square brackets in order to indicate that it is a 'virtual' number. For example, I assigned n° 035 Schreiber number [Schr.IX.642a].

In this catalogue, there are some woodcuts from the early sixteenth century. One good example of these is n° 047, *Christ Appears to the Virgin*, which should clearly, on the basis of stylistic arguments (e.g. the shape of the columns) be dated after 1500. Another example is n° 129, where the representation of a turkey (*Gallus Indicus*) makes the dating of the print to the fifteenth century impossible from a historical perspective.[5] I have included these prints for the simple reason that Schreiber himself also includes a number of sixteenth-century works. Moreover, it is impossible and senseless to try to maintain such a strict cut-off point as '1499 vs. 1500'. Schreiber used the oeuvre of Albrecht Dürer for his own, imprecise, boundary line. If a print pre-dated Dürer's work stylistically (even if it was later, chronologically), then it was included. His definitions are, consequently, open to interpretation.

I have always included 'modern impressions', namely, woodcuts pulled from old blocks, particularly within the past two hundred years. Interesting examples of these are *The Man of Sorrows* (n° 054) and the series *The Nine Worthies* (n° 120 - n° 125). The woodblocks for these prints were acquired by the Soloani firm in Modena, which produced

12

reprints from the old blocks between 1640 and 1870. The woodblocks are now preserved at the Pinacoteca of Modena (see also n° 078). Facsimiles are never included, although it remains unclear whether n° 144 is one or not.

In contrast, there are also three groups of fifteenth-century woodcuts (or woodcuts that, at first glance, appear to be from the fifteenth century) that have not been included in the catalogue. First are a number of illustrations in the Print Room that were removed from printed books. These are often selections of images that were amassed during the nineteenth century. The cut-out prints – which were usually removed from sixteenth-century publications, but also from a few incunables – were occasionally glued into little notebooks. Although this is an interesting phenomenon, I did not include any of these because they were originally book illustrations and not independent prints. Nevertheless, a few book illustrations were included under certain conditions. For example, the woodcuts n° 070 and n° 087 are illustrations from incunables that Schreiber had included. Schreiber often included woodcuts that appeared in books if he discovered that they had also been issued separately.

The second group consists of two copies after Lucas van Leyden. Specifically, the Print Room has an unknown partial copy of *The Baptism of Christ in the River Jordan* (H.40). According to the inscription, the metal cut was made in *Ga(n)daui in heremo s(an)cti Joha(n)nis* (fig. 1). Another example is *The Virgin and Child* (H.197), a woodcut that dates to c. 1515, of which the Print Room possesses an unknown, hand-coloured copy in reverse (fig. 2). I would definitely have included these prints in the catalogue if I had not recognised them as copies after Lucas van Leyden.

The third category of omitted fifteenth-century woodcuts consists of the block books in the collection. The Royal Library owns four beautiful examples of these, which deserve to be described in a separate catalogue.[6]

Group 2: Northern engravings of the fifteenth century (n° 151 - n° 477) [+ 478]

The prints discussed in the section on Northern engraving are presented according to Max Lehrs's *Geschichte und Kritischer Katalog des deutschen, niederlandischen, und französischen Kupferstichs im 15. Jahrhunderts*, 9 vols., Vienna, 1908-34. Although it is true that numerous studies have since been published in which certain engravings are examined in greater detail, no single publication is as comprehensive as Lehrs's catalogue. The prints in this portion of the catalogue are grouped and organised according to the artist to whom they are attributed, be it an anonymous hand, such as the Master of Saint Erasmus or the Master of the Martyrdom of the 10,000, or a known master, such as Martin Schongauer or Israhel van Meckenem. I have always included copies immediately after the works by the artist concerned. Thus, n° 291 - n° 302 represent the copies after Martin Schongauer. Copies executed by known engravers from the fifteenth century (Israhel van Meckenem working

13

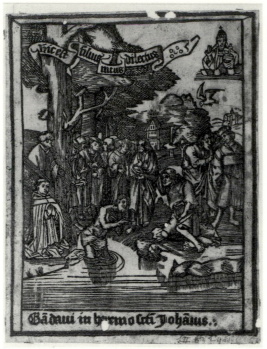

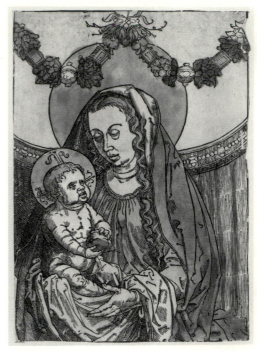

fig. 1:
Unrecorded copy after Lucas van Leyden, *The Baptism of Christ in the River Jordan* (H.40) [with addition of a monk], metal cut, 130 x 98 mm. Brussels, Printroom, S.II.8324

fig. 2:
Unrecorded copy in reverse after Lucas van Leyden, *The Virgin and the Child* (H.197), coloured woodcut, 243 x 169 mm. Brussels, Printroom, S.V.63316

after Martin Schongauer, for example), however, are listed under the copyist. Thus, n° 322 (*Christ Crowning the Virgin*), a copy by the Master I C after Schongauer, is placed under the Master I C. The original nineteenth-century photographic impressions of fifteenth-century prints have also been included in the catalogue. In one case, the original print has since disappeared (n° 385); in other cases these photographs convey something about the history of the collection (e.g. n° 334).

Prints that were not known to Lehrs but are, without doubt, from the fifteenth century, are discussed in two groups. The first consists of those prints from the 'pre-Schongauer-period' (n° 194 - n° 204). I have dated all of these prints to c. 1450-1470. The second 'group' consists of unknown prints from c. 1500 (n° 441- n° 477). So, I have not attempted to make any firm attributions – in particular, for the anonymous, pre-Schongauer engravings – for the simple reason that Lehrs's rigorous attributions are not always convincing.

I have been somewhat stricter in the use of dating to determine which engravings should be included than I was with the woodcuts. A few prints that Lehrs had either explicitly rejected or did not know, but about which I had serious doubts as to whether they had been executed in the fifteenth century, have not been included. Thus, for example, *The Mass of St Gregory* (fig. 3), an engraving that Passavant dated to the fifteenth century, has not been included because Lehrs correctly describes it as: '. . . *eine rohe, bereits dem sechzehnten Jahrhundert angehörige Arbeit und fehlt daher in dem nachfolgenden Verzeichniss'.*[7]

14

fig. 3:
Anonymus 16th century, *The Mass of St. Gregory*,
engraving, 81 x 56 mm. Brussels, Printroom, S.II.183

fig. 4:
Albrecht Dürer, *Five Lansquenets and an Oriental on Horseback*
[ca. 1495] (B.88), engraving, 131 x 145 mm. Brussels, Printroom,
S.II.5662

I have also omitted all the fifteenth-century prints by Albrecht Dürer, whose works are consistently discussed in the context of the sixteenth century in all other catalogues. Traditionally, even Dürer's earliest engravings from the 1490s are not catalogued among the 'early' prints (see, e.g. fig. 4). This approach has significant consequences. For example, Israhel van Meckenem's copy of Albrecht Dürer's *The Promenade* is included in the catalogue (n° 432), while the original (fig. 5), which is also in the collection, is not.

One print that did not fit in at all with Lehrs's conception of his catalogue has been included, nevertheless, because of its immense significance. It is the Spanish engraving *The Fifteen Mysteries and the Virgin on a Rosary*, executed in 1488 by Francisco Doménech (n° 478). No original impressions are known of this print, but the plate is still preserved in the Royal Library.

Group 3: The collection of niello prints (n° 479 - n° 510)

The thirty-two items that are discussed in this section are actually not true prints. A niello plate is a metal plate (often silver or gold) in which an image is first engraved into the plate and then the engraved lines are filled with a black substance. The surface is then cleaned and polished, while the black lines remain (see, n° 510).[8] Theophilus Presbyter described this technique in the twelfth century in his *Diversarium Artium Schedulae*. It is a

fig. 5:
Albrecht Dürer, *The Promenade* (or: *Young Couple Treatened by Death*) [ca. 1498] (B.94), engraving, 197 x 121 mm. Brussels, Printroom, S.I.1405

technique that has been used by goldsmiths since antiquity. Niello plates were used for the decoration of religious objects and in many instances they were also used for adorning knife handles or boxes. Occasionally, prints were made from these decorative plates before the lines were filled, in order to check the progress of the work and, following the completion of the plate, to provide a final record of the image. The resulting impressions are called niello prints. They were made primarily in Italy at the end of the fifteenth and the beginning of the sixteenth century. By the beginning of the nineteenth century, the extreme rarity of these images resulted in the manufacture of numerous forgeries and copies that were sold on the open market. The provenance of the nielli (which are usually not larger than a postage stamp) is consequently of great importance. Most of the niello prints in the Royal Library came from one of two old collections. For this reason, I decided to organise them according to the collection from which they came.

The first is the collection of Johannes van t'Sestich who was born in Mechelen c. 1575 and became a professor of law at the University of Leuven. He also served as the president of the university several times. Van t'Sestich died in Leuven on 8 November 1634.[9] In handwritten notes that van t'Sestich compiled in 1600 when attending courses at Leuven given by Gerardus Corselius (*Ad instituta Iustiniani auctarum*), he appended various prints to his notes, as was the custom at the time.[10] In 1857 Louis Alvin identified no less than twenty-

nine of these as niello prints. How the Leuven professor came by the prints remains a mystery. In 1866, six doubles of nielli in the collection came into the possession of a Parisian dealer named Clément. The Library had not sold them to Clément, but exchanged them for six comparable prints. In this way, the Royal Library came to own n° 238 (Martin Schongauer), n° 546 (Giovanni Antonio da Brescia), and n° 566 (Domenico Campagnola), together with three other valuable, but later prints.[11] On 24 March 1866, Clément sold the niello prints to the Bibliothèque Nationale in Paris for 2,000 FF.[12]

The second group is the Brisard collection from Gent. In 1834, J. Duchesne wrote the following about it: *La collection formée par cet amateur . . . renferme des pièces du plus haut intérèt. Presque toutes sont d'une parfaite conservation . . . Ainsi . . . M. Brisard a desiré posséder les estampes les plus anciennes, et il a réussi à se procurer plusieurs nielles très curieux.*[13] The Royal Library purchased the seven niello prints in this collection in 1847.

The Print Room also has the thirty-two items that Bartsch described at the beginning of his Volume 13 of copies or facsimiles of niello plates and prints then belonging to the Marchese Jacopo Durazzo in Genoa.[14] According to Alexandre Zanetti, these facsimiles were executed by Antonio Dal Pian from Venice and a certain [Giovanni] 'David' from Genoa. They were supposedly intended to be illustrations for a publication by Mauro Boni that was never completed.[15]

Since the nineteenth century, the original prints from the aforementioned van t'Sestich and Brisard collections, together with the Durazzo-facsimiles, three additional original prints (n° 507 - n° 509), and one niello plate (n° 510), are all kept in a single wooden box. Because I do not wish to give rise to misunderstandings, I have not included the Durazzo-facsimiles (and some other facsimiles and doubtful pieces) in this catalogue. Indeed, 'the study of nielli is as intriguing as it is frustrating. It is riddled with misinformation and forgery. Thus, in this case *fools rush in where angels fear to tread.'*[16]

Group 4: Early Italian engravings (n° 511 - n° 574)

The section on Italian engravings is based upon the single great reference work, Arthur M. Hind, *Early Italian Engraving*, 7 vols., London 1938-48. The collection of early Italian prints from the fifteenth and early sixteenth centuries at the Royal Library is relatively small. It consists of sixty-two engravings and two woodcuts. Although the last two were not catalogued by Hind, an exception was made to include them here (n° 553 and n° 567). The second exception in the compilation of this section is print n° 550, *A Street with Various Buildings*, probably after Donato Bramante. Due to the figures included in this print, it appears that it should be dated closer to 1550. This is why Hind did not include it in his catalogue. It was purchased from the Milanese collection of Luigi Angiolini, together with two other prints after Bramante, which Hind correctly does date to the fifteenth century (n° 548 and n° 549). Because of this common provenance, I decided to regard the three prints as a single 'group'.

As with the use of Lehrs's work as a model for the first group of this catalogue, the decision to follow Hind for the organisation of this section has had a few noteworthy consequences. Consider, for example, a copy after Marcantonio Raimondi, executed by Jacopo Francia. While this engraving has been included in the catalogue (n° 570), no prints by Marcantonio himself have been, even though the Royal Library has a good collection of his work. Another consequence is that the magnificent series of chiaroscuro woodcuts by Andrea Andreani (1599) after Andrea Mantegna have been excluded from the catalogue. For, in contrast with Lehrs, Hind did not include any later copies.

The formation of the collection: an undertaking from the second half of the nineteenth century

The collection of 'early' prints in the Royal Library was acquired primarily between c. 1850 and 1914.[17] Thereafter, while there were occasionally new acquisitions of old prints for the collection, large purchases were no longer made. Moreover, in the course of the twentieth century, astronomical prices had to be paid for early woodcuts and engravings, which required a shift in emphasis for the purchasing programme of the Royal Library. Thus, the history of how the collection of 'early' prints was formed cannot, in principle, be separated from the acquisition policy of the Library as a whole and from that of the Print Room in particular. Nevertheless, I would like to mention a few important purchases and acquisitions, without going into the entire history in detail.[18]

The Royal Library of Belgium was formally established by Royal Decree on 19 June 1837. At that time, it consisted of two divisions: the manuscript department and the department of printed books, which also comprised coins, medallions and prints. Naturally, the history of the Library itself goes much further back. On 12 April 1559, it was decided that all of the then dispersed books in the ruler's possession had to be gathered together in order to provide him and his successors with the opportunity '*d'y povoir prendre passetemps à lire esdicts livres*'.[19] The 'Library of Burgundy' represented the nucleus of this collection, while the collection of manuscripts was already regarded as its crown jewel.

It was the intention from the very beginning that the Belgian Royal Library would amass a collection of prints that would be representative of the history of graphic arts throughout Western Europe. Thus, as early as 1840, the first head curator, Baron Frédéric Auguste de Reiffenberg (1795-1850), noted the necessity of having the important Van Parys collection properly mounted and establishing a good, general classification system for it. Acquired in 1840 for the total sum of 15,000 BEF, the Van Parys collection consisted of no less than 14,318 loose prints, 77 copperplates, and 12 volumes of mounted prints. In 1892, Max Lehrs learned from the curator of the Print Room, Henry Hymans, that this collection was probably the origin of the majority of the twenty-four early Northern prints whose provenance was then 'unknown'.[20]

18

During the second half of the nineteenth century, there was a strong preference for the purchase of prints from the former Low Countries and for Germanic works, in particular prints by such pivotal figures as Martin Schongauer, Israhel van Meckenem and (for the early sixteenth century) Albrecht Dürer, of course. The young Belgian nation desired a tangible past and the acquisition of stocks of art was an important part of that. From the 1850s onwards, early prints were purchased on a relatively large scale and in some cases extremely high prices were paid.

The first noteworthy purchase that caused quite a stir and has yet to become a settled matter was the so-called *Madonna of 1418* (n° 085). In 1844, this woodcut was found on the inside of a chest.[21] It was removed and came into the possession of the Mechelen painter Jan Frans de Noter. In the course of 1844, the head curator, De Reiffenberg, acquired the *Madonna* for the Royal Library for the impressive sum of 500 BEF. He justified his purchase in the 1845 issue of the *Annuaire de la Bibliothèque royale de Belgique* with arguments bearing a nationalistic tinge: '*Attentif à ne pas laisser sortir du pays des choses précieuses que Paris ou Londres n'hésiterait pas à nous enlever, nous sommes parvenu à acquerir ce trésor, au prix de 500 francs, véritable bagatelle pour un morceau de cette importance, unique et inédit . . . Voilà donc Bruxelles en possession d'un monument qui n'existe nulle part, et qui, selon toute apparence, est un monument national, l'oeuvre de nos anciens "printers". L'école flamande de peinture s'y montre en effet avec son caractère natif et individuel. Raison de plus pour nous applaudir de cette conquête.*'[22] The woodcut, which had suffered greatly from humid conditions and had been torn into pieces, was restored and has since then occupied an important place in the collection. But even soon after its purchase, serious questions were raised concerning its 1418 dating. Currently, it is generally accepted that the print should be dated much later, around 1450-60, and that its place of origin is more likely the Upper Rhineland than Flanders. The 1418 date might be either a nineteenth-century forgery, or else a reference to something that occurred in that year.[23]

In the 1848 *Annuaire*, De Reiffenberg noted that various prints by 'old German masters' ('*plusieurs anciens maîtres allemands*') had been acquired form the Weiss collection (Dresden), the Weber collection (Cologne/Bonn), and the Estrade collection (Brussels).[24] He then added with pride that the collection of Dürer prints in the Royal Library was nearly complete and one of the most attractive collections known ('. . . *ont presque complété notre oeuvre d'Albert Durer, qui est aujourd'hui un des beaux que l'on puisse citer*'). The Weiss collection also boasted a few Schongauer prints, but I could not determine which, specifically.[25] Regardless, De Reiffenberg's commentary suggests that at that point in time he was following a thought-out purchasing programme.

As has already been mentioned, in 1849 a group of seven extremely rare niello prints (n° 500 - n° 506) from the Brisard collection (Gent) were purchased by the Royal Library. This collection was one of the most remarkable from the early nineteenth century. However, it is only as of 1858 that we can speak of a systematic and large-scale purchase of 'early' mas-

ters. In that year, eighteen early prints were acquired from the de Borluut de Noortdonck collection (Gent).[26] The most remarkable purchase, however, dates from 1859. In that year, no less than thirty-five engravings by Martin Schongauer were purchased from the Leipzig print dealer Wilhelm Eduard Drugulin (1825-79) for substantial sums of money.[27] Thus, slightly less than half of the Schongauer prints in the collection of the Royal Library – which today consists of seventy-six original prints – were purchased at one time. *The Virgin and Child in a Courtyard* (n° 251), a print that is far from flawless with its stains and hand-drawn border, demonstrates that the buyers were far from stingy, as 877 BEF and 50 centimes was paid for it.[28] In addition, in 1859, the Royal Library purchased from Drugulin five engravings from the Master FVB, four from the Master MZ, and fifteen from Israhel van Meckenem.

The second truly large purchase took place just one year later, in 1860, when the collection of the Gent painter Jozef Paelinck was auctioned off.[29] Paelinck was born on 20 March 1781. He went to Paris as a young man and came to work in David's atelier. He became a successful artist.[30] His collection of prints, which he used primarily for study purposes for himself and his pupils, was extremely extensive. Paelinck returned to Gent and subsequently established himself in Brussels. The following was noted in a report on the sale of his collection: '*Entouré d'envieux, harcelé par des critiques trop sévères, l'artiste abandonna peu à peu ses études et se renferma plus que jamais dans sa bibliothèque laborieusement rassemblée, et qui lui offrit dans sa veillesse des consolations douces et constantes.*'[31] He died in 1839, but his collection was not sold until 20 November 1860. The Royal Library acquired seventeen Schongauers and thirteen engravings by Israhel van Meckenem. In addition, the Print Room became the owner of six prints by or after Andrea Mantegna, but significantly less was paid for these than for the works by the 'Northern' artists (n° 529, 531-534 and n° 542).

Another fourteen early prints were acquired in 1865 at the auction of the renowned collection of Chevalier Joseph-Guillaume-Jean Camberlyn d'Amougies.[32] The subtlety coloured *Family of St Anne* (n° 190), an engraving then attributed to the Master ES was purchased for the sum of 262 BEF and 50 centimes. Later, Lehrs correctly attributed the print to the Master of the Martyrdom of the 10,000. According to Lugt, who singles out this print, it is a superb example of '*la concurrence faite par la gravure à l'enluminure*'.[33] One other noteworthy piece is *The Stigmatization of St Francis*, which was identified as an 'anonymous German work from c. 1480' when it was purchased and is now attributed to the Master WA (n° 329). Camberlyn was born in Gent in 1783 and made a career in the Dutch army. Following the Belgian revolution (1830), he settled in Brussels, where he occupied himself primarily with his collection. He died in 1861 and his collection was auctioned off in Paris on 25 April 1865.[34]

In 1892, Max Lehrs compiled a concise inventory of fifteenth-century northern engravings. Among the smaller collections, he regarded that of the Royal Library as one of the best organised ones in Europe ('*eines der bestgeordneten auf den Continent*').[35]

20

The last large purchase was made while Henry Hymans was the curator of the Print Room. Between 9 and 21 May 1894, in Stuttgart, successful bids were made on prints from the collection of Luigi Angiolini (Milan).[36] Among the most noteworthy acquisitions were nine engravings of the Passion by the Master AG, in the first state (n° 307, n° 309, n° 311- n° 314, n° 316 - n° 318), as well as the three previously mentioned prints after Bramante (n° 548 - n° 550).

Between 1911 and 1914, the famous Delbecq-Schreiber Passion (see, e.g. n° 008) was purchased in four lots of five woodcuts each from the art dealer J. Baer for a grand total of 10,000 BEF. As noted above, from this time onwards, early prints were no longer systematically purchased.

Thus, the majority of the early Northern engravings (Group 2) were acquired thanks to a few thought-out and extremely successful buying campaigns. The collection of Italian prints (Group 4), meanwhile, appears to have been amassed more by happenstance and, furthermore, at much less expense. For example, the largest sum paid out for an Italian work was 200 BEF, which was spent in 1856 for a good impression of *The Virgin and Child Enthroned with St Anne* by the north Italian engraver, the Master Na. Dat (with the Mouse Trap) (n° 573). It is clear that Italian prints were not the top priority for the Royal Library. Nevertheless, there are a few noteworthy Italian works in the collection. Consider, for example, the admirable collection of Mantegna's work, which provides a representative overview of his oeuvre, even though there are no perfect early impressions. Another striking – and to the best of my knowledge, otherwise unknown – print is the counter proof of *The Presentation of Christ* by Lorenzo Costa (n° 572), which was purchased from the Brussels sculptor Starké in 1875 for 60 BEF.

'Early' prints were not only purchased, exchanged or acquired through donations. A good number were also transferred to the Print Room from other collections in the Royal Library. Following an initial important, but accidental discovery c. 1850 of a large number of fragments of woodcuts that had been used to pad the binding of a book, head curator Alvin requested that all of the rare books and manuscripts be systematically examined for prints and other treasures. In 1857, Alvin wrote that this investigation had been successful, resulting in the transfer of dozens of prints to the print department. The most important find by far were the niello prints, mentioned above, that had been included in Van t'Sestich's hand-written notes of c. 1600.[37] Other prints that were transferred to the print department include *The Ship of St Ursula* (n° 105) and the magnificent *St Barbara* (n° 138). The latter is, without question, the most beautiful metal cut in the dotted manner in the collection. The most important engraving in the entire collection was transferred from the manuscript collection to the Print Room on 2 May 1857. The unique impression of *The Large Coat of Arms of Charles the Bold, Duke of Burgundy* (n° 331) was initially attributed to the Master of 1466, and then to the Master W A. As with the *Madonna of 1418* (n° 085) this print is also regularly discussed and gives rise to occasional controversy.[38]

Today, prints that were included in manuscripts are no longer removed. They belong together. In many cases, maintaining the single entity is also essential, although it is striking that prints preserved in manuscripts are generally less well known by those who study prints. When Max Lehrs visited his good friend Henry Hymans in 1892 in order to make an inventory of the engravings in the Royal Library, he restricted himself to the Print Room collection.[39] Apparently, he did not visit the manuscript division, where various extremely rare early engravings (as well as woodcuts) have gone unnoticed to this very day. In this catalogue, many of these prints are recorded and published for the first time (see, e.g. n° 194 - n° 201 and n° 204).

When the Royal Library of Belgium was established in 1837, the Manuscript Department already possessed a basic collection, including a selection of absolutely top quality pieces. In contrast, the collection of early prints had to be built up from virtually nothing when (in the second half of the nineteenth century) good impressions of the work of certain artists were either virtually impossible to find or prohibitively expensive. This is the most important reason why the print collection of the Belgian Royal Library should not be compared with such long-established collections as those in Vienna, London, Paris or Berlin. It is also the reason why the success with which a relatively good overview of early European prints was amassed at the Royal Library before the beginning of the twentieth century is all the more impressive.[40]

NOTES

[1] Other strengths include, for example, the Pieter I Bruegel, the James Ensor and the Wierix prints, and Anthony van Dyck's *Iconography*.
[2] Alvin 1857a.
[3] Lehrs 1892.
[4] This concept is based upon: Richard S. Field, *A Census of Fifteenth-Century Prints in Public Collections of the United States and Canada*, New Haven (Connecticut) 1995.
[5] For this, see: Möller 1981, p. 313: '*Die Angaben über das Ankunftsdatum des "Gallus Indicus" schwanken zwischen 1519/20 und 1525*'. My thanks to Arnout Balis for this reference.
[6] A *Biblia pauperum* (Inc. B 1590); a *Speculum humanae salvationis* (Inc. B 1596); a *Pomerium spirituale* (Ms. 12070), and *The Legend of St Servatius* (Print Room, Ms 18.972).
[7] Passavant II.233.157; Lehrs, 1892, p. 480.
[8] For basic literature regarding niello plates and prints, see: Alvin 1857a; Dutuit 1888; Hind 1936; Blum 1950; Washington 1973, pp. 528-31; TIB, vol. 24.1 Commentary, pp. 1-2; and Lambert 1999, pp. 3-4.
[9] G. van Doorselaer, art. 't Sestich (Jean van)' in: *Biographie nationale*, vol. 25, Brussels 1930-32, col. 619-20.
[10] The manuscript is preserved in the Manuscript Department (Ms. 4086) (VDG 2774). On fol. 483, one can read: '*Dictavit clarissimus Dom. Doct. Gerardus Corselius I.V. Doctor-Postmodum primarius antecessor M.D.C. Excepit Ioann. van Sestich postmodum I.U. Doctor ac Praeses Collegii Donatiani et deinde regius decretorum professor*'. The manuscript contains many additional, more recent prints.
[11] Doubles from the Print Room of the Royal Library were never sold, but exchanged. In this specific case, it is obviously most regrettable that the van t'Sestich collection was torn apart.
[12] Lambert 1999, p. xlix and p. 4.
[13] Duchesne 1834, pp. 326-27.
[14] TIB, vol. 24.1 Commentary, pp. 1-2. The original items were sold in 1872 (H. G. Gutekunst, *Catalog der kostbaren und altberühmten Kupferstich-Sammlung des Marchese Jacopo Durazzo in Genua*, vol. 1, Stuttgart, 19 November 1872).
[15] A. Zanetti, *Le premier siècle de la calcographie ou catalogue raisonné des estampes du cabinet de feu M. le Comte Léopold Cicognara, avec un appendice sur les nielles du même cabinet: Ecole d'Italie*, Venice 1837, p. 94.
[16] Washington 1973, p. 528.

[17] The last very important purchase took place in March 1914 (see n° 008).

[18] For a general overview of the history of the print department, see: Marie Mauquoy-Hendrickx, 'Het Prentenkabinet', in: *Liber Memorialis 1559-1969*, Brussels 1969, pp. 231-69 (exists also in a French edition).

[19] W. Vanderpijpen, 'Koninklijke Bibliotheek (1559-1794)', in: E. Aerts, M. Baelde, a.o. (eds.), *De centrale overheids-instellingen van de Habsburgse Nederlanden (1482-1795)*, vol. 2, Brussels 1994, p. 921 (exists also in a French edition).

[20] Lehrs 1892, p. 480: '*Die Mehrzahl der in dem nachstehenden Verzeichniss ohne Provenienz aufgeführten 24 Blätter dürfte daher aus der Sammlung van Parys stammen.*'

[21] De Reiffenberg 1845(a), p. 258: '*Il y a quelques semaines, on allait briser à Malines un vieux coffre dont on avait extrait des archives moisies. Dans l'intérieur du couvercle était collée une estampe à peine visible*'.

[22] De Reiffenberg 1845(a), p. 259 and p. 263.

[23] Lebeer 1981.

[24] De Reiffenberg 1848, p. 26.

[25] Lehrs 1892, p. 480.

[26] Lugt, *Ventes* 24531. For archival evidence on this sale see: Brussels, State Archives of Belgium, *Archives of the Royal Library Albert I*, n° 203 (2348x).

[27] F. Lugt, *Les marques de collections de dessins & d'estampes*, vol. 1, Amsterdam 1921, p. 490. For archival evidence on this sale see: Brussels, State Archives of Belgium, *Archives of the Royal Library Albert I*, n° A440.

[28] The most expensive 'early' print purchased by the Royal Library in the nineteenth century was Martin Schongauer's *The Bearing of the Cross* (n° 221), which was bought from the Brussels print dealer Van Gogh on 25 June 1875, for the sum of 1,100 BEF. On 10 February 1883, 1,000 BEF was paid for Israhel van Meckenem's *St Anne with Mary and the Child* (n° 389).

[29] Lugt, *Ventes* 25811. For archival evidence on this sale, see: Brussels, State Archives of Belgium, *Archives of the Royal Library Albert I*, n° 334 and n° A440.

[30] On Jozef Paelinck (1781-1839), see: Denis Coekelberghs & Pierre Loze (eds.), *Om en rond het neo-classicisme in België 1770-1830* (exhibition cat.), Elsene (Brussels) 1985, pp. 193-201 (exists also in a French edition). See also: Maurice Heins, art. 'Paelinck (Joseph)', in: *Biographie nationale*, vol. 16, Brussels 1901, col. 448-52.

[31] 'Le cabinet de Jos. Palinck', *Bulletin du Bibliophile Belge*, 16, 1860, p. 384.

[32] Lugt, *Ventes* 28481. For archival evidence on this sale, see: Brussels, State Archives of Belgium, *Archives of the Royal Library Albert I*, n° 349 and n° A440.

[33] F. Lugt, *Les marques de collections de dessins & d'estampes*, vol. 1, Amsterdam 1921, p. 47.

[34] Ibid, pp. 93-4.

[35] Lehrs 1892, pp. 479-80.

[36] Lugt, *Ventes* 53517.

[37] Alvin 1857(a) and Alvin 1857(b). See also: Brussels, State Archives of Belgium, *Archives of the Royal Library Albert I*, n° 341 and n° A 440.

[38] See also: Brussels, State Archives of Belgium, *Archives of the Royal Library Albert I*, n° 358 (5018 O)

[39] Lehrs 1892.

[40] There are a few significant lacunas in the collection. For example, there is not one engraving by Alaert Du Hameel, who was, without doubt, one of the leading engravers active in the Low Countries at the end of the fifteenth century.

I.

ANONYMOUS WOODCUTS
METAL CUTS AND WHITE-LINE PRINTS
OF THE
FIFTEENTH AND EARLY SIXTEENTH
CENTURIES

I.

Anonymous Woodcuts, Metal cuts and White-line prints of the Fifteenth and Early Sixteenth Centuries

WOODCUTS

001 THE ANNUNCIATION Inc A 1212 RP
 102 x 71 mm back pastedown
 coloured

Affixed to the back pastedown of a *Breviarium Antverpiense* (Venice: Johannes Hamman for Cornelius de Bomberg, 1496) (Polain, 869).
Provenance: The book was purchased in 1837 from the Collection Charles Van Hulthem.
Literature: Schr.I.39c; Dodgson 1929, pl. XVII, 26.

002 THE ANNUNCIATION Ms.11237, fol. 64v
 60 x 53 mm coloured

Inserted in a sixteenth-century Dutch manuscript with devotional texts. The book was intended for the Poor Clares (1516-19). See also n° 006, n° 075, and n° 088.
Provenance: Paris, Bibliothèque nationale (stamp on fol. 1r).
Literature: [Schr.IX.49.ab].

003 THE NATIVITY AND ANNUNCIATION TO THE Ms.4604, fol. 30r
 SHEPHERDS WITH THE MAGI AND ST JEROME coloured
 114 x 81 mm

Inserted in a sixteenth-century Dutch *Sammelband* with ascetic texts (*Die VII blijscapen van Maria die Moeder Gods*: fols. 1-146). It seems likely that this print was made in (or for) the Carmelite convent Onze-Lieve-Vrouw-ten-Troost in Peutie, near Vilvoorde (Belgium, Brabant). It is related stylistically to n° 034. Another print from this convent was similarly inserted in this manuscript (n° 065). See also n° 011, n° 065, and n° 111.
Provenance: Unknown.
Literature: [Schr.IX.90.b]; VDG 2400. See also n° 065.

004 THE BAPTISM OF CHRIST Ms.4660-61, fol. 155v
 85 x 68 mm coloured

Inserted in a sixteenth-century Dutch *Sammelband* with ascetic texts. See also n° 059 and n° 063.
Provenance: Bruges, Jesuits (noted on fol. 2r: *Societatis Jesu Brugis*). The manuscript was originally in a convent (cf. note on fol. 1r: '*Dezen boeckin hebbe ic toe ghelaete(n) naer mij(ne) doot m(et) hoerlof va(n) ons eerweerdeghe mater prioresse mij(n) lieve kint suster Tanneki(n) Cosins . . .* ').
Literature: [Schr.IX.131.m]; VDG 2401.

005 THE TRANSFIGURATION OF CHRIST Ms.IV.4, fol. 43v
approx. 104 x 67 mm coloured

This print may be an impression of (or else a copy after?) Schr.I.140b. Inserted in a fifteenth-century Dutch and Latin manuscript with lives of saints and prayers. The print is seriously damaged.
Provenance: Unknown (possibly the Northern Netherlands). The manuscript was recorded in the inventory on 15 October 1952, but was already in the collection for an unknown amount of time prior to this.
Literature: Schr.I.140b (?); Deschamps & Mulder 2000, pp. 39-40.

006 CHRIST AND THE WOMAN OF SAMARIA Ms.11237, fol. 93v
68 x 52 mm coloured

Inserted in a sixteenth-century Dutch manuscript with devotional texts. The book was intended for the Poor Clares (1516-19). See also n° 002, n° 075, and n° 088.
Provenance: See n° 002.
Literature: [Schr.IX.141.d].

007 CHRIST IN THE HOUSE OF SIMON Ms.II.2098,
92 x 74 mm between fols.154-155
 coloured

Inserted in a sixteenth-century Dutch manuscript of sermons (dated 1574) with texts by Henricus Cool. The date 1574, which appears twice in the manuscript, pertains to Cool's preaching and not to the execution of the manuscript (cf. *Manuscrits datés conservés en Belgique*, VI: *1541-1600*, Brussels, 1991, n° A464). See also n° 062.
Provenance: The manuscript was purchased in 1898 at the Van den Eynden Sale, Antwerp (16 BEF).
Literature: [Schr.IX.147m]; VDG 2017.

008 CHRIST IN THE HOUSE OF SIMON fol.rés.S.II.137459
(*Delbecq-Schreiber Passion*, n° 1) coloured
89 x 67 mm

This print belongs to the so-called *Delbecq-Schreiber Passion*, a series of twenty coloured woodcuts. The woodcuts were affixed into a manuscript, individual folios of which were sold in 1845. Twenty-one, not twenty, prints were sold, as the series contained a copy in reverse of one subject (*The Crucifixion*, see n° 028). According to the auction catalogue (pp.15-16), these prints, along with a series of seven circular woodcuts of the *Seven Sorrows of the Virgin* (present location unknown) and various other prints, were put in one manuscript. The woodcuts were consistently mounted on the leaves of the manuscript and were given a decorative penwork border. The manuscript contains a Latin commentary on the Passion, which is related to Heinrich Suso's *Honderd Artikelen*. On the basis of the handwriting, the manuscript was probably written c.1500.
Provenance: Collection of Jan Frans van de Velde, librarian for the University of Gent (1743-1823). Purchased by Jean-Babtiste Delbecq (1771-1840) on 5 August 1833. Delbecq Sale,

Paris, 18 February 1845 ff. (Lugt, *ventes* 17629). See: Delande and T. Thoré, *Catalogue des estampes anciennes formant la collection de feu M. Delbecq, de Gand. Première partie: Ecole allemande, 15e et 16e siècles*, Paris 1845, n° 60. Purchased by an unknown art dealer; bought by Wilhelm Ludwig Schreiber (1855-1932) in 1890 from Georg Gutekunst, Stuttgart. Schreiber Sale, Vienna, 1909 (bought by Joseph Baer & co., Frankfurt) (Lugt, *ventes* 67281). See: *Catalogue de la collection précieuse de W.L. Schreiber ... contenant les monuments très anciens de la gravure sur bois ... Vente enchères à Vienne* (1909) n° 65. Purchased by the Royal Library from J. Baer in four parts of five prints each in February 1911, December 1911, January 1913 and March 1914, for a total of 10,000 BEF.
Literature: Schr.I.148; H.*Dutch*.XII.138; Heitz 12 (1908); Heitz 29 (1912); Hisette 1914; Heitz 77 (1932); Delen 1932; Delen 1933; Delen 1943; De Meyer 1970, p. 14 and ill. 20-23; Cockx-Indestege 1990 (with comprehensive bibliography).

009 THE LAST SUPPER fol.rés.S.II.137460
(*Delbecq-Schreiber Passion*, n° 2) coloured
87 x 65 mm
Provenance: See n° 008.
Literature: Schr.I.175. See also n° 008.

010 AGONY IN THE GARDEN fol.rés.S.II.137461
(*Delbecq-Schreiber Passion*, n° 3) coloured
87 x 67 mm
Provenance: See n° 008.
Literature: Schr.I.198. See also n° 008.

011 AGONY IN THE GARDEN Ms.4604, fol. 250v
73 x 62 mm coloured
Inserted into a sixteenth-century Dutch *Sammelband* with ascetic texts. See also n° 003, n° 065, and n° 111.
Provenance: See n° 003.
Literature: [Schr.IX.204.b]. See also n° 003.

012 THE BETRAYAL OF CHRIST fol.rés.S.II.137462
(*Delbecq-Schreiber Passion*, n° 4) coloured
88 x 66 mm
Provenance: See n° 008.
Literature: Schr.I.222. See also n° 008.

013 CHRIST BEFORE ANNAS fol.rés.S.II.137463
(*Delbecq-Schreiber Passion*, n° 5) coloured
88 x 66 mm
Provenance: See n° 008.
Literature: Schr.I.232. See also n° 008.

014 CAIAPHAS TEARING HIS CLOTHES
(*Delbecq-Schreiber Passion*, n° 6)
88 x 66 mm
Provenance: See n° 008.
Literature: Schr.I.239. See also n° 008.

fol.rés.S.II.142467
coloured

015 THE MOCKING OF CHRIST
(*Delbecq-Schreiber Passion*, n° 7)
88 x 66 mm
Provenance: See n° 008.
Literature: Schr.I.253. See also n° 008.

fol.rés.S.II.152771
coloured

016 CHRIST BEFORE PILATE
(*Delbecq-Schreiber Passion*, n° 8)
88 x 66 mm
Provenance: See n° 008.
Literature: Schr.I.259. See also n° 008.

fol.rés.S.II.142466
coloured

017 PILATE WASHING HIS HANDS
(*Delbecq-Schreiber Passion*, n° 9)
88 x 66 mm
Colour plate I
Provenance: See n° 008.
Literature: Schr.I.278. See also n° 008.

fol.rés.S.II.142464
coloured

018 THE FLAGELLATION
(*Delbecq-Schreiber Passion*, n° 10)
88 x 66 mm
Provenance: See n° 008.
Literature: Schr.I.297. See also n° 008.

fol.rés.S.II.142463
coloured

019 THE CROWNING WITH THORNS
AND THE MOCKING OF CHRIST
(*Delbecq-Schreiber Passion*, n° 11)
88 x 66 mm
Provenance: See n° 008.
Literature: Schr.I.324. See also n° 008.

fol.rés.S.II.152772
coloured

020 ECCE HOMO
(*Delbecq-Schreiber Passion*, n° 12)
88 x 66 mm
Provenance: See n° 008.
Literature: Schr.I.332. See also n° 008.

fol.rés.S.II.152773
coloured

021 THE BEARING OF THE CROSS Ms.4919, fol. 182r
 93 x 69 mm coloured

Inserted into a fifteenth-century manuscript with Dutch prayers.

Provenance: The manuscript came from the St Elisabeth convent at Grootebroek (prov. Noord-Holland, in the Northern Netherlands) (handwritten note on fol. 182r, the page to which the woodcut was affixed: *'dit boec hoert in . . . e broec in sinte Elisabeths conuent'*. Another note (from the eighteenth or nineteenth century) on fol. 1r reads: *'Ex Bibliotheca P(atru)m Discalceatorum seminarii Missionum'*.

Literature: [Schr.IX.349m]; VDG 838; Meertens 1934, p. 39; Marrow 1979, p. 245, n° 212; Deschamps & Mulder 1998, pp. 19-21.

022 THE BEARING OF THE CROSS fol.rés.S.II. 152774
 (*Delbecq-Schreiber Passion*, n° 13) coloured
 87 x 66 mm

Provenance: See n° 008.
Literature: Schr.I.351. See also n° 008.

023 CHRIST STRIPPED OF HIS RAIMENT fol.rés.S.II.142510
 (*Delbecq-Schreiber Passion*, n° 14) coloured
 87 x 65 mm

Provenance: See n° 008.
Literature: Schr.I.366. See also n° 008.

024 CRUCIFIXION WITH THE VIRGIN AND ST JOHN Ms.21056, fol. 4r
 102 x 65 mm coloured

The woodcut was inserted in a French and Italian manuscript, with a description by Lambertus Darmont of a journey to the Holy Land (sixteenth century). See also n° 025.

Provenance: Unknown.
Literature: [Schr.IX.442.a]; VDG 7440.

025 CRUCIFIXION WITH THE VIRGIN AND ST JOHN Ms.21056, fol. 83r
 101 x 65 mm coloured

The same woodcut as n° 024.
Provenance: See n° 024.
Literature: See n° 024.

026 CRUCIFIXION fol.rés.S.II.36008
 WITH THE VIRGIN AND ST JOHN coloured
 68 x 55 mm

This woodcut is printed on velum.

Provenance: Purchased from Gutekunst (Stuttgart). Recorded in the inventory on 15 January 1887 (20 BEF).

Literature: Schr.I.460; Antwerp 1930, p. 86.

028 CRUCIFIXION fol.rés.S.II.152770
(*Delbecq-Schreiber Passion*, n° 15) coloured
88 x 66 mm
Provenance: See n° 008.
Literature: Schr.I.488. See also n° 008.

029 THE DESCENT FROM THE CROSS fol.rés.S.II.142508
(*Delbecq-Schreiber Passion*, n° 16) coloured
88 x 67 mm
Provenance: See n° 008.
Literature: Schr.I.500. See also n° 008.

030 THE LAMENTATION fol.rés.S.IV.14848
(with printed decorative border) coloured
110 x 80 mm (incl. border)
Colour plate II
The Dutch woodcut text below reads: *'Tonser Lieu Vrouwen te Betenie'*. This print was made in the convent of the canonesses regular of St Augustine, called Bethanië, near Mechelen. The holes along the left edge of the paper indicate that the woodcut was bound into a volume (a manuscript?) at some point in time.
Provenance: Purchased from J. van Overloop, Antwerp. Recorded in the inventory on 20 November 1933.
Literature: [Schr.IX.508c]; Lebeer 1947, p. 456; Brussels 1961, n° 1; De Meyer 1970, p. 13 and ill.10; Mauquoy-Hendrickx 1975, pp. 181-82.

031 THE LAMENTATION fol.rés. S.II.11638
(without decorative border) not coloured
75 x 52 mm
Copy (?) after n° 030. This print may also have been printed at the Bethanië convent near Mechelen. At one time, this woodcut (together with n° 057) was bound into a volume (a manuscript?).
Provenance: Gift of F. Van der Haeghen (Gent). Entered in the inventory on 9 December 1869.
Literature: [Schr.IX.508d].

032 THE LAMENTATION rés. S.IV.16642, in
(without decorative border) front of fol. 1r
78 x 58 mm sparsely coloured
Copy (?) in reverse after n° 030. Inserted in a Dutch manuscript *Stationes ecclesiarum urbis Romae* (after 1515). The manuscript is kept in the Print Room and not in the Manuscript Department.
Provenance: Purchased from Mr Macoir, Brussels. Entered in the inventory on 31 July 1934.
Literature: [Schr.IX.508e]; Miedema 1996.150.N8.

033 THE ENTOMBMENT fol.rés. S.II. 142507
(*Delbecq-Schreiber Passion*, n° 17) coloured
88 x 67 mm
Provenance: See n° 008.
Literature: Schr.I.527. See also n° 008.

034 THE HOLY FAMILY IN EGYPT fol.rés. S.II.142511
105 x 80 mm coloured
Colour plate II
The Dutch woodcut text below reads: '*Ghepri(n)t tonser liever suet vrouwe(n) te(n) troost*'. The woodcut was printed in the Carmelite convent of Onze-Lieve-Vrouw-ten-Troost in Peutie, near Vilvoorde (Belgium, Brabant).
Provenance: Collection Schreiber (See Heitz 14 (1908), n° 4). Purchased by the Royal Library from Baer (Frankfurt am Main) (400 BEF). Entered in the inventory on 17 January 1913.
Literature: Schr.I.638; Heitz 14 (1908), n° 4; Van der Linden 1908, pp. 412-13; Kruitwagen 1924, p. 47; Spamer 1930, pp. 22 and 33; Lebeer 1935, p. 202; Lebeer 1953, pp. 209-10; Ampe 1964, pp. 77-78; De Meyer 1970, p. 14 and ill. 15; Van der Stock 2000, pp.147-48, n° 249a.

035 CHRIST'S FALL AT CEDRON BROOK fol.rés. S.I. 2354
(*Seven Falls of Christ*, n° 1) coloured
123 x 85 mm
This print belongs to a series of seven images referred to as the *Seven Falls of Christ*, five of which are preserved. Each woodcut contains two lines of Dutch text (cut into the wood). The woodcut text at the top reads: '*Dits de(n) yrste(n) val doe(n) Jhesus werdt ghe / worpe(n) va(n)de(n) steegher in dat water Credo(n)*'. A closely related series of seven prints with German captions is preserved in the National Museum of Stockholm (Schr.I.642; 644; 646; 652; 654; 659 and 685). Another closely related print with the *Seven Falls of Christ* (from c.1480) is located in Vienna, Albertina. The Brussels series may be based upon the print in Vienna.
Provenance: Unknown.
Literature: [Schr.IX.642a]; Antwerp 1930, pp. 83-84; De Meyer 1970, ill. 9; Marrow 1979, p. 287 (note 376), pp. 296-97 (note 445) and p. 307 (note 526).

036 CHRIST'S FALL ON THE WAY TO HEROD fol.rés. S.I. 2355
(*Seven Falls of Christ*, n° 2) coloured
117 x 86 mm
The Dutch woodcut text at the top reads: '*Dit is de(n) andere(n) val die Jhesus viel inde(n) / weghe als he(m) Pylat(us) sandt tot Herodem*'.
Provenance: See n° 035.
Literature: [Schr.IX.644a]. See also n° 035.

037 CHRIST'S FALL ON THE STEPS OF fol.rés. S.I. 2356
 THE HALL OF JUSTICE coloured
 (*Seven Falls of Christ*, n° 3)
 119 x 85 mm

The Dutch woodcut text at the top reads: *'Dits de(n) derde(n) val als Ihesus ned(er)viel op / die trappe(n) van Pilat(us) huyse door grote py(n)'*.
Provenance: See n° 035.
Literature: [Schr.IX.646a]. See also n° 035.

038 CHRIST'S FALL BEFORE THE COLUMN fol.rés. S.I.2357
 OF THE FLAGELLATION coloured
 (*Seven Falls of Christ*, n° 4)
 119 x 89 mm

The Dutch woodcut text at the top reads: *'Dits de(n) vierde(n) val als Ihesus geghecselt / vander colo(n)nen neder viel machteloos'*.
Provenance: See n° 035.
Literature: [Schr.IX.652a]. See also n° 035.

039 CHRIST'S FALL WHILE BEARING THE CROSS fol.rés. S.I.2358
 (*Seven Falls of Christ*, n° 5) coloured
 118 x 84 mm

The Dutch woodcut text at the top reads: *'Dits de(n) vyfste(n) val doe(n) Jhesus mette(n) cru / ce ghelade(n) ghi(n)c v(er)ordeelt om o(n)se mesdade(n)'*.
Provenance: See n° 035.
Literature: [Schr.IX.654a]. See also n° 035.

040 CHRIST'S FALL WHILE BEARING THE CROSS Ms.5106, fol. 9v
 113 x 87 mm coloured

Inserted into a sixteenth-century Dutch (Utrecht) Breviary (vol. 1). See also n° 102 (Ms.4249-50).
Provenance: Antwerp Jesuits (inscribed on fol. 1r: *'Soc(ieta)tis Iesu Ant(verpiensis) D.P.'* (fol. 1r)).
Literature: [Schr.IX.654m]; VDG 588.

041 THE PREPARATION FOR THE CRUCIFIXION fol.rés. S.II.142509
 (*Delbecq-Schreiber Passion*, n° 18) coloured
 87 x 65 mm

Provenance: See n° 008.
Literature: Schr.I.663. See also n° 008.

042 CHRIST NAILED TO THE CROSS fol.rés. S.II.7793
 91 x 67 mm coloured

This print is a free copy after n° 043. The holes indicate that the print was sewn into a codex
(a manuscript?) at one time. This woodcut belongs with n° 056 and n° 061, all of which
were included in the same codex.
Provenance: Gift of F. Van der Haeghen (Gent). Entered in the inventory on 10 April 1865.
Literature: Schr.I.673 (=Schr.I.674?); Heitz 14 (1908), n° l7; Antwerp 1930, p. 80.

043 CHRIST NAILED TO THE CROSS fol.rés. S.II.142506
 (*Delbecq-Schreiber Passion*, n° 19) coloured
 87 x 66 mm

Provenance: See n° 008.
Literature: Schr.I.675. See also n° 008.

044 LAMENTATION WITH MATER DOLOROSA fol.rés. S.I.23264
 and fragment of THE SIXTH JOY OF THE VIRGIN not coloured
 two fragments: together >258 x >205 mm

This print bears the Dutch text '*die.VI.blischap*' cut into the woodblock. The fragments were
probably recycled as lining for a book cover. It belongs with n° 045. The two pieces may
have been part of the same print.
Provenance: Unknown. The same (?) provenance as n° 122?
Literature: [Schr.IX.687m]; Nijhoff 380a.

045 LAMENTATION WITH MATER DOLOROSA fol.rés.S.I.23250
 and THE SEVENTH JOY OF THE VIRGIN not coloured
 two fragments: together >292 x >200 mm

This print bears the Dutch text '*die.VII.blischap*' cut into the woodblock. The fragments were
probably recycled as lining for a book cover. See also n° 044.
Provenance: Unknown. The same (?) provenance as n° 122?
Literature: [Schr.IX.687n]; Nijhoff 380b; De Meyer 1970, ill.6.

046 CHRIST IN LIMBO fol.rés.S.II.142465
 (*Delbecq-Schreiber Passion*, n° 20) coloured
 87 x 66 mm

Colour plate I
Provenance: See n° 008.
Literature: Schr.I.691. See also n° 008.

047 CHRIST APPEARS TO THE VIRGIN fol.rés.S.II.6779
 104 x 79 mm coloured

Belongs to a group of eight from a Dutch prayer book dating from 1552/53 (Ms.22012). This
woodcut dates from the sixteenth century. See also n° 049, n° 210 and n° 437.

Provenance: Gift of M. Van der Beelen. Entered in the inventory on 10 April 1863. See also n° 049.
Literature: [Schr.IX.701b]. See also n° 049.

048 THE CORONATION (OF THE VIRGIN) fol.rés.S.I.23299
BY THE TRINITY coloured
Fragment (cut out: >115 x >140 mm)
Cut out. This fragment may have been recycled as lining for a book cover.
Provenance: Recorded in the inventory as *'de la collection reliée par J. Weber 1851'*. See also n° 130.
Literature: [Schr.IX.731b].

049 THE HOLY SPIRIT Ms.22012, fol. 32v
Fragment (cut out): 64 x 62 mm coloured
Inserted in a Dutch prayer book dating from 1552/53 (cf. the colophon on fol. 171v: *'Gheent ende volschreue(n) is dit / boeckske te Bruesel int jaer / ons heere(n) M ccccc en(de) liij / op den xvi dach va(n) Appril'*). See also n° 047, n° 210 and n° 437.
Provenance: Catharina vanden Brugge (coat of arms and note on fol. 1r: *'suster Catharina vanden Brugge a(n)no 1552'*). The manuscript was written in Brussels and was given to the Royal Library by Mr Van der Beelen. Entered in the inventory on 10 April 1863.
Literature: [Schr.IX.752a]; VDG 864.

050 THE INFANT JESUS WITH A BIRD Ms.IV.511,
(New Year's Greeting) front pastedown
187 x 135 mm coloured
Colour plate IV
Affixed to the front pastedown of a German prayer book with lives of the saints. See also n° 051.
Provenance: Purchased from the book dealer Allan G. Thomas (London) in 1968.
Literature: Schr.II.783; Heitz 1 (1909), n° 13; Heitz 22 (1911), n° 15.

051 THE INFANT JESUS WITH A BIRD Ms.IV.511,
(New Year's Greeting) back pastedown
165 x 133 mm coloured
Affixed to the back pastedown of a German prayer book with lives of the saints. See also n° 050.
Provenance: See n° 050.
Literature: Schr.II.784; Heitz 1 (1909), n° 14. See also n° 050.

052 CHRIST AS SAVIOR Ms.II.4557, fol. 1v
(with decorative border) coloured
>100 x >72 mm (trimmed)

Printed on velum and inserted in a Dutch prayer book (before 1522). Latin prayers were written on the verso of the print (fol. 1r).

Provenance: Purchased from De Becker, Brussels. Entered in the inventory on 5 January 1909.

Literature: [Schr.IX.834m].

053 CHRIST IN THE WINEPRESS Ms.2945, fol. 136r
 90 x 64 mm coloured

Inserted in a sixteenth-century Dutch *Sammelband* with ascetic texts. See also n° 074. Two lines of Dutch text were added in letterpress under the print: *'Ick hebbe die persse alleen ghetreden / ende om uwer sonden al gheleden'*.

Provenance: Inscribed on the spine of the manuscript: *'Desen . . . toe Anna Somers die . . .'*; Paris, Bibliothèque nationale (stamps on fols. 3r and 219v).

Literature: [Schr.IX.844m]; VDG 2433.

054 MAN OF SORROWS fol.rés.S.IV.367
 (half figure) not coloured
 395 x 255 mm

Modern impression. The woodblock was acquired by the Soloani firm (Modena), which produced reprints from the old block between 1640 and 1870. The woodblock is now preserved at the Pinacoteca of Modena (see also n° 078 and n° 114 - n° 120). The LK (Ludwig Krug) monogram is not original.

Provenance: Purchased from G. Lebrun, Brussels. Entered in the inventory on 12 April 1932.

Literature: Schr.II.854; Heitz 80 (1933), n° 37.

055 MAN OF SORROWS fol.rés.S.I.23191
 (half figure) sparsely coloured
 104 x 72 mm

Provenance: Unknown.

Literature: Schr.II.870; Antwerp 1930, pp. 85-86.

056 MAN OF SORROWS fol.rés.S.II.7791
 (half figure) coloured
 95 x 68 mm

The holes indicate that this print was sewn into something (a manuscript?) at one time. This woodcut belongs with n° 042 and n° 061. The Latin woodcut text in the banderole reads: *'Ecce homo'*

Provenance: Gift F. Van der Haeghen (Gent). Entered in the inventory on 10 April 1865.

Literature: Schr.II.873; Antwerp 1930, p. 80.

057 MAN OF SORROWS (STANDING IN THE TOMB) fol.rés.S.II.11637
 91 x 52 mm not coloured

At one time, this woodcut was bound in with n° 031 in one volume (a manuscript?). The Dutch woodcut text below reads: *'O XPE* [Christe] *Iesu dyn heylighe / passie cruys naeghelen / ende doot speere gheef / selen croone traenen wo(n) / de(n) root. Zweet water / bloet ende U pyne groot / moeten mynder zielen / troost zyn ter lester noot.'*
Provenance: Gift of F. Van der Haeghen (Gent). Entered in the inventory on 9 December 1869.
Literature: Schr.II.874.

058 MAN OF SORROWS Ms.18982, fol. 16v
 104 x 76 mm (with decorative border) coloured

Inserted in a sixteenth-century Dutch and Latin prayer book. See also n° 064 and n° 067. The Latin woodcut text in the banderole reads: *'Ecce . homo .'*
Provenance: Paris, Bibliothèque nationale (?) (traces of a stamp on fol. 75v).
Literature: Schr.II.892a (?); VDG 860.

059 MAN OF SORROWS Ms.4660-61, fol. 138v
 82 x 64 mm coloured

Inserted in a sixteenth-century Dutch *Sammelband* with ascetic texts. See also n° 004 and n° 063. The Latin woodcut text in the banderole reads: *'Ecce . homo .'*
Provenance: See n° 004.
Literature: [Schr.IX.896m]. See also n° 004.

060 MAN OF SORROWS (KNEELING) Ms.4583, fol. 8v
 93 x 70 mm coloured

Inserted in a fifteenth- (early sixteenth- ?) century Dutch *Sammelband* with ascetic texts. The Dutch woodcut text in the banderole reads: *'O me(n)sche om dyn mesdade(n) / bin ic mette(n) cruce ghelade(n)'*. This print is the same as the next woodcut (n° 061).
Provenance: Paris, Bibliothèque nationale (stamps on fols. 2r and 357v).
Literature: Schr.II.903; VDG 2399.

061 MAN OF SORROWS (KNEELING) fol.rés.S.II.7792
 92 x 68 mm coloured

The holes indicate that this print was sewn into something at one time (a manuscript?). The Dutch woodcut text in the banderole reads: *'O me(n)sche om dyn mesdade(n) / bin ic mette(n) cruce ghelade(n)'*. This woodcut belongs with n° 042 and n° 056. It is the same as the previous woodcut (n° 060).
Provenance: Gift of F. Van der Haeghen (Gent). Entered in the inventory on 10 April 1865.
Literature: Schr.II.903; Antwerp 1930, pp. 80-81; De Meyer 1970, ill. 17.

062 MAN OF SORROWS (KNEELING) Ms.II.2098,
 121 x 87 mm between fols. 86-87
 coloured

Inserted in a sixteenth-century Dutch manuscript of sermons (dated 1574) with texts by
Henricus Cool. The Dutch woodcut text below reads: *'O heere Ih(es)us duer de cracht / va(n)
huwer ledy(n)ghe en(de) wo(n)den / vergheeft al onse zonden'*. See also n° 007.
Provenance: See n° 007.
Literature: [Schr.IX.908bbb]. See also n° 007.

063 MAN OF SORROWS Ms.4660-61, fol. 73v
 98 x 74 mm coloured

Inserted in a sixteenth-century Dutch *Sammelband* with ascetic texts. See also n° 004 and
n° 059.
Provenance: See n° 004.
Literature: [Schr.IX.909m]. See also n° 004.

064 MAN OF SORROWS WITH THE VIRGIN Ms.18982, fol. 23v
 91 x 82 mm coloured

The woodcut text below reads: *'Ghepri(n)t te(n) carmelytersse te(n) troost vive deo'*. The
woodcut was printed at the Carmelite convent of Onze-Lieve-Vrouw-ten-Troost in Peutie,
near Vilvoorde (Belgium, Brabant). Inserted in a sixteenth-century Dutch and Latin prayer
book. See also n° 058 and n° 067.
Provenance: See n° 058.
Literature: [c. Schr.913.1]. See also n° 058.

065 CHRIST'S FALL WHILE BEARING THE CROSS Ms.4604, fol. 206v
 105 x 72. mm coloured
 Colour plate II

Inserted in a sixteenth-century Dutch *Sammelband* with ascetic texts. The Dutch woodcut
text in the banderole reads: *O ghi alle die hier lijdt voer bi / Siet wat ic leden heb om di*. The
woodcut text below reads: *'Ghepri(n)t to(n)ser liever vrouwe(n) te(n) troost'*. The woodcut was
printed at the Carmelite convent of Onze-Lieve-Vrouw-ten-Troost in Peutie, near Vilvoorde
(Belgium, Brabant) and was placed just before the text *'Die gulden litanije van der passien ons
liefs heeren'* (fols. 207r – 223r). See also n° 003, n° 011 and n° 111.
Provenance: See n° 003.
Literature: Schr.II.924a; VDG 2400; Dodgson 1903.67.A39; Heitz 49 (1918), n° 6; Kruitwagen
1924, pp. 47-48; Lebeer 1935, p.202; Lebeer 1953, p.210; Ampe 1964, p.77; De Meyer 1970,
p.14 and ill.16; Van der Stock 2000, pp. 148-49 (n° 249b). See also n° 003.

066 THE CRUCIFIXION fol.rés.S.I.23042
 111 x 81 mm (with decorative border) coloured

The Dutch woodcut text reads: *'O my(n) god waer heb / dy my ghelaten'*. The following was
written in brown ink on the verso of the print: *'By my U lieve dochtere Sustere Ma(rie) /*

Speeckardt'. This print was probably made at the Bethanië convent near Mechelen (compare, e.g. the border and the style with n° 030). It is not clear whether the nun Marie Speeckardt made the print, coloured it or gave it to someone as a present. This print is identical to n° 067.

Provenance: Previously in *'incunabel n° 1017'* (which is noted on the verso of the print). It is not yet clear to which incunabula, precisely, this refers. There is no trace of the earlier presence of the print in either the book with inventory number 1017 (=Inc. B 191) or the incunabula with the location number Inc. B 1017. Inc A 1017 may have been meant instead, which is: Hugo Spechtshart, *Flores musicae*, Strasbourg: Johann Prüss, 1488. This incunabula was originally in the Fétis Collection (n° 5939; Polain, 2036 or 2036A). However, this book disappeared prior to 1923.

Literature: Schr.II.933; Antwerp 1930, p.82; De Meyer 1970, ill.13.

067 THE CRUCIFIXION Ms.18982, fol. 12v
107 x 78 mm (with decorative border) coloured

Inserted in a sixteenth-century Dutch and Latin prayer book. See also n° 058 and 064. The Dutch woodcut text reads: *'O my(n) god waer heb / dy my ghelaten'*. This print is identical to n° 066.

Provenance: See n° 058.
Literature: Schr.II.933. See also n° 058 and n° 066.

068 THE CRUCIFIXION fol.rés.S.IV.14847
114 x 76 mm coloured

This sixteenth-century print has a prayer handwritten in Dutch on the verso. Most likely it was at one point folio *xcv* [95] in a manuscript.

Provenance: Purchased from J. van Overloop, Antwerp. Entered in the inventory on 20 November 1933.
Literature: [Schr.IX.933a].

069 THE CRUCIFIXION fol.rés.S.I.23186
91 x 72 mm coloured

Provenance: Unknown.
Literature: Schr.II.935.

070 CHRIST ON THE CROSS WITH A MONK fol.rés.S.I.42425
95 x 73 mm not coloured

This is not a single-sheet woodcut, but an illustration of the *Speculum passionis Domini Nostri Ihesu Christi* [Nuremberg: Ulrich Pinder, 1507] fol. LXIr (VD16, P 2807). Modern impression (?)

Provenance: Unknown.
Literature: Schr.II.966; Heitz 84 (1934) n° 14.

071 MATER DOLOROSA Ms.3059, fol. 41v
 109 x 75 mm (with decorative border) coloured
 Colour plate III

Inserted in a sixteenth-century (1549) Dutch and Latin *Sammelband* with ascetic texts and prayers, inscribed on fol. 95v: *'Dit boeck heeft ghescreue(n) suster Lijsbeth van Elderen int iaer ons heren MVc en(de) xlix, ter bede van suster Lodowijca van Brigille Donat(i)nne gheprofesijt int clooster van S(inte) Elysabeth in den berch van Synae* [Sion] *binnen Bruesse . . .'*. See also n° 090 and n° 094.

Provenance: This manuscript was written for the St Elisabeth convent of Brussels, called Sion (canonesses regular of St Augustine), as noted in the inscription on fol. 95v (see above). Paris, Bibliothèque nationale (stamps on fols.1r and 96r).

Literature: [Schr.IX.1013m]; VDG 2425; De Meyer 1970, ill.11.

072 THE ASSUMPTION OF THE VIRGIN fol.rés.S.II. 26535
 119 x 89 mm (excl. typographical text) coloured

There are various notes from the fifteenth or sixteenth centuries in Dutch handwriting on the verso of this print. The words *'Nazaret'* and *'beginhof'*, for example, appear but the implications of these notes remain uncertain.

Provenance: Purchased from Laurent Claessens, bookbinder in Brussels. Entered in the inventory on 2 February 1880 (25 BEF).

Literature: Schr.II.1017a; Antwerp 1930, p. 84.

073 VIRGIN AND CHILD fol.rés.S.V.63314
 236 x 180 mm coloured (stencil)
 Colour plate IV

A coat of arms from a St Luke's guild was added to the bottom of this print and was signed: *'Aert ... [illegible] ... s'*.

Provenance: Collection Constantin Le Paige (Liège). Collection Prof. Joseph Brassinne, head librarian of the University Library (Liège). Collection Armand Delhez (Liège); purchased from this collection by the Royal Library. Entered in the inventory on 6 June 1955.

Literature: Schr.II.1024a.

074 VIRGIN AND CHILD (SEATED) Ms.2945, fol. 2v
 85 x 53 mm coloured

This print is identical to n° 075. Inserted in a sixteenth-century Dutch *Sammelband* with ascetic texts. See also n° 053.

Provenance: See n° 053.

Literature: [Schr.IX.1027ba].

075 VIRGIN AND CHILD (SEATED) Ms.11237, fol. 51v
 85 x 53 mm coloured

Inserted in a sixteenth-century Dutch manuscript with devotional texts (for the Poor Clares, 1516-19). See also n° 002, n° 006, and n° 088. This print is identical to n° 074.

Provenance: See n° 002.
Literature: [Schr.IX.1027ba].

076 'BYZANTINE' MADONNA fol.rés.S.I. 23188
 >347 x 83 mm (trimmed) coloured
The woodcut text immediately below the image reads: *'Ghepri(n)t to(n)ser liever vrouwe(n) te(n) troost'*. A prayer to the Virgin was cut into the wood below this (*'Ghebet tot ons lieve vrouwe vanden / troost voer een salighe doot'*). Thirty-four lines of this prayer are preserved, while an unknown portion was cut off. This woodcut was printed at the Carmelite convent of Onze-Lieve-Vrouw-ten-Troost in Peutie, near Vilvoorde (Belgium, Brabant).
Provenance: Unknown.
Literature: Schr.II.1034; Antwerp 1930, pp. 84-85; Lebeer 1935, p. 202; Van der Stock 1998, p.32; Van der Stock 2000, p.149 (n° 249c) (with bibliography).

077 VIRGIN AND CHILD (WITH INDULGENCE) fol.rés. S.VI.28914
 approx. 130 x 94 mm coloured
Provenance: Most likely this woodcut was exported to England from the Southern Netherlands as early as the sixteenth century, for there is a sixteenth-century inscription in the lower margin reading: *'To good mastors oxsynbregh'*. In 1938 the print was found in the lining of an old binding (London) (traces of sewing and a fold in upper margin); after 1938, T.O. Mabbott Collection (New York). Purchased by the Royal Library (H. Tenner Sale, Heidelberg). Entered in the inventory on 20 October 1979.
Literature: [Schr.IX.1036m]; Heitz 99 (1940), n° 13.

078 VIRGIN AND CHILD WITH FOUR SAINTS fol.rés.S.IV.368
 263 x 360 mm not coloured
Modern impression. The woodblock of this Italian print was acquired by the Soloani firm (Modena), which produced reprints from the old block between 1640 and 1870. The woodblock is now preserved at the Pinacoteca of Modena (see also n° 054 and n° 114 - n° 120). In the lower left there is a monogram: *TM* (or *MT*).
Provenance: Purchased from Mr G. Lebrun, Brussels. Entered in the inventory on 12 April 1932.
Literature: Schr.II.1045; De Meyer 1970, ill. 5.

079 VIRGIN AND CHILD IN GLORY fol.rés.S.II.6796
 >98 x >86 mm (small fragment) coloured
According to the inventory, this print came from a handwritten catechism dated 1557.
Provenance: Recorded in the inventory on 20 June 1863. It may have been transferred from the Manuscript Department of the Royal Library.
Literature: [Schr.IX.1048aa]. Probably a copy in reverse after Schr.II.1048a.

080 VIRGIN AND CHILD IN GLORY fol.rés.S.I.23189
two fragments: together >288 x >192 mm coloured

This fragment may have been recycled as lining for a book cover.
Provenance: Unknown. The same (?) provenance as n° 122?
Literature: Schr.II.1049.

081 VIRGIN AND CHILD WITH AN ANGEL fol.rés.S.I.23263
121 x 81 mm coloured

A sixteenth-century inscription in the upper margin (recto) reads: *'Olie van foillie* [foelie =
mace] *om III st(uvers) / om die maege te froteren'*. There are various fragments from a
sixteenth-century Dutch handwritten text on the verso, including several names and an
address: *'woonende / inde Cruppelstraete'*. Below the print, two lines of text in Dutch and two
lines in French were composed in moveable type: *'Saligheydt, ghesontheydt sal tot hem keeren
/ die met betrouwe(n) aenbidde(n) de Moeder des Heeren / Salut, santé, viendra à ceux-là, & bon-
heur, / Qui adorent parfoy la Mere du Seigneur'*. This print definitely dates from the sixteenth
century.
Provenance: Unknown.
Literature: [Schr.IX.1061m].

082 VIRGIN AND CHILD (STANDING) fol.rés.S.II.2522
139 x 69 mm (=S.I. 23190)

In contrast to what Schreiber notes, this print is coloured.
Provenance: Purchased in Amsterdam. Entered in the inventory on 14 February 1860.
Recorded as *'extrait d'un manuscrit acquis à la Vente Van Noort'*.
Literature: Schr.II.1071; Antwerp 1930, p. 86.

083 VIRGIN AND CHILD WITH ST CATHERINE fol.rés.S.III.37341
103 x 78 mm traces of colour

Provenance: Purchased from J. Baer (Frankfurt) in July 1922 (50 BEF).
Literature: Schr.II.1141a.

084 VIRGIN AND CHILD FLANKED rés.S.III.30076, fol. 86v
BY ST CATHERINE AND ST BARBARA coloured
82 x 82 mm

Inserted in a Dutch-German-French prayer book (c.1500). The manuscript is kept in the
Print Room and not in the Manuscript Department. The print was probably made in
Mariënwater (Northern Netherlands, prov. Noord-Brabant). It is very close to Schr.II.1154.
Provenance: The manuscript was given by Mr A. de Bassompierre, Brussels. Entered in the
inventory on 20 August 1921.
Literature: [Schr.IX.1153a]; De Kreek 1986, pp. 18-19 and 25-26.

085 VIRGIN AND CHILD WITH FOUR FEMALE SAINTS fol.rés.S.I.42529
(So-called *Madonna of 1418*) traces of colour
>377 x 245 mm

Provenance: Found in Mechelen on the inside of a box for archives prior to May 1844
(Reiffenberg 1845(a), p. 258: *'. . . on allait briser à Malines un vieux coffre dont on avait extrait
des archives moisies. Dans l'intérieur du couvercle était collée une estampe à peine visible'*). In 1844
in the Collection Ryckbos, Mechelen, and in the Collection Jan Frans (and not: Jan Baptiste)
de Noter, painter and architect, Mechelen. The print (*'les fragments'*, according to Baron de
Reiffenberg in 1845(a) and 1845(b)) was then removed from the box and put back together.
Purchased for the Royal Library by baron Frederic de Reiffenberg in 1844 (500 BEF). Due
to the rather mysterious provenance of this print, it has been speculated that it is a fake or
that the date was erroneously dated (or deliberately falsely so) (see, e.g. Ruelens 1877,
pp. 25-26). G. Severeyns made a lithograph copy in 1844/45 (see, e.g. Reiffenberg 1845(c).
Archival sources: Files on this particularly enigmatic print are kept in both the Print Room
(without inventory number) and the Manuscript Department (Ms.II.4398: *'L'Estampe de
1418. Dossier . . . formé par le Baron de Reiffenberg'*). Several newspapers have reported in 1844
and 1845 on the new acquisition, e.g. *Athenaeum* (London, 25 November 1844 and 4
October 1845, with a reduced copy by M. Folkard); *L'Artiste* (24 November 1844) and *L'Écho
du monde* (1 December 1844).
Literature: Schr.II.1160; Reiffenberg 1845(a), pp. 255-63; Reiffenberg 1845(b); Reiffenberg
1845(c); De Brou 1846; Van Lokeren 1846; Luterau 1846; Reiffenberg 1846(a), pp. 26-29;
Reiffenberg 1846(b); Reiffenberg 1847(a), pp. 33-35 and 281-82; Reiffenberg 1847(b);
Reiffenberg 1848, pp. 26-26; De Brou 1859; Renouvier 1859, pp. 51-52; Passavant, vol. 1,
pp. 109-10; Alvin 1877; Ruelens 1877; Hymans 1903; Delen 1924, pp. 41-44 and pl. V; Hind
1935, vol.1, pp. 109-13; Körner 1979, pp. 85-86; Lebeer 1981. See also: Heitz 3 (1906), n° 5.

086 ST ADRIAN WITH A MONK fol.rés.S.II.5086
108 x 76 mm sparingly coloured

This print may have been made at or for the Geraardsbergen Abbey, where St Adrian is
worshiped.
Provenance: Purchased from the Collection Jozef Paelinck, Brussels (Sale Heussner,
Brussels: Lugt, *Ventes* 25811) on 20 November 1860.
Literature: Schr.II.1175; Heitz 2 (1901), n° 36.

087 ST ANNE, THE VIRGIN AND CHILD fol.rés.S.II.146707
80 x 62 mm not coloured

This print is not a single-leaf woodcut, but a book illustration that appeared in Johannes
Gerson, *Donatus moralisatus*, Cologne [Heinrich Quentell, about 5 July 1498] [also recorded
as: Retro Minores] (GW 10870).
Provenance: Purchased from Louis de Ridder, Brussels. Entered in the inventory on
30 December 1913.
Literature: Schr.III.1208.

088 ST ANNE, THE VIRGIN AND CHILD Ms.11237, fol. 76r
 72 x 56 mm coloured

Inserted in a sixteenth-century Dutch manuscript with devotional texts (for the Poor Clares, 1516-19). See also n° 002, n° 006, and n° 075.
Provenance: See n° 002.
Literature: [Schr.IX.1209m].

089 ST AUBERT OF CAMBRAI fol.rés.S.I.23253
 >293 x >197 mm (fragment) not coloured

This fragment may have been recycled as lining for a book cover.
Provenance: Unknown.
Literature: [Schr.IX.1240m].

090 ST AUGUSTINE Ms.3059, fol. 55r
 105 x 74 mm coloured
 Colour plate III

Inserted in a sixteenth-century (1549) Dutch and Latin *Sammelband* with ascetic texts (see also n° 071 and n° 094). In the upper left there is a monogram: 𝕴𝖞𝖈. In the lower right, a small drum appears as an identifying mark 🪘 . It is possible that this print was made in the Carmelite convent of Onze-Lieve-Vrouw-ten-Troost in Peutie, near Vilvoorde (Belgium, Brabant). It is stylistically very close to n° 034 and may have even been made by the same hand. It should be noted that prints were also made in the convent of the canonesses regular of St Augustine, called Bethanië, near Mechelen (see n° 030 and n° 131).
Provenance: See n° 071.
Literature: [Schr.IX.1246m]. See also n° 071.

091 ST BARBARA fol.rés.S.I.42652
 188 x 139 mm coloured

This print has a German text cut into the woodblock reading: *'O Sancta Barbara / Bit gott fü(r) unns'*.
Provenance: Unknown.
Literature: [Schr.IX.1250aa].

092 ST BERNARD WITH THE VIRGIN AND CHILD Ms.II.2934, fol. 206r
 (*Lactatio Sancti Bernardi*)
 147 x 112 mm (with decorative border) coloured

This manuscript contains a collection of sermons written in Dutch by Willem van den Brande (1566), priest at the Groot Begijnhof of Mechelen. The woodcut text below reads: *'Tonser liev(en) vrouwe(n) ten troost'*. The woodcut was printed at the Carmelite convent of Onze-Lieve-Vrouw-ten-Troost in Peutie, near Vilvoorde (Belgium, Brabant).
Provenance: Mechelen (Groot Begijnhof) (Josijnken Goewaerts) (cf. the inscription on fol. 1v: *'Desen boeck hoort toe Josijnken Goewaerts wonende tot Mechelen opt groot beghijnhof op die Hochstraet'*) The owner of the manuscript also appears to have written it. The manuscript

was purchased by the Royal Library from Nijhoff (Amsterdam). It was recorded in the inventory on 15 July 1902.
Literature: [Schr.IX.1276aa]; Van der Stock 2000, pp. 149 and 151 (n° 249d).

093 ST CATHERINE OF SIENA fol.rés.S.I.23265
 100 x 81 mm coloured

This print may originate from the sixteenth century. One line of text in Latin and one in Dutch were added typographically below: 'S. Catharine de Sena, Ora pro nobis. / S. Cathalijne vander Senen, bidt'.
Provenance: According to a note made in pencil on the verso, this print came from the State Archives of Belgium (Brussels).
Literature: [Schr.IX.1345aa].

094 ST ELISABETH Ms.3059, fol. 51v
 109 x 75 mm (with decorative border) coloured
 Colour plate III

Inserted in a sixteenth-century (1549) Dutch and Latin *Sammelband* with ascetic texts and prayers (see also n° 071 and n° 090).
Provenance: See n° 071.
Literature: [Schr.IX.1406m]; De Meyer 1970, ill.12. See also n° 071.

095 ST ELISABETH Ms.8587-89, fol. 227v
 89 x 68 mm coloured

Inserted in a manuscript with the lives of saints written in Dutch (c.1510).
Provenance: Baex (according to a note on the recto of the third flyleaf reading: *Emptus hic liber à Baex 1644*); Antwerp, Jesuits (according to an old number (*Ms.42*) on the verso of the fourth flyleaf).
Literature: [Schr.IX.1406n]; VDG 3381.

096 ST EMERANTIA Ms.5237, fol. 8v
 165 x 111 mm coloured

Affixed in a Latin missal for the Benedictine abbey of Gembloux (c.1535).
Provenance: The manuscript comes from the Benedictine abbey of Gembloux.
Literature: [Schr.IX.1408n]; VDG 436.

097 ST FRANCIS RECEIVING THE STIGMATA Ms.II.1561, fol. 54v
 IN THE PRESENCE OF A NUN traces of colour
 77 x 57 mm

Copy in reverse after an engraving by the master WA (L.VII.39.15) by an unidentified sixteenth-century artist. See also n° 329. The woodcut was affixed to the verso of a title page in a printed book (the *Imitatio Christi*) that was bound into a *Sammelband* containing various religious texts. It is followed by a work by Jean Gerson (Paris, Jean Petit and Gaspar Philippe, 1501) (fols. 55r-184v). The print was made in the Brussels convent of the Gray

Sisters, called Bethlehem. The Gray Sisters were sisters of the third order of St Francis and were established in Brussels by the end of the fifteenth century. They converted to the Poor Clares at the beginning of the sixteenth century. The woodcut text below reads: *'Gheprent te Brucel ten grauwen / susteren gheheten bedlehem'*. See also n° 438.

Provenance: Purchased from Van Trigt, Brussels. Entered in the inventory on 23 January 1894.

Literature: [Schr.IX.1432m]; L.VII.41.15d; VDG 2052; Lebeer 1935, p. 202; Lebeer 1953, pp. 208-209; Van der Stock 2000, p. 147 (n° 248).

098 THE MASS OF ST GREGORY fol.rés.S.V.63312
 c. 375 x 260 mm coloured

Below the print, seven lines of text in French were added typographically. The woodcut is severely damaged. At some point it had been affixed to something. A fragment from another woodcut (with the head of a saint) was added (upside down) in the upper left.

Provenance: Collection Constantin Le Paige (Liège). Collection Prof. Joseph Brassinne, head librarian of the University Library (Liège). Collection Armand Delhez (Liège); purchased from this collection by the Royal Library. Entered in the inventory on 6 June 1955.

Literature: [Schr.IX.1455a].

099 ST HUBERT fol.rés.S.I.23251
 127 x 94 mm coloured
 Colour plate IV

Below four lines of woodcut texts in Dutch are added: *'O heilighe m(aer)scalc s(anctus) Hubert va(n) Arde(n)ne(n) / Bescermt al onse schone vijf sinne(n) / Voer die popelsi raseri en(de) plage(n) groet / En(de) voer den haestighe(n) o(n)versiene(n) doet'*.

Provenance: Unknown. In the collection prior to 1859.

Literature: Schr.III.1501; Renouvier 1859, p. 44; Antwerp 1930, p. 82.

100 THE HEAD OF ST JOHN THE BAPTIST fol.rés.S.I.23261
 two fragments: together >268 x >189 mm coloured (stencil)

This sixteenth-century woodcut was probably recycled as lining for a book cover.

Provenance: Unknown. The same (?) provenance as n° 122?

Literature: [Schr.IX.1510m].

101 ST JOHN THE BAPTIST STANDING fol.rés.S.IV.14846
 126 x 106 mm (=S.I.23252)
 coloured

A sixteenth-century woodcut.

Provenance: Purchased from J. van Overloop, Antwerp. Entered in the inventory on 20 November 1933.

Literature: [Schr.IX.1513a].

102 ST JEROME (AS A SCHOLAR) Ms.4249-50, fol. 9v
 101 x 76 mm coloured

Inserted in a sixteenth-century Dutch (Utrecht) breviary (vol. 2). See also n° 040 (Ms.5106, fol. 9v).
Provenance: Antwerp Jesuits (inscribed on fol. 1r: *'Soc(ieta)tis Jesu Ant(verpiensis) D P'*).
Literature: [Schr.IX.c.1544], VDG 588.

103 ST SEVERUS WITH TWO WEAVERS fol.rés.S.V. 63315
 219 x 158 mm coloured
 Colour plate IV

Provenance: Collection Constantin Le Paige (Liège). Collection Prof. Joseph Brassinne, head librarian of the University Library (Liège). Collection Armand Delhez (Liège); purchased from this collection by the Royal Library. Entered in the inventory on 6 June 1955.
Literature: [Schr.IX.1695m]; Brussels 1961, n° 16 (The saint is incorrectly identified as St Blasius).

104 ST TRUDO fol.rés.S.V. 63313
 211 x 155 mm coloured

Provenance: Collection Constantin Le Paige (Liège). Collection Prof. Joseph Brassinne, head librarian of the University Library (Liège). Collection Armand Delhez (Liège); purchased from this collection by the Royal Library. Entered in the inventory on 6 June 1955.
Literature: [Schr.IX1704m]; Brussels 1961, n° 17 and pl. 2; Brussels 1969, n° 210.

105 THE SHIP OF ST URSULA fol.rés.S.I.42653
 240 x 177 mm not coloured

A handwritten note on the print reads: *'Cette estampe était collée sur une des ais de bois de la couverture du Ms. 1810 lectionarium du XIVe Siècle. Détaché avec l'autorisation de M. Alvin le 26 mai 1839'* [sic ! read: 1859]. Ms.1810 is a Dominican breviary (fourteenth century).
Provenance: The provenance of the manuscript is unknown.
Literature: Schr.III.1711.

106 ST WILGEFORTIS (ST UNCUMBER) Ms.4210, fol. 1v
 120 x 84 mm not coloured

Inserted in a Dutch moralising treatise (sixteenth century): *'Ee(n) dialogo hoe die Redene die ziele v(er)troost die in menigherhande bocoringhe es'*. This is a Dutch version of Isidorus of Sevilla's *Liber sententiarum*. The woodcut is signed: *Eecke*. (See also Schr.II.913). This may be a reference to the village of Eke (prov. Oost-Vlaanderen, Belgium).
Provenance: Unknown.
Literature: [Schr.IX.1732k]; VDG 2434.

107 TWO APOSTLES [with the Creed?] fol.rés.S.I.23266
 two fragments: together >275 x >190 mm coloured

Perhaps the fragments were recycled as lining for a book cover.
Provenance: Unknown.
Literature: [Schr.IX.1759e].

108 THE SACRED HEART AND THE WOUNDS fol.rés.S.I. 23249
 OF CHRIST coloured
 32 mm diameter

Provenance: Unknown. There is an unknown mark: *EKL* (not in Lugt) on the verso of this print.
Literature: Schr.IV.1802.

109 THE SACRED MONOGRAM IHS WITH THE DOVE fol.rés.S.III.37342
 113 x 78 mm coloured

In addition to the Dutch text cut in a circle around the monogram ('*+Den zoete(n) name ons heere(n) Jh(es)u Xri(stu) ende zijnder glorioser moeder en(de) maget Maria zij ghebenedijt i(n) d(e) eeuwicheit. Amen+*'), four lines of text in Dutch below were also cut into the woodblock: '*Hebt Ihesus dicwijle in uwen mont / Draecht Ihesus altijts in uwen gront / Neempt Ihesus voer U in uwen wercke(n) / So sal U Ihesus in sijnder mi(n)ne(n) stercke(n)*'.
Provenance: Collection L. Rosenthal (Munich) (Cat. 90, n° 64). Purchased from J. Baer (Frankfurt). Entered in the inventory in July 1922 (100 BEF).
Literature: Schr.IV.1819; Delen 1924, p. 39 and pl. II.1; Antwerp 1930, p. 81; Van der Stock 1998, pl. XIII.

110 THE SACRED MONOGRAM IHS AND MARIA fol.rés.S.I 23262
 88 x 69 mm coloured

A handwritten note on the print reads: '*cette estampe était collée sur la garde d'une livre d'heures mss sans date*'.
Provenance: Gift of R. Chalon. Entered in the inventory on 5 December 1864.
Literature: Schr.IV.1825; Hymans 1907, p. 371; Antwerp 1930, p. 81.

111 THE SACRED MONOGRAM IHS Ms.4604, fol. 255v
 62 x 62 mm coloured

Inserted in a sixteenth-century Dutch *Sammelband* with ascetic texts. See also n° 003, n° 011, and n° 065. The Dutch text cut around the monogram reads: '*Vreest d(at) ordeel / Ontsiet de helle / voersiet de doot / Suect hemelrijck.* The Latin text reads: *Dulce nome(n) d(omi)ni n(ost)ri Ih(es)u Xri(stu) et gloriose virginis matris eius Marie sit benedictu(m) in secula Amen*'.
Provenance: See n° 003.
Literature: [Schr.IX.1825b]. See also n° 003.

112 *ECCE PANIS ANGELORUM* ('1467') fol.rés.S.V.70810
264 x 170 mm coloured
After 1530, a forgery (?)
Provenance: < 1895, Collection H. Cordemans de Bruyne (Mechelen). Given to the Royal
Library by Ms. De Bray-Cordemans, Brussels. Entered in the inventory on 15 May 1957.
Literature: [cf. Schr.IV.1838m; Schr.IV.1838n; and Schr.IV.1940]; Cordemans de Bruyne 1895,
pl. II; Bergmans 1898, p. 40; Godenne 1956; Ampe 1962, pp. 42-43; Vervliet 1962 (with
bibliography); Heireman 1973 (with bibliography); Mauquoy-Hendrickx 1975 (with
bibliography).

113 DEATH (*COGITA MORI*) fol.rés.S.I.42428
82 x 55 mm sparsely coloured
This print was originally a book illustration and not an independent print. See Willem van
Brantheghem, *Pomarium Mysticum*, Antwerp: Willem Vorsterman 1535 (NK 485). Damage
to the woodblock above the skull indicates that this impression was pulled after 1535.
Provenance: Unknown.
Literature: [Schr.IX.1889b].

114 THE NINE WORTHIES (1): JOSHUA fol.rés.S.II.62766
approx. 300 x 273 mm not coloured
Modern impression. The woodblocks for this series of three figures were acquired by the
Soloani firm (Modena), which produced reprints from the old blocks between 1640 and
1870 (see also n° 054 and n° 078). When the Soloani firm shut down, the blocks went to
Milan where the 'GM' monogram and the year '1510' ('1550') were added (see n° 115, n°
117 and n° 120). New impressions were made at this point, with the nineteenth-century
modifications. The three woodblocks are now preserved at the Pinacoteca of Modena.
Provenance: Prior to 1895 in the Collection of Luigi Angiolini (Milan); purchased from this
collection during the sale held between 8 and 22 May 1895 (Sale Gutekunst, Stuttgart: Lugt,
Ventes 53517). This print belongs to a lot of three that was purchased for a total sum of
11 BEF, 16 centimes. See n° 116 and n° 119.
Literature: Schr.IV.1946(1); Schroeder 1971, pp. 143-144, 153-154, and ills. 13, 15, and 16;
Van Anrooij 1997, p. 176.

115 THE NINE WORTHIES (1): JOSHUA fol.rés.S.II.54891
approx. 300 x 273 mm not coloured
Modern impression. Signed: 'GM 1510'. See also n° 114.
Provenance: Purchased at the Don Fréderic de Sevilla (Marquis de Négron) Sale (Bluff,
Brussels). Recorded in the inventory on 20 May 1893.
Literature: Schr.IV.1946(1); Nijhoff 384. See also n° 114.

116 THE NINE WORTHIES (2): CHARLEMAGNE fol.rés.S.II.62765
300 x 270 mm not coloured
Modern impression. See also n° 114.
Provenance: See n° 114.
Literature: Schr.IV.1946(2). See also n° 114.

117 THE NINE WORTHIES (2): CHARLEMAGNE fol.rés.S.II.54890
300 x 270 mm not coloured
Modern impression. Signed: *'GM 1510'*. See also n° 114.
Provenance: See n° 115.
Literature: Schr.IV.1946(2); Nijhoff 385. See also n° 114.

118 THE NINE WORTHIES (3): HECTOR OF TROY fol.rés.S.II.22886
300 x 260 mm not coloured
Modern impression. Unknown copy with the letter(s) *R* or *RI* (stamped) on a shield on the breast of the horse. See also n° 114.
Provenance: Purchased at the Bluff Sale, Brussels. Entered in the inventory on 27 April 1876.
Literature: [Schr.IX.1946(3)]. See also n° 114.

119 THE NINE WORTHIES (3): HECTOR OF TROY fol.rés.S.II.62764
300 x 269 mm not coloured
Modern impression. See n° 114.
Provenance: See n° 114.
Literature: [Schr.IX.1946(3)]. See also n° 114.

120 THE NINE WORTHIES (3): HECTOR OF TROY fol.rés.S.III.47282
300 x 270 mm not coloured
Modern impression. Signed *GM 1550* (sic). See also n° 114.
Provenance: Fiévez Sale, Brussels. Entered in the inventory in January 1924.
Literature: [Schr.IX.1946(3)]; Nijhoff 386. See also n° 114.

121 THE NINE WORTHIES fol.rés.S.II.26157
Nineteenth-century photograph (<1879). The original is in Metz, Stadtbibliothek.
Provenance: The photograph was donated by count F. Van der Straeten-Ponthoz on 8 June 1879, possibly in response to an article by Fétis (1877), who mentioned the print. Van der Straeten-Ponthoz wrote a book *Les neuf Preux*, Pau, 1864.
Literature: Schr.IV.1947; Fétis 1877.

122 THE NINE WORTHIES (1): HECTOR OF TROY fol.rés.S.I.23361
two fragments: together >283 x >195 mm slightly coloured
The first of four fragments (see also n° 123, n° 124, and n° 125).
Provenance: The fragments were recycled as lining for the binding of a copy of Johannes Huss's *Opuscula* . . . This is most likely the copy with the inventory number VB 2.268 A RP

in the Royal Library. The book contains Jan Huss, *De anatomia Antichristi* . . . [Strasbourg: Johann Schott, 1524]. (VD 16, H 6162) and Otto Brunfels, *De ratione decimarum . . . propositiones* [Strasbourg: Johann Schott, 1924] (VD 16, B 8565). Louis Alvin, then director of the Royal Library, had the prints removed with warm water and transferred to the Print Department. Fétis 1877 (p. 72) noted: *'Outre les fragments de la série des neuf Preux ..., il y avait des images de sainteté, des feuilles d'arabesques, etc'.*
Literature: Schr.IV.1949(1); Fétis 1877; Hind 1935, vol.1, p. 157; Nijhoff 387a; Schroeder 1971, pp. 142-143 and ills. 9, 10, 12, and 18; Husband 1995, p. 75; Van Anrooij 1997, pp. 174-176.

123 THE NINE WORTHIES (2): DAVID fol.rés.S.I.23362
 two fragments: together >293 x >208 mm slightly coloured
Provenance: See n° 122.
Literature: Schr.IV.1949(2); Nijhoff 388. See also n° 122.

124 THE NINE WORTHIES (3): ARTHUR fol.rés.S.I.23363
 two fragments: together >295 x >187 mm slightly coloured
This print has long been identified as Alexander the Great (?).
Provenance: See n° 122.
Literature: Schr.IV.1949(3); Nijhoff 387b. See also n° 122.

125 THE NINE WORTHIES (4): GODFRIED
 OF BOUILLON fol.rés.S.I.23364
 two fragments: together >287 x >210 mm slightly coloured
 Colour plate V
Provenance: See n° 122.
Literature: Schr.IV.1949(4); Nijhoff 389. See also n° 122.

126 THE SWINDLED LOVER fol.rés.S.III.25542
 >280 x >241 mm not coloured
Modern impression. The woodblock is in Berlin (Kupferstichkabinett).
Provenance: Collection Th. Hippert, Brussels, prior to 1919 (on verso: collection mark Lugt 1377); purchased from this collection (Fiévez Sale, Brussels). Recorded in the inventory on 21 March 1921.
Literature: Schr.IV.1976.

127 DECORATIVE PAPER WITH ANIMALS fol.rés.S.V.71313
 280 x >351 mm (=S.I.23293 ?)
 (large fragment and 5 small fragments) not coloured
This print was affixed to the inside of a case for a lute. See also n° 128. A complete copy of this woodcut is in the Collection of M. Jadot (280 x approx. 370 mm) (see illustration). The print dates from the sixteenth century or later. See also n° 128 and n° 129.
Provenance: Unknown.
Literature: [Schr.IX.2006a].

128 DECORATIVE PAPER WITH ANIMALS fol.rés.S.V.71314
 approx. 70 x 60 mm (small fragment) (=S.I.23294 ?)
 not coloured

This fragment and n° 127 may have originally formed one piece.
Provenance: See n° 127.
Literature: [Schr.IX.2006a].

129 DECORATIVE PAPER WITH ANIMALS fol.rés.S. II.93381
 277 x >175 mm (large fragment) (=S.I.23295 ?)
 not coloured

In addition to stylistic arguments, the representation of the turkey provides clear evidence
that this print dates from the sixteenth century or later (see on this topic, Möller 1981). See
also n° 127 and n° 128.
Provenance: Purchased from Tavernier (Gent). Entered in the inventory on 22 December
1904 (7 BEF, 20 centimes).
Literature: [Schr.IX.2006b].

FIFTEENTH-CENTURY WOODCUT: UNIDENTIFIABLE

130 Fragment, possibly from THE DESCENT OF THE fol.rés. S.I.23297
 CROSS or THE LAMENTATION coloured
 >210 x >42 mm

This print was recycled as lining for a book cover. The entry in the inventory reads: *'Extrait
d'une reliure début XVIe'*.
Provenance: Entered in the inventory as *'de la collection reliée par J. Weber 1851'*. See also
n° 048.
Literature: None.

METAL CUTS AND WHITE-LINE PRINTS

131 THE VIRGIN AND JESUS WITH LAZARUS AND fol.rés.S.V.70811
 MARTHA IN BETHANY not coloured
 131 x 97 mm

This print was made in the convent of the canonesses regular of St Augustine, called
Bethanië, near Mechelen, as indicated by the text along the lower edge of the metal cut: *'Ex
bethania p(ro)pe mechliniam tradit(ur) pressa'*. This print bears a strong resemblance to an
engraving (not a metal cut!) by the monogramist G.M., which was affixed in a psaltery and
prayer book belonging to Luciëndal (c.1485) (St John's College, Cambridge).
Provenance: Collection Auguste de Bruyne, Mechelen, prior to 1862 (*Catalogue de la
Bibliothèque de feu M. Aug. de Bruyne*, n° 1551); purchased from this collection by Auguste
Coster on 16 May 1890 (120 BEF). Following the death of Coster, the print was bought by

the Galerie Fiévez, Brussels, in 1907. Collection H. Cordemans de Bruyne. Collection P. Lemoine, Brussels. Given to the Royal Library by Madame De Bray-Cordemans, Brussels. Entered in the inventory on 15 May 1957.

Literature: Schr.V.2219; Van Even 1870, p. 104; Hymans 1877(a), p. 18; Bradshaw 1889, pp. 247-53 (copy in Cambridge); De Raadt 1892; Cordemans-de Bruyne 1895, pp. 20-23; James 1913, p. 207 (copy in Cambridge); Lebeer 1947, pp. 454-55; Godenne 1956, pp. 61-65; Ampe 1962, pp. 43-47; H. *Dutch*, XIII.p.92; Leuven 1971, pp. 249-50, n° MS/5; Mauquoy-Hendrickx 1975, pp. 186-87 and pl. 3; Arnould 1993, pp. 205-06 (copy in Cambridge); Van der Stock 1998, p. 31.

132 CRUCIFIXION fol.rés.S.II.23205
 106 x 75 mm traces of colour

Provenance: Bought from M. Thibaudeau, print dealer in London. Entered in the inventory on 23 March 1877 (75 BEF).

Literature: Schr.V.2320.

133 THE LAST JUDGMENT fol.rés.S.II.26547
 61 x 46 mm coloured

Provenance: There is an unidentified mark: *EKL* (not in Lugt) on the verso of this print. Purchased from M. Claessens, bookbinder in Brussels. Entered in the inventory on 2 February 1880 (20 BEF).

Literature: Schr.V.2410

134 THE HOLY TRINITY WITH ST JAMES fol.rés.S.I.23291
 AND ST JEROME not coloured
 120 x 91 mm

Modern impression. The iconographic identification by Schreiber (*Die hl. Dreifaltigkeit zwischen St Crispin und St Crispian*) is not correct. The original copperplate (metal cut) is preserved in the Royal Library of Belgium, Chalco. n° 2029A (=S.II.45438) (121 x 92 mm) (see illustration). See also n° 135.

Provenance: The copperplate (metalcut) was purchased from the Collection A. De Bruyne (Mechelen) together with a galvanic copy of this plate (S.II.45439) on 12 May 1890 (Lugt, *Ventes* 49113) (367 BEF, 50 centimes).

Literature: Schr.V. 2441; Hymans 1877(a), pp. 17-18; Heitz 66 (1928), p. 8, n° 5; Ampe 1962, p. 44; Van der Stock 1998, p. 31 (fig. 13).

135 THE HOLY TRINITY WITH ST JAMES fol.rés.S.V.70813
 AND ST JEROME not coloured
 120 x 91 mm

Modern impression. See n° 134.

Provenance: Gift of Madame De Bray-Cordemans, Brussels. Entered in the inventory on 15 May 1957.

Literature: See n° 134.

136 CRUCIFIXION WITH FRANCISCAN SAINTS Ms.2992-93, fol. 32v
 120 x 81 mm coloured

Inserted in a Dutch prayer book (c.1510). The saints are St Francis, St Clara and St Bernard of Siena (together with the Virgin and St John).
Provenance: Groenendaal, canons regular of St Augustine (inscribed on the verso of the second flyleaf). Paris, Bibliothèque nationale (stamp on fol. 1r).
Literature: Schr.V.2470; Heitz 51 (1920), n° 40; Biemans 1984, pp. 238-9; *De luister van Groenendaal. Ruusbroec,* Brussels 1993, p. 59.

137 THE MADONNA AND CHILD IN GLORY Inc.B.449 R.P., front cover
 123 x 82 mm

Printed on the leather of the front cover of: Guilielmus Ockham, *Quaestiones et decisiones in IV libros Sententiarum. Centilogium theologicum,* ed. Augustinus de Ratisbona, Jodocus Badius Ascensius, Lyons: Johannes Trechsel, 9-10 November 1495 (Polain, 2909 (IV)). See also n° 141.
Provenance: Collection Petrus Hukeshoven, Carmelite monastery, Cologne (bought in Trier in 1514). Collection Philip Olemaert, Carmelite monastery, Brussels. Collection Henricus Smit, 1616. Discalced Carmelites, Leuven (seventeenth century).
Literature: Schr.V.2498a; Theele 1927 (and pl. XIX); Brussels 1930, n° 235.

138 ST BARBARA fol.rés.S.II.6026
 177 x 119 mm coloured
 Colour plate V

Provenance: According to Hymans 1877(a), this was found in the binding of Johannes Herolt, *Sermones Discipuli de tempore et de sanctis* (Cologne, Ulrich Zell, c.1470) (*'incunable 2685'*). It is not clear which incunable this could be (see, e.g. Inc.B 25: Polain, 1889). Transferred to the Print Department on 14 September 1862. Recorded in the inventory (1862) as: *'Trouvé dans une reliure / incunable 2685'.*
Literature: Schr.V.2548 (=Schr.V.2547, but without decorative border); Passavant, vol. 1, p. 87; Hymans 1877(a), pp. 13 and 16; Heitz 43 (1916), n° 77; Fleischman 1998, ill. 4.

139 ST BARBARA Ms.2310-23, back cover
 approx. 123 x 82 (?) mm

Printed on the leather of the back cover of the manuscript: Guillielmus de Canitia, *Dieta Salutis* (fifteenth century), a Latin *Sammelband* with theological-ascetic tracts, etc, as well as historical texts (e.g. a copy of a bull, letters, chronicles, etc). See also n° 140.
Provenance: Benedictine abbey of Brauweiler (St Nicholas), near Cologne (fol. 1r: *Liber sancti Nicolai in Bruwyire*). Paris, Bibliothèque nationale (stamps on fols 2r and 383v).
Literature: Schr.V.2555; VDG 2089; Theele 1927 (and pl. XX); Brussels 1930, n° 234.

140 ST CATHERINE Ms.2310-23, front cover
 123 x c. 82 mm
Printed on the leather of the back cover of the manuscript: Guillielmus de Canitia, *Dieta Salutis* (fifteenth century). This print is identical to n° 141.
Provenance: See n° 139.
Literature: Schr.V.2577b. See also n° 139.

141 ST CATHERINE Inc.B.449, R.P. back cover
 123 x 82 mm
Printed on the leather of the back cover of Guilielmus Ockham, *Quaestiones et decisiones in IV libros Sententiarum. Centilogium theologicum*, ed. Augustinus de Ratisbona, Jodocus Badius Ascensius, Lyons: Johannes Trechsel, 9-10 November 1495 (Polain, 2909 (IV)). See also n° 137. This print is identical to n° 140.
Provenance: See n° 137.
Literature: Schr.V.2577b. See also n° 137.

142 ST DOROTHY fol.rés.S.II.8311
 61 x 46 mm traces of vermilion
Provenance: Prior to 1865 in the Collection of Chevalier J. Camberlyn d'Amougies, Brussels (on the verso: collection mark, Lugt 514); purchased from this collection on 25 April 1865 (Sale E. Guichardot Paris: Lugt, *Ventes* 28481) (15 BEF, 75 centimes).
Literature: Schr.V.2608.

143 MASS OF ST GREGORY fol.rés.S.II.21244
 46 x 35 mm coloured (stencil)
Provenance: Purchased from M. Zweibrücken (Malmédy). Entered in the inventory on 2 July 1874.
Literature: Schr.V.2660.

144 ST MICHAEL fol.rés.S.I.23267
 recto and verso: fragment not coloured
Modern facsimile (?) after Schr.V.2710. Schreiber mentions a lithograph copy by J. Ph. Berjeau, which may be the same as this print (see also n° 027). Schr. V.2710 is a copy after Master E.S. (L.II.221.152a).
Provenance: Unknown.
Literature: Schr.V.2710; L.II.221.152a.

145 *ARBOR PORPHIRIANA* fol.rés.S.II.21235
 >95 x 80 mm not coloured

Modern impression printed from a metal plate (erroneously cited in the inventory as a *'planche en bois'*) that belonged to M. De Bruyne (Mechelen). See also n° 146.
Provenance: Given by M. De Bruyne (Mechelen) to the Royal Library. Entered in the inventory on 23 May 1874.
Literature: Schr.VI.2766; Schreiber-Heitz 1908.

146 *Arbor Porphiriana* fol.rés.S.II.142145
 >95 x 80 mm not coloured

Modern impression. Much weaker than n° 145.
Provenance: Unknown (the inventory number is incorrect).
Literature: See n° 145.

147 CRUCIFIXION WITH THE TWO THIEVES fol.rés.S.III.58603
 149 x 99 mm not coloured

Copy after the Master of the Calvary (L.I.298.3).
Provenance: According to Schreiber, this (?) print came from a shop run by Ms. Krug in Antwerp. According to Lehrs, the print was there in 1885. In that year Krug offered it to the Dresden Print Department for the incredible sum of 10,000 French Francs. The Royal Library purchased this print from Mr Sauboua, Brussels, on 19 June 1924 for a smaller (but unknown) amount.
Literature: Schr.VI.2867; L.I.298.3a.

148 ST DOROTHY fol.rés.S.II.5778
 123 x 71 mm not coloured

A fragment of a woodcut of the Large Rosary by Hans Süss von Kulmbach (Geisberg 891-7) is printed on the verso. See ill. 148v.
Provenance: Purchased from Alexandre Pinchart, Keeper of the State Archives of Belgium, Brussels, on 19 July 1861. This belonged to a lot of thirteen prints that were purchased for a total sum of 100 BEF. See also n° 174.
Literature: Schr.VI.2870; L.IV.265.74; Hymans 1877(a), pp. 19-20.

149 ST PETER MARTYR fol.rés.S.II.16204
 103 x 73 mm not coloured

Modern impression made in 1780 from a plate owned by Mr Gumpeltzheym (Ratisbonne). Erroneously identified in the inventory (1872) as St Bartolmy.
Provenance: Purchased by the Royal Library from Van Gogh, Brussels. Entered in the inventory on 27 January 1872 (3 BEF).
Literature: Schr.VI.2873; Dodgson 1903.207-08.B34.

150 THE FRANCISCAN PELBARTUS IN THE GARDEN fol.rés.S.II.5711
 215 x 160 mm (cut out) not coloured

White line woodcut. This print appeared on the title page of: Pelbartus de Themswar, *Sermonis Pomerii de Sanctis* [Augsburg: Johann Otmar, not before 1502]. It is sometimes attributed to Daniel Hopfer (Eyssen 1904). This attribution is not credible. Trimmed outside the border. The roundels (from separate blocks) are silhouetted.

Provenance: Purchased from M. Papillon, Brussels. Entered in the inventory in February 1861.

Literature: Schr.VI.2875 (roundels) and 2876; Passavant, vol. 1, p. 101; Hymans 1877(a), pp. 21-22; Eyssen, 1904, p. 44.1; Hind 1935, vol.1, p. 196; Dodgson 1911.202-XI.2; Rhodes 1958; Hébert II.220.2808ter.

II.

Northern Engravings of the Fifteenth Century

II.
Northern Engravings of the Fifteenth Century

MASTER OF THE NUREMBERG PASSION
(German engraver. Active c.1450)

151 THE NATIVITY (=L.I.253.1) fol.rés.S.I.42433
 Nineteenth-century photograph.
 Original print in Breslau.

AFTER THE MASTER OF THE CALVARY
(German engraver. Active c.1450)

- CRUCIFIXION WITH THE TWO THIEVES fol.rés.S.III.58603
 (=L.I.298.3a)
 See n° 147 (=Schr.VI.2867).

MASTER OF THE GARDENS OF LOVE
(German engraver. Active c.1450)

152 THE LITTLE GARDEN OF LOVE (=L.I.323.20) fol.rés.S.I.42423
 Nineteenth-century photograph.
 Original print in the Arenberg Collection.

MASTER E S
(German engraver and draughtsman. Active c.1445/50 - c.1467)

153 ST CHRISTOPHER fol.rés. S.II.2506
 144 x 109 mm
Provenance: Sale of the Collection Weber in 1855. Collection of Ch. de Férol; purchased
from this collection during the sale held on 7-8 December 1859 (Sale Guichardot, Paris:
Lugt, *Ventes* 25136) (619 BEF, 50 centimes).
Literature: L.II.200.140; Lehrs 1892, p. 482, n° 7; Hébert I.51.112; Bevers 1986-87, n° 62,
ill. 68.

154 ST HUBERT (=L.II.209.147) fol.rés. S.I.42422
 Nineteenth-century photograph.
 Original print in Oxford.

155 COAT OF ARMS OF THE PASSION fol.rés. S.II.62987
 AND THE LAMB OF GOD
 171 x 117 mm

Provenance: In the Collection of Giuseppe Storck (Milan), inventory number 841 (on the verso: collection mark Lugt 2319) in 1805. Prior to 1895 in the Collection of Luigi Angiolini (Milan); purchased from this collection during the sale held between 8 and 22 May 1895 (Sale Gutekunst, Stuttgart: Lugt, *Ventes* 53517) (91 BEF, 88 centimes).
Literature: L.II.265.189; Washington 1967-68, n° 8; Bevers 1986-87, n° 89, ill. 91.

156 THE LIFE OF THE VIRGIN (=L.II.275.193) fol.rés.S.I.42416
 Nineteenth-century photograph.
 Original print in Dresden.

157 THE PASSION (=L.II.277.194) fol.rés.S.I.42418
 Nineteenth-century photograph
 Original print in Dresden

- SCENES FROM THE PASSION (=L.II.278.194b) fol.rés. S.II.7787-90
 (Master E S; probably retouched by Meckenem)
 See n° 415: Israhel van Meckenem (= L.IX.344.441).

158 THE PASSION (=L.II.278.195) fol.rés.S.I.42417
 Nineteenth-century photograph.
 Original print in Dresden.

159 THE LIFE OF CHRIST AND OTHER fol.rés.S.I.42419
 REPRESENTATIONS
 (=L.II.280.196)
 Nineteenth-century photograph.
 Original print in Dresden.

- THE LIFE OF CHRIST AND OTHER fol.rés. S.II.7786
 RELIGIOUS SCENES (=L.II.281.196a)
 (Master E S; probably retouched by Meckenem)
 See n° 416: Israhel van Meckenem (= L.IX.344.442).

160 THE TWELVE APOSTLES, SEATED (=L.II.281.197) fol.rés.S.I.42421
 Nineteenth-century photograph.
 Original print in Dresden.

161 SEVERAL SAINTS AND
 THE MASSACRE OF THE INNOCENTS fol.rés.S.I.42420
 (=L.II.285.199)
 Nineteenth-century photograph.
 Original print in Dresden.

162 WOMAN WITH A HELMET AND A SHIELD fol.rés.S.I.42413
(=L.II.309.220)
Nineteenth-century photograph, probably by W. Hoffmann (Dresden).
Original print in Dresden.

AFTER MASTER E S

- VIRGIN AND CHILD STANDING ON A SERPENT fol.rés. S.II.34580
(=L.II.133.71b)
See n° 387: Israhel van Meckenem (= L.IX.190.189).

- ST MICHAEL (recto and verso: fragment) fol.rés.S.I.23267
(=L.II.221.152a)
See n° 144 (=Schr.V.2710).

- ST CATHERINE
(cf. L.II.236.166)
See n° 201

AFTER MASTER E S BY WOLFGANG AURIFABER (WOLFGANG THE GOLDSMITH)
(German goldsmith. Active in Augsburg, c.1477)

163 VIRGIN AND CHILD WITH ABBOT LUDWIG (1477) fol.rés. S.II.225
350 x approx. 222 mm (=S.I.23177)
Modern impression: counter-proof. Plate in Augsburg Cathedral.
Provenance: Purchased from Van der Kolk on 16 March 1853.
Literature: L.II.145.80a (with bibliography).

164 VIRGIN AND CHILD WITH ABBOT LUDWIG (1477) fol.rés. S.II.24197
350 x approx. 222 mm
Modern impression: counter-proof. Plate in Augsburg Cathedral.
Provenance: Prior to 1848, in the Collection of K.F.F. von Nagler, Berlin (on the verso: collection mark Lugt 2529). Kupferstichkabinett der Staatlichen Museen, Berlin (on the verso: collection mark Lugt 1606 and 'Tilgungs Stempel'). Purchased from Ms. Buttstaedt, print dealer in Berlin (together with n° 165, for 28 BEF, 13 centimes) on 5 February 1878.
Literature: See n° 163.

165 VIRGIN AND CHILD WITH ABBOT LUDWIG (1477) fol.rés. S.II.24196
350 x approx. 222 mm
Modern impression. Plate in Augsburg Cathedral.
Provenance: Prior to 1826, in the Collection of Count Wilhelm Heinrich Ferdinand Karl von Lepell (on the verso: collection mark Lugt 1672). Kupferstichkabinett der Staatlichen

Museen, Berlin (on the verso: collection mark Lugt 1606 and 'Tilgungs Stempel') by 1835. Purchased from Ms. Buttstaedt, print dealer in Berlin (together with n° 164 for 28 BEF, 13 centimes) on 5 February 1878.
Literature: see n° 163.

MASTER OF THE BERLIN PASSION
(Northwest German or Netherlandish engraver - Lower Rhine. Active c.1450 - 70)
See also n° 199 - n° 202.

166 THE FALL OF MAN (=L.III.21.2) fol.rés. S.I.42411
Nineteenth-century photograph.
Original print in Liège (University Library).

167 CHRIST ON THE CROSS (=L.III.80.30.II) fol.rés. S.I.42412
Nineteenth-century photograph.
Original print in Liège (University Library).

168 ST ANTHONY (=L.III.100.59) fol.rés.S.I.42410
Nineteenth-century photograph.
Original print in Liège (University Library).

169 ST CHRISTOPHER (=L.III.102.61) fol.rés.S.I.42409
Nineteenth-century photograph.
Original print in Liège (University Library).

MASTER OF SAINT ERASMUS (group of)
(Lower Rhine 'workshop'. Active c.1450 - 70)

[Master with the Flower Borders]
See also n° 196.

170 THE BETRAYAL AND THE CAPTURE OF CHRIST Ms.II.1035, fol. 75v
74 x 54 mm coloured
Colour plate VI

Inserted in a manuscript with devotional texts (devotional tracts, prayers, etc). See also n° 171, n° 194, and n° 195.
Provenance: Maria Vande Velde. The inscription *'dit boechen hoort toe Maria vande Velde'* was added to the first flyleaf, probably in the sixteenth century. Collection Thomas Philips (Cheltenham) (inscribed on the first flyleaf: *4012 mss. Ph.*). Acquired by the Royal Library in 1888.
Literature: L.III.186.51; Hébert I.62.161.

171 THE BEARING OF THE CROSS Ms.II.1035, fol. 107v
75 x 54 mm coloured
Colour plate VI
Inserted in a manuscript with devotional texts (devotional tracts, prayers, etc). See also
n° 170, n° 194, and n° 195.
Provenance: See n° 170.
Literature: L.III.188.566.

172 VIRGIN AND CHILD fol.rés. S.II.21245
51 x 22 mm (cut out)
Provenance: Purchased from Zweibrücken (Malmédy) on 2 July 1874 (50 centimes). This
print belonged to a lot of ten that were described in the inventory as *extraites de livres*. I have
been unable to trace the other nine prints.
Literature: L.III.204.78; Lehrs 1892, p. 488, n° 106.

173 VIRGIN AND CHILD WITH AN APPLE fol.rés.S.I.42407
(=L.III.206.81)
Nineteenth-century photograph.
Original print in Liège (University Library).

[Master of St Erasmus]
See also n° 197.

174 ENTRY INTO JERUSALEM fol.rés. S.II.5781
61 x 40 mm
Provenance: Purchased from Alexandre Pinchart, Keeper of the State Archives of Belgium,
Brussels, on 19 July 1861. This belonged to a lot of 13 prints that were purchased for a total
sum of 100 BEF. See also n° 148.
Literature: L.III.241.8; Lehrs 1892, p. 488, n° 105.

175 ENTRY INTO JERUSALEM (=L.III.241.9) fol.rés. S.I.42405
Nineteenth-century photograph, probably by W. Hoffmann (Dresden).
Original print in Darmstadt.

[Master of the Dutuit Mount of Olives]

176 ST LAWRENCE fol. rés. S.II.8314 (Master S)
74 x 53 mm (plate) coloured
This engraving was printed on one sheet, together with the engraving of St John the Baptist
(sixteenth century) monogrammed by Master S (= H.293). The attribution of this fifteenth-
century engraving (n° 176) to Master S (by Hollstein) is clearly incorrect.
Provenance: Prior to 1865, in the Collection of Chevalier J. Camberlyn d'Amougies,

Brussels; purchased from this collection (Sale E. Guichardot, Paris: Lugt, *Ventes* 28481) (5 BEF, 25 centimes) on 25 April 1865.

Literature: L.III.323.63; Lehrs 1892, p. 489, n° 109; H.*Dutch*.XIII.270 (and 293).

[Master of the Martyrdom of the 10,000]

177-189 The following 13 prints marked with an asterisk (*) are bound into a Latin and Dutch prayer book. The manuscript is kept in the Print Room and not in the Manuscript Department.

177 THE VISITATION* rés. S.II.86244, fol. 1v
 77 x 52 mm coloured

Provenance: In the Collection of Maria Isabella van Zurpele (Diest, Belgium) in the eighteenth century (see fol. 1r). The manuscript was purchased by the Royal Library from Raoul van Sulpen, Brussels, on 25 January 1899 (1000 BEF).

Literature: L.III.362.16; Lebeer 1931; Schuppisser 1991, p. 396.

178 THE CIRCUMCISION* rés. S.II.86245, fol. 4v
 79 x 54 mm coloured

Provenance: See n° 177.

Literature: L.III.364.18. See also n° 177.

179 THE ADORATION OF THE MAGI* rés. S.II.86246, fol. 5v
 78 x 53 mm coloured

Provenance: See n° 177.

Literature: L.III.464.19. See also n° 177.

180 THE PRESENTATION IN THE TEMPLE* rés. S.II.86247, fol. 6v
78 x 53 mm coloured

Provenance: See n° 177.

Literature: Not in Lehrs. See also n° 177.

181 THE FLIGHT INTO EGYPT* rés. S.II.86249, fol. 8r
 78 x 53 mm coloured

Provenance: See n° 177.

Literature: L.III.465.20; Antwerp 1930, p. 155. See also n° 177.

182 THE MASSACRE OF THE INNOCENTS* rés. S.II.86248, fol. 7r
 78 x 52 mm coloured

Provenance: See n° 177.

Literature: L.III.365.21. See also n° 177.

183 CHRIST IN THE HOUSE OF SIMON*
78 x 52 mm
Provenance: See n° 177.
Literature: L.III.368.27. See also n° 177.

rés. S.II.86250, fol. 9r
coloured

184 THE RAISING OF LAZARUS*
73 x 52 mm
Provenance: See n° 177.
Literature: L.III.369.28. See also n° 177.

rés. S.II.86251, fol. 10r
coloured

185 CHRIST DRIVING OUT THE MONEY-LENDERS*
74 x 53 mm
Provenance: See n° 177.
Literature: Not in Lehrs. See also n° 177.

rés. S.II.86252, fol. 11r
coloured

186 CHRIST STRIPPED OF HIS RAIMENT*
77 x 53 mm
Provenance: See n° 184.
Literature: L.III.375.(39). See also n° 177.

rés. S.II.86253, fol. 12v
coloured

187 PREPARATIONS FOR THE CRUCIFIXION*
78 x 53 mm
Provenance: See n° 177.
Literature: L.III.375.40. See also n° 177.

rés. S.II.86254, fol. 13v
coloured

188 THE ENTOMBMENT*
78 x 53 mm
Provenance: See n° 177.
Literature: L.III.378.(45). See also n° 177.

rés. S.II.86255, fol. 16r
coloured

189 CHRIST IN LIMBO*
78 x 53 mm
Provenance: See n° 177.
Literature: L.III.379.46. See also n° 177.

rés. S.II.86256, fol. 17r
coloured

190 THE FAMILY OF ST ANNE
97 x 69 mm
Colour plate VI

fol.rés. S.II.8306
coloured

Purchased by the Royal Library (1865) as the work of Master E S.
Provenance: Prior to 1865 in the Collection of Chevalier J. Camberlyn d'Amougies, Brussels; purchased from this collection (Sale E. Guichardot, Paris: Lugt, *Ventes* 28481) on 25 April 1865 (262 BEF, 50 centimes).
Literature: L.III.392.65; Lehrs 1892, p. 488, n° 107.

191 ST PETER fol.rés. S.II.8307
71 x 49 mm coloured

Entered in the inventory of the Royal Library in 1865 as the work of a *'Maitre anonyme primitif'*.
Provenance: Prior to 1865 in the Collection of Chevalier J. Camberlyn d'Amougies, Brussels (on the verso: collection mark Lugt 514); purchased from this collection (Sale E. Guichardot, Paris: Lugt, *Ventes* 28481) on 25 April 1865 (111 BEF, 30 centimes).
Literature: L.III.393.66; Lehrs 1892, p. 489, n° 108; Geisberg 1909, p.120 and p.129, note 75.

192 ST PETER (=L.III.394.68) fol.rés.S.I.42408
Nineteenth-century photograph.
Original print in Liège (University Library).

193 ST MICHAEL (=L.III.400.77) fol.rés.S.I.42406
Nineteenth-century photograph.
Original print in Liège (University Library).

PRINTS BELONGING TO LEHRS III, BUT NOT MENTIONED BY LEHRS
See also n° 180 and n° 185.

194 THE AGONY IN THE GARDEN Ms.II.1035, fol. 69v
72 x >48 mm (left edge: trimmed) coloured
Colour plate VII

Inserted in a manuscript with devotional texts (devotional tracts, prayers, etc). See also n° 170, n° 171, and n° 195.
Provenance: See n° 170.
Literature: Not in Lehrs.

195 CHRIST APPEARING TO MARY MAGDALENE Ms.II.1035, fol. 153v
80 x 58 mm coloured
Colour plate VII

Inserted in a manuscript with devotional texts (devotional tracts, prayers, etc). See also n° 170, n° 171, and n° 194. The style of this print is very close to Schuppisser 1991, p. 399, ill. 3.
Provenance: See n° 170.
Literature: Not in Lehrs.

196 THE LAST JUDGEMENT* Ms. 11059, fol. 113r
74 x 51 mm coloured
Colour plate VIII

The following prints marked with an asterisk (*) (n° 196 - n° 202) are bound in a Dutch prayer book from Arnhem from the second half of the fifteenth century.
Provenance: Helle Staeckebrans (inscribed on fol. 2r: *'Dyt boeck hoert toe / Helle Staeckebrans . . .'*); Paris Bibliothèque nationale (stamp on fol. 218r has been effaced).

Literature: Not in Lehrs. See also L.III.202.77a (copy by the Master with the Flower Borders). VDG 785.

197 MARTYRDOM OF ST ERASMUS* Ms.11059, fol. 160v
 63 x 42 mm coloured
 Colour plate VIII
This print is very similar to L.III.274.84. (Master of St Erasmus).
Provenance: See n° 196.
Literature: Not in Lehrs. See also n° 196.

198 MASS OF ST GREGORY* Ms. 11059, fol. 17v
 73 x 50 mm coloured
 Colour plate VIII
Provenance: See n° 196.
Literature: Not in Lehrs. See also n° 196.

199 ST AGNES* Ms. 11059, fol. 165r
 67 x 42 mm coloured
 Colour plate VIII
Master of the Berlin Passion?
Provenance: See n° 196.
Literature: Not in Lehrs. See also n° 196.

200 ST BARBARA* Ms. 11059, fol. 166r
 86 x 60 mm coloured
 Colour plate IX
Master of the Berlin Passion?
Provenance: See n° 196.
Literature: Not in Lehrs. See also n° 196.

201 ST CATHERINE* Ms. 11059, fol. 164r
 90 x 64 mm coloured
 Colour plate IX
Master of the Berlin Passion? Copy after (or model for?) Master E S (L.II.236.166).
Provenance: See n° 196.
Literature: Not in Lehrs. See also n° 196.

202 THE INFANT JESUS WITH THE INSTRUMENTS Ms. 11059, fol. 84v
 OF THE PASSION* coloured
 55 x 21 mm (cut out)
 Colour plate IX
Only the infant Jesus and the crucified Christ remain from the original engraving; the rest was cut away. This print may be L.III.117.80: Master of the Berlin Passion.

Provenance: See n° 196.

Literature: L.III.117.80 (?). H. *Dutch*. XII.105.80 (?). See also n° 196.

203 ST AGATHA fol.rés. S.II.8322

 68 x 48 mm coloured

In the inventory (1865), this print is said to be the work of a *'maître de l'école brugeoise (1466)'*. In 1892 Lehrs described this print as part of the work of the Master of St. Erasmus. He noted that it, along with the engraving of St. Lawrence (n° 176), were part of a single group: *'... gehören zu einer Folge von verschiedenen Heiligen unter ähnlichen Portalen, aus welcher mir bis jetzt 15 Blatt bekant sind'* (Lehrs 1892, p. 490, n° 110). In his general catalogue (L.IX.252.303), however, Lehrs associates this print with Israhel van Meckenem, an attribution that he justifies as follows: *'Ich rechnete den Stich ... zur Portalfolge des Erasmus-Meisters und erkannte erst 1905 durch Auffindung der bezeichneten Gertrud, dass die heilige Agathe zu den von Meckenem gestochenen Blättern zu rechnen sei'*. Yet, Lehr's second attribution is unsustainable for obvious stylistic reasons

Provenance: Prior to 1865 in the Collection of Chevalier J. Camberlyn d'Amougies, Brussels (on the verso: collection mark Lugt 514); purchased from this collection (Sale E. Guichardot Paris: Lugt, *Ventes* 28481) on 25 April 1865 (95 BEF, 45 centimes).

Literature: L.IX.252.303 (Meckenem); Passavant.II.269.55; Lehrs 1892, p. 490, n° 110; H.*German* XXIV.119.303 (as: *'not by Meckenem'*).

204 ST ANNE WITH THE VIRGIN AND CHILD Ms. IV.433, fol. 99v

 71 x 52 mm coloured

 Colour plate X

Inserted in a Latin manuscript (c.1500) containing various religious texts and fragments from Henricus Suso's *Buchlein der Ewigen Weisheit*. The image is printed on velum. Only part of the print was inked; the rest was printed without ink. St Anne's throne was rendered in blind tooling (which is not visible in the photograph).

Provenance: On fol. 2r, there is a reference to the Brethren of the Common Life in Weidenbach (Cologne): *'o(mn)es fr(atr)es in Wyde(n)bach vi- / uentes'*. Purchased from A. Van Loock, Brussels, in 1966.

Literature: Not in Lehrs.

MASTER WITH THE BANDEROLES

(Northwest German / Netherlandish engraver -Lower Rhine. Active c.1450 - 75)

205 ST BARBARA (=L.IV.105.72) fol.rés. S.I.42404

 Nineteenth-century photograph.

 Original print in the Arenberg Collection.

UNKNOWN MASTERS

206 THE LAMENTATION: GUILD PRINT OF THE fol.rés. S.I.42434
RHETORICIANS' CHAMBER 'DE DOORNE KROONE'
OF NIEUWPOORT
141 x 104 mm

Modern impression. No single contemporary impression is known. On 26 February 1868, the copperplate was still in the collection of the rhetoricians' chamber of Nieuwpoort (Belgium). In 1890 the plate was in the Collection of Adolphe Kempynck, Alderman of Nieuwpoort.

Provenance: According to Lehrs (1892, p. 501), the engravings (see also n° 212) were purchased by Louis Alvin, probably ('*wahrscheinlich*') from the numismatist Renier Chalon who received them, together with a letter (dated 26 February 1868) from Mr Coppieters, Nieuwpoort. The letter, now preserved together with the print, was purchased in November 1890 by Henri Hymans (Chalon Sale): '*der . . . den . . . Brief von Coppieters über die Stiche im November 1890 auf der Auction Chalon für mich erstand. In dem Brief befanden sich Abdrücke der Platten von Nieuport, die aber auf unerklärliche Weise verschwanden, bevor Hymans das ihm zugeschlagene Lot erhalten hatte*' (Lehrs 1892, p. 501, note 44).

Literature: L.IV.221.16; Lecluyse 1845; Lehrs 1892, p. 500, n° 181.

207 LAMENTATION (state II) fol.rés. S.II.4658
>265 x 206 mm

Engraving by an unknown Dutch engraver, retouched and monogrammed by Israel van Meckenem. A piece of the top of the print was torn off.

Provenance: On the verso there is a mark from an unidentified collection dated 1803 (not in Lugt). Purchased from the Collection of Jozef Paelinck, Brussels (Sale Heussner, Brussels: Lugt, *Ventes* 25811) on 20 November 1860 (24 BEF, 20 centimes).

Literature: L.IV.229.22(II); Lehrs 1892, p. 495, n° 132; Washington 1967-68, n° 260; H. *German*.XXIV.233.[638.II]; Hébert I.124.520.

208 VIRGIN AND CHILD fol.rés. S.II.36007
72 x 48 mm coloured

Provenance: Purchased from Gutekunst, Stuttgart, on 15 January 1887 (22 BEF, 50 centimes).

Literature: L.IV.242.41; Lehrs 1892, p. 504, n° 186.

209 ST MICHAEL fol.rés. S.II.24204
87 x 68 mm

Provenance: Recorded in the 1868 Sale Gutekunst (Auction I) (?). Purchased from Ms. Buttstaedt, print dealer in Berlin, on 5 February 1878 (82 BEF, 50 centimes). Buttstaedt's collection mark (Lugt 318) and an unidentified collection mark (JKES) are on the verso.

Literature: L.IV.263.69a; Lehrs 1892, p. 504, n° 187.

- ST DOROTHY (=L.IV.265.74) fol.rés.S.II.5778
 See n° 148 (= Schr.VI.2870).

210 THE ARMS OF CHRIST fol.rés. S.II.6785
 90 x 77 mm coloured

On the verso of the print there is a text in Dutch, handwritten by the Franciscan Frans Backer from Leuven. A note in pencil reads: *'fr. récollet de Louvain'* (ill. 210v). The print belongs to a group of eight from a Dutch prayer book dating from 1552/53 (Ms. 22012). See also n° 047, n° 049 and n° 437.
Provenance: Given by Mr Van der Beelen on 10 April 1863. See also n° 049.
Literature: L.IV.268.78; Lehrs 1892, p. 502, n° 183. See also n° 049.

211 THE IHS MONOGRAM WITH THE HEART fol.rés.S.II.29788
 OF CHRIST coloured
 107 x 68 mm

The text reads: *'Ghebenedyt moet syn d(en) suete nae(me) Ih(esu)s en Maria synder liever moeder inder ewicheit'.*
Provenance: Prior to 7 June 1882, this print was inserted in *Epistelen ende Evangelien* (Deventer, Jacob van Breda, 1493) (Inc. 1385 bis; Polain, 1409).
Literature: L.IV.268.79; Lehrs 1892, p. 503, n° 184.

212 COAT OF ARMS OF THE RHETORICIANS' fol.rés. S.I.42437
 CHAMBER DE DOORNE KROONE' OF
 NIEUPORT WITH REBUS: *'van vroescepe dinne 1491'*
 141 x 104 mm

Modern impression. No single contemporary impression is known. In 1845 the copperplate was in the Collection of Mr Kesteloot. The plate was in the Collection of P.C. Lecluyse, Nieuwpoort, in 1868. Maybe in the Collection Kempynck, Nieuwpoort, in 1890.
Provenance: See n° 206.
Literature: L.IV.269.80; Lecluyse 1845; Lehrs 1892, p. 503, n° 185; Hymans 1907, p. 137.
See also n° 206.

MARTIN SCHONGAUER
(German painter and engraver. Colmar c.1450 - Breisach 1491)

213 THE ANNUNCIATION fol.rés. S.II.11404
 162 x 112 mm

Provenance: Purchased from Van Gogh, print dealer in Brussels on 4 June 1869 (225 BEF).
Literature: L.V.39.1; Lehrs 1892, p. 482, n° 10; Washington 1967-68, n° 64; Hébert I.69.198; TIB, vol. 8.1 Commentary, n° 0801.001; H.*German*.XLIX.15.1 (with comprehensive bibliography).

214 THE ARCHANGEL GABRIEL fol.rés. S.II.2371
(companion piece to n° 215)
165 x 102 mm

Provenance: Purchased from Drugulin, Leipzig, in June 1859 (135 BEF). On the verso: *W.D.* (collection mark Drugulin: Lugt 2612).
Literature: L.V.42.2; Lehrs 1892, p. 482, n° 8; Washington 1967-68, n° 114; Hébert I.69.197a; TIB, vol. 8.1 Commentary, n° 0801.002; Paris 1991.58.33; H.*German*.XLIX.17.2 (with comprehensive bibliography).

215 THE VIRGIN fol.rés. S.II.2372
(companion piece to n° 214)
172 x 118 mm

Provenance: Purchased from Drugulin, Leipzig, in June 1859 (168 BEF, 75 centimes). On the verso: W.D. (collection mark Drugulin: Lugt 2612).
Literature: L.V.43.3; Lehrs 1892, p. 482, n° 9; Washington 1967-68, n° 115; Hébert I.69.197b; TIB, vol. 8.1 Commentary, n° 0801.003; Paris 1991.59.34; H.*German*.XLIX.19.3 (with comprehensive bibliography).

216 THE NATIVITY fol.rés. S.II.4640
158 x 158 mm

This print was probably switched with n° 217 when they were entered into the inventory. This is evident from the prices paid for each.
Provenance: Purchased from the Collection of Jozef Paelinck, artist-painter, on 20 November 1860 at the Heussner Sale, Brussels (Lugt, *Ventes* 25811) (352 BEF).
Literature: L.V.46.4; Lehrs 1892, p. 482, n° 11; Washington 1967-68, n° 74; Hébert I.71.200; TIB, vol. 8.1 Commentary, n° 0801.004; Paris 1991.57.32; H.*German*.XLIX.21.4 (with comprehensive bibliography).

217 THE NATIVITY fol.rés. S.II.4639
266 x 168 mm
Colour plate XI

See n° 216.
Provenance: Purchased from the Collection of Jozef Paelinck, artist-painter on 20 November 1860 at the Heussner Sale, Brussels (Lugt, *Ventes* 25811) (165 BEF).
Literature: L.V.50.5; Lehrs 1892, p. 482, n° 12; Washington 1967-68, n° 38; Hébert I.69.199; Landau & Parshall 1994, p. 51 and fig. 24; TIB, vol. 8.1 Commentary, n° 0801.005; H.*German*.XLIX.23.5 (with comprehensive bibliography).

218 THE ADORATION OF THE MAGI (state II) fol.rés. S.II.2373
252 x 168 mm

Provenance: Purchased from Drugulin, Leipzig, in June 1859 (337 BEF, 50 centimes). On the verso: W.D. (collection mark Drugulin: Lugt 2612).

Literature: L.V.56.6; Lehrs 1892, p. 482, n° 13; Washington 1967-68, n° 39; Hébert I.71.201; TIB, vol. 8.1 Commentary, n° 0801.006; H.*German*.XLIX.27.6(II) (with comprehensive bibliography).

219 THE FLIGHT INTO EGYPT fol.rés. S.II.1983
 255 x 169 mm
Provenance: Purchased from the Collection Borluut de Noortdonck (Gent 13/18 December 1858: Lugt, *Ventes* 24531) (34 BEF, 10 centimes).
Literature: L.V.62.7; Lehrs 1892, p. 482, n° 14; Washington 1967-68, n° 40; Hébert I.71.202; Paris 1991.48.25; TIB, vol. 8.1 Commentary, n° 0801.007; H.*German*.XLIX.29.7 (with comprehensive bibliography).

220 THE BAPTISM OF CHRIST fol.rés. S.II.26329
 158 x 158 mm
Provenance: Collection Fountaine Walker, Ness Castle, Inverness (Scotland). On the verso: collection mark Lugt 2545. Purchased from Ms. Buttstaedt, print dealer in Berlin (112 BEF, 50 centimes) (Lugt 318) by 17 January 1880. [The Fountaine Walker Collection was auctioned off at Sotheby's at a later date (1 and 2 May 1893).] There is an unknown mark on the verso: EKL (not in Lugt).
Literature: L.V.66.8; Lehrs 1892, p. 482, n° 15; Washington 1967-68, n° 76; Hébert I.71.203; TIB, vol. 8.1 Commentary, n° 0801.008; H.*German*.XLIX.31.8 (with comprehensive bibliography).

221 THE BEARING OF THE CROSS fol.rés. S.II.22135
 285 x 432 mm
 Colour plate XI
Provenance: Purchased from Schmidt, Brussels (Van Gogh, print dealer in Brussels) on 25 June 1875 (1100 BEF).
Literature: L.V.69.9; Lehrs 1892, p. 484, n° 29a; Hébert I.72.216; Paris 1991.50.27; Landau & Parshall 1994, p. 53 and fig. 29; TIB, vol. 8.1 Commentary, n° 0801.009; H.*German*.XLIX.33.9 (with comprehensive bibliography).

222 THE BEARING OF THE CROSS fol.rés. S.I.31946
 (large fragment)
Fragments from other prints applied to the verso of this one reflect older restoration(s). On the left, part of the print has been torn away.
Provenance: Unknown. In the collection prior to 1892.
Literature: Lehrs 1892, p. 484, n° 29b. See also n° 221.

223 THE BEARING OF THE CROSS fol.rés. S.I.31945
259 x 404 mm

The print contains several wormholes.
Provenance: Unknown. In the collection prior to 1892.
Literature: Lehrs 1892, p. 484, n° 29c. See also n° 221.

224 THE CRUCIFIXION fol.rés. S.II.2378
121 x 86 mm

Provenance: Purchased from Drugulin, Leipzig in June 1859 (72 BEF). On the verso:
W.D. (collection mark Drugulin: Lugt 2612).
Literature: L.V.85.12; Lehrs 1892, p. 484, n° 30; Hébert I.72.219; TIB, vol. 8.1 Commentary,
n° 0801.012; H.*German*.XLIX.39.12 (with comprehensive bibliography).

225 THE CRUCIFIXION fol.rés. S.II.4642
195 x 151 mm

Provenance: Purchased from the Collection of Jozef Paelinck, artist-painter, on 20
November 1860, at the Heussner Sale, Brussels (Lugt, *Ventes* 25811) (187 BEF).
Literature: L.V.92.13; Lehrs 1892, p. 484, n° 31; Washington 1967-68, n° 63; Hébert I.72.220;
TIB, vol. 8.1 Commentary, n° 0801.013; H.*German*.XLIX.42.13 (with comprehensive
bibliography).

226 THE CRUCIFIXION WITH FOUR ANGELS fol.rés. S.II.2508
288 x 193 mm

Four lines of text in German were handwritten on the verso of this print.
Provenance: Prior to 1859, in the Ch. de Férol Collection. Sold on 7/8 December 1859
Guichardot, Paris (Lugt, *Ventes* 25136) (619 BEF, 50 centimes). An unknown mark: EKL (not
in Lugt), is on the verso.
Literature: L.V.95.14; Lehrs 1892, p. 484, n° 32; Washington 1967-68, n° 46; Hébert I.72.221;
TIB, vol. 8.1 Commentary, n° 0801.014; Paris 1991.52.28; H.*German*.XLIX.44.14 (with
comprehensive bibliography).

227 CHRIST APPEARING TO MARY MAGDALENE fol.rés. S.II.4643
160 x 159 mm

Defects were retouched in pen.
Provenance: Purchased from the Collection of Jozef Paelinck, artist-painter, on 20
November 1860, at the Heussner Sale, Brussels (Lugt, *Ventes* 25811) (154 BEF).
Literature: L.V.102.15; Lehrs 1892, p. 484, n° 33; Hébert I.72.222; Washington 1967-68, n° 77;
TIB, vol. 8.1 Commentary, n° 0801.015; H.*German*.XLIX.47.15 (with comprehensive
bibliography).

228 THE DEATH OF THE VIRGIN (state II) fol.rés. S.II.4645
 257 x 171 mm
 Colour plate XI

A handwritten text on the verso reads: *'soit III st(uvers) 1557'*. This may be the price of the engraving in 1557. The print was remargined. The upper border was completed with pen. Provenance: Purchased from the Collection of Jozef Paelinck, artist-painter, on 20 November 1860, at the Heussner Sale, Brussels (Lugt, *Ventes* 25811) (50 BEF, 60 centimes). There is an unknown mark on the verso: EKL (not in Lugt).
Literature: L.V.106.16(II); Lehrs 1892, p. 484, n° 39; Hymans 1907, p. 208 and 233; Washington 1967-68, n° 41; Hébert I.75.229; Landau & Parshall 1994, pp. 52-53 and fig. 24; Paris 1999.49.26; TIB, vol. 8.1 Commentary, n° 0801.016; H.*German*.XLIX.51.16(II) (with comprehensive bibliography).

229 CHRIST CROWNING THE VIRGIN fol.rés. S.II.4649
 163 x 155 mm

Defects were retouched in pen.
Provenance: Purchased from the Collection of Jozef Paelinck, artist-painter, on 20 November 1860, at the Heussner Sale, Brussels (Lugt, *Ventes* 25811) (143 BEF). An unidentified collection mark (Lugt 198) is on the verso.
Literature: L.V.111.17; Lehrs 1892, p. 485, n° 68; Hébert I.71.267; TIB, vol. 8.1 Commentary, n° 0801.017; H.*German*.XLIX.54.17 (with comprehensive bibliography).

230 CHRIST BLESSING THE VIRGIN fol.rés. S.II.2401
 158 x 150 mm

Defects were retouched in pen.
Provenance: An unknown collection mark (not in Lugt) is on the verso. Purchased from Drugulin, Leipzig in June 1859 (202 BEF, 50 centimes).
Literature: L.V.114.18; Lehrs 1892, p. 485, n° 67; Washington 1967-68, n° 75; Hébert I.81.266; TIB, vol. 8.1 Commentary, n° 0801.018; H.*German*.XLIX.56.18 (with comprehensive bibliography).

231-244 THE PASSION OF CHRIST (12 different plates)

231 THE AGONY IN THE GARDEN fol.rés. S.II.10968
 163 x 114 mm

Defects were retouched in pen. The figure of Christ and some of the rocks were traced over in red pencil on the verso of the print.
Provenance: Purchased from Goupil (100 BEF) on 15 April 1868.
Literature: L.V.122.19; Lehrs 1892, p. 483, n° 16; Hébert I.71.204; TIB, vol. 8.1 Commentary, n° 0801.019; H.*German*.XLIX.57.19 (with comprehensive bibliography).

232 THE BETRAYAL AND CAPTURE OF CHRIST fol.rés. S.II.1984
 159 x 116 mm (=S.I.31589)

The figure '*8 fl(orijnen)*' is written on the verso. This may have been the price of the print at some unknown point in time.

Provenance: Purchased from the Collection Borluut de Noortdonck (Gent 13/18 December 1858: Lugt, *Ventes* 24531) (13 BEF, 20 centimes).

Literature: L.V.128.20; Lehrs 1892, p. 483, n° 17; Washington 1967-68, n° 52; Hébert I.71.205; TIB, vol. 8.1 Commentary, n° 0801.020; H.*German*.XLIX.59.20 (with comprehensive bibliography).

233 THE BETRAYAL AND CAPTURE OF CHRIST fol.rés. S.II.31284
 163 x 116 mm

Provenance: Purchased from Gutekunst, Stuttgart (150 BEF, 50 centimes) on 20 May 1884.

Literature: See n° 232.

234 CHRIST BEFORE CAIAPHAS fol.rés. S.II.2507
 (formerly: *Christ before Annas*)
 162 x 112 mm

Provenance: Prior to 1859, in the Ch. de Férol Collection. Sold on 7/8 December 1859, Guichardot, Paris (Lugt, *Ventes* 25136) (194 BEF, 25 centimes).

Literature: L.V.132.21; Lehrs 1892, p. 483, n° 18; Washington 1967-68, n° 53; Hébert I.71.206; TIB, vol. 8.1 Commentary, n° 0801.021; H.*German*.XLIX.60.21 (with comprehensive bibliography).

235 THE FLAGELLATION fol.rés. S.II.10965
 163 x 115 mm

Provenance: Purchased from Goupil (250 BEF) on 12 February 1868. On the verso of this print there is an unknown mark: EKL (not in Lugt).

Literature: L.V.136.22; Lehrs 1892, p. 483, n° 19; Washington 1967-68, n° 54; Hébert I.71.207; TIB, vol. 8.1 Commentary, n° 0801.022; H.*German*.XLIX.62.22 (with comprehensive bibliography).

236 CHRIST CROWNED WITH THORNS fol.rés. S.II.2374
 161 x 114 mm

The print was remargined.

Provenance: Purchased from Drugulin, Leipzig in June 1859 (84 BEF, 38 centimes). On the verso: W.D. (collection mark Drugulin: Lugt 2612).

Literature: L.V.139.23; Lehrs 1892, p. 483, n° 20; Washington 1967-68, n° 55; Hébert I.71.208; TIB, vol. 8.1 Commentary, n° 0801.023; H.*German*.XLIX.63.23 (with comprehensive bibliography).

237 CHRIST BEFORE PILATE fol.rés. S.II.2375
 161 x 113 mm
Provenance: Purchased from Drugulin, Leipzig in June 1859 (67 BEF, 50 centimes). On the verso: W.D. (collection mark Drugulin: Lugt 2612).
Literature: L.V.141.24; Lehrs 1892, p. 483, n° 21; Washington 1967-68, n° 57; Hébert I.71.209; TIB, vol. 8.1 Commentary, n° 0801.024; H.*German*.XLIX.64.24 (with comprehensive bibliography).

238 ECCE HOMO fol.rés. S.II.8956
 162 x 113 mm
Provenance: From an exchange made with Clément, Paris, on 5 January 1866. Probably exchanged for one niello from the collection van Sestich (cf. n° 479 - n° 499), now in the Bibliotheque nationale, Paris. See introduction p. 17. There is an unknown mark: EKL (not in Lugt) on the verso of this print.
Literature: L.V.145.25; Lehrs 1892, p. 483, n° 22; Hébert I.71.210; TIB, vol. 8.1 Commentary, n° 0801.025; H.*German*.XLIX.65.25 (with comprehensive bibliography).

239 THE CARRYING OF THE CROSS WITH fol.rés. S.II.2376
 ST VERONICA
 151 x 113 mm
Provenance: Collection of Canon C.W. von Blücher, Brunswick (1755-1826) (on the verso: collection mark Lugt 2710). Ca.1826-28 (?), Heinrich Füssli (1755-1829), print dealer in Zurich (collection mark Lugt 1008 on the verso). Purchased from Drugulin, Leipzig in June 1859 (54 BEF). On the verso: W.D. (collection mark Drugulin: Lugt 2612).
Literature: L.V.147.26; Lehrs 1892, p. 483, n° 23; Washington 1967-68, n° 58; Hébert I.71.211; TIB, vol. 8.1 Commentary, n° 0801.026; H.*German*.XLIX.66.26 (with comprehensive bibliography).

240 THE CRUCIFIXION fol.rés. S.II.10719
 164 x 115 mm
Provenance: Purchased from Danlos & Delisle on 6 May 1867 (36 BEF).
Literature: L.V.151.27; Lehrs 1892, p. 483, n° 24; Washington 1967-68, n° 59; Hébert I.71.212; TIB, vol. 8.1 Commentary, n° 0801.027; H.*German*.XLIX.67.27 (with comprehensive bibliography).

241 THE ENTOMBMENT fol.rés. S.II.4641
 164 x 115 mm
Provenance: Purchased from the Collection of Jozef Paelinck, artist-painter, on 20 November 1860, at the Heussner Sale, Brussels (Lugt, *Ventes* 25811) (275 BEF).
Literature: L.V.155.28; Lehrs 1892, p. 483, n° 25; Washington 1967-68, n° 60; Hébert I.72.213; TIB, vol. 8.1 Commentary, n° 0801.028; H.*German*.XLIX.69.28 (with comprehensive bibliography).

242 CHRIST IN LIMBO fol.rés. S.II.2377
165 x 116 mm
Provenance: Purchased from Drugulin, Leipzig in June 1859 (74 BEF, 25 centimes). There is an unknown mark: EKL (not in Lugt) on the verso.
Literature: L.V.160.29; Lehrs 1892, p. 483, n° 26; Washington 1967-68, n° 61; Hébert I.72.214; TIB, vol. 8.1 Commentary, n° 0801.029; H.*German*.XLIX.70.29 (with comprehensive bibliography).

243 THE RESURRECTION fol.rés. S.II.87485
163 x 115 mm
Provenance: London, British Museum, Print Room (on the verso: collection mark Lugt 300). British Museum duplicate (on the verso: Lugt mark 305). Purchased from Gutekunst, Stuttgart (400 BEF) on 19 February 1900.
Literature: L.V.162.30; Washington 1967-68, n° 62; Hébert I.72.215; TIB, vol. 8.1 Commentary, n° 0801.030; H.*German*.XLIX.71.30 (with comprehensive bibliography).

244 THE RESURRECTION fol.rés.S.II.63121
162 x 113mm (=S.I.31344)
Provenance: Prior to 1895 in the Collection of Luigi Angiolini (Milan); purchased from this collection during the sale held between 8 and 22 May 1895 (Sale Gutekunst, Stuttgart: Lugt, *Ventes* 53517) (89 BEF, 25 centimes).
Literature: See n° 243.

245 CHRIST AS SAVIOR fol.rés. S.II.2400
85 x 57 mm
Provenance: See n° 253.
Literature: L.V.169.32; Lehrs 1892, p. 485, n° 64; TIB, vol. 8.1 Commentary, n° 0801.032; H.*German*.XLIX.86.32 (with comprehensive bibliography).

246 CHRIST AS SAVIOR, ENTHRONED (state I) fol.rés. S.II.4648
168 x 120 mm
Provenance: Purchased from the Collection Jozef Paelinck, artist-painter, on 20 November 1869 at the Heussner Sale, Brussels (Lugt, *Ventes* 25811) (165 BEF).
Literature: L.V.171.33(I); Lehrs 1892, p. 485, n° 66; Hébert I.78.265; TIB, vol. 8.1 Commentary, n° 0801.033; H.*German*.XLIX.90.33(I) (with comprehensive bibliography).

247 MAN OF SORROWS WITH THE VIRGIN fol.rés. S.II.8652
AND ST JOHN (state III)
193 x 155 mm
Damaged, with old retouches in pen.
Provenance: Purchased from the Collection Chevalier J. Camberlyn d'Amougies, Brussels on 29 November 1865 at the Guichardot Sale, Paris (Lugt, *Ventes* 28481 or 28700) (43 BEF, 10 centimes).

Literature: L.V.173.34(III); Lehrs 1892, p. 485, n° 65; Hébert I.78.264; TIB, vol. 8.1 Commentary, n° 0801.034; H.*German*.XLIX.94.34(III) (with comprehensive bibliography).

248 SMALL VIRGIN AND CHILD fol.rés. S.II.4644
 89 x 62 mm

Provenance: Purchased from the Collection Jozef Paelinck, artist-painter, on 20 November 1860 at the Heussner Sale, Brussels (Lugt, *Ventes* 25811) (26 BEF, 60 centimes).
Literature: L.V.179.35; Lehrs 1892, p. 484, n° 34; Washington 1967-68, n° 65; Hébert I.72.223; TIB, vol. 8.1 Commentary, n° 0801.035; H.*German*.XLIX.96.35 (with comprehensive bibliography).

249 VIRGIN AND CHILD ON A GRASSY BENCH fol.rés. S.II.2381
 120 x 83 mm

Provenance: Collection of Thomas Emmerson (Crawhall) in 1857 (Lugt, *Ventes* 23015). Purchased from Drugulin, Leipzig, in June 1859 (540 BEF). On the verso: W.D. (collection mark Drugulin: Lugt 2612).
Literature: L.V.185.36; Lehrs 1892, p. 484, n° 37; Washington 1967-68, n° 44; Hébert I.72.226; TIB, vol. 8.1 Commentary, n° 0801.036; H.*German*.XLIX.98.36 (with comprehensive bibliography).

250 VIRGIN AND CHILD WITH THE PARROT (state II) fol.rés. S.II.2380
 >143 x 108 mm

Provenance: Purchased from Drugulin, Leipzig, in June 1859 (121 BEF, 50 centimes). On the verso: W.D. (collection mark Drugulin: Lugt 2612).
Literature: L.V.188.37; Lehrs 1892, p. 484, n° 36; Washington 1967-68, n° 36; Hébert I.72.225; TIB, vol. 8.1 Commentary, n° 0801.037; H.*German*.XLIX.102.37 (with comprehensive bibliography).

251 VIRGIN AND CHILD IN A COURTYARD fol.rés. S.II.2382
 166 x 119 mm

Remargined, borderline completed in pen. See also n° 386 (copy in reverse by Israhel van Meckenem).
Provenance: Collection of François Debois, engraver, Paris, 1833. On the verso: F.D.1833 (collection mark François Debois: Lugt 985). Purchased from Drugulin, Leipzig, in June 1859 (877 BEF, 50 centimes). On the verso: W.D. (collection mark Drugulin: Lugt 2612). There are also two indications of unidentifiable collection(s) on the verso.
Literature: L.V.192.38; Lehrs 1892, p. 484, n° 38; Hébert I.72.228; TIB, vol. 8.1 Commentary, n° 0801.038; Paris 1991.55.30; H.*German*.XLIX.104.38 (with comprehensive bibliography).

252 VIRGIN AND CHILD WITH AN APPLE fol.rés. S.II.2379
 173 x 125 mm

Provenance: Purchased from Drugulin, Leipzig, in June 1859 (202 BEF, 50 centimes). On the verso: W.D. (collection mark Drugulin: Lugt 2612).

Literature: L.V.195.39; Lehrs 1892, p. 484, n° 35; Washington 1967-68, n° 48; Hébert I.72.224; TIB, vol. 8.1 Commentary, n° 0801.039; H.*German*.XLIX.106.39 (with comprehensive bibliography).

253-264 THE TWELVE APOSTLES (12/12)

253 ST PETER (1) fol.rés. S.II.2383
89 x 42 mm
Provenance: Collection Giuseppe Storck (Milan), inventory number 7264, in 1798. Purchased from Drugulin, Leipzig, in June 1859. The series (excluding n° 261, but including n° 245 and n° 321) was purchased for a total sum of 219 BEF, 37 centimes.
Literature: L.V.206.41; Lehrs 1892, p. 484, n° 40; Hébert I.75.230; TIB, vol. 8.1 Commentary, n° 0801.041; H.*German*.XLIX.110.41 (with comprehensive bibliography).

254 ST PAUL (2) fol.rés. S.II.2394
90 x 44 mm
Provenance: See n° 253.
Literature: L.V.209.42; Lehrs 1892, p. 484, n° 41; Washington 1967-68, n° 73; Hébert I.75.241 TIB, vol. 8.1 Commentary, n° 0801.042; H.*German*.XLIX.112.42 (with comprehensive bibliography).

255 ST ANDREW (3) fol.rés. S.II. 2384
90 x 45 mm
Provenance: See n° 253.
Literature: L.V.211.43; Lehrs 1892, p. 484, n° 42; Hébert I.75.231; TIB, vol. 8.1 Commentary, n° 0801.043; H.*German*.XLIX.113.43 (with comprehensive bibliography).

256 ST JAMES THE GREATER (4) fol.rés. S.II.2385
89 x 43 mm
Provenance: See n° 253.
Literature: L.V.214.44; Lehrs 1892, p. 484, n° 43; Hébert I.75.232; TIB, vol. 8.1 Commentary, n° 0801.044; H.*German*.XLIX.114.44 (with comprehensive bibliography).

257 ST JOHN (5) fol.rés. S.II.2386
90 x 48 mm
Provenance: See n° 253.
Literature: L.V.218.45; Lehrs 1892, p. 484, n° 44; Washington 1967-68, n° 71; Hébert I.75.233; TIB, vol. 8.1 Commentary, n° 0801.045; H.*German*.XLIX.115.45 (with comprehensive bibliography).

258 ST THOMAS (6) fol.rés. S.II.2393
91 x 51 mm
Provenance: See n° 253.

Literature: L.V.220.46; Lehrs 1892, p. 484, n° 45; Washington 1967-68, n° 72; Hébert I.75.240; TIB, vol. 8.1 Commentary, n° 0801.046; H.*German*.XLIX.116.46 (with comprehensive bibliography).

259 ST JUDAS THADDEUS (7) fol.rés. S.II.2391
88 x 46 mm
Provenance: See n° 253.
Literature: L.V.223.47; Lehrs 1892, p. 484, n° 46; Washington 1967-68, n° 68; Hébert I.75.236; TIB, vol. 8.1 Commentary, n° 0801.047; H.*German*.XLIX.117.47 (with comprehensive bibliography).

260 ST PHILIP (8) fol.rés. S.II.2387
90 x 50 mm
Provenance: See n° 253.
Literature: L.V.225.48; Lehrs 1892, p. 484, n° 47; Washington 1967-68, n° 69; Hébert I.75.234; TIB, vol. 8.1 Commentary, n° 0801.048; H.*German*.XLIX.118.48 (with comprehensive bibliography).

261 ST BARTHOLOMEW (9) fol.rés. S.II.1986
87 x 41 mm
Provenance: Purchased from the Collection Borluut de Noortdonck (Gent 13/18 December 1858: Lugt, *Ventes* 24531) (24 BEF, 20 centimes).
Literature: L.V.228.49; Lehrs 1892, p. 484, n° 48; Hébert I.75.235; TIB, vol. 8.1 Commentary, n° 0801.049; H.*German*.XLIX.119.49 (with comprehensive bibliography).

262 ST MATTHEW (10) fol.rés. S.II.2390
89 x 48 mm
Provenance: See n° 253.
Literature: L.V.231.50; Lehrs 1892, p. 484, n° 49; Hébert I.75.237; TIB, vol. 8.1 Commentary, n° 0801.050; H.*German*.XLIX.120.50 (with comprehensive bibliography).

263 ST SIMON (11) fol.rés. S.II.2392
90 x 46 mm
Provenance: See n° 253.
Literature: L.V.232.51; Lehrs 1892, p. 484, n° 50; Washington 1967-68, n° 70; Hébert I.75.239; TIB, vol. 8.1 Commentary, n° 0801.051; H.*German*.XLIX.121.51 (with comprehensive bibliography).

264 ST JAMES THE LESSER (12) fol.rés. S.II.2389
87 x 41 mm
Provenance: See n° 253.
Literature: L.V.235.52; Lehrs 1892, p. 484, n° 51; Hébert I.75.238; TIB, vol. 8.1 Commentary, n° 0801.052; H.*German*.XLIX.122.52 (with comprehensive bibliography).

265 ST ANTHONY fol.rés. S.II.2395

 87 x 61 mm

Provenance: Purchased from Drugulin, Leipzig, in June 1859 (67 BEF, 50 centimes).

Literature: L.V.240.53; Lehrs 1892, p. 485, n° 53; Washington 1967-68, n° 66; Hébert I.76.242; TIB, vol. 8.1 Commentary, n° 0801.053; H.*German*.XLIX.128.53 (with comprehensive bibliography).

266 ST ANTHONY TORMENTED BY DEMONS (state II) fol.rés. S.I.44150

 305 x 228 mm

Provenance: Unknown. In the collection prior to 1892.

Literature: L.V.243.54; Lehrs 1892, p. 485, n° 54; Washington 1967-68, n° 37; Hébert I.76.243; TIB, vol. 8.1 Commentary, n° 0801.054S2; H.*German*.XLIX.132.54(II) (with comprehensive bibliography).

267 ST CHRISTOPHER fol.rés. S.II.4646

 161 x 113 mm

Defects retouched in pen.

Provenance: Purchased from the Collection Jozef Paelinck, artist-painter, on 20 November 1860 at the Heussner Sale, Brussels (Lugt, *Ventes* 25811) (13 BEF, 20 centimes).

Literature: L.V.252.56; Lehrs 1892, p. 485, n° 55; Washington 1967-68, n° 81; Hébert I.76.244; TIB, vol. 8.1 Commentary, n° 0801.056; H.*German*.XLIX.136.56 (with comprehensive bibliography).

268 ST GEORGE fol.rés. S.II.2396

 56 x 74 mm

Defects retouched in pen. There is also a drawing of St George on the verso of this print (see illustration 268v).

Provenance: Purchased from Drugulin, Leipzig, in June 1859 (101 BEF, 50 centimes).

Literature: L.V.255.57; Lehrs 1892, p. 485, n° 56; Washington 1967-68, n° 78; Hébert I.76.246; TIB, vol. 8.1 Commentary, n° 0801.057; H.*German*.XLIX.137.57 (with comprehensive bibliography).

269 ST JOHN THE BAPTIST fol.rés. S.II.4647

 154 x 104 mm

Provenance: Purchased from the Collection Jozef Paelinck, artist-painter, on 20 November 1860 at the Heussner Sale, Brussels (Lugt, *Ventes* 25811) (176 BEF).

Literature: L.V.261.59; Lehrs 1892, p. 485, n° 57; Washington 1967-68, n° 50; Hébert I.78.249; TIB, vol. 8.1 Commentary, n° 0801.059; H.*German*.XLIX.140.59 (with comprehensive bibliography).

270 ST JOHN ON PATMOS fol.rés. S.II.36028
160 x 113 mm
Provenance: Purchased from Dietrich, Brussels, on 18 January 1887 (150 BEF).
Literature: L.V.264.60; Lehrs 1892, p. 485, n° 58; Washington 1967-68, n° 45; Hébert I.78.250;
TIB, vol. 8.1 Commentary, n° 0801.060; H.*German*.XLIX.142.60 (with comprehensive
bibliography).

271 ST MARTIN DIVIDING HIS CLOAK fol.rés. S.II.2397
155 x 105 mm
Provenance: Purchased from Drugulin, Leipzig, in June 1859 (135 BEF).
Literature: L.V.271.62; Lehrs 1892, p. 485, n° 60; Washington 1967-68, n° 47; Hébert I.78.252;
TIB, vol. 8.1 Commentary, n° 0801.062; Paris 1991.54.29; H.*German*.XLIX.146.62 (with
comprehensive bibliography).

272 ST MICHAEL SLAYING THE DRAGON fol.rés. S.II.1987
160 x 114 mm
Provenance: Purchased from the Collection Borluut de Noortdonck (Gent 13/18 December
1858: Lugt, *Ventes* 24531) (126 BEF).
Literature: L.V.273.63; Lehrs 1892, p. 485, n° 61; Washington 1967-68, n° 84; Hébert I.78.253;
TIB, vol. 8.1 Commentary, n° 0801.063; Paris 1991.56.31; H.*German*.XLIX.148.63 (with
comprehensive bibliography).

273 ST SEBASTIAN (large) fol.rés. S.II.2398
157 x 112 mm
Provenance: Prior to 1845, in the Collection of Joseph Grünling, Vienna (on the verso:
collection mark Lugt 3463). Purchased from Drugulin, Leipzig, in June 1859 (270 BEF). On
the verso: W.D. (collection mark Drugulin: Lugt 2612).
Literature: L.V.280.65; Lehrs 1892, p. 485, n° 62; Washington 1967-68, n° 82; Hébert I.78.254;
Landau & Parshall 1994, p. 53 and fig. 30; TIB, vol. 8.1 Commentary, n° 0801.065;
H.*German*.XLIX.151.65 (with comprehensive bibliography).

274 ST CATHERINE (large) fol.rés. S.II.2399
142 x 101 mm
Provenance: Purchased from Drugulin, Leipzig, in June 1859 (54 BEF).
Literature: L.V.294.70; Lehrs 1892, p. 485, n° 63; Washington 1967-68, n° 83; Hébert I.78.260;
TIB, vol. 8.1 Commentary, n° 0801.070; H.*German*.XLIX.160.70 (with comprehensive
bibliography).

275 ST MARK'S LION fol.rés. S.II.30153
87 mm diameter
Provenance: Purchased from Gutekunst, Stuttgart, on 15 February 1883 (125 BEF).
Literature: L.V.302.73; Lehrs 1892, p. 485, n° 69; Washington 1967-68, n° 100; Hébert I.80.269;

TIB, vol. 8.1 Commentary, n° 0801.073; H.*German*.XLIX.163.73 (with comprehensive bibliography).

276 THE FOURTH WISE VIRGIN fol.rés. S.II.2402
 120 x 78 mm
Provenance: Prior to 1838, in the Collection of William Esdaile (London). On both the recto and the verso there is a 'W.E.' (collection mark Esdaile: Lugt 2617). An inscription in English on the verso, identifies the subject as *'one of the / wise virgins'*. Purchased from Drugulin, Leipzig, in June 1859 (111 BEF, 37 centimes). On the verso: W.D. (collection mark Drugulin: Lugt 2612). A second copy of this print was purchased at the Jozef Paelinck Sale (Heussner, Brussels, 20 November 1860; Lugt *Ventes* 25811) (22 BEF). Although this print was then inventoried in the Collection of the Royal Library (inventory number S.II.4650), there is no trace of it now.
Literature: L.V.312.79; Lehrs 1892, p. 485, n° 70; Washington 1967-68, n° 102; Hébert I.81.275; TIB, vol. 8.1 Commentary, n° 0801.079; H.*German*.XLIX.171.79 (with comprehensive bibliography).

277 THE FOURTH FOOLISH VIRGIN fol.rés. S.II.2403
 120 x 81 mm
Provenance: Purchased from Drugulin, Leipzig, in June 1859 (74 BEF, 25 centimes). On the verso: W.D. (collection mark Drugulin: Lugt 2612).
Literature: L.V.318.84; Lehrs 1892, p. 485, n° 71; Hébert I.81.280; TIB, vol. 8.1 Commentary, n° 0801.084; H.*German*.XLIX.176.84 (with comprehensive bibliography).

278 THE FIFTH FOOLISH VIRGIN fol.rés. S.II.34579
 115 x 70 mm (=S.I.31948)
Provenance: Purchased from Dietrich, Brussels, on 15 February 1886 (87 BEF, 50 centimes).
Literature: L.V.318.85; Hébert I.81.181; TIB, vol. 8.1 Commentary, n° 0801.085; H.*German*.XLIX.177.85 (with comprehensive bibliography).

279 A MILLER WITH TWO DONKEYS fol.rés.S.II.4652
 88 x 131 mm
Defects retouched in pen.
Provenance: Purchased from the Collection Jozef Paelinck, artist-painter, on 20 November 1860, at the Heussner Sale, Brussels (Lugt *Ventes* 25811) (77 BEF).
Literature: L.V.327.88; Lehrs 1892, p. 486, n° 74; Hébert I.82.284; TIB, vol. 8.1 Commentary, n° 0801.088; H.*German*.XLIX.192.88 (with comprehensive bibliography).

280 TWO MOORS (OR TURKS) IN CONVERSATION fol.rés.S.II.2404
 89 x 50 mm
Provenance: Purchased from Drugulin, Leipzig, in June 1859 (84 BEF, 37 centimes).
Literature: L.V.329.89; Lehrs 1892, p. 486, n° 75; Hébert I.82.285; TIB, vol. 8.1 Commentary, n° 0801.089; H.*German*.XLIX.193.89 (with comprehensive bibliography).

281 PEASANT FAMILY GOING TO MARKET fol.rés.S.II.15965
158 x 160 mm

Provenance: Purchased at the Blokhuysen Sale, Rotterdam on 20 November 1871 (48 BEF, 74 centimes).

Literature: L.V.330.90; Lehrs 1892, p. 486, n° 73; Washington 1967-68, n° 34; Hébert I.82.283; TIB, vol. 8.1 Commentary, n° 0801.090; Paris 1991.47.24; H.*German*.XLIX.195.90 (with comprehensive bibliography).

282 FAMILY OF PIGS fol.rés.S.II.2406
>60 x 93 mm (trimmed)

Provenance: Prior to 1838, in the Collection of William Esdaile (London). On both the recto and the verso there is a 'W.E'. (collection mark Esdaile: Lugt 2617). Purchased from Drugulin, Leipzig, in June 1859 (151 BEF, 87 centimes). On the verso: W.D. (collection mark Drugulin: Lugt 2612).

Literature: L.V.335.91; Lehrs 1892, p. 486, n° 78; Washington 1967-68, n° 89; Hébert I.82.290; TIB, vol. 8.1 Commentary, n° 0801.091; H.*German*.XLIX.197.91 (with comprehensive bibliography).

283 GRIFFIN fol.rés.S.II.4653
99 x 94 mm

Provenance: Purchased from the Collection of Jozef Paelinck, artist-painter, on 20 November 1860 at the Heussner Sale, Brussels (Lugt, *Ventes* 25811) (39 BEF, 60 centimes).

Literature: L.V.337.93; Lehrs 1892, p. 486, n° 77; Washington 1967-68, n° 88; Hébert I.82.288; TIB, vol. 8.1 Commentary, n° 0801.093; H.*German*.XLIX.200.93 (with comprehensive bibliography).

284 ELEPHANT fol.rés.S.II.2405
105 x 147 mm

Provenance: Purchased from Drugulin, Leipzig, in June 1859 (84 BEF, 37 centimes). On the verso: W.D. (collection mark Drugulin: Lugt 2612).

Literature: L.V.339.94; Lehrs 1892, p. 486, n° 76; Washington 1967-68, n° 87; Hébert I.82.287; TIB, vol. 8.1 Commentary, n° 0801.094; H.*German*.XLIX.201.94 (with comprehensive bibliography).

285 TWO SHIELDS WITH A GRIFFIN'S CLAW AND fol.rés.S.II.8653
A ROOSTER HELD BY A TURK
77 mm diameter

Provenance: On the verso: collection mark of Birmann & Söhne, painters and art dealers in Basle (Lugt 414c) (See also Lugt 2110). Purchased from the Collection Chevalier J. Camberlyn d'Amougies, Brussels, on 25 April 1865 (Sale Guichardot, Paris: Lugt, *Ventes* 28481) (34 BEF, 69 centimes).

Literature: L.V.349.100; Lehrs 1892, p. 486, n° 79; Hébert I.85.296; TIB, vol. 8.1 Commentary, n° 0801.100; H.*German*.XLIX.205.100 (with comprehensive bibliography).

286 SHIELD WITH A GREYHOUND, fol.rés.S.II.20960
HELD BY A SAVAGE
77 mm diameter

Provenance: Purchased from Danz, Leipzig, on 17 March 1874 (60 BEF).
Literature: L.V.352.102; Lehrs 1892, p. 486, n° 80; Washington 1967-68, n° 96; Hébert I.85.298;
TIB, vol. 8.1 Commentary, n° 0801.102; H.*German*.XLIX.207.102 (with comprehensive
bibliography).

287 SHIELD WITH A STAG, HELD BY A SAVAGE fol.rés.S.II.2407
78 mm diameter

Provenance: Purchased from Drugulin, Leipzig, in June 1859 (74 BEF, 25 centimes). On the
verso: W.D. (collection mark Drugulin: Lugt 2612).
Literature: L.V.354.103; Lehrs 1892, p. 486, n° 81; Washington 1967-68, n° 97; Hébert I.85.299;
TIB, vol. 8.1 Commentary, n° 0801.103; H.*German*.XLIX.208.103 (with comprehensive
bibliography).

288 TWO SHIELDS WITH A RABBIT AND A fol.rés.S.II.4654
MOOR'S HEAD, HELD BY A SAVAGE
74 mm diameter

Provenance: Purchased from the Collection of Jozef Paelinck, artist-painter, on 20
November 1860 at the Heussner Sale, Brussels (Lugt, *Ventes* 25811) (24 BEF, 20 centimes).
Literature: L.V.355.104; Lehrs 1892, p. 486, n° 82; Washington 1967-68, n° 95; Hébert I.85.300;
TIB, vol. 8.1 Commentary, n° 0801.104; H.*German*.XLIX.208.104 (with comprehensive
bibliography).

289 A BISHOP'S CROSIER fol.rés.S.II.4655
286 x 121 mm

Provenance: Purchased from the Collection of Jozef Paelinck, artist-painter, on 20
November 1860 at the Heussner Sale, Brussels (Lugt, *Ventes* 25811) (165 BEF).
Literature: L.V.357.105; Lehrs 1892, p. 486, n° 83; Hymans 1907, p. 233; Washington 1967-68,
n° 111; Hébert I.85.301; TIB, vol. 8.1 Commentary, n° 0801.105; H.*German*.XLIX.215.105
(with comprehensive bibliography).

290 A CENSER fol.rés.S.II.4656
279 x 210 mm

Provenance: On the verso: B (unknown collection mark, not in Lugt but close to Lugt 327).
Purchased from the Collection of Jozef Paelinck, artist-painter, on 20 November 1860 at the
Heussner Sale, Brussels (Lugt, *Ventes* 25811) (275 BEF).
Literature: L.V.359.106; Lehrs 1892, p. 486, n° 84; Hymans 1907, p. 233; Washington 1967-68,
n° 110; Hébert I.85.302; TIB, vol. 8.1 Commentary, n° 0801.106; H.*German*.XLIX.217.106
(with comprehensive bibliography).

AFTER MARTIN SCHONGAUER

291 CRUCIFIXION WITH FOUR ANGELS fol.rés. S.I.42447
 284 x 187 mm
Copy in same direction by unidentified sixteenth-century artist.
Provenance: Unknown. In the collection prior to 1892.
Literature: L.V.98.14a; Lehrs 1892, p. 484, n° 32a; TIB, vol. 8.1 Commentary, n° 0801.014 C1;
H.*German*.XLIX.44.14a (with bibliography).

- CHRIST CROWNING THE VIRGIN (= L.V.113.17b) fol.rés. S.I.23359
 See n° 322: Master I C (= L.VI.164.3).

292 BETRAYAL AND CAPTURE OF CHRIST (state III) fol.rés. S.I.42980
 160 x 110 mm (plate)
Copy in same direction by Adrian Huybrechts (Huberti) (1584), with added decorative
border and at the bottom a dedication to Dr Marcus Wissekercke and three lines of text.
Provenance: Unknown. In the collection prior to 1892.
Literature: L.V.130.20d(III); Lehrs 1892, p. 483, n° 28a; TIB, vol. 8.1 Commentary, n° 0801.020
C4 S3; H.*German*.XLIX.59.20d(III) (with comprehensive bibliography).

293 CHRIST BEFORE CAIAPHAS fol.rés. S.I.31591
 (formerly identified as: Annas) (state II)
 160 x 110 mm
Copy in reverse by Adrian Huybrechts (Huberti) (1584).
Provenance: Unknown. In the collection prior to 1892.
Literature: L.V.134.21d(II); Lehrs 1892, p. 483, n° 28b; TIB, vol. 8.1 Commentary, n° 0801.021
C4 S2; H.*German*.XLIX.61.21d(II) (with comprehensive bibliography).

- CHRIST BEFORE PILATE (= L.V.143.24c) fol.rés. S.I.10385
 See n° 323: Master I C (= L.VI.169.9).

294 CHRIST BEFORE PILATE (state II) fol.rés. S.I.31593
 159 x 110 mm
Copy in same direction by Adrian Huybrechts (Huberti) (1584).
Provenance: Unknown. In the collection prior to 1892.
Literature: L.V.144.24e; Lehrs 1892, p. 483, n° 28c; TIB, vol. 8.1 Commentary, n° 0801.024 C5
S2; H.*German*.XLIX.64.24e(II) (with bibliography).

295 ECCE HOMO fol.rés. S.I.31592
 160 x 110 (plate)
Copy in reverse by Adrian Huybrechts (Huberti) (1584), with added decorative border and
at the bottom a dedication to Dr Marcus Wissekercke and three lines of text.
Provenance: Unknown. In the collection prior to 1892.

Literature: L.V.147.25b; Lehrs 1892, p. 484, n° 28d; TIB, vol. 8.1 Commentary, n° 0801.025 C2; H.*German*.XLIX.66.25b (with bibliography).

296 ENTOMBMENT fol.rés. S.II.411
 >132 x >119 mm (trimmed on all sides) (= S.I.31590)
Copy in reverse by unidentified artist.
Provenance: Purchased from Buffa (Amsterdam) in May 1854 (10 BEF, 58 centimes).
Literature: L.V.157.28a; Lehrs 1892, p. 483, n° 27; TIB, vol. 8.1 Commentary, n° 0801.028 C1; H.*German*.XLIX.66.28a (with bibliography).

297 ENTOMBMENT (state I) fol.rés. S.II.131109
 164 x 114 mm
Copy in reverse by Adrian Huybrechts (Huberti) (1584).
Provenance: Purchased from the Collection A. Freiherr von Lanna (Sale Gutekunst, Stuttgart 11/22 Mai 1909) (51 BEF). On the verso two collection marks Lugt n° 2773.
Literature: L.V.158.28f; TIB, vol. 8.1 Commentary, n° 0801.028 C6 S1; H.*German*.XLIX.69.28f (I) (with bibliography).

298 ENTOMBMENT (state II) fol.rés. S.II.1985
 158 x 110 mm
Copy in reverse by Adrian Huybrechts (Huberti) (1584).
Provenance: Purchased from the Collection Borluut de Noortdonck (Gent 13/18 December 1858: Lugt, *Ventes* 24531) (44 BEF).
Literature: L.V.158.28f; Lehrs 1892, p. 484, n° 28e; TIB, vol. 8.1 Commentary, n° 0801.028 C6 S2; H.*German*.XLIX.69.28f(II) (with bibliography).

- RESURRECTION (= L.V.164.30c) fol.rés. S.II.8535
 See n° 325: Wenzel von Olmütz (= L.VI.207.19).

- VIRGIN AND CHILD IN A COURT (= L.V.194.38b) fol.rés. S.II.2411
 See n° 386: Israhel van Meckenem (= L.IX.189.187).

- ST PAUL (= L.V.210.42d) fol.rés. S.I.25676
 See n° 326: Wenzel von Olmütz (= L.VI.221.33).

- ST THOMAS (= L.V.222.46g) fol.rés. S.II.4661
 See n° 390: Israhel van Meckenem (= L.IX.228.254).

- ST PHILIP (= L.V.227.48h) fol.rés. S.II.10718
 See n° 391: Israhel van Meckenem (= L.IX.229.256).

- ST BARTHOLOMEW (= L.V.229.49c) fol.rés. S.II.2388
 See n° 321: Master W H (= L.VI.147.18).

- ST BARTHOLOMEW (= L.V.230.49g) fol.rés. S.I.22820
 See n° 392: Israhel van Meckenem (= L.IX.229.257).

299 ST ANTHONY (state I) fol.rés. S.IV.3963
 89 x 60 mm (Wierix)
Copy in reverse by Hieronymus Wierix (1564).
Provenance: Purchased from the Havenith Collection, Brussels, in December 1932.
Literature: L.V.243.53g(I); Mauquoy-Hendrickx n° 1063(I); TIB, vol. 8.1 Commentary, n° 0801.053 C7 S1.

300 ST ANTHONY (state II) fol.rés. S.IV.3964
 89 x 60 mm (Wierix)
Copy in reverse by Hieronymus Wierix (1564). Second state, published by Cornelisz Visscher. With the address of Cornelisz. Visscher (lower right).
Provenance: Purchased from the Havenith Collection, Brussels, in December 1932.
Literature: L.V.243.53g(II); Mauquoy-Hendrickx n° 1063(II); TIB, vol. 8.1 Commentary, n° 0801.053 C7 S2.

- ST ANTHONY TORMENTED BY DEVILS
 (= L.V.249.54e.I) fol.rés. S.V.84422
 See n° 340: Master FVB (= L.VII.146.40.I).

- ST ANTHONY TORMENTED BY DEVILS
 (= L.V.249.54e.II) fol.rés. S. II.2413
 See n° 341: Master FVB (= L.VII.146.40.II).

- ST JOHN ON PATMOS (= L.V.267.60d) fol.rés. S.I.31947
 See n° 402: Israhel van Meckenem (?) (= L.IX.295.363).

301 ST LAWRENCE fol.rés. S.II.24193
 161 x 96 mm
Deceptive eighteenth-century copy in same direction.
Provenance: Purchased as an original from Buttstaedt, print dealer in Berlin (Lugt 318) on 5 February 1878 (98 BEF, 12 centimes).
Literature: L.V.269.61a; Lehrs 1892, p. 485, n° 59; TIB, vol. 8.1 Commentary, n° 0801.061 C1; H.*German*.XLIX.69.28f(II) (with bibliography).

- ST SEBASTIAN (= L.V.282.65d) fol.rés. S.II.4664
 See n° 404: Israhel van Meckenem (=L.IX.306.381)

- ST BARBARA (L.V. pp. 287 - 91: undescribed copy) fol.rés. S.V.27484
 See n° 406: Israhel van Meckenem (L.IX. p. 313: undescribed copy).

-	THE FIRST WISE VIRGIN (= L.V.309.76c)	fol.rés. S.II.2417
	See n° 411: Israhel van Meckenem (= L.IX.331.419).	

-	THE THIRD WISE VIRGIN (= L.V.312.78d)	fol.rés. S.II.4667
	ee n° 412: Israhel van Meckenem (= L.IX.332.421).	

-	THE FIFTH WISE VIRGIN (= L.V.314.80c)	fol.rés. S.II.6136
	See n° 413: Israhel van Meckenem (= L.IX.333.423).	

-	THE FIRST FOOLISH VIRGIN (= L.V.315.81b)	fol.rés.S.II.4651
	See n° 306: Master I E (= L.VI.51.48).	

-	THE FIFTH FOOLISH VIRGIN (= L.V.321.85d)	fol.rés. S.III.24591
	See n° 414: Israel van Meckenem (= L.IX.335.428).	

302 A FOOLISH VIRGIN (= L.V.325.86b) 4° S.II.62915 (Graf,U.)
153 x 99 mm
Copy in reverse by Urs Graf.
Provenance: Prior to 1895 in the Collection of Luigi Angiolini (Milan); purchased from this collection during the sale held between 8 and 22 May 1895 (Sale Gutekunst, Stuttgart: Lugt, *Ventes* 53517) (24 BEF, 28 centimes).
Literature: L.V.325.86b; TIB, vol. 8.1 Commentary, n° 0801.086 C2; H. *German*.XI.14.7; H.*German*.XLIX.190.86b (with bibliography).

APOCRYPHA: NOT SCHONGAUER

303 THE NATIVITY fol.rés. S.I.31949
198 x 291 mm
Provenance: Unknown. In the collection prior to 1892.
Literature: L.V.374.2; Lehrs 1892, p. 486, note 11; Hébert I..87.314.

-	CHRIST IN THE WILDERNESS	fol.rés. S.I.42448
	ATTENDED BY ANGELS (L.V.374.6)	
	See n° 305: Master I E (L.VI.27.5).	

304 THE VIRGIN STANDING [UNDER THE CROSS] fol.rés. S.II.1222
127 x 79 mm
Provenance: Purchased from Mr. Mulhausen, a German engineer who worked in Spain (20 BEF), in November 1857.
Literature: L.V.375.8; Lehrs 1892, p. 486, note 11; Hébert I.87.315.

FOLLOWERS OF SCHONGAUER

MASTER I E
(German engraver. Active c.1480 - 1500)

305 CHRIST IN THE WILDERNESS fol.rés. S.I.42448
ATTENDED BY ANGELS (state II)
298 x 225 mm

Second state with the false monogram of Schongauer added at lower left.
Provenance: Unknown. In the collection prior to 1892.
Literature: L.VI.27.5; Lehrs 1892, p. 486, n° 85; Washington 1967-68, n° 116; Hébert I.92.342;
TIB, vol. 8.1 Commentary, n° 0803.001 S2.

306 THE FIRST FOOLISH VIRGIN fol.rés.S.II.4651
114 x 74 mm

Copy in reverse after Martin Schongauer.
Provenance: Purchased from the Collection of Jozef Paelinck, artist-painter, on
20 November 1860 at the Heussner Sale, Brussels (Lugt, *Ventes* 25811) (46 BEF, 20 centimes).
Literature: L.V.315.81b; L.VI.51.48; Lehrs 1892, p. 486, n° 72; TIB, vol. 8.1 Commentary,
n° 0801.081 C3; H.*German*.XLIX.173.81b (with comprehensive bibliography).

MASTER AG
(German engraver. Apprentice in Schongauer's workshop in Colmar ? Active c.1470 - 90)

307-318 THE PASSION

307 LAST SUPPER (state I) fol.rés. S.II.62899
151 x 109 mm

Provenance: J. Sigmund Bermann, print dealer in Vienna by 1834 (on the verso: collection
mark Lugt n° 235). Prior to 1895 in the Collection of Luigi Angiolini (Milan); purchased
from this collection during the sale held between 8 and 22 May 1895 (Sale Gutekunst,
Stuttgart: Lugt, *Ventes* 53517). The series of nine prints (S.II.62899-907) was purchased for
the total sum of 46 BEF, 59 centimes.
Literature: L.VI.105.7(I); Paris 1991.62.36; TIB, vol. 9.2 Commentary, n° 0910.007 S1.

308 LAST SUPPER (state III) fol.rés. S.II.1847
146 x 109 mm (=S.I.16887)

Provenance: Purchased from the Collection Borluut de Noortdonck (Gent 13/18 December
1858: Lugt, *Ventes* 24531) (1 BEF, 65 centimes).
Literature: L.VI.105.7(III); Lehrs 1892, p. 486, n° 86; TIB, vol. 9.2 Commentary,
n° 0910.007 S3.

309 AGONY IN THE GARDEN (state I) fol.rés. S.II.62900
145 x 107 mm (= S.I.16888)
Provenance: Prior to 1895 in the Collection of Luigi Angiolini (Milan); purchased from this collection during the sale held between 8 and 22 May 1895 (Sale Gutekunst, Stuttgart: Lugt, *Ventes* 53517). See also n° 307.
Literature: L.VI.106.8(I); Washington 1967-68, n° 121; Hébert I.89.324; Paris 1991.63.37; TIB, vol. 9.2 Commentary, n° 0910.008 S1.

310 AGONY IN THE GARDEN (state I) fol.rés. S.II.4856
145 x 108 mm
Provenance: Purchased from the Collection of Jozef Paelinck, artist-painter, on 20 November 1860 at the Heussner Sale, Brussels (Lugt, *Ventes* 25811) (11 BEF).
Literature: Lehrs 1892, p. 487, n° 87. See also n° 309.

311 BETRAYAL AND CAPTURE OF CHRIST (state I) fol.rés. S.II.62901
144 x 108 mm
Provenance: Prior to 1895 in the Collection of Luigi Angiolini (Milan); purchased from this collection during the sale held between 8 and 22 May 1895 (Sale Gutekunst, Stuttgart: Lugt, *Ventes* 53517). See also n° 307.
Literature: L.VI.106.9(I); Hébert I..89.325; Paris 1991.64.38; TIB, vol. 9.2 Commentary, n° 0910.009 S1.

312 CHRIST BEFORE PILATE (state I) fol.rés. S.II.62902
147 x 109 mm
Provenance: Dated '9 *September 1807*' on the verso (in an unknown collection). Prior to 1895 in the Collection of Luigi Angiolini (Milan); purchased from this collection during the sale held between 8 and 22 May 1895 (Sale Gutekunst, Stuttgart: Lugt, *Ventes* 53517). See also n° 307.
Literature: L.VI.107.10(I); Hébert I.89.326; TIB, vol. 9.2 Commentary, n° 0910.010 S1.

313 FLAGELLATION (state I) fol.rés. S.II.62903
150 x 112 mm
Provenance: Dated '9 *September 1807*' on the verso (in an unknown collection). Prior to 1895 in the Collection of Luigi Angiolini (Milan); purchased from this collection during the sale held between 8 and 22 May 1895 (Sale Gutekunst, Stuttgart: Lugt, *Ventes* 53517). See also n° 307.
Literature: L.VI.108.11(I); Hébert I.89.327; TIB, vol. 9.2 Commentary, n° 0910.011 S1.

314 CHRIST CROWNED WITH THORNS (state I) fol.rés. S.II.62904
147 x 108 mm
Provenance: Dated '9 *September 1807*' on the verso (in an unknown collection). Prior to 1895 in the Collection of Luigi Angiolini (Milan); purchased from this collection during the sale

held between 8 and 22 May 1895 (Sale Gutekunst, Stuttgart: Lugt, *Ventes* 53517). See also n°
307.
Literature: L.VI.108.12(I); Hébert I.89.328; TIB, vol. 9.2 Commentary, n° 0910.012 S1.

315 CHRIST CROWNED WITH THORNS (state I) fol.rés. S.II.10930
 144 x 107 mm
Provenance: Purchased from Goupil, Brussels, on 25 October 1867 (80 BEF).
Literature: Lehrs 1892, p. 487, n° 88. See also n° 314.

316 CHRIST BEARING THE CROSS (state I) fol.rés. S.II.62905
 144 x 108 mm
Provenance: Dated '*9 September 1807*' on the verso (in an unknown collection). Prior to 1895
in the Collection of Luigi Angiolini (Milan); purchased from this collection during the sale
held between 8 and 22 May 1895 (Sale Gutekunst, Stuttgart: Lugt, *Ventes* 53517). See also n°
307.
Literature: L.VI.109.13(I); Hébert I.89.329; TIB, vol. 9.2 Commentary, n° 0910.012 S1.

317 CRUCIFIXION (state I) fol.rés.S.II.62906
 146 x 107 mm
Provenance: Dated '*9 September 1807*' on the verso (in an unknown collection); also on the
verso: G.W. (unknown collection mark, not in Lugt). Prior to 1895 in the Collection of Luigi
Angiolini (Milan); purchased from this collection during the sale held between 8 and
22 May 1895 (Sale Gutekunst, Stuttgart: Lugt, *Ventes* 53517). See also n° 307.
Literature: L.VI.109.14(I); Hébert I.89.330; TIB, vol. 9.2 Commentary, n° 0910.014 S1.

318 ENTOMBMENT (state I) fol.rés. S.II.62907
 147 x 111 mm
Provenance: Prior to 1895 in the Collection of Luigi Angiolini (Milan); purchased from this
collection during the sale held between 8 and 22 May 1895 (Sale Gutekunst, Stuttgart: Lugt,
Ventes 53517). See also n° 307.
Literature: L.VI.110.15(I); Hébert I.89.331; TIB, vol. 9.2 Commentary, n° 0910.015 S1.

319 ST GEORGE fol.rés. S.II.31165
 113 x 169 mm
 Colour plate XII
Purchased in 1884 as '*Martin Schongauer*'.
Provenance: Purchased from Danlos, Paris, on 18 February 1884 (450 BEF).
Literature: L.VI.116.19; Lehrs 1892, p. 487, n° 89; Washington 1967-68, n° 122; Hébert
I.91.335; TIB, vol. 9.2 Commentary, n° 0910.019.

320 COAT OF ARMS OF THE PRINCE-BISHOP fol.rés.S.II.8333
RUDOLPH II VON SCHERENBERG AND OF
THE WÜRZBURG CATHEDRAL CHAPTER (state I)
198 x 196 mm

This print was apparently commissioned by Georg Reyser, a printer, and used to illustrate missals published in Würzburg. This print is page 9 from the missal, dating from 1484. The print was entered as *'Martin Schongauer (?)'* in the inventory (1865).
Provenance: Purchased from Leblanc (Clément; Paris) (108 BEF, 80 centimes) on 25 April 1865.
Literature: L.VI.124.31; Lehrs 1892, p. 487, n° 90; Hymans 1907, p. 137; TIB, vol. 9.2 Commentary, n° 0910.031.S1.

MASTER W H
(German engraver. Active late 1470s - c.1489)

321 ST BARTHOLOMEW (state I) fol.rés. S.II.2388
91 x 50 mm

Copy in reverse after Martin Schongauer. Acquired together with the series n° 253-264.
Provenance: Purchased from Drugulin, Leipzig, in June 1859.
Literature: L.V.229.49c(I); L.VI.147.18(I); Lehrs 1892, p. 484, n° 52; TIB, vol. 8.1 Commentary, n° 0801.049 C3 S1; TIB, vol. 9.2 Commentary, n° 0920.018 S1; H.*German*.XLIX.119.49c (with comprehensive bibliography).

MASTER I C
(German engraver. Active in Cologne c.1480 - c.1500)

322 CHRIST CROWNING THE VIRGIN fol.rés. S.I. 23359
160 x 158 mm

Copy in same direction after Martin Schongauer. Old retouches were added in pen, hand coloured and trimmed along the right side. This print was in Ms. 5060, a seventeenth-century manuscript with Bible commentary in Dutch. The print was transferred to the Print Room.
Provenance: The provenance of the manuscript is unknown.
Literature: L.V.113.17b; L.VI.164.3; Lehrs 1892, p. 494, n° 120; VDG 295; TIB, vol. 8.1 Commentary, n° 0801.017 C2; H.*German*.XLIX.54.17b (with bibliography).

323 CHRIST BEFORE PILATE (state I) fol.rés. S. I.10385
161 x 113mm

Copy in same direction after Martin Schongauer. Schongauer's monogram was added in pen in the lower right.
Provenance: Unknown. In the collection prior to 1892.
Literature: L.V.143.24c; L.VI.169.9(I); Lehrs 1892, p. 493, n° 119; TIB, vol. 8.1 Commentary, n° 0801.024 S1; H.*German*.XLIX.64.24c (with bibliography).

WENZEL VON OLMÜTZ (WENCESLAUS DE OLOMUSCZ)
(Bohemian engraver. Active from 1480 - 1500)

324 LAMENTATION OF CHRIST (L.VI.201.10) fol.rés. S.I.42449
Nineteenth-century photograph, probably by W. Hoffmann (Dresden).
Original print in Dresden.

325 RESURRECTION fol.rés. S.II.8535
164 x 116 mm (plate)
Copy in same direction after Martin Schongauer. Modern impression.
Provenance: Purchased from the Collection Chevalier J. Camberlyn d'Amougies, Brussels
(Sale Guichardot, Paris: Lugt, *Ventes* 28481 or 28700) (8 BEF, 40 centimes) on 25 April 1865.
There is an unknown mark on the verso: EKL (not in Lugt).
Literature: L.V.164.30c; L.VI.207.19; Lehrs 1892, p. 487, n° 91; Hébert I.98.384; TIB, vol. 8.1
Commentary, n° 0801.030 C3; TIB, vol. 9.2 Commentary, n° 0909.019; H.*German*.XLIX.72.30c
(with comprehensive bibliography).

326 ST PAUL fol.rés. S.I.25676
>91 x >51 mm (trimmed)
Copy in same direction after Martin Schongauer.
Provenance: Unknown. In the collection prior to 1892.
Literature: L.V.210.42d; L.VI.221.33; Lehrs 1892, p. 487, n° 92; Hébert I.100.406; TIB, vol. 8.1
Commentary, n° 0801.042 C4; TIB, vol. 9.2 Commentary, n° 0909.033; H.*German*.XLIX.112.42d
(with comprehensive bibliography).

AFTER WENZEL VON OLMÜTZ

327 MARTYRDOM OF ST SEBASTIAN fol.rés. S.II.182
95 x 137 mm (=S.I.25675)
At least fifty impressions of this eighteenth-century deceptive copy were known to Lehrs.
Provenance: Purchased from the Verachter Collection, Antwerp, on 24 July 1852 (30 BEF).
Literature: L.VI.232.50a; Lehrs 1892, p. 487, n° 93; Hébert I.100.391; TIB, vol. 9.2
Commentary, n° 0909.050 C1 (with comprehensive bibliography).

MASTER B R WITH THE ANCHOR
(German engraver - Lower Rhine. Active 1480s)

328 ARISTOTLE AND PHYLLIS fol.rés. S.II.1930
117 x 81 mm
Untraceable in May 1999.
Provenance: Purchased from the Collection Borluut de Noortdonck (Gent 13/18 December
1858: Lugt, *Ventes* 24531) (25 BEF, 30 centimes).
Literature: L.VI.308.13; Lehrs 1892, p. 494, n° 126; TIB, vol. 9.2 Commentary, n° 0919.013.

MASTER W A
(South Netherlandish engraver, worked c.1465-85, probably in Bruges and at the court of Charles the Bold)

329 THE STIGMATIZATION OF ST FRANCIS (state II) fol.rés. S.II.8308
74 x 48 mm slightly coloured
Colour plate XII
Entered in the inventory of 1865 as *'Maitre anonyme allemand (1480)'*.
Provenance: Purchased from the Collection of Chevalier J. Camberlyn d'Amougies, Brussels (Sale Guichardot, Paris: Lugt, *Ventes* 28481 or 28700) (215 BEF, 25 centimes) on 25 April 1865.
Literature: L.VII.39.15(II); Lehrs 1892, p. 490, n° 111; Lehrs 1895.12.16(II); H. *Dutch.* XII.212.15.

330 SHIP fol.rés. S.II.62992
173 x 125 mm traces of red colour
Provenance: Prior to 1895 in the Collection of Luigi Angiolini (Milan); purchased from this collection during the sale held between 8 and 22 May 1895 (Sale Gutekunst, Stuttgart: Lugt, *Ventes* 53517) (190 BEF, 38 centimes).
Literature: L.VII.65.39; Lehrs 1895.15.37; H.*Dutch*.XII.220.39.

331 THE LARGE COAT OF ARMS OF CHARLES fol.rés. S.II.1053
 THE BOLD, DUKE OF BURGUNDY (=S.I.23097)
335 x 203 mm (plate)
This print was photographed by Edmond Fierlants (c.1859?). The photograph is in the collection (see: Fierlants, fol.). Labargé made a lithograph facsimile in 1859. See, e.g, Alvin 1859(a).
Provenance: The print was found in Ms. 15960-62 (*Notes et documents relatifs à la famille de Villegas*) in the Manuscript Collection of the Royal Library of Belgium. The engraving was transferred to the Print Room on 2 May 1857. The manuscript was later transferred to the State Archives of Belgium (Brussels) (*Varia Arch. de Familles*, 1981, n° 34). Currently, the following note from Louis Alvin can be found between fols. 23 and 24: '*Cette feuille remplace la gravure des armoi- / ries de Charles le Téméraire, qui a été enlevée de / ce volume pour être placée dans la collection des / estampes où elle figure sous le n° . . . [open space] de l'inventaire / Bruxelles, le 27 juin 1857 / Le conservateur en chef / L. Alvin'*.
Literature: L.VII.72.48; Alvin 1859(a); Alvin 1859(b); De Brou 1859; Harzen 1859(a); Harzen 1859(b); Renouvier 1859, p. 143; Alvin 1876; Pinchart 1876; Alvin 1877; Hymans 1877(b); Wittert 1877; Willshire 1883, pp. 214-19; Lehrs 1892, p. 490, n° 112; Lehrs 1895.16.44; Van Bastelaer 1903; VDG 8487; Lebeer 1936; H.*Dutch*.XII.225.48.

332 INTERIOR OF A GOTHIC CHURCH (state I) fol.rés. S.II.63970
>115 x >130 mm (trimmed)
Provenance: Purchased at the Bluff Sale (Brussels) on 5 July 1895. According to Lehrs 1895: *'1895 auf einer Büchauction bei Bluff in Brüssel (8. Juli) in einem Convolut minderwerthiger*

Blätter für 2 fr. 50 erworden'.
Literature: L.VII.91.63(I); Lehrs 1895.18.53(I); H.*Dutch*.XII.240.63.

AFTER MASTER W A

| - | ST FRANCIS RECEIVING THE STIGMATA | Ms. II.1561, fol. 54v |

- ST FRANCIS RECEIVING THE STIGMATA Ms. II.1561, fol. 54v
IN THE PRESENCE OF A NUN (= L.VII.41.15d)
See n° 097.

333 MONSTRANCE (state I) fol.rés. S.II.26461
 260 x 115 mm
Described in the inventory of 1880 as *'Alart Du Hameel ? – rarissime'*.
Provenance: Prior to 5 December 1876, in the Collection of Carl Eduard von Liphart (1808-1891) (Florence). On the verso: collection mark of Liphart (Lugt 1687). Liphart Sale of 1876 (Lugt, *Ventes* 36886). Purchased from Drugulin, Leipzig (1879 Sale), (395 BEF, 6 centimes) on 25 January 1880.
Literature: L.VII.81.53a(I); Lehrs 1892, p. 491, n° 113; Hymans 1907, p. 233

334 MONSTRANCE (state I) fol.rés. S.I.42424
 Nineteenth-century photograph.
 Original print in Bologna.
Provenance: The photograph was sent to the Royal Library on 25 March 1890 by Max Lehrs (Printroom Dresden).
Literature: L.VII.81.53a(I).

MASTER FVB
(South Netherlandish engraver. Worked c.1480 - 1500 in Bruges)

335 THE CRUCIFIXION fol.rés. S.V.96769
 181 x 128 mm
Provenance: Purchased at auction, Kornfeld & Klipstein (Bern), on 8 June 1966.
Literature: L.VII.124.7; H.*Dutch*.XII.146.7 (with bibliography); Brussels 1969, n° 208; Hébert I.165.769.

336-339 CHRIST AND THE TWELVE APOSTLES (4/13)

336 ST PETER fol.rés. S.II.2424
 180 x 96 mm
Provenance: Purchased from Drugulin, Leipzig in June 1859 (168 BEF, 75 centimes). On the verso: W.D. (collection mark Drugulin: Lugt 2612).
Literature: L.VII.137.26; Lehrs 1892, p. 494, n° 121; H.*Dutch*.XII.152.26 (with bibliography; Hébert I.166.778.

337 ST JAMES THE LESSER fol.rés. S.II.2427
 182 x 97 mm
Provenance: Purchased from Drugulin, Leipzig in June 1859 (168 BEF, 75 centimes). On the
verso: W.D. (collection mark Drugulin: Lugt 2612).
Literature: L.VII.140.31; Lehrs 1892, p. 494, n° 122; H.*Dutch*.XII.152.31 (with bibliography).

338 ST MATTHEW fol.rés. S.II.2425
 181 x 97 mm
Provenance: Purchased from Drugulin, Leipzig in June 1859 (121 BEF, 50 centimes). On the
verso: W.D. (collection mark Drugulin: Lugt 2612).
Literature: L.VII.141.34; Lehrs 1892, p. 494, n° 123; H.*Dutch*.XII.152.34 (with bibliography).

339 ST SIMON fol.rés. S.II.2426
 183 x 97 mm
Provenance: Purchased from Drugulin, Leipzig in June 1859 (168 BEF, 75 centimes). On the
verso: W.D. (collection mark Drugulin: Lugt 2612).
Literature: L.VII.142.36; Lehrs 1892, p. 494, n° 124; H.*Dutch*.XII.152.36 (with bibliography);
Washington 1967-68, n° 129; Hébert I.167.785.

340 ST ANTHONY TORMENTED BY DEVILS (state I ?) fol.rés. S.V.84422
 298 x 215 mm
Copy in reverse after Martin Schongauer (see n° 266). This print was significantly damaged
and heavily reworked. Numerous parts of the impression are missing. The monogram is
VB+ and not FVB+.
Provenance: Purchased from P. & D. Colnaghi, London on 31 August 1961.
Literature: L.V.249.54e; L.VII.146.40(I); H.*Dutch*.XII.156.40(I); H.*German*.XXIV.231[631(I)];
Hébert I.168.787; TIB, vol. 8.1 Commentary, n° 0801.054 C5 S1; H.*German*.XLIX.133.54e(I)
(with comprehensive bibliography).

341 ST ANTHONY TORMENTED BY DEVILS (state II) fol.rés. S.II.2413
 290 x 223 mm
Copy in reverse after Martin Schongauer (see n° 266). The monogram FVB erased, and
replaced by Meckenem's monogram. Entered in the inventory of the Royal Library in 1859
as the work of '*Israhel van Meckenem*'.
Provenance: Purchased from Drugulin, Leipzig in June 1859 (101 BEF, 25 centimes).
Literature: L.V.249.54e; L.VII.146.40(II); Lehrs 1892, p. 494, n° 125; H.*Dutch*.XII.156.40(II);
H.*German*.XXIV.231[631(II)]; TIB, vol. 8.1 Commentary, n° 0801.054 C5 S2; H.*German*.
XLIX.133.54e(II) (with comprehensive bibliography).

MASTER I A M OF ZWOLLE (IDENTIFIED AS: JOHAN VAN DEN MIJNNESTEN ?)
(Dutch goldsmith and engraver. Active in Zwolle c.1462 - 1504)

342 THE ADORATION OF THE MAGI fol.rés. S.II.4638
 359 x 257 mm
This print is damaged and has been retouched in various places.
Provenance: Purchased from the Collection of Jozef Paelinck, artist-painter, on 20 November 1860 at the Heussner Sale, Brussels (Lugt, *Ventes* 25811) (44 BEF).
Literature: L.VII.176.1; Lehrs 1892, p. 491, n° 114; H.*Dutch*.XII.253.1 (with bibliography); Washington 1967-68, n° 136; Hébert I.170.798.

343 CALVARY (state III) fol.rés. S.II.1988
 356 x 250 mm (=S.I.23280)
Provenance: Purchased from the Collection Borluut de Noortdonck (Gent 13/18 December 1858: Lugt, *Ventes* 24531) (110 BEF).
Literature: L.VII.188.6(III); Lehrs 1892, p. 491, n° 115; H.*Dutch*.XII.260.6(III) (with bibliography); Washington 1967-68, n° 134; Hébert I.173.811; Paris 1997.44.13.

344 THE LAMENTATION OF CHRIST fol.rés. S.I.42450
 260 x >212 mm (trimmed)
Provenance: Unknown. In the collection prior to 1892.
Literature: L.VII.192.7; Lehrs 1892, p. 491, n° 116; H.*Dutch*.XII.262.7 (with bibliography); Hébert I.170.804.

AFTER ALART DU HAMEEL
(South Netherlandish architect and engraver. Active c.1478 - c.1506)

345 THE LAST JUDGEMENT fol.rés. S.II.62776
 246 x 350 mm
Copy in reverse. The print dates from the middle of the sixteenth century. Signed: HIERONYMVS / BOS INVENTOR (lower right).
Provenance: Prior to 1895 in the Collection of Luigi Angiolini (Milan); purchased from this collection during the sale held between 8 and 22 May 1895 (Sale Gutekunst, Stuttgart: Lugt, *Ventes* 53517) (13 BEF, 78 centimes).
Literature: L.VII.236.2a; TIB, vol. 9 Commentary, n° 0911.002 C1.

MASTER PW OF COLOGNE
(Cologne engraver. Active along the Rhine c.1490-1503)

346 THE WAR OF SWITZERLAND (Sixth Plate) fol.rés. S.I. 30962
 approx. 253 x 195 mm (large fragment)
This print is severely damaged.
Provenance: Unknown. In the collection prior to 1892.

Literature: L.VII.291.18f; Lehrs 1892, p. 494, n° 127; Schleuter 1935.65.8-13; TIB, vol. 9.2 Commentary, n° 0902.018F.

347 COAT OF ARMS OF WALTHER VON BILSEN fol.rés. S.II.31262
 67 mm diameter

This *ex libris* came from Ms.234 (front pastedown), a manuscript on canon law (Nicolaus Tedeschi, *Lectura super libros Decretalium*). The manuscript is dated 1471 (colophon on fol. 472r). The print entered the inventory of the Print Room on 6 May 1884. C. Ruelens noted the following in the manuscript: *'Cette gravure à été détachée le 20 juillet 1883 / et remise au Cabinet des Estampes'*. See also n° 348.

Provenance: Walter von Bilzen, Canon of the cathedral chapter in Aachen. The fifteenth-century inscription on the page affixed to the front pastedown reads: *'liber Wolteri de Blisia cono(n)ici Aquen(sis)'*. Aachen Cathedral Library (gift of Walter von Bilzen). Paris, Bibliothèque nationale (see, e.g, the stamps on fols. 1r and 472v).

Literature: L.VII.293.19; Lehrs 1892, p. 494, n° 128; Hymans 1907, p. 107; Lyna 1921, p. 37; Lyna 1923; VDG 2609; Schleuter 1935.66.15; *Manuscrits datés conservés en Belgique*, IV: 1461-1480, Brussels 1982, pp. 64-65, n° 528; TIB, vol. 9.2 Commentary, n° 0902.019.

348 COAT OF ARMS OF WALTHER VON BILSEN Ms. 222, fol. 1r
 65 mm diameter

This *ex libris* was affixed into Ms. 222, a manuscript on canon law (Guido Guisi, *Rosarium super decreto*). See also n° 347.

Provenance: Walter von Bilzen, Canon of the cathedral chapter in Aachen. The fifteenth-century inscription on fol. 1r reads: *'liber Wolteri de Blisia cono(n)ici Aquen(sis)'*. Aachen Cathedral Library (gift of Walter von Bilzen). Paris, Bibliothèque nationale (see, e.g, the stamps on fols. 3r and 320r).

Literature: VDG 2573. See also n° 347.

AFTER MASTER PW OF COLOGNE

348[bis] VIRGIN AND CHILD WITH ST ANNE Ms. 10758, fol. 95v
 64 x 41 mm

Glued into a Latin-German prayer book (1530/31). See also n° 476. Undiscribed copy in reverse. The print is very close to the 'original' (L.VII.272.8). See also: TIB, vol. 9.2 Commentary, n° 0902.008 (C1, C2 and C3).

Provenance: Luxembourg, Jesuits (folio 1r: *Collegij Societatis Jesv Luxemburgi*). Paris Bibliothèque nationale (stamps on fols. 1r and 132v).

Literature: Not in Lehrs. VDG 877.

MASTER F I
(German or Netherlandish engraver. Active c.1490 - 1500)

349 THE CRUCIFIXION fol.rés.S.II.29535
 80 x 53 mm
Provenance: Purchased from M. Lefèvre, priest in Cherain (Luxembourg) on 15 December 1881. This print was pasted into a sixteenth-century Dutch missal from Namur or Luxembourg (now Ms. II.433) (50 BEF). It appears to have been removed from the manuscript at the time of the sale.
Literature: L.VII.355.1; Lehrs 1892, p. 493, n° 118; VDG 425.

MASTER OF THE BOCCACIO ILLUSTRATIONS
(South Netherlandish engraver. Active in Bruges c.1470 - 90)

350 THE CROWNING WITH THORNS fol.rés. S.I.17
 72 x 50 mm coloured
Provenance: Unknown. In the collection prior to 1892.
Literature: L.VII.394.14(1D); Lehrs 1892, p. 492, n° 117; H.*Dutch*.XII.116.14 (with bibliography).

351 CHRIST ON THE CROSS fol.rés. S.II.24195
 73 x 53 mm coloured
 Colour plate XIII
One of the soldiers (Stephaton) gives Christ vinegar on a sponge attached to a lance. On the recto and the verso of the paper on which the print is glued, there is a handwritten text in Dutch: *'Ic hebbe dorst. Mij dorst ... '* (for further information, see: L.VII.396.18).
Provenance: Purchased from Ms. Buttstaedt , print dealer in Berlin on 5 February 1878 (97 BEF, 50 centimes). On the verso, Buttstaedt collection mark (Lugt 318); there is also an unidentified mark on the verso: EKL (not in Lugt). See ill.351v.
Literature: L.VII.396.18(1H); Lehrs 1892, p. 500, n° 180; H.*Dutch*.XII.116.18 (with bibliography).

HOUSEBOOK MASTER (MASTER OF THE AMSTERDAM CABINET)
(German printmaker, draughtsman and painter. Active in the Middle Rhineland c.1470-1500)

352 MOTHER WITH TWO CHILDREN AND fol.rés.S.I.42414
 AN EMPTY COAT OF ARMS (= L.VIII.158.84)
 Nineteenth-century photograph (probably by W. Hoffman, Dresden).
 Original Print in Militisch, Collection of Graff Maltzan.

353 BEARDED MAN WITH fol.rés. S.I.42415
 AN EMPTY COAT OF ARMS (= L.VIII.159.85)
 Nineteenth-century photograph (probably by W. Hoffman, Dresden).
 Original Print in Militisch, Collection of Graff Maltzan.

AFTER THE HOUSEBOOK MASTER

- COMBAT OF TWO WILD MEN ON fol.rés. S.I.25795
 HORSEBACK (= L.VIII.133.56a)
 See: n° 423: Israhel van Meckenem (=L.IX.383.491).

- THE ILL-MATCHED COUPLE (= L.VIII.148.73a) fol.rés. S.II.1943
 See: n° 422: Israhel van Meckenem (=L.IX.380.488(II)).

MAIR VON LANDSHUT
(German draughtsman, engraver and painter. Active in Bavaria (Munich) c.1485-1510)

354 ADORATION OF THE MAGI fol.rés. S.II.4637
 >108 x >164 mm (trimmed)
Provenance: Purchased from the Collection of Jozef Paelinck, artist-painter, on 20 November 1860 at the Heussner Sale, Brussels (Lugt, *Ventes* 25811) (50 BEF, 60 centimes).
Literature: L.VIII.300.6; Lehrs 1892, p. 487, n° 94.
355 ST CATHERINE (= L.VIII.311.12) fol.rés. S.I.42451
 Nineteenth-century photograph.
 Original Print in Breslau.

AFTER MAIR VON LANDSHUT

356 GOTHIC HOUSE AND A STANDING COUPLE fol.rés. S.II.328
 227 x 171 mm (plate)
Deceptive copy after L.17. This copy first appears after 1802.
Provenance: Purchased from De Bast, Brussels, on 3 December 1853 (2 BEF).
Literature: L.VIII.317.17a; Lehrs 1892, p. 487, n° 95; Hébert I.110.452.

MASTER M Z (MATHIAS ZAISINGER OR ZASINGER ?)
(German engraver. Active in Munich c.1500)

357 IDOLATRY OF SALOMON fol.rés. S.II.63148
 186 x 157 mm
Provenance: Prior to 1895 in the Collection of Luigi Angiolini (Milan); purchased from this collection during the sale held between 8 and 22 May 1895 (Sale Gutekunst, Stuttgart: Lugt, *Ventes* 53517) (7 BEF, 22 centimes).
Literature: L.VIII.347.1; Hébert I.113.457; Paris 1991.96.62.

358 VIRGIN AND CHILD BY A FOUNTAIN fol.rés. S.II.2428
 180 x 155 mm
Provenance: Purchased from Drugulin, Leipzig in June 1859 (18 BEF). On the verso: W.D. (collection mark Drugulin: Lugt 2612).

Literature: L.VIII.348.2; Lehrs 1892, p. 487, n° 946; Washington 1967-68, n° 150; Hébert I.113.458.

359 THE BEHEADING OF ST JOHN THE BAPTIST fol.rés. S.II.4671
 198 x 145 mm
Impression from the worn plate.
Provenance: Purchased from the Collection of Jozef Paelinck, artist-painter, on 20 November 1860 at the Heussner Sale, Brussels (Lugt, *Ventes* 25811) (13 BEF, 20 centimes).
Literature: L.VIII.353.5; Lehrs 1892, p. 487, n° 97; Hébert I.113.459.

360 ST CATHERINE fol.rés. S.II.2430
 126 x 86 mm
Provenance: Purchased from Drugulin, Leipzig in June 1859 (15 BEF, 75 centimes). On the verso: W.D. (collection mark Drugulin: Lugt 2612).
Literature: L.VIII.356.8; Lehrs 1892, p. 488, n° 102; Hébert I.115.467.

361 MARTYRDOM OF ST CATHERINE fol.rés. S.II.4672
 308 x 256 mm (trimmed)
Provenance: Purchased from the Collection of Jozef Paelinck, artist-painter, on 20 November 1860 at the Heussner Sale, Brussels (Lugt, *Ventes* 25811) (33 BEF).
Literature: L.VIII.357.9; Lehrs 1892, p. 488, n° 99; Hébert I.113.464.

362 ST URSULA fol.rés. S.II.2429
 128 x 85 mm
Described in the inventory of 1859 as *'belle'*.
Provenance: Purchased from Drugulin, Leipzig in June 1859 (13 BEF, 50 centimes). On the verso: W.D. (collection mark Drugulin: Lugt 2612).
Literature: L.VIII.359.11; Lehrs 1892, p. 488, n° 100; Hébert I.115.466.

363 FOUR SOLDIERS fol.rés. S.II.4673
 123 x 155 mm
Provenance: Purchased from the Collection of Jozef Paelinck, artist-painter, on 20 November 1860 at the Heussner Sale, Brussels (Lugt, *Ventes* 25811) (55 BEF).
Literature: L.VIII.362.13; Lehrs 1892, p. 488, n° 104; Washington 1967-68, n° 151; Hébert I.116.475.

364 THE EMBRACE fol.rés. S.II.87486
 157 x 113mm
Provenance: Purchased from Gutekunst (Stuttgart) on 19 February 1900 (260 BEF).
Literature: L.VIII.365.16; Washington 1967-68, n° 149; Hébert I.115.470; Paris 1991.97.63.

365 THE BALL fol.rés. S.II.63149
221 x 308 mm
Provenance: Prior to 1895 in the Collection of Luigi Angiolini (Milan); purchased from this collection during the sale held between 8 and 22 May 1895 (Sale Gutekunst, Stuttgart: Lugt, *Ventes* 53517) (106 BEF, 32 centimes).
Literature: L.VIII.367.17; Hymans 1907, p. 70; Washington 1967-68, n° 152; Hébert I.115.468; Paris 1991.93.60.

366 THE TOURNAMENT fol.rés. S.II.2431
222 x 314 mm
Colour plate XIII
Provenance: Purchased from Drugulin, Leipzig in June 1859 (101 BEF, 25 centimes). On the verso: W.D. (collection mark Drugulin: Lugt 2612).
Literature: L.VIII.369.18; Lehrs 1892, p. 488, n° 103; Washington 1967-68, n° 153; Hébert I.115.469; Paris 1991.94.61.

367 THE WOMAN WITH THE OWL fol.rés. S.II.54030
160 x 124 mm
Provenance: Purchased from Gutekunst (Stuttgart) on 18 February 1893 (80 BEF).
Literature: L.VIII.371.19; Washington 1967-68, n° 148; Hébert I.116.476.

368 THE WOMAN WITH THE OWL fol.rés. S.II.132778
162 x 122 mm
Provenance: Ca.1860, Collection of D.G. de Arozarena (South America and Paris) (on the verso: collection mark Lugt 109). December 1909, purchased from the Ruhneu Collection, Boerner Sale (Leipzig).
Literature: See n° 367.

369 THE DEAD KING AND HIS THREE SONS fol.rés. S.II.8874
174 x 249 mm
Provenance: Purchased from the Collection of Chevalier J. Camberlyn d'Amougies, Brussels on 27 November 1865 (Sale Guichardot, Paris: Lugt, *Ventes* 28481 or 28700) (12 BEF, 60 centimes).
Literature: L.VIII.376.21; Lehrs 1892, p. 488, n° 98; Washington 1967-68, n° 147; Hébert I.113.460; Paris 1991.92.59.

370 ARISTOTLE AND PHYLLIS fol.rés. S.II.63150
182 x 131 mm
Provenance: Prior to 1895 in the Collection of Luigi Angiolini (Milan); purchased from this collection during the sale held between 8 and 22 May 1895 (Sale Gutekunst, Stuttgart: Lugt, *Ventes* 53517) (73 BEF, 50 centimes).
Literature: L.VIII.377.22; Hébert I.116.473.

AFTER MASTER M Z

371 ST URSULA fol.rés. S.II.326
128 x 84 mm
Provenance: Purchased from De Bast on 2 December 1853 (2 BEF).
Literature: L.VIII.359.11a; Lehrs 1892, p. 488, n° 101.

ISRAHEL VAN MECKENEM
(German engraver and goldsmith. Meckenheim near Münstereifel c.1440/45 - Bocholt 10 November 1503)

372 JUDITH WITH THE HEAD OF HOLOPHERNES fol.rés. S.II.62961
215 x 322 mm
Provenance: Prior to 1895 in the Collection of Luigi Angiolini (Milan); purchased from this collection during the sale held between 8 and 22 May 1895 (Sale Gutekunst, Stuttgart: Lugt, *Ventes* 53517) (144 BEF, 38 centimes).
Literature: L.IX.8.8; Hymans 1907, p. 257; H.*German*.XXIV.3.8 (with comprehensive bibliography); Hébert I.117.481; Paris 1991.102.67; Landau & Parshall 1994, p. 59.

373 - 379 THE LIFE OF THE VIRGIN (after Hans Holbein the Elder) (6+1 / 12)

373 THE PRESENTATION OF THE VIRGIN IN fol.rés. S.II.2408
THE TEMPLE (state II)
268 x 183 mm
Provenance: Purchased from Drugulin, Leipzig in June 1859 (67 BEF, 50 centimes).
Literature: L.IX.56.52; Lehrs 1892, p. 495, n° 133; Hymans 1907, p. 207; Washington 1967-68, n° 218; Koreny 1972, pp. 52-53; H.*German*.XXIV.20.52(II) (with comprehensive bibliography on p. 19); Hébert I.127.545.

374 THE MARRIAGE OF THE VIRGIN fol.rés. S.II.1211
269 x 183 mm
Provenance:, Purchased from Mr Mulhausen, a German engineer (Cologne) who worked in Spain, in November 1857 (60 BEF).
Literature: L.IX.57.53; Lehrs 1892, p. 495, n° 134; Washington 1967-68, n° 219; Koreny 1972, pp. 58-59; H.*German*.XXIV.20.53 (with comprehensive bibliography on p. 19); Hébert I.129.546.

375 THE ANNUNCIATION fol.rés. S.I.22819
 264 x 182 mm coloured
 Colour plate XIV

Provenance: Unknown. There is an unknown collection mark (PR or RR) on the verso (not in Lugt). In the collection prior to 1892.
Literature: L.IX.59.54; Lehrs 1892, p. 495, n° 134; Hymans 1907, p. 207 and 219; Washington 1967-68, n° 220; Koreny 1972, p. 60; H.*German*.XXIV.20.54 (with comprehensive bibliography on p. 19); Hébert I.129.547.

376 THE MASSACRE OF THE INNOCENTS fol.rés. S.II.2409
 264 x 182 mm
 Colour plate XIV

Provenance: Collection of François Debois, engraver, Paris, 1833. On the verso: F.D.1833 (or 1837 ?) (collection mark François Debois: Lugt 985). Purchased from Drugulin, Leipzig, in June 1859 (148 BEF, 50 centimes).
Literature: L.IX.66.58; Lehrs 1892, p. 495, n° 136; Washington 1967-68, n° 224; Koreny 1972, pp. 64-65; H.*German*.XXIV.21.58 (with comprehensive bibliography on p. 19); Hébert I.129.551.

377 JESUS AMONG THE DOCTORS fol.rés. S.II.2410
 270 x 184 mm

Provenance: Collection of Robert Balmanno in 1829 (collection mark Lugt 213 on the verso); sale 1830. Collection William Esdaile (collection mark Lugt 2617 on the recto and the verso); sale 1838. Purchased from Drugulin in June 1859, Leipzig (121 BEF, 50 centimes).
Literature: L.IX.68.59; Lehrs 1892, p. 495, n° 137; Hymans 1907, p. 207; Washington 1967-68, n° 225; Koreny 1972, p. 65; H.*German*.XXIV.21.59 (with comprehensive bibliography on p. 19); Hébert I.129.552.

378 THE DEATH OF THE VIRGIN fol.rés. S.II.4659
 268 x 182 mm

Provenance: Purchased from the Collection of Jozef Paelinck, artist-painter, on 20 November 1860 at the Heussner Sale, Brussels (Lugt, *Ventes* 25811) (110 BEF).
Literature: L.IX.69.60; Lehrs 1892, p. 495, n° 138; Hymans 1907, p. 207 and 208; Washington 1967-68, n° 226; Koreny 1972, p. 66-68; H.*German*.XXIV.21.60 (with comprehensive bibliography on p. 19); Hébert I.129.553.

379 THE DEATH OF THE VIRGIN fol.rés.S.II.62962
 >253 x 180 mm

Provenance: Prior to 1895 in the Collection of Luigi Angiolini (Milan); purchased from this collection during the sale held between 8 and 22 May 1895 (Sale Gutekunst, Stuttgart: Lugt, *Ventes* 53517) (341 BEF, 25 centimes).
Literature: See n° 378.

380 THE NATIVITY (state III) fol.rés.S.II.63151
 69 x 48 mm

Provenance: Drugulin (Leipzig). On the verso: WD (collection mark Drugulin: Lugt 2612); Prior to 1895 in the Collection of Luigi Angiolini (Milan); purchased from this collection during the sale held between 8 and 22 May 1895 (Sale Gutekunst, Stuttgart: Lugt, *Ventes* 53517) (49 BEF, 88 centimes).

Literature: L.IX.84.71; H.*German*.XXIV.26.71(III) (with comprehensive bibliography on p. 22).

381 THE CRUCIFIXION (state II) fol.rés.S.II.21257
 70 x 48 mm coloured

When purchased, attributed to Master I A M of Zwolle (Passavant.II.183.59). There is a fragment of a handwritten Latin prayer in twelve lines on the verso.

Provenance: Purchased from Zweibrücken (Malmédy) on 2 July 1874.

Literature: L.IX.120.105(II); Lehrs 1892, p. 499, n° 177; H.*German*.XXIV.43.105(II) (with comprehensive bibliography on p. 22).

382-384 THE LARGEST PASSION SERIES (3/12)

382 CHRIST BEFORE PILATE (state II) fol.rés. S.I.22818
 (PILATE WASHING HIS HANDS)
 203 x 143 mm

Provenance: Unknown. In the collection before 1892. There is an unknown mark on the verso: EKL (not in Lugt).

Literature: L.IX.157.147(II); Lehrs 1892, p. 495, n° 129; Washington 1967-68, n° 188; Robels 1972, pp. 33-35; H.*German*.XXIV.61.147 (II) (with comprehensive bibliography on p. 56); Hébert I.123.510.

383 THE CRUCIFIXION (MAN OF SORROWS RESTING) fol.rés. S.II.36
 207 x 145 mm

Provenance: Purchased from van Marcke (Liège) in December 1851 (12 BEF).

Literature: L.IX.161.150; Lehrs 1892, p. 495, n° 130; Washington 1967-68, n° 191; H.*German*.XXIV.65.150 (with comprehensive bibliography on p. 56); Hébert I.123.513.

384 CHRIST AT EMMAUS fol.rés. S.II.4657
 >203 x 145 mm

This print is largely restored.

Provenance: Purchased from the Collection of Jozef Paelinck, artist-painter, on 20 November 1860 at the Heussner Sale, Brussels (Lugt, *Ventes* 25811) (35 BEF, 20 centimes).

Literature: L.IX.164.153; Lehrs 1892, p. 495, n° 131; Hymans 1907, p. 207 and 215; Washington 1967-68, n° 194; H.*German*.XXIV.68.153 (with comprehensive bibliography on p. 56); Hébert I.123.516.

385 VIRGIN WITH THE CHILD BATHING fol.rés. S.I.42446
 (=L.IX.187.182)
 Nineteenth-century photograph.
 Original print was formerly in Wroclaw; Breslau, Stadtbibliothek (present location
 unknown).

386 VIRGIN AND CHILD IN A COURT (state II) fol.rés. S.II.2411
 165 x 114 mm
Copy in reverse after M. Schongauer (see n° 251).
Provenance: Purchased from Drugulin, Leipzig in June 1859 (135 BEF, 50 centimes). On the
verso: WD (collection mark Drugulin: Lugt 2612). There is also an unidentified collection
mark on the verso: B.v.G. (not in Lugt).
Literature: L.V.194.38b; L.IX.189.187; Lehrs 1892, p. 495, n° 139; H.*German*.XXIV.82.187 (II);
Behling 1972, pp. 2-3; Hébert I.119.488; TIB, vol. 8.1 Commentary, n° 0801.038 C2 S3;
H.*German*.XLIX.104.38b (with comprehensive bibliography).

387 VIRGIN AND CHILD, fol.rés. S.II.34580
 STANDING ON A SERPENT slightly coloured
 107 x 72 mm
Copy in reverse after Master E S.
Provenance: Collection Eugeen Felix (Sale 1885: for 40 marks, but not sold). Purchased
from Dietrich, Brussels on 15 February 1886 (150 BEF).
Literature: L.II.133.71b; L.IX.190.189; Lehrs 1892, p. 481, n° 6; H.*German*.XXIV.83.189 (with
comprehensive bibliography).

388 VIRGIN AND CHILD WITH ROSARY ON fol.rés. S.II.4660
 THE CRESCENT
 274 x 187mm
Provenance: Purchased from the Collection of Jozef Paelinck, artist-painter, on 20
November 1860 at the Heussner Sale, Brussels (Lugt, *Ventes* 25811) (187 BEF).
Literature: L.IX.197.199; Lehrs 1892, p. 496, n° 140; H.*German*.XXIV.87.199 (with
bibliography); Hébert I.119.490.

389 ST ANNE WITH MARY AND THE CHILD fol.rés. S.II.30151
 (state III) traces of colour
 211 x 136 mm
Provenance: Purchased from Papillon, Brussels on 10 February 1883 (1,000 BEF).
Literature: L.IX.213.221(III); Lehrs 1892, p. 497, n° 156; Hymans 1907, p. 91;
H.*German*.XXIV.95.221(III) (with comprehensive bibliography).

390 - 392 THE TWELVE APOSTLES (3/13)

390 ST THOMAS (state II) fol.rés. S.II.4661
 96 x 67mm
Copy in reverse after Martin Schongauer (see n° 258).
Provenance: Purchased from the Collection of Jozef Paelinck, artist-painter, on 20
November 1860 at the Heussner Sale, Brussels (Lugt, *Ventes* 25811) (24 BEF, 20 centimes).
Literature: L.V.222.46g; L.IX.228.254; Lehrs 1892, p. 496, n° 143; H.*German*.XXIV.105.254(II)
(with bibliography on p. 103); TIB, vol. 8.1 Commentary, n° 0801.046 C7; Hébert I.131.566;
H.*German*.XLIX.116.46g (with comprehensive bibliography).

391 ST PHILIP (state II) fol.rés. S.II.10718
 >88 x >57mm (trimmed)
Copy in reverse after Martin Schongauer (see n° 260).
Provenance: Purchased from Danlos & Delisle on 6 May 1867 (27 BEF, 50 centimes).
Literature: L.V.227.48h; L.IX.229.256; Lehrs 1892, p. 496, n° 141 H.*German*.XXIV.105.256(II)
(with bibliography on p. 103); Hébert I.131.562; TIB, vol. 8.1 Commentary, n° 0801.048 C8;
H.*German*.XLIX.118.48h (with comprehensive bibliography).

392 ST BARTHOLOMEW fol.rés. S.I.22820
 96 x 65 mm
Copy in reverse after Martin Schongauer (see n° 261).
Provenance: Unknown. In the collection prior to 1892.
Literature: L.V.230.49g.; L.IX.229.257; Lehrs 1892, p. 496, n° 142; H.*German*.XXIV.106.257(I)
(with bibliography on p. 103); Hébert I.131.563; TIB, vol. 8.1 Commentary, n° 0801.049 C7;
H.*German*.XLIX.119.49g (with comprehensive bibliography).

393 - 398 THE TWELVE APOSTLES WITH THE CREED (6/6)
The most common representation of the creed is the series of the twelve Apostles, each
accompanied by a text bearing part of the creed. This motif goes back to a sixth-century
sermon from pseudo-Augustine. Here, each of the Apostles was associated with a specific
part of the text. Joined together, the six prints form an Apostle or Creed screen. As a
catechetical scheme it caries the basic affirmations of the Western Church. Van Meckenem
follows the traditional text-image relationship, although his ordering of apostles and text
is somewhat corrupt.
1. [St. Peter] *'Credo in Deum p(atrem) ...'* [St. Andrew] *'Et in Ihe(sum) Chr(istu)m ...'* (= n° 393)
2. [St. James the Greater] *'Qui conceptus est ...'* [St. John] *'Passus sub Po(n)tio (Pilato) ...'* (= n°
394). Israhel van Meckenem erred here by associating St. John the Baptist's text with St.
James the Great, and vice versa.
3. [St. Thomas] *'Desce(n)dit ad inferna ...'* [St. James the Lesser] *'Asce(n)dit ad celos ...'* (= n°
395)
4. [St. Philip] *'Inde ventur(us) e(st) iudicare ...'* [St. Bartholomew] *'Credo in Sp(iritu)m
Sanctu(m)'* (= n° 396). The artist incorrectly included St. Bartholomew before St. Philip.

5. [St. Matthew] *'Sancta(m) ecc(les)iam catholica(m) ...'* [St. Simon] *'Remissione(m)*
pec(cat)orum' (= n° 397). The artist incorrectly included St. Simon before St. Matthew.
6. [St. Judas Thaddaeus] *'Carnis resurrectionem'* [St. Matthias] *'Et vitam eterna(m) ame(n)'*
(= n° 398). The artist incorrectly included St. Matthias before St. Judas Thaddeus.

393 ST PETER AND ST ANDREW (1) fol.rés. S.II.1937
 201 x 141 mm
Provenance: Brisard Collection (Gent, Belgium); sold in 1849 for 260 BEF. Purchased from
the collection Borluut de Noortdonck (Gent 13/18 December 1858: Lugt, *Ventes* 24531) (a
total of 308 BEF was paid for the entire set).
Literature: L.IX.245.294; Duchesne 1834, p. 329; Lehrs 1892, p. 496, n° 144; Washington
1967-68, n° 197; H.*German*.XXIV.115.294 (with bibliography); Hébert I.132.582.

394 ST JAMES THE GREATER AND ST JOHN (2) fol.rés. S.II.1938
 (state II)
 202 x 142 mm
Provenance: See n° 393.
Literature: L.IX.246.295; Duchesne 1834, p. 329; Lehrs 1892, p. 496, n° 145;
H.*German*.XXIV.116.295(II) (with bibliography); Hébert I.132.583.

395 ST THOMAS AND ST JAMES THE LESSER (3) fol.rés. S.II.1939
 202 x 141 mm
Provenance: See n° 393.
Literature: L.IX.247.296; Duchesne 1834, p. 329; Lehrs 1892, p. 496, n° 146; Washington
1967-68, n° 198; H.*German*.XXIV.116.296 (with bibliography); Hébert I.132.584.

396 ST BARTHOLOMEW AND ST PHILIP (4) fol.rés. S.II.1940
 201 x 142 mm
Provenance: See n° 393.
Literature: L.IX.247.297; Duchesne 1834, p. 329; Lehrs 1892, p. 496, n° 147;
H.*German*.XXIV.116.297 (with bibliography); Hébert I.132.585.

397 ST SIMON AND ST MATTHEW fol.rés. S.II.1941
 202 x 141 mm
Provenance: See n° 393.
Literature: L.IX.248.298; Duchesne 1834, p. 329; Lehrs 1892, p. 496, n° 148;
H.*German*.XXIV.117.298 (with bibliography); Hébert I.132.586.

398 ST MATTHIAS AND ST JUDAS THADDEUS (6) fol.rés. S.II.1942
 203 x 143 mm
Provenance: See n° 393.
Literature: L.IX.249.299; Duchesne 1834, p. 329; Lehrs 1892, p. 496, n° 149;
H.*German*.XXIV.117.299 (with bibliography); Hébert I.132.587.

399 ST ANTHONY AND A DEVIL fol.rés. S.II.2412
 129 x 74 mm

Provenance: Purchased from Drugulin, Leipzig, in June 1859 (50 BEF, 62 centimes). On the verso: W.D. (collection mark Drugulin: Lugt 2612).
Literature: L.IX.265.316; Lehrs 1892, p. 496, n° 150; H.*German*.XXIV.127.316 (with bibliography).

400 THE MASS OF ST GREGORY (state II) fol.rés. S.II.62759
 159 x 102 mm

Unique impression. I believe that the attribution to van Meckenem is incorrect because this print is of inferior quality.
Provenance: Prior to 1895 in the Collection of Luigi Angiolini (Milan); purchased from this collection during the sale held between 8 and 22 May 1895 (Sale Gutekunst, Stuttgart: Lugt, *Ventes* 53517) (223 BEF, 13 centimes).
Literature: L.IX.285.350; H.*German*.XXIV.137.350(II) (with bibliography).

401 THE MASS OF ST GREGORY (state V) fol.rés. S.II.4663
 215 x 145 mm

The print bears an inscription promising 45,000 years' relief from purgatory for each recitation of three prayers made before the image.
Provenance: Purchased from the Collection of Jozef Paelinck, artist-painter, on 20 November 1860 at the Heussner Sale, Brussels (Lugt, *Ventes* 25811) (71 BEF, 50 centimes).
Literature: L.IX.288.353(V); Lehrs 1892, p. 497, n° 153; Hymans 1907, p. 230 and 233; Washington 1967-68, n° 214; H.*German*.XXIV.139.353(V) (with comprehensive bibliography); Hébert I.137.614; Landau & Parshall 1994, p. 58 and fig. 35.

402 ST JOHN ON PATMOS fol.rés. S.I.31947
 160 x 113 mm

Unsigned copy in reverse after Martin Schongauer (see n° 270).
Provenance: Unknown. In the collection prior to 1892.
Literature: L.V.267.60d; L.IX.295.363; Lehrs 1892, p. 499, n° 178; H.*German*.XXIV.143.363 ("not by Meckenem"); TIB, vol. 8.1 Commentary, n° 0801.060 C4; H.*German*.XLIX.142.60d (with comprehensive bibliography); Hébert I.134.593.

403 ST LAWRENCE (state IV) fol.rés. S.II.2414
 123 x 73 mm

Provenance: Collection of William Esdaile (on the recto: collection mark Lugt 2617). Purchased from Drugulin, Leipzig, in June 1859 (47 BEF, 25 centimes).
Literature: L.IX.298.368(IV); Lehrs 1892, p. 497, n° 154; H.*German*.XXIV.145.368 (with bibliography).

404 ST SEBASTIAN fol.rés. S.II.4664
>141 x >94 mm (trimmed)

Copy in reverse after Martin Schongauer (see n° 273). Several additions in pen.
Provenance: Purchased from the Collection of Jozef Paelinck, artist-painter, on 20
November 1860 at the Heussner Sale, Brussels (Lugt, *Ventes* 25811) (16 BEF, 50 centimes).
Literature: L.V.282.65d; L.IX.306.381; Lehrs 1892, p. 497, n° 155; H.*German*.XXIV.149.381;
Hébert I.134.599; TIB, vol. 8.1 Commentary, n° 0801.065 C4; H.*German*.XLIX.151.65d (with
comprehensive bibliography).

405 THE STONING OF ST STEPHEN fol.rés. S.II.4662
152 x 196 mm

Provenance: Purchased from the Collection of Jozef Paelinck, artist-painter, on 20
November 1860 at the Heussner Sale, Brussels (Lugt, *Ventes* 25811) (126 BEF, 50 centimes).
The figure n° '107' was noted in brown ink in the upper right of the recto.
Literature: L.IX.308.383; Lehrs 1892, p. 496, n° 152; Washington 1967-68, n° 174;
H.*German*.XXIV.150.383 (with comprehensive bibliography); Hébert I.134.595.

406 ST BARBARA fol.rés. S.V.27484
93 x 59 mm

Copy in reverse after Martin Schongauer (L.V.287.68). This print was purchased as *'Israhel
van Meckenem'*. Although I agree with this attribution, this engraving is not the same as
L.IX.313.390 or L.IX.313.391. Indeed, this engraving cannot be equated with any of the
copies after Schongauer (e.g, L.V.287.68g) or after Meckenem that are described by Lehrs.
Provenance: Purchased from Mr Bonnivert, Antwerp, on 21 December 1950.
Literature: Not in Lehrs.

407 ST BARBARA fol.rés. S.II.2415
160 x 101 mm

Provenance: Purchased from Drugulin, Leipzig, in June 1859 (84 BEF, 37 centimes). On the
verso: unknown mark B.v.G. (not in Lugt).
Literature: L.IX.314.393; Lehrs 1892, p. 497, n° 157; H.*German*.XXIV.154.393 (with
comprehensive bibliography); Hébert I.140.637.

408 ST ELISABETH (state II) fol.rés. S.II.4665
160 x 110 mm some traces of colour

Provenance: Collection Frans Rechberger in 1800 (on the verso: collection mark Lugt 2133
and the year '1800'). Purchased from the Collection of Jozef Paelinck, artist-painter, on 20
November 1860 at the Heussner Sale, Brussels (Lugt, *Ventes* 25811) (93 BEF, 50 centimes).
Literature: L.IX.318.398; Lehrs 1892, p. 498, n° 159; Washington 1967-68, n° 181;
H.*German*.XXIV.156.398(II) (with comprehensive bibliography); Hébert I.140.641.

409 ST CATHERINE (state I) fol.rés. S.II.2416
160 x 109 mm
Provenance: Collection of William Esdaile (on the recto: collection mark Lugt 2617); sale
1838. Purchased from Drugulin, Leipzig, in June 1859 (111 BEF, 37 centimes). On the verso:
W.D. (collection mark Drugulin: Lugt 2612).
Literature: L.IX.322.406(I); Lehrs 1892, p. 498, n° 158; Washington 1967-68, n° 204;
H.*German*.XXIV.00.406(I) (with comprehensive bibliography).

410 ST MARGARET fol.rés. S.II.4666
>147 x >79 mm (trimmed)
Provenance: Purchased from the Collection of Jozef Paelinck, artist-painter, on 20
November 1860 at the Heussner Sale, Brussels (Lugt, *Ventes* 25811) (48 BEF, 80 centimes).
Literature: L.IX.324.409; Lehrs 1892, p. 498, n° 160; Washington 1967-68, n° 203;
H.*German*.XXIV.00.409 (with comprehensive bibliography); Hébert I.142.642.

411 - 414 THE WISE AND THE FOOLISH VIRGINS (4/10)

411 THE FIRST WISE VIRGIN fol.rés. S.II.2417
117 x 79 mm
Copy in reverse after Martin Schongauer.
Provenance: Purchased from Drugulin, Leipzig, in June 1859 (27 BEF). On the verso: W.D.
(collection mark Drugulin: Lugt 2612).
Literature: L.V.309.76c; Lehrs 1892, p. 498, n° 161; L.IX.331.419; H.*German*.XXIV.163.419;
TIB, vol. 8.1 Commentary, n° 0801.076 C3; H.*German*.XLIX.169.76c (with bibliography);
Hébert I.127.534.

412 THE THIRD WISE VIRGIN fol.rés. S.II.4667
117 x 84 mm
Copy in reverse after Martin Schongauer.
Provenance: Purchased from the Collection of Jozef Paelinck, artist-painter, on
20 November 1860 at the Heussner Sale, Brussels (Lugt, *Ventes* 25811) (52 BEF, 80 centimes).
Literature: L.V.312.78d; Lehrs 1892, p. 498, n° 162; L.IX.332.421; H.*German*.XXIV.164.421;
TIB, vol. 8.1 Commentary, n° 0801.078 C4; H.*German*.XLIX.170.78d (with comprehensive
bibliography); Hébert I.127.536.

413 THE FIFTH WISE VIRGIN fol.rés. S.II.6136
[117 x 80 mm] untraceable
Copy in reverse after Martin Schongauer. This print is cited in the 1862 inventory but is
currently untraceable. Given the exceptionally low price paid for this print (in comparison
with the other prints by van Meckenem that were purchased in the same period), it may
have been a reproduction. It is also striking that it is not cited in Lehrs 1892.
Provenance: Cels Sale on 18 March 1862 (8 BEF, 29 centimes).

Literature: L.V.314.80c; L.IX.333.423; H.*German*.XXIV.164.423; TIB, vol. 8.1 Commentary, n°
0801.080 C3; H.*German*.XLIX.172.80c (with comprehensive bibliography); Hébert I.127.538.

414 THE FIFTH FOOLISH VIRGIN fol.rés. S.III.24591
 119 x 81 mm
Copy in reverse after Martin Schongauer (see n° 278).
Provenance: Purchased from Tavernier, Antwerp, on 21 February 1921 (28 BEF).
Literature: L.V.321.85d; L.IX.335.428; H.*German*.XXIV.166.428; TIB, vol. 8.1 Commentary, n°
0801.085 C4; H.*German*.XLIX.172.80c (with comprehensive bibliography).

415 SCENES FROM THE PASSION fol.rés. S.II.7787-90
 (four scenes: cut out)
Not by Meckenem, but by Master E S; probably retouched by Meckenem.
Provenance: From an exchange (*'echangées'*) with M. Van der Haegen (Gent) on 10 April
1865. What was exchanged is not noted in the 1865 inventory. See also n° 416.
Literature: L.II.278.194b; L.IX.344.441; Lehrs 1892, pp. 180-181, n° 1-4;
H.*German*.XXIV.170.441 (with comprehensive bibliography).

416 SCENES FROM THE LIFE OF CHRIST AND OTHER fol.rés. S.II.7786
 RELIGIOUS SCENES
 (only one scene: cut out)
Not by Meckenem, but by Master E S; probably retouched by Meckenem.
Provenance: From an exchange (*'echangées'*) with M. Van der Haegen (Gent) on 10 April
1865. What was exchanged is not noted in the 1865 inventory. See also n° 415.
Literature: L.II.281.196a; L.IX.344.442; Lehrs 1892, p. 181, n° 5; H.*German*.XXIV.170.442
(with bibliography).

417 CHRIST CHILD, ST ANNE WITH MARY AND THE fol.rés. S.II.62981-86
 CHILD, VARIOUS SAINTS
 (six scenes: cut out)
Provenance: Prior to 1895 in the Collection of Luigi Angiolini (Milan); purchased from this
collection during the sale held between 8 and 22 May 1895 (Sale Gutekunst, Stuttgart: Lugt,
Ventes 53517) (53 BEF, 81 centimes).
Literature: L.IX.351.447; H.*German*.XXIV.174.447 (with bibliography); Hébert I.139.628.

418 SIX FEMALE SAINTS fol.rés. S.II.62975-80
 (six scenes: cut out)
Provenance: Prior to 1895 in the Collection of Luigi Angiolini (Milan); purchased from this
collection during the sale held between 8 and 22 May 1895 (Sale Gutekunst, Stuttgart: Lugt,
Ventes 53517) (47 BEF, 25 centimes).
Literature: L.IX.353.448; H.*German*.XXIV.175.448 (with bibliography); Hébert I.139.627.

419 THE LAMB OF GOD, ST VERONICA, SYMBOLS fol.rés. S.II.62969-74
 OF THE FOUR EVANGELISTS (state II)
 (six scenes: cut out)
Provenance: Prior to 1895 in the Collection of Luigi Angiolini (Milan); purchased from this collection during the sale held between 8 and 22 May 1895 (Sale Gutekunst, Stuttgart: Lugt, *Ventes* 53517) (177 BEF, 19 centimes).
Literature: L.IX.354.449; H.*German*.XXIV.175.449(II) (with bibliography); Hébert I.139.626.

420 MAN OF SORROWS, SKULLS, SCENES FROM fol.rés. S.II.62963-68
 THE DANCE OF DEATH
 (six scenes: cut out)
Provenance: Prior to 1895 in the Collection of Luigi Angiolini (Milan); purchased from this collection during the sale held between 8 and 22 May 1895 (Sale Gutekunst, Stuttgart: Lugt, *Ventes* 53517) (84 BEF, 21 centimes).
Literature: L.IX.355.450; H.*German*.XXIV.176.450 (with bibliography); Hébert I.139.625.

421 CHILDREN'S BATH (state III) fol.rés. S.II.2421
 108 x 136 mm
Provenance: Purchased from Drugulin, Leipzig in June 1859 (60 BEF, 75 centimes). On the verso: W.D. (collection mark Drugulin: Lugt 2612).
Literature: L.IX.371.478; Lehrs 1892, p. 499, n° 171; H.*German*.XXIV.184.478(III) (with comprehensive bibliography); Hébert I.146.669.

422 THE ILL-MATCHED COUPLE (state II) fol.rés. S.II.1943
 146 x 114 mm
Copy in reverse after the Housebook Master.
Provenance: Purchased from the Collection Borluut de Noortdonck (Gent 13/18 December 1858: Lugt, *Ventes* 24531) (41 BEF, 80 centimes).
Literature: L.VIII.148.73a; L.IX.380.488(II); Lehrs 1892, p. 498, n° 164; H.*German*.XXIV.188.488(II) (with comprehensive bibliography); Hébert I.142.646.

423 COMBAT OF TWO WILD MEN ON HORSEBACK fol.rés. S.I.25795
 137 x 199 mm
Copy in reverse after the Housebook Master.
Provenance: Unknown. In the collection prior to 1892.
Literature: L.VIII.133.56a; L.IX.383.491; Lehrs 1892, p. 499, n° 175; H.*German*.XXIV.189.491 (with comprehensive bibliography); Hébert I.150.684.

424 FOUR APES WITH THEIR YOUNG fol.rés. S.II.1944
 83 x 109 mm (only the lower portion of the print)
Provenance: Purchased from the Collection Borluut de Noortdonck (Gent 13/18 December 1858: Lugt, *Ventes* 24531) (34 BEF, 10 centimes).

Literature: L.IX.388.498; Lehrs 1892, p. 499, n° 172; H.*German*.XXIV.192.498 (with bibliography); Hébert I.148.673b.

425 - 430 SCENES OF DAILY LIVE (6/12)

425 THE CHURCHGOERS fol.rés. S.II.2420
 167 x 110 mm
Provenance: Prior to 1784, in the Collection of John Barnard, London. On the verso: JB. (collection mark Barnard: Lugt 1420). Purchased from Drugulin, Leipzig, in June 1859 (168 BEF, 75 centimes). On the verso: W.D. (collection mark Drugulin: Lugt 2612).
Literature: L.IX.389.499; Lehrs 1892, p. 499, n° 168; Washington 1967-68, n° 233; H.*German*.XXIV.192.499 (with comprehensive bibliography on p. 192); Hébert I.145.653; Filedt Kok 1990; Landau & Parshall 1994, p. 61 and fig. 40

426 THE ILL-MATCHED COUPLE fol.rés. S.II.2418
 161 x 110 mm
Provenance: Purchased from Drugulin, Leipzig, in June 1859 (236 BEF, 25 centimes).
Literature: L.IX.392.502; Lehrs 1892, p. 498, n° 165; Washington 1967-68, n° 236; H.German.XXIV.193.502 (with comprehensive bibliography on p. 192); Hébert I.142.650; Landau & Parshall 1994, p. 61 and fig. 37.

427 THE ANGRY WIFE fol.rés. S.II.10281
 >154 x 104 mm
A missing part of the print has been drawn in below. The pants and the dog are missing.
Provenance: Purchased from Goupil, Brussels, on 15 February 1867 (50 BEF).
Literature: L.IX.394.504; Lehrs 1892, p. 498, n° 166; Washington 1967-68, n° 238; H.*German*.XXIV.193.504 (with comprehensive bibliography on p. 192); Behling 1972, pp.10-11; Hébert I.142.652; Landau & Parshall 1994, p. 61 and fig. 39..

428 THE LUTE PLAYER AND THE SINGER (state II) fol.rés. S.II.2419
 164 x 108 mm
Provenance: June 1859, Purchased from Drugulin, Leipzig (148 BEF, 50 centimes).
Literature: L.IX.396.506(II); Lehrs 1892, p. 498, n° 167; Hymans 1907, p. 207; Washington 1967-68, n° 240; H.*German*.XXIV.194.506(II) (with comprehensive bibliography on p. 192); Hébert I.145.656; Paris 1991.106.71.

429 WOMAN SPINNING AND A VISITOR fol.rés. S.II.4668
 162 x 110 mm
Provenance: Purchased from the Collection of Jozef Paelinck, artist-painter, on 20 November 1860 at the Heussner Sale, Brussels (Lugt, *Ventes* 25811) (198 BEF). There is an unknown mark on the verso: EKL (not in Lugt).
Literature: L.IX.399.509; Lehrs 1892, p. 499, n° 169; Hymans 1907, p. 207, 215 and 219;

Washington 1967-68, n° 243; Paris 1999.107.72; H.*German*.XXIV.196.509 (with comprehensive bibliography on p. 192); Hébert I.145.660.

430 COUPLE PLAYING CARDS fol.rés. S.IV.86327
 171 x 118 mm
Provenance: Prior to 1935/37 in the Collection of Fürst zu Oettingen-Wallerstein (Maihingen, Bavière) (on the verso collection mark Lugt 2715a). Purchased from Richard Zinser, Brussels, on 6 November 1939.
Literature: L.IX.400.510; Brussels 1961, n° 2 and pl. 1; H.*German*.XXIV.196.510 (with comprehensive bibliography on p. 192); Hébert I.145.661.

431 THE MORRIS DANCE (state III) fol.rés. S.II.37
 174 mm diameter
Provenance: Purchased from Van Marcke (Liège) in December 1851 (20 BEF). There is an unknown mark on the verso: EKL (not in Lugt).
Literature: L.IX.402.512; Lehrs 1892, p. 499, n° 170; Winther 1972, p. 89 and fig. 117; H.*German*.XXIV.197.512(III) (with comprehensive bibliography); Hébert I.146.666.

432 THE PROMENADE fol.rés. S.IV.22817
 (YOUNG COUPLE THREATENED BY DEATH)
 184 x 118 mm
Copy in reverse after Albrecht Dürer (B.94). See introduction, ill. 5
Provenance: Probably until 1920 in the Collection of John Postle Hesseltine (London), exchange-broker and engraver, born in 1843 (on the verso: collection mark Lugt 1508). British Museum, Print Room (on the verso: collection mark Lugt 300). Sold as a 'double' by the curator of the Print Room, Campbell Dodgson (mark Lugt 305, with the monogram 'C.D.'). Purchased by the Royal Library from J. Van Overloop, Antwerp, on 19 July 1935. Due to an error during the conservation, all the information on the verso of the print went lost (September 2001).
Literature: L.IX.404.513; H.*German*.XXIV.197.513 (with comprehensive bibliography); Hébert I.145.663.

433 LUCRETIA fol.rés. S.II.10280
 263 x 181 mm
Provenance: Purchased from Goupil, Brussels, on 15 February 1867 (140 BEF).
Literature: L.IX.406.516; Lehrs 1892, p. 498, n° 163; Washington 1967-68, n° 231; H.*German*.XXIV.199.516 (with comprehensive bibliography).

434 COAT OF ARMS WITH TUMBLING BOY (state II) fol.rés. S.II.4669
 (trimmed)
Provenance: Purchased from the Collection of Jozef Paelinck, artist-painter, on 20 November 1860 at the Heussner Sale, Brussels (Lugt, *Ventes* 25811) (88 BEF).

Literature: L.IX.410.521; Lehrs 1892, p. 499, n° 173; Hymans 1907, p. 136; Washington 1967-68, n° 206; H.*German*.XXIV.200.521(II) (with comprehensive bibliography).

435 COAT OF ARMS WITH A LION (state I) fol.rés. S.II.2422
 127 x 91 mm
Provenance: Purchased from Drugulin, Leipzig, in June 1859 (60 BEF, 75 centimes). On the verso: W.D. (collection mark Drugulin: Lugt 2612).
Literature: L.IX.411.522(I); Lehrs 1892, p. 499, n° 174; Hymans 1907, p. 137; Washington 1967-68, n° 207; H.*German*.XXIV.201.522(I) (with bibliography).

436 CROSIER (state III) fol.rés. S.II.4670
 >339 x 105 mm (trimmed)
The monogram was added in pencil.
Provenance: Purchased from the Collection of Jozef Paelinck, artist-painter, on 20 November 1860 at the Heussner Sale, Brussels (Lugt, *Ventes* 25811) (165 BEF).
Literature: L.IX.438.587(III); Lehrs 1892, p. 499, n° 176; Hymans 1907, p. 233; H.*German*.XXIV.00.587B (III) (with comprehensive bibliography).

- LAMENTATION fol.rés. S.II.4658
 See n° 207: (Unknown Dutch engraver, retouched and monogrammed by Meckenem (=L.IV.229.22(II)).

- ST ANTHONY TORMENTED BY DEVILS fol.rés. S.II.2413
 See n° 341: Master FVB after Marin Schongauer, retouched and monogrammed by Meckenem (=L.VII.146.40(II)).

AFTER ISRAHEL VAN MECKENEM

437 MAN OF SORROWS STANDING IN THE TOMB fol.rés. S.II.6784
 110 x 87 mm
Copy in reverse. The print belongs to a group of eight from a Dutch prayer book dating from 1552/53 (Ms. 22012). See also n° 047, n° 049, and n° 210.
Provenance: Given by Mr Van der Beelen on 10 April 1863. See also n° 049.
Literature: L.IX.79.169a; Lehrs 1892, p. 502, n° 182; H.*German*.XXIV.76.169a (with bibliography). See also n° 049.

438 MAN OF SORROWS IN THE TOMB Ms. II.1561, fol. 153v
 40 mm diameter
Inserted in a manuscript containing various religious texts (see n° 097).
Provenance: See n° 097.
Literature: Not in Lehrs (?); VDG 2052. This print is very close to H.*German*.XXIV.172.445(a).

439 ST CHRISTOPHER fol.rés. S.I.22821
165 x 105 mm
Provenance: Unknown. In the collection prior to 1892.
Literature: L.IX.273.328a; Lehrs 1892, p. 496, n° 151; Washington 1967-68, n° 209;
H.*German*.XXIV.131.328a (with comprehensive bibliography).

440 THE LARGE MAJUSCULE ALPHABET fol.rés. S.II. 32133-38
Woodcut copies (book illustrations)
Five letters: D, E, M, P, and S. Six letters were purchased in 1885; one has since disappeared.
Provenance: Purchased from H. Buttstaedt, print dealer in Berlin, on 25 January 1885 (9
BEF, 38 centimes).
Literature: After L.IX.428.566-71; Hymans 1907, p. 134: '*Majuscules dont Israël de Meckenem
a fait des copies*'; Angerman 1972; H.*German*.XXIV.212-13. (with bibliography).

PRINTS NOT IN LEHRS AND NOT ATTRIBUTED TO SPECIFIC HANDS

441 - 452 THE LIFE OF CHRIST

441 CHRIST AMONG THE DOCTORS fol.rés. S.II.5027
44 x 35 mm
This series was printed on parchment and probably came from a manuscript. All the prints
were executed by the same hand.
Provenance: Purchased from the Collection of Jozef Paelinck, Brussels (Sale Heussner,
Brussels: Lugt, *Ventes* 25811) on 20 November 1860. Together with some other prints
('*Collection de 19 pièces imprimées sur velin & extraits divers volumes des XVe & XVIe S*') (7 BEF,
70 centimes).
Literature: Not in Lehrs.

442 JOHN THE BAPTIST IN PRISON fol.rés. S.II.5026
(Two Disciples of St. John are Sent to Christ)
46 x 35 mm
The identification of the subject is not entirely certain.
Provenance: See n° 441.
Literature: See n° 441.

443 CHRIST HEALING A MAN BORN BLIND fol.rés. S.II. 5030
(fragment)
Provenance: See n° 441.
Literature: See n° 441.

444 CHRIST HEALING A PARALYTIC MAN fol.rés. S.II.5017
47 x 35 mm
Provenance: See n° 441.
Literature: See n° 441.

445 CHRIST HEALING A PARALYTIC MAN fol.rés. S.II.5033
(fragment)
Provenance: See n° 441.
Literature: See n° 441.

446 CHRIST HEALING A LEPER fol.rés. S.II.5024
44 x 35 mm
Provenance: See n° 441.
Literature: See n° 441.

447 CHRIST HEALING THE SON OF THE fol.rés. S.II.5025
WIDOW OF NAIN
47 x 35 mm
Provenance: See n° 441.
Literature: See n° 441.

448 THE CALLING OF ST PETER AND ST ANDREW fol.rés. S.II.5029
45 x 36 mm
Provenance: See n° 441.
Literature: See n° 441.

449 TRANSFIGURATION OF CHRIST fol.rés. S.II.5028
(fragment)
Provenance: See n° 441.
Literature: See n° 441.

450 CHRIST PREACHING IN THE OPEN fol.rés. S.II.5023
47 x 37 mm
Provenance: See n° 441.
Literature: See n° 441.

451 CHRIST BEFORE CAIAPHAS fol.rés. S.II.5022
47 x 36 mm
Provenance: See n° 441.
Literature: See n° 441.

452 CHRIST AT EMMAUS fol.rés. S. II.5016
 45 x 35 mm
Provenance: See n° 441.
Literature: See n° 441.

453-465 VIRGIN AND CHILD ON THE CRESCENT and a series of twelve engravings with
the LIFE OF THE VIRGIN (one oval and 12 medallions). The prints (marked with an
asterisk *) were glued into a prayer book from the Northern Netherlands (c.1500). The
manuscript is kept in the Print Room and not in the Manuscript Department.

453 VIRGIN AND CHILD ON THE CRESCENT* rés. S.V.81636, fol. 14r
 48 x 30 mm (oval) coloured
 Colour plate XIV
Provenance: The manuscript was purchased from Frits Lugt, Paris, on 6 August 1960.
Literature: Not in Lehrs. Brussels 1961, n° 3; Brussels 1969, n° 209.

454 CHRIST APPEARS TO THE VIRGIN* rés. S.V.81637, fol. 25v
 26 mm diameter coloured
Provenance: See n° 453.
Literature: See n° 453.

455 THE ANNUNCIATION* rés. S.V.81638, fol. 36v
 26 mm diameter coloured
Provenance: See n° 453.
Literature: See n° 453.

456 THE VISITATION* rés. S.V.81639, fol. 42r
 26 mm diameter coloured
Provenance: See n° 453.
Literature: See n° 453.

457 THE NATIVITY* rés. S.V.81640, fol. 45v
 26 mm diameter coloured
Provenance: See n° 453.
Literature: See n° 453.

458 THE ADORATION OF THE MAGI* rés. S.V.81641, fol. 49v
 25 mm diameter coloured
Provenance: See n° 453.
Literature: See n° 453.

459 PENTECOST*
 26 mm diameter
Provenance: See n° 453.
Literature: See n° 453.

rés. S.V.81642, fol. 53r
coloured

460 THE ASSUMPTION OF THE VIRGIN*
 26 mm diameter
Provenance: See n° 453.
Literature: See n° 453.

rés. S.V.81643, fol. 60v
coloured

461 THE LAMENTATION*
 26 mm diameter
Provenance: See n° 453.
Literature: See n° 453.

rés. S.V.81644, fol. 68r
coloured

462 THE CRUCIFIXION*
 26 mm diameter
Provenance: See n° 453.
Literature: See n° 453.

rés. S.V.81645, fol. 92r
coloured

463 VIRGIN AND CHILD ENTHRONED
 AND CROWNED BY TWO ANGELS*
 29 mm diameter
Provenance: See n° 453.
Literature: See n° 453.

rés. S.V. 81646, fol. 101r
coloured

464 CHRIST AMONG THE DOCTORS*
 26 mm diameter
Provenance: See n° 453.
Literature: See n° 453.

rés. S.V.81647, fol. 126r
coloured

465 THE ENTOMBMENT*
 27 mm diameter
Provenance: See n° 453.
Literature: See n° 453.

rés. S.V.81648, fol. 157r
coloured

466 - 471 Six medallions with scenes from the PASSION OF CHRIST, the SACRED HEART, and the VIRGIN AND CHILD ON THE CRESCENT. These prints (marked with two asterisks**) were glued into a Dutch manuscript (after 1514) with devotional texts, prayers, and texts for the devotional hours.

466 CHRIST BEFORE PILATE** Ms.II.3688, fol. 98v
22 mm diameter coloured
Provenance: Purchased from Ms. Best, Brussels, in 1907.
Literature: Not in Lehrs.

467 BEARING OF THE CROSS** Ms.II.3688, fol. 100r
28 mm diameter coloured
Provenance: See n° 466.
Literature: See n° 466.

468 MAN OF SORROWS RESTING** Ms.II.3688, fol. 114v
24 mm diameter coloured
Provenance: See n° 466.
Literature: See n° 466.

469 THE HEART OF CHRIST AND I.H.S. MONOGRAM** Ms.II.3688, fol. 149v
29 mm diameter coloured
Provenance: See n° 466.
Literature: See n° 466.

470 MAN OF SORROWS, STANDING IN THE TOMB** Ms.II.3688, fol. 235r
20 mm diameter coloured
Provenance: See n° 466.
Literature: See n° 466.

471 VIRGIN AND CHILD ON THE CRESCENT** Ms.II.3688, fol. 237v
16 mm diameter coloured
Provenance: See n° 466.
Literature: See n° 466.

472 MAN OF SORROWS, STANDING IN THE TOMB Ms.IV.317, fol. 94r
24 mm diameter coloured
Glued into a German-Latin-Dutch manuscript (c.1520) with devotional texts.
Provenance: Maaseik (Belgium), St Augustinessen (St Agnes). Agnes Mueleneers (inscription on fol. 121v: *S(uster) Agnes Mueleneers*). Voorschoten, Willem de Vreese (ex libris). Wantje de Vreese - Van de Poll. Jim Overdiep - de Vreese. Purchased by the Royal Library in 1964.
Literature: Not in Lehrs.

473-474 The next two prints (marked with three asterisks ***) were inserted in a Latin prayer book (c.1500) for Pope Alexander VI Borgia (the so-called 'Borgia Hours'). Seven roundels were glued in the form of a cross on the otherwise blank first leaf. These appear to be contemporary with the rest of the manuscript. Five of these contain prayers in a minute handwriting. The other two contain coloured prints touched with gold.

473 MAN OF SORROWS, STANDING IN THE TOMB*** Ms.IV.480, fol. 1r
27 mm diameter coloured
Colour plate XIV

Provenance: Pope Alexander VI Borgia (coat of arms on fol. 15v). Collection Count Alphonse Couret, Orleans (nineteenth century). Collection Martin Bodmer, Cologny-Genève. Purchased by the Royal Library in 1967 (London, Sotheby's, Sale 11 July 1966, n° 234).
Literature: Not in Lehrs.

474 ST JEROME*** Ms.IV.480, fol. 1r
Colour plate XIV coloured
27 mm diameter
Provenance: See n° 473.
Literature: Not in Lehrs.

475 VIRGIN AND CHILD ON THE CRESCENT Ms.II.7265, last fol.
66 x 43 mm coloured
Glued into a manuscript with Dutch prayers and scriptural passages (c.1480).
Provenance: Hasselt (Belgium), Sint-Catharinadal (Franciscan Nuns). Agnes van Myellen (*'dit boexken hoert nesken van myellen toe'*). Purchased from R. Simonson, bookseller in Brussels (Sale in 1943).
Literature: Not in Lehrs.

476 VIRGIN AND CHILD ON THE CRESCENT Ms.10758, fol. 60v
21 mm diameter coloured
Glued into a Latin-German prayer book (1530/31). See also n° 348bis.
Provenance: See n° 348bis
Literature: Not in Lehrs. VDG 877.

477 VIRGIN AND CHILD ON THE CRESCENT fol.rés. S.I.44153
22 mm diameter
Provenance: Unknown. There is an unknown mark on the verso: EKL (not in Lugt).
Literature: Not in Lehrs.

SPANISH ENGRAVING

FRANCISCO DOMÉNECH
(Barcelona, c.1445 - Valencia, after 1494)

478 THE FIFTEEN MYSTERIES AND plano rés. S.II.1231
 THE VIRGIN ON A ROSARY (1488)
 345 x 277 mm

Modern impression. No single contemporary impression is known. The original copperplate is preserved in the Royal Library of Belgium, Chalcographie (n° 0679C) (345 x 277 mm) (see illustration). There was an oil sketch of the *Carrying of the Cross* on the back of the plate that has since disappeared (see illustration). According to Lehrs 1892, this was a copy after Sebastian del Piombino (Madrid, Prado). On the verso are some illegible words, scratched in the copper. On the recto, the print is signed and dated at the bottom centre: *'fr[ater] francisco domenech A[nno] d[ivinae] g[ratiae] 1*4*8*8*'*. Doménech was a Dominican monk. In 1487 he was assigned by the Dominicans of Játiva as a student of theology to the 'Estudio General dominicano de Santa Catalina Virgin y mártir' in Barcelona. He seems to have completed his course of study in 1489, and it appears from documents from 1491, 1493 and 1494 that he subsequently was attached to the cloister of Valencia. As he is not mentioned in documents after 1494, he may have died at an early age. Passavant incorrectly regarded this print as German or Dutch. Lehrs (1892) thought it might be Southern French or Spanish in origin. There is a second modern impression from this plate in the collection (fol. rés. S.I.45399).

Provenance: The copperplate was purchased from Mr Mulhausen, a German engineer who worked in Spain, in November 1857 (100 BEF).

Literature: Carderera 1864; Zahn 1864; Passavant II.226.114; Lehrs 1892, p. 500, n° 179; Rosell y Tores 1873; Serra y Boldú 1925; H.*Dutch* V, p. 265; Aldana Fernándeze 1970; Bauman 1989, pp. 137-39; Carrete Parrondo 1996, p. 45; Winston-Allen 1997, pp. 57-58.

III.

Nielli

III.
Nielli

COLLECTION JOHANNES VAN SESTICH (LEUVEN, BELGIUM)

See introduction pp. 16-17.

479 TWO NAKED CHILDREN WITH A DOG Alvin 1(a)
28 x 43 mm
Provenance: Manuscript van Sestich (Ms.4086), fol. 3r; 132v or 268r.
Literature: Duchesne 1826.250.294; Alvin 1857(a).1; Passavant I.281.294; Dutuit 1888.213.404; Hind 1936.52.219; Lambert 1999.24.81.

480 TWO NAKED CHILDREN WITH A DOG Alvin 1(b)
29 x 44 mm
Provenance: See n° 479.
Literature: See n° 479.

- TWO NAKED CHILDREN WITH A DOG (= Alvin 1(c))
Now in the Bibliothèque nationale, Paris (Ea 27 rés., p.47.Cl.96 A 75512)
(= Lambert 1999.24.81). See also n° 479 and n° 480.

481 PORTRAIT OF A LADY Alvin 2(a)
35 x 28 mm
Provenance: Manuscript van Sestich (Ms.4086), fol. 25r or 382r.
Literature: Bartsch XXIII.56.17; Duchesne 1826.275.347; Alvin 1857(a). 2; Passavant I.281.347; Dutuit 1888.266.602 (Venetian School); Blum 1950.31.163 (Venetian School ?); TIB vol. 24.1. Commentary n° 2401.017 (Milan School ?); Lambert 1999.17.56.

- PORTRAIT OF A LADY (= Alvin 2(b))
Now in the Bibliothèque nationale, Paris (Ea 27 rés.,p.31.Cl.96 A 74388)
(= Lambert 1999.17.56). See also n° 481.

482 THREE WOMEN DANCING Alvin 3(a)
(Peregrino da Cesena)
46 x 40 mm
Provenance: Manuscript van Sestich (Ms.4086), fol. 28r or 337r.
Literature: Duchesne 1826.248.287 (Peregrino da Cesena); Alvin 1857(a).3; Passavant I.281.287; Dutuit 1888.326.697 (Peregrino da Cesena); Hind 1936.53.223; Blum 1950.18.61; Lambert 1999.28.97 (Peregrino da Cesena).

483 THREE WOMEN DANCING Alvin 3(b)
 (Peregrino da Cesena)
 42 x 39 mm
Provenance: See n° 482.
Literature: See n° 482.

484 PANEL OF ORNAMENT Alvin 4(a)
 WITH TWO NAKED PUTI
 23 x 55 mm
See also n° 505.
Provenance: Manuscript van Sestich (Ms.4086), fol. 52r or 140r or 254v.
Literature: Duchesne 1834, p. 327 (Nicoleta da Modena); Alvin 1857(a).4; Passavant
I.339.747 and V.101.110; Dutuit 1888.272.622.

485 PANEL OF ORNAMENT Alvin 4(b)
 WITH TWO NAKED PUTI
 21 x 54 mm
Pulled from the worn plate.
Provenance: See n° 484.
Literature: See n° 484.

- PANEL OF ORNAMENT
 WITH TWO NAKED PUTI (= Alvin 4(c))
 Dutuit 1888.272.622 noted that at the time (1888) the print was located in the
 Bibliothèque nationale, Paris. The print is not cited in Lambert 1999.
 See also n° 484 and n° 485.

486 THREE CHILDREN DANCING Alvin 5(a)
 (Peregrino da Cesena)
 20 x 36 mm
Peregrino da Cesena's monogram has been cut off.
Provenance: Manuscript van Sestich (Ms.4086), fol. 101r or 411r or 445r.
Literature: Duchesne.1826.249.291 (Peregrino da Cesena); Alvin 1857(a).5; Passavant
I.281.291; Passavant.V.214.49; Dutuit 1888.326.698 (Peregrino da Cesena); Blum 1950.19.63;
Lambert 1999.29.98 (Peregrino da Cesena).

487 THREE CHILDREN DANCING Alvin 5(b)
 (Peregrino da Cesena)
 20 x 36 mm
Pulled from the worn plate. The monogram has been cut off.
Provenance: See n° 486.
Literature: See n° 486.

- THREE CHILDREN DANCING (= Alvin 5(c))
 Now in the Bibliothèque nationale, Paris (Ea 27 rés., p.47.Cl.96 A 74410
 (= Lambert 1999.29.98). See also n° 486 and n° 487.

488 THE TRIUMPH OF NEPTUNE Alvin 6(a)
(Peregrino da Cesena)
27 x 60 mm
Provenance: Manuscript van Sestich (Ms.4086), fol. 71r or 204v or 270v or 450v.
Literature: Bartsch XIII.208.5; Duchesne 1826.212.214 (Peregrino da Cesena); Alvin 1857(a).6; Passavant I.279.214 and V.209.19; Dutuit 1888.317.680 (Peregrino da Cesena); Hind 1936.48.194 (Peregrino da Cesena); Blum 1950.21.78; Washington 1973.542.B-13 (Peregrino da Cesena); TIB, vol. 25 Commentary, n° 2503.003; Lambert 1999.27.92 (Peregrino da Cesena).

489 THE TRIUMPH OF NEPTUNE Alvin 6(b)
(Peregrino da Cesena)
28 x 60 mm
Provenance: See n° 488.
Literature: See n° 488.

- THE TRIUMPH OF NEPTUNE (= Alvin 6(c))
 Now in the Bibliothèque nationale, Paris (Ea 27 rés., p.15.Cl.96 A 75485)
 (= Lambert 1999.27.92). See also n° 488 and n° 489.

- THE TRIUMPH OF NEPTUNE (= Alvin 6(d))
 This print was probably exchanged. Present whereabouts unknown.
 See also n° 488 and n° 489.

490 MERCURY AND THE INFANT BACCHUS Alvin 7
46 x 44 mm
Provenance: Manuscript van Sestich (Ms.4086), fol. 294r.
Literature: Duchesne 1826.214.218; Alvin 1857(a).7; Passavant I.279.218; Dutuit 1888.184.302 (Peregrino da Cesena); Hind 1936.48.197 (probably Bolognese); Blum 1950.26.119; Lambert 1999.21.68 (Francesco Francia et son atelier).

491 SAMSON AND THE LION Alvin 8
20 x 40 mm
Provenance: Manuscript van Sestich (Ms.4086), fol. 401v.
Literature: Duchesne 1826.136.18; Alvin 1857(a).8; Passavant I.276.18 and V.208.7 (Peregrino da Cesena); Dutuit 1888.105.9; Hind 1936.43.164; Blum 1950.22.86.

492 WARRIOR (MARS) Alvin 9
34 x 30 mm
Provenance: Manuscript van Sestich (Ms.4086), fol.94r.
Literature: Bartsch XIII.291.66 (Nicoletto da Modena); Duchesne 1826.241.272; Alvin
1857(a).9; Passavant I.280.272 and V.94.66; Dutuit 1888.204.366.

493 BACCHANAL Alvin 10(a)
(Francesco Francia?)
46 x 38 mm
Provenance: Manuscript van Sestich (Ms.4086), fol. 251r or 275r or 440v.
Literature: Duchesne.1826.214.219 (Peregrino da Cesena); Alvin 1857(a).10; Passavant
I.279.219 and V.210.21 (Peregrino da Cesena); Dutuit 1888.184.303 (Francesco Francia ?);
Hind 1936.48.193 (Francesco Francia ?); Lambert 1999.20.65 (Francesco Francia et son
atelier).

494 BACCHANAL Alvin 10(b)
47 x 38 mm
Provenance: See n° 493.
Literature: See n° 493.

- BACCHANAL (= Alvin 10(c))
Now in the Bibliothèque nationale, Paris (Ea 27 rés?,p.26.Cl.96 A 75502)
(= Lambert 1999.20.65). See also n° 493 and n° 494.

495 ALLEGORY (ADVERSITY?) Alvin 11
>48 x 31 mm (trimmed)
Provenance: Manuscript van Sestich (Ms.4086), fol. 36v.
Literature: Duchesne 1826.255.303 (*Allégorie sur la Navigation* by Peregrino da Cesena);
Alvin 1857(a).11; Passavant I.281.303; Dutuit 1888.324.693 (Peregrino da Cesena);
Hind1936.52.221 (Peregrino da Cesena); Blum 1950.19.64.

496 WOMAN WITH FIVE CHILDREN Alvin 12(a)
(Allegory of Peace and Abundance)
(Peregrino da Cesena)
43 x 27 mm
The monogram has been cut off.
Provenance: Manuscript van Sestich (Ms.4086), fol. 18r or 33r or 40r.
Literature: Alvin 1857(a).12 (Peregrino da Cesena); Passavant I.322.654 and V.212.34
(Peregrino da Cesena); Dutuit 1888.322.690 (Peregrino da Cesena); Blum 1950.20.71;
Lambert 1999.32.110 (Peregrino da Cesena).

497 WOMAN WITH FIVE CHILDREN Alvin 12(b)
(Allegory of Peace and Abundance)
(Peregrino da Cesena)
44 x 27 mm
Provenance: See n° 496.
Literature: See n° 496.

- WOMAN WITH FIVE CHILDREN (= Alvin 12(c))
(Allegory of Peace and Abundance)
Now in the Bibliothèque nationale, Paris (Ea 27 rés., p.16.Cl.96 A 75487)
(= Lambert 1999.32.110). See also n° 496 and n° 497.

498 TRIUMPH OF AMOR Alvin 13
(Francesco Francia?)
52 x 24 mm
Provenance: Manuscript van Sestich (Ms.4086), fol. 289r.
Literature: Alvin 1857(a).13; Passavant I.319.643; Dutuit 1888.207.380 (Francesco Francia?);
Hind 1936.52.216; Blum 1950.20.73 (Peregrino da Cesena); Lambert 1999.20.67 (Francesco
Francia et son école).

499 A MAN SEATED ON A STUMP Alvin 14
(Francesco Francia?)
53 x 29 mm
After the 'Spinario'.
Provenance: Manuscript van Sestich (Ms.4086), fol. 277r.
Literature: Bartsch XIII.292.67 (Nicoletto da Modena); Duchesne 1826.261.316; Alvin
1857(a).14; Passavant I.281.316 and V.94.67; Dutuit 1888.234.481 (Francesco Francia?); Blum
1950.38.226; TIB, vol. 25 Commentary, n° 2503.013.

COLLECTION BRISARD (GENT, BELGIUM)

See introduction p. 17

500 HOMAGE TO VENUS (state I) Alvin (p.41)
(Francesco Francia?)
60 mm diameter
See also n° 508.
Provenance: Purchased from the Collection Brisard (n° 627), Gent, in 1847.
Literature: Bartsch XIII.101.6; Duchesne 1826.229.243; Duchesne 1834.p.327; Alvin
1857(a).p.41; Passavant I.279.243 and V.201.9 and 210.24 (Peregrino da Cesena); Dutuit
1888.187.313 (Francesco Francia); Lambert 1999.20.66 (Francesco Francia?).

501 ALLEGORY WITH AN OLD WOMAN Alvin (p.43)
CARRIED AROUND IN A TRIUMPH
61 x 37/31 mm (parallelogram)
Provenance: Purchased from the Collection Brisard (n°628), Gent, in 1847.
Literature: Duchesne 1826.253.299; Duchesne 1834.p.327; Alvin 1857(a).(p.43); Dutuit
1888.215.412.

502 PANEL OF ORNAMENT Alvin (p.45)
WITH TWO MEDUSA HEADS
56 x 95 mm
Duchesne (1826) interpreted the letters SCOF as *'Stephanus Caesenas opus fecit'*.
Provenance: Purchased from the Collection Brisard (n°630), Gent in 1847.
Literature: Duchesne 1826.287.370; Duchesne 1834.p.327; Passavant I.281.370 and V.218.71;
Alvin 1857(a).(p.45); Dutuit 1888.330.706; Hind 1936.59.264 (Peregrino da Cesena); Blum
1950.23.90; TIB, vol. 25 Commentary, n° 2503.009; Lambert 1999.34.114.

503 LEMMET OF A KNIFE, Alvin (p.46)
WITH CHILDREN DANCING
16 (maximum) x 134 mm
Provenance: Purchased from the Collection Brisard (n°631), Gent, in 1847.
Literature: Duchesne 1826.p.219, n°Z.; Alvin 1857(a).(p. 46).

504 TWO HEADS AND A SKULL Alvin (p.49-52)
>41 x 56 mm
Style of Hans Sebald and Bartel Beham. There are traces of two additional medallions
above, but in the three impressions known (Brussels, London and Paris) the prints have
been cut down across the two upper corners.
Provenance: Purchased from the Collection Brisard (n°632), Gent, in 1847.
Literature: Duchesne.1834.pp.327-8 (*'certainement de la main d'un ancien graveur Italien'*);
Alvin 1857(a).(pp.49-52); Passavant I.336.735; Dutuit 1888.255.258-260; Hind V.145.(IV);
Lambert 1999.18.57 (*'Prince, princesse et tête de mort'*).

505 PANEL OF ORNAMENT Alvin (p.49)
WITH TWO NAKED CHILDREN
23 x 55 mm
See also n° 484 and n° 485.
Provenance: Purchased from the Collection Brisard (n°633), Gent, in 1847.
Literature: See n° 484.

506 BUST OF A WARRIOR Alvin (p.44)
(Jacopo de Bologne?)
40 x 29 mm (fragment: left half)
Provenance: Purchased from the Collection Brisard (n°639), Gent, in 1847.
Literature: Duchesne.1826.272.339; Duchesne.1834.p.327; Alvin 1857(a).(p.44); Dutuit 1888.257.570; Hind.1936.56.248 (Bolognese); Lambert 1999.25.84 (Bologne?).

507-510 DIFFERENT PROVENANCES

507 TRIUMPH OF MARS (state II) rés. S.II.110809
(or *Triumph of Amor*)
(Peregrino da Cesena)
59 x 92 mm
Provenance: Purchased from Mr Magnier, Brussels, on 20 February 1907 (300 BEF).
Literature: Bartsch XIII.207.4 (Peregrino da Cesena); Duchesne 1826.215.220.I. (Peregrino da Cesena); Passavant I.279.220 and V.209.18 (Peregrino da Cesena); Dutuit 1888.316.679.II. (Peregrino da Cesena); Hind 1936.48.198b; TIB, vol. 25 Commentary, n° 2503.002; Matile 1998.190. C-3; Lambert 1999.27.93.

508 HOMAGE TO VENUS rés. S.II.5709
60 mm diameter
Copy in same direction after n° 500 (Francesco Francia?).
Provenance: Purchased from Mr Papillon, Brussels, on 17 February 1861.
Literature: Duchesne.1826.229.243; Passavant I.279.243 and V.210.24; Dutuit 1888.188.314.
See also n° 500.

509 PANEL OF ORNAMENT WITH A BIRD rés.S.II.8533
AND A GRIFFIN
43 x 64 mm
Provenance: Prior to 1865 in the Collection of Chevalier J. Camberlyn d'Amougies, Brussels (on the verso: collection mark Lugt 514); purchased from this collection on 25 April 1865 (Sale E. Guichardot Paris: Lugt, *Ventes* 28481) (53 BEF, 55 centimes).
Literature: Duchesne.1826.288.371; Dutuit 1888.272.620 (Peregrino da Cesena); Blum 1950.24.100; Lambert 1999.34.115.

NIELLO COPPERPLATE

510 PORTRAIT OF A WOMAN WITH A FALCON rés. S.II.10381
(Mary of Burgundy ?)
45 mm diameter
Southern Netherlands (?), fifteenth or early sixteenth century (or nineteenth-century falsification?). No impressions from this plate are known.
Provenance: Purchased from J. Petit on 13 March 1867 (50 centimes).
Literature: None.

IV.

EARLY ITALIAN ENGRAVINGS

IV.
Early Italian Engravings

FLORENTINE: FINE MANNER

511 ST JEROME IN PENITENCE, fol.rés. S.II.677
 WITH TWO SHIPS IN A HARBOUR
 218 x 279 mm

Modern, probably a late eighteenth-century impression. No single contemporary impression is known (c.1480-1500). Traces of nail holes are visible in the upper left and right corners. In the nineteenth century, the copperplate (with print n° 512 on the other side) was in the possession of Alessandro da Morrona. The copperplate was sold at Eugène Piot's auction in 1890. See also n° 512.
Provenance: Purchased from Van Marck (Liège) in January 1856 (40 BEF).
Literature: Hind I.48.58; Washington 1973.44.11; TIB, vol. 24.2 Commentary, n° 2405.029; Lambert 1999.90.195.

512 THE INFERNO ACCORDING TO DANTE fol.rés. S. II.22085
 (oblong plate)
 223 x 284 mm (plate)

After the fresco in Campo Santo of Pisa (see also n° 513). Modern, probably a late eighteenth-century impression. No single contemporary impression is known (c.1480-1500). Traces of nail holes are visible in the upper left and right corners. In the nineteenth century, the copperplate (with print n° 511 on the other side) was in the possession of Alessandro da Morrona. The copperplate was sold at Eugène Piot's auction in 1890. See also n° 511. The print was recorded in the inventory (1875) as *'Baccio Baldini'*.
Provenance: Purchased from Schmidt, Brussels (Sale van Gogh, Brussels) on 9 June 1875.
Literature: Hind I.49.59; Washington 1973.42.10; Landau & Parshall 1994, pp. 162-63; TIB, vol. 24.2 Commentary, n° 2405.028; Matile 1998.43.17 (with comprehensive bibliography); Lambert 1999.90.196 a and b.

513 THE INFERNO ACCORDING TO DANTE fol.rés. S.II.679
 (oblong plate)
 219 x 280 mm (trimmed)

Modern, probably a late eighteenth-century impression. The print was recorded in the inventory (1856) as *'Baccio Baldini'*. The corners were trimmed, thereby removing the nail holes and the inscription. See also n° 512.
Provenance: Purchased from Van Marck (Liège) in January 1856 (25 BEF).
Literature: See n° 512.

FLORENTINE: FINE MANNER. BOOK ILLUSTRATION

514 DIVINE COMEDY: DANTE LOST IN THE WOOD; FS.XI.1 RP, fol. 13r
ESCAPING, AND MEETING VIRGIL (Canto I)
>90 x 175 mm (trimmed)

Book illustration for Dante's *Divine Comedy*, with commentary by Cristoforo Landino (Florence, Nicolò di Lorenzo della Magna, 30 August 1481). See also n° 515 (and n° 516).
Provenance: Collection Horatius Morandius. Collection Robert Walsingham Martin (*ex libris*). Collection Fernand J. Nyssen (*ex libris*). Given to the Royal Library by Mrs Fernand J. Nyssen in 1965. See Brussels 1967, n° 2.
Literature: Hind I.110.1; Donati 1962; Brussels 1967, n° 2; Brussels 1969, n° 325; Washington 1973, p. 14, ill. 2-1 (Baccio Baldini); Dreyer 1984; TIB, vol. 24.1 Commentary, n° 2403.093; Matile 1998.40.16; Lambert 1999.84.183.

515 DIVINE COMEDY: DANTE AND VIRGIL, WITH FS.XI.1 RP, fol. 22v
THE VISION OF BEATRICE (Canto II)
97 x 176 mm

See n° 514.
Provenance: See n° 514.
Literature: Hind I.110.2; TIB, vol. 24.1 Commentary, n° 2403.094. See also n° 514.

516 DIVINE COMEDY: DANTE AND VIRGIL, WITH fol.rés. S.II.7824
THE VISION OF BEATRICE (Canto II)
95 x 172 mm

This print was cut out of a copy of Dante's *Divine Comedy*, with commentary by Cristoforo Landino (Florence, Nicolò di Lorenzo della Magna, 30 August 1481) (fol. 22v). See also n° 514 and n° 515.
Provenance: Prior to 1865, in the Collection of Chevalier J. Camberlyn d'Amougies, Brussels (collection mark on the verso: Lugt 514); purchased from this collection (Sale E. Guichardot, Paris: Lugt, *Ventes* 28481) on 24 April 1865 (39 BEF, 90 centimes).
Literature: Hind I.110.2; TIB, vol. 24.1 Commentary, n° 2403.094. See also n° 514.

CRISTOFANO ROBETTA
(Cristofane di Michele Martini, called Cristofano Robetta. Florence 1462 - after 1535)

517 ADAM AND EVE WITH THE INFANTS fol.rés. S.II.2083
CAIN AND ABEL (the smallest plate)
172 x 136 mm

Provenance: Purchased from the Collection Borluut de Noortdonck (Gent 13/18 December 1858: Lugt, *Ventes* 24531) (35 BEF, 20 centimes).
Literature: Hind I.199.4; TIB, vol. 25 Commentary, n° 2521.004.

518 THE ADORATION OF THE MAGI fol.rés. S.I.30214
 302 x 279 mm
The original copperplate was in the possession of Giuseppe Vallardi (1790-1810) and was
acquired by the British Museum in 1888. *An Allegory of the Power of Love* (n° 519) is on the
back of this plate. The general composition of this print depends on Filippino Lippi's
Adoration of the Magi of 1466 (Florence, Uffizi).
Provenance: Unknown.
Literature: Hind I.200.10; Washington 1973.296.118; TIB, vol. 24.2 Commentary, n° 2521.010;
Matile 1998.107.56 (with comprehensive bibliography); Lambert 1999.130.256.

519 AN ALLEGORY OF THE POWER OF LOVE fol.rés. S.I.30215
 298 x 276 mm
The original copperplate was in the possession of Giuseppe Vallardi (1790-1810) and was
acquired by the British Museum in 1888. *The Adoration of the Magi* (n° 518) is on the back of
this plate.
Provenance: Unknown.
Literature: Hind I.205.29; Washington 1973.300.120; TIB, vol. 25 Commentary, n° 2521.043;
Matile 1998.108.59 (with comprehensive bibliography); Lambert 1999.138.269.

520 AN ALLEGORY OF ENVY (state II) fol.rés. S.II.2084
 256 x 178 mm
Marks of holes near the centre of the upper and lower margins. The print was made up.
Defects were retouched in pen. The town in the background is copied in reverse from
Dürer (*Hercules at the Crossroads*, B. 73)
Provenance: Purchased from the Collection Borluut de Noortdonck (Gent 13/18 December
1858: Lugt, *Ventes* 24531) (16 BEF, 50 centimes).
Literature: Hind I.206.31; Washington 1973.298.119; TIB, vol. 25 Commentary, n° 2521.042;
Matile 1998.108.58 (with comprehensive bibliography); Lambert 1999.141.271.

THE SO-CALLED 'TAROCCHI CARDS OF MANTEGNA'
The usual title by which these prints have been known, the 'Tarocchi Cards of Mantegna',
is unfortunate, since they neither form a pack of *Tarocchi*, nor do they bear any near or def-
inite relation to Mantegna, and the very assumption that they are playing-cards at all has
been called in question.

521 TERPSICHORE fol.rés. S. II.359
 178 x 98 mm traces of colour
Provenance: Purchased from Van Marck (Liège) on 22 December 1851.
Literature: Hind I.235.13a; Washington 1973.103.25; TIB, vol. 24.3 Commentary, n°
2406.013a.

522 RHETORIC fol.rés. S.II.18646
178 x 97 mm traces of colour
Provenance: Purchased from Van Gogh (Brussels) on 16 April 1873 (60 BEF).
Literature: Hind I.236.23a; TIB, vol. 24.3 Commentary, n° 2406.023a; Lambert 1999.152.299.

523 MERCURY fol.rés. S.II.23
178 x 97mm traces of colour
Provenance: Purchased from Van Marck (Liège) on 22 December 1851 (40 BEF).
Literature: Hind I.239.42a; Washington 1973.142.55; TIB, vol. 24.3 Commentary, n° 2406.042a; Lambert 1999.157.318.

NORTH ITALIAN

524 KING LOUIS IX OF FRANCE fol.rés. S.II.22
PRESENTING A THORN TO BARTOLOMEO
DE BRAGANTIIS, BISHOP OF VICENZA
194 x 133 mm
Northeast Italy, probably Vicenza, about 1490. Modern impression. No single contemporary impression is known.
Provenance: Purchased from Van Marck (Liège) on 22 December 1851 (45 BEF).
Literature: Hind I.264.46; Hymans 1907, p. 323; TIB, vol. 24.3 Commentary, n° 2409.021.

525 THE VIRGIN AND CHILD ENTHRONED, fol.rés. S.II.45692
ADORED BY A POPE, EMPEROR, AND
DOMINICAN SAINTS, FLANKED BY TEN
SCENES FROM THE FIFTEEN
MYSTERIES OF THE ROSARY
222 x 183 mm
Probably Milanese, about 1490. Modern impression. The only impressions known are modern, and from a crudely reworked plate, which appears to indicate that a large number had been printed. See also n° 526.
Provenance: Purchased at the Auguste de Bruyne Sale (Mechelen) (Lugt, *Ventes* 49113) on 12 May 1890.
Literature: Hind I.272.71; TIB, vol. 24.4 Commentary, n° 2411.016; Lambert 1999.179.385.

526 THE VIRGIN AND CHILD ENTHRONED, fol.rés. S.II.40484
ADORED BY A POPE, EMPEROR, AND
DOMINICAN SAINTS, FLANKED BY TEN
SCENES FROM THE FIFTEEN
MYSTERIES OF THE ROSARY
222 x 183 mm

Modern impression. See n° 525.

Provenance: Purchased at the Bluff Sale, Brussels, on 2 June 1888.

Literature: See n° 525.

527 ST JEROME SEATED BY A ROCK, READING fol.rés. S.II.13009
169 x 140 mm

North Italian, about 1500.

Provenance: Prior to 1870, in the Collection of Th. Hippert (1839-1919), Brussels (on the verso: collection mark Lugt 1377); purchased from this collection on 8 June 1870 (15 BEF).

Literature: Hind I.274.79; TIB, vol. 24.4 Commentary, n° 2417.022.

ANDREA MANTEGNA
(Italian painter and engraver. Isola di Cartura, near Vicensa c.1431 - Mantua, 1506)

528 VIRGIN AND CHILD (state II) fol.rés. S.II.17257
233 x 220 mm

Late impression. This print was printed on the verso of a French sixteenth-century calendar. See ill. 528v.

Provenance: Purchased from Clement, Paris: Sale Collection Dr Pons d'Aix on 9 April 1872 (55 BEF).

Literature: Hind V.10.1; Washington 1973.194.77; TIB, vol. 25 Commentary, n° 2506.003 S2; London-New York 1992.219.48; Lambert 1999.190.398 a and b.

529 THE ENTOMBMENT (state II) fol.rés.S.II.5399
(horizontal plate)
(state III)
>263 x 450 mm (trimmed)

Provenance: Purchased from the Collection of Jozef Paelinck, Brussels (Sale Heussner, Brussels: Lugt, *Ventes* 25811) on 20 November 1860 (46 BEF, 20 centimes).

Literature: Hind V.10.2 ; Washington 1973.170.70; TIB, vol. 25 Commentary, n° 2506.001 S3; London-New York 1992.202.39; Matile 1998.77.33 (with comprehensive bibliography); Lambert 1999.191.399 a, b and c.

530 BACCHANAL WITH SILENUS fol.rés. S.I.22815
>276 x >430 mm (trimmed)

Provenance: Unknown.

Literature: Hind V.12.3; Washington 1973.186.74; TIB, vol. 25 Commentary, n° 2506.007;

London-New York 1992.280.75; Matile 1998.82.35 (with comprehensive bibliography); Lambert 1999.194.401.

531 BACCHANAL WITH A WINE VAT fol.rés. S.II.5403
289 x 470 mm
Provenance: Purchased from the Collection of Jozef Paelinck, Brussels (Sale Heussner, Brussels: Lugt, *Ventes* 25811) on 20 November 1860 (46 BEF, 20 centimes). There are two unknown marks on the verso: EKL and C(?).V.D. (not in Lugt).
Literature: Hind V.13.4; Washington 1973.182.73; TIB, vol. 25 Commentary, n° 2506.006; London-New York 1992.279.74; Matile 1998.82.36 (with comprehensive bibliography); Lambert 1999.197 a and b.

532 BATTLE OF THE SEA GODS (left half) fol.rés. S.II.5402
330 x 427 mm
Provenance: Purchased from the Collection of Jozef Paelinck, Brussels (Sale Heussner, Brussels: Lugt, *Ventes* 25811) on 20 November 1860 (28 BEF, 60 centimes).
Literature: Hind V.15.5; Washington 1973.188.75; TIB, vol. 25 Commentary, n° 2506.004; London-New York 1992.285.79; Lambert 1999.198.403 a and b.

533 BATTLE OF THE SEA GODS (right half) fol.rés. S.II.5401
330 x 411 mm
Provenance: Purchased from the Collection of Jozef Paelinck, Brussels (Sale Heussner, Brussels: Lugt, *Ventes* 25811) on 20 November 1860 (26 BEF, 40 centimes).
Literature: Hind V.15.6; Washington 1973.188.76; TIB, vol. 25 Commentary, n° 2506.005; London-New York 1992.285.79; Matile 1998.82.37 (with comprehensive bibliography); Lambert 1999.198.403 a and b.

MANTEGNA SCHOOL
See also: Brussels, Print Room, *sub*: Andreani, Andrea (*The Triumph of Caesar*, chiaroscuro woodcuts, after Mantegna) (plano). *See introduction p. 18*

534 THE FLAGELLATION: WITH THE PAVEMENT fol.rés.S.II.5398
389 x 301 mm (=S.I.22817)
In the Washington 1973 catalogue, attributed to the School of Andrea Mantegna (Zoan Andrea (?)); in the London-New York 1992 catalogue, attributed to Andrea Mantegna (?).
Provenance: Purchased from the Collection of Jozef Paelinck, Brussels (Sale Heussner, Brussels: Lugt, *Ventes* 25811) on 20 November 1860 (26 BEF, 40 centimes).
Literature: Hind V.17.8; Washington 1973.200.78; TIB, vol. 25 Commentary, n° 2506.009; London-New York 1992.195.36; Matile 1998.77.31 (with comprehensive bibliography); Lambert 1999.201.406 a and b.

535 DESCENT INTO LIMBO plano.rés. S.II.26258
 420 x 340 mm

In the Washington 1973 catalogue, attributed to the School of Andrea Mantegna (Zoan
Andrea (?)); in the London-New York 1992 catalogue, attributed to Andrea Mantegna (?).
Provenance: Purchased from M. Dauloz, print dealer in Paris on 7 January 1880 (120 BEF).
Literature: Hind V.18.9; Washington 1973.208.80; TIB, vol. 25 Commentary, n° 2506.013;
London-New York 1992.263.67; Matile 1998.74.30 (with comprehensive bibliography);
Lambert 1999.201.408 a and b.

536 THE TRIUMPH OF CAESAR: THE ELEPHANTS fol.rés. S.II.112122
 (Giulio Campagnola?)
 289 x 260 mm

Late impression. A second impression (a fragment of unspecified dimensions) is men-
tioned in the inventory (S.II.112123), but is currently untraceable.
Provenance: Prior to 1907 in the Collection of Auguste Coster. Purchased from the Galerie
Fiévez, Brussels, on 15 April 1907.
Literature: Hind V.22.14; Washington 1973, p. 216 (Zoan Andrea); TIB vol. 25 Commentary
n° 2506.017a; London-New York 1992.377.118; Matile 1998.86.43 (with comprehensive
bibliography); Lambert 1999.206.415 a and b.

537 THE TRIUMPH OF CAESAR: THE ELEPHANTS fol.rés. S.II.62782
 (Giovanni Antonio da Brescia?)
 282 x 259 mm

Provenance: Prior to 1895 in the Collection of Luigi Angiolini (Milan); purchased from this
collection during the sale held between 8 and 22 May 1895 (Sale Gutekunst, Stuttgart: Lugt,
Ventes 53517) (13 BEF, 78 centimes).
Literature: Hind V.23.14a; Washington 1973, pp. 216-17 (G.A. da Brescia); TIB, vol. 25
Commentary n° 2506.017b; London-New York 1992.375.117; Lambert 1999.206.416.

538 THE TRIUMPH OF CAESAR: fol.rés. S.II.10283
 SOLDIERS CARRYING TROPHIES (=S.I.22814)
 (Giulio Campagnola?)
 >233 x 260 mm (trimmed)

This print was never completed; no impressions from a completed plate are known.
Provenance: Purchased from Goupil, Brussels, on 15 February 1867 (40 BEF).
Literature: Hind V.23.15; Washington 1973.214.82 (Zoan Andrea?); TIB, vol. 25
Commentary n° 2506.018a; London-New York 1992.387.123 (Giulio Campagnola?);
Lambert 1999.206.417 a and b.

539 THE TRIUMPH OF CAESAR: fol.rés. S.I.22816
SOLDIERS CARRYING TROPHIES
(Mantegna's premier engraver?)
277 x >260 mm
The pilaster was cut off from this impression.
Provenance: Unknown.
Literature: Hind V.23.15b; Washington 1973, p. 217; TIB, vol. 25 Commentary n° 2506.01
London-New York 1992.381.120; Matile 1998.86.41; Lambert 1999.208.419.

540 THE TRIUMPH OF CAESAR: THE SENATORS fol.rés. S.I.42432
(Mantegna's premier engraver?)
285 x 265 mm
Provenance: Unknown.
Literature: Hind V.24.16; Washington 1972, p. 217; TIB, vol. 25 Commentary, n° 2506.19a;
London-New York 1992.389.126; Matile 1998.86.40 (with comprehensive bibliography);
Lambert 1999.209.420 a, b and c.

541 THE TRIUMPH OF CAESAR: THE SENATORS fol.rés. S.II.2072
(Mantegna's premier engraver?)
273 x 262 mm
Provenance: Purchased from the Collection Borluut de Noortdonck (Gent 13/18 December
1858: Lugt, *Ventes* 24531) (4 BEF, 12 centimes). There is an unknown mark on the verso: EKL
(not in Lugt).
Literature: See n° 540.

542 HERCULES AND ANTAEUS fol.rés. S.II.5400
(Mantegna's premier engraver?)
339 x 235 mm
Provenance: Purchased from the Collection of Jozef Paelinck, Brussels (Sale Heussner,
Brussels: Lugt, *Ventes* 25811) on 20 November 1860 (57 BEF, 20 centimes).
Literature: Hind V.25.17; Washington 1973.218.83; TIB, vol. 25 Commentary, n° 2506.020;
London-New York 1992.313.93; Matile 1998.82.38 (with comprehensive bibliography);
Lambert 1999.210.422 a and b.

543 FOUR WOMEN DANCING fol.rés. S.II.112124
(Mantegna's premier engraver?)
224 x 339 mm
Late impression.
Provenance: Prior to 1907 in the Collection of Auguste Coster. Purchased from the Galerie
Fiévez, Brussels, on 15 April 1907.
Literature: Hind V.27.21 (Zoan Andrea?); Washington 1973.228.85 (Zoan Andrea ?); TIB,
vol. 25 Commentary, n° 2506.029a; London-New York 1992.433.138; Matile 1998.84.39 (with
comprehensive bibliography); Lambert 211.424.

146

544 ALLEGORY OF THE FALL OF IGNORANT plano rés. S.II.42911
 HUMANITY *(Virtus Combusta)*
 (Giovanni Antonio da Brescia?)
 269 x 417 mm

The composition actually consists of two parts, printed with two distinct plates, and then affixed to one another. Only the top half is preserved in the collection. The upper corners were rounded off, thereby removing the two nail holes that are visible in other impressions.
Provenance: Purchased from G.J. Clough (London) on 5 October 1889 (30 BEF).
Literature: Hind V.27.22 (Zoan Andrea); Washington 1973.222.84 (Zoan Andrea); TIB, vol. 25 Commentary, n° 2506.026; London-New York 1992.453.148 (Giovanni Antonio da Brescia); Lambert 1999.213.426.

GIOVANNI ANTONIO DA BRESCIA
(Italian engraver. Active in Mantua c.1490 and in Rome, until at least 1525)

545 HERCULES AND ANTAEUS (the smaller plate) fol.rés. S.II.41478
 252 x 172 mm

Late impression, from the oxidised plate.
Provenance: Prior to 1869, Collection C. Wiesböck, Vienna (on the verso: collection mark Lugt 2576). Prior to 1889 in the Collection Cuvelier, Lille. Purchased from Papillon, Brussels (Sale Collection Cuvelier, Lille) on 2 May 1889.
Literature: Hind V.36.3; Washington 1973.238.88; TIB, vol. 25 Commentary, n° 2511.018a; London-New York 1992, p. 303, no. 87; Matile 1998.92.44 (with comprehensive bibliography); Lambert 1999.223.434 a and b.

546 TORSO OF HERCULES: AFTER THE
 ANTIQUE (state I) fol.rés. S.II.8954
 156 x 83 mm

Provenance: Prior to 1835, Collection of E. Durand, Paris (on the recto: collection mark Lugt 741). Acquired in an exchange with M. Clément, Paris, on 5 January 1866. See introduction p. 17.
Literature: Hind V.42.19(I); TIB, vol. 25 Commentary, n° 2511.028; Lambert 1999.229.447 (state I).

AFTER LEONARDO DA VINCI
(Italian artist. Vinci 15 April 1452 - Amboise 2 Mai 1519)

547 THE LAST SUPPER: WITH THE SPANIEL fol.rés. S.I.25
(Giovanni Pietro da Birago ? (= the Master of the *Sforza Book of Hours*))
226 x 450 mm

Late impression. This print is a copy after *The Last Supper* executed by Leonardo da Vinci in the monastery Santa Maria delle Grazie in Milan. It was engraved soon after the completion of the fresco.
Provenance: Unknown.
Literature: Hind V.88.9; Milan 1984.59.38 and pp. 49-50; London 1987.198.215; Landau & Parshall 1994, p. 163 and 165; TIB, vol. 24.4 Commentary, n° 2413.001; Lambert 1999.267.518.

AFTER DONATO BRAMANTE
(Italian architect. Near Urbino 14 April 1444 - Rome 11 March 1514)

548 A STREET WITH VARIOUS BUILDINGS,
COLONNADES AND AN ARCH (state II) fol.rés. S.II.62779
(Cesare Cesariano?)
242 x 367 mm

With the inscription *'BRAMANTI AR / CHITECTI / OPVS'*, in three lines above, in the middle.
Provenance: Prior to 1895 in the Collection of Luigi Angiolini (Milan); purchased from this collection during the sale held between 8 and 22 May 1895 (Sale Gutekunst, Stuttgart: Lugt, *Ventes* 53517).
Literature: Hind V.104.2; Hymans 1907, p. 2 and 17; Milan 1984.46.33; TIB, vol. 24.4 Commentary, n° 2412.002.

549 A STREET WITH VARIOUS BUILDINGS, fol.rés. S.II.63272
COLONNADES AND AN ARCH (second version) (state II)
255 x 363 mm

Copy in reverse after n° 548. With the inscription *'BRAMANTI ARCHITECTI / OPVS'*, in two lines above, in the middle. The publisher's address was added in the white space of the pavement, above the step, in the middle of the foreground: *'Nicolo Van Aelst for. Rome'*. Van Aelst was a printer and publisher born in Brussels c.1527 but active in Rome, with a workshop on the Via della Pace, until his death in 1613. The print was part of a lot of ten that was purchased in 1895, for the sum of 6 BEF, 57 centimes.
Provenance: Prior to 1895 in the Collection of Luigi Angiolini (Milan); purchased from this collection during the sale held between 8 and 22 May 1895 (Sale Gutekunst, Stuttgart: Lugt, *Ventes* 53517).
Literature: Hind V.105.2a; TIB, vol. 24.4 Commentary, n° 2412.002 C1 S2; Matile 1998.178.116 (state I).

550 A STREET WITH VARIOUS BUILDINGS fol.rés. S.II.63265
279 x 415 mm

Due to the figures introduced to this print, it appears that it should be dated closer to 1550. This is why Hind did not include it in his catalogue. Inscribed '*SVNTVS CENSVM NON SVPERET*' on a building, right; and '*SABET*' over the door of the same building.

Provenance: Prior to 1895 in the Collection of Luigi Angiolini (Milan); purchased from this collection during the sale held between 8 and 22 May 1895 (Sale Gutekunst, Stuttgart: Lugt, Ventes 53517).

Literature: cf. Hind V.105.2.

JACOPO DEI BARBARI

(Italian painter, engraver and woodcutter. Probably Venice, c.1460/70 - possibly Mechelen or Brussels, by 1516)

551 JUDITH WITH THE HEAD OF HOLOFERNES fol.rés. S.II.7838
177 x 84 mm

Provenance: Purchased from the Collection of Chevalier J. Camberlyn d'Amougies, Brussels, on 24 April 1865 (Sale Guichardot, Paris: Lugt, *Ventes* 28481) (21 BEF).

Literature: Hind V.151.7; Washington 1973.364.139; TIB, vol. 24.4 Commentary, n° 2410.001; Matile 1998.128.78 (with comprehensive bibliography); Lambert 1999.317.601.

552 TWO OLD MEN READING fol.rés. S.II.62770
(TWO PHILOSOPHERS)
132 x 108 mm

Provenance: Prior to 1895 in the Collection of Luigi Angiolini (Milan); purchased from this collection during the sale held between 8 and 22 May 1895 (Sale Gutekunst, Stuttgart: Lugt, *Ventes* 53517) (128 BEF, 63 centimes).

Literature: Hind V.152.11; Washington 1973.378.146; TIB, vol. 24.4 Commentary, n° 2410.015; Lambert 1999.318.605.

553 COMBAT BETWEEN MEN AND SATYRS plano rés. S.II.62771
385 x 540 mm

Woodcut.

Provenance: Prior to 1895 in the Collection of Luigi Angiolini (Milan); purchased from this collection during the sale held between 8 and 22 May 1895 (Sale Gutekunst, Stuttgart: Lugt, *Ventes* 53517) (13 BEF, 12 centimes).

Literature: Passavant III.141.31.

AFTER JACOPO DEI BARBARI

554 ST CATHERINE fol.rés. S.II.7839
(Antonio Maria Zanetti?)
190 x 120 mm
Eighteenth-century woodcut copy after Jacopo dei Barbari.
Provenance: Prior to 1865, in the Collection of Chevalier J. Camberlyn d'Amougies, Brussels (on the verso: collection mark Lugt 514); purchased from this collection (Sale E. Guichardot, Paris: Lugt, *Ventes* 28481) on 24 April 1865 (5 BEF, 83 centimes).
Literature: Hind V.152.8 (copy 3); Matile 1998.128.78 (with comprehensive bibliography); TIB, vol. 24.4 Commentary, n° 2410.008; cf. Lambert 1999.317.602.

BENEDETTO MONTAGNA
(Italian engraver. Vicenza, c.1480 - between 1555 and 1558)

555 ST GEORGE (state III) fol.rés. S.I.22813
210 x 175 mm
The monogram (B.M.) below, has been trimmed away.
Provenance: Unknown.
Literature: Hind V.177.9; Washington 1973.314.124 (state I); TIB, vol. 25 Commentary, n° 2512.023 S 3; Lambert 1999.353.655(II).

556 ST JEROME SEATED BENEATH AN ARCH fol.rés. S.II.10284
OF ROCK
280 x 229 mm
Provenance: Purchased from Goupil, Brussels, on 15 February 1867 (90 BEF).
Literature: Hind V.182.25; TIB, vol. 25 Commentary, n° 2512.025; Lambert 1999.360.667.

557 MAN SEATED BY A PALM TREE (state I) fol.rés. S.II.63028
116 x 80 mm
Provenance: Prior to 1895 in the Collection of Luigi Angiolini (Milan); purchased from this collection during the sale held between 8 and 22 May 1895 (Sale Gutekunst, Stuttgart: Lugt, *Ventes* 53517) (13 BEF, 88 centimes).
Literature: Hind V.183.31(I); Washington 1973.322.128; TIB, vol. 25 Commentary, n° 2512.044; Lambert 1999.362.672.

558 SATYR FAMILY fol.rés. S.II.17287
158 x 105 mm
Provenance: Acquired from Clement, Paris: Sale Collection Dr Pons d'Aix on 9 April 1872 (40 BEF, 40 centimes).
Literature: Hind V.184.35; Washington 1973.326.130; TIB, vol. 25 Commentary, n° 2512.031; Lambert 1999.363.676.

GIULIO CAMPAGNOLA
(Italian painter, engraver and miniaturist, Padua, c.1482 - Venice, c.1516)

559 CHRIST AND THE WOMAN OF SAMARIA fol.rés. S.I.12359
(state I)
130 x 187 mm
Colour plate XVI
Provenance: Unknown. The figure *'114'* was noted in ink in the lower right of the recto.
Literature: Hind V.200.11; Washington 1973, pp. 395 and 401; Landau & Parshall 1994, pp. 262-63; Matile 1998.140.89 (with comprehensive bibliography); TIB, vol. 25 Commentary, n° 2518.002; Lambert 1999.381.705.

560 LANDSCAPE WITH SHEPHERD AND SATYR fol.rés. S.I.9367
165 x 175 mm
Provenance: Unknown.
Literature: Hind V.204.22; Lambert 1999.384.712 a and b.

AFTER GIULIO CAMPAGNOLA

561 THE YOUNG SHEPHERD (state I) fol.rés.S.II.85301
134 x 79 mm (=S.I.9595)
Copy in reverse, after the second state of Giulio's *Young Shepherd*.
Provenance: Gift from Mr Abbé de Hondt, priest in Uytkerke, near Blankenberge (prov. West Vlaanderen, Belgium). Entered in the inventory on 24 November 1898.
Literature: Hind V.200.10b; TIB, vol. 25 Commentary, n° 2818.009 C 2.

DOMENICO CAMPAGNOLA
(Italian engraver. Venice (?), c.1500 - Padua, 10 December 1564)

562 THE DESCENT OF THE HOLY SPIRIT fol.rés. S.I.12362
(state II)
188 x 175 mm (roundel)
Provenance: Unknown.
Literature: Hind V.210.1; Washington 1973.434.158; TIB, vol. 25 Commentary, n° 2519.003; Lambert 1999.389.716.

563 THE BEHEADING OF A SAINT fol.rés. S.I.12361
(St Catherine?)
189 x 176 mm (roundel)
Provenance: Unknown.
Literature: Hind V.210.2; Washington 1973.432.157; TIB, vol. 25 Commentary, n° 2519.007; Lambert 1999.390.317 a and b.

564 THE ASSUMPTION OF THE VIRGIN (state I) fol.rés. S.I.12363
 288 x 197 mm
Provenance: Unknown.
Literature: Hind V.211.3; Washington 1973.420.152; TIB, vol. 25 Commentary, n° 2519.004 S
1; Lambert 1999.390.718(I).

565 BATTLE OF NAKED MEN fol.rés. S.II.26362
 220 x 228 mm
A second impression of this print was purchased from the Angiolini Collection (Milan)
(Gutekunst, Stuttgart) between 8 and 22 May 1895. It was given the inventory number
S.II.62804, but is currently untraceable.
Provenance: Acquired at the Drugulin Sale (Leipzig) on 25 January 1880 (47 BEF).
Literature: Hind V.211.4; Washington 1973.428.156; TIB, vol. 25 Commentary, n° 2519.013;
Lambert 1999.391.719 a and b.

566 VENUS RECLINING IN A LANDSCAPE fol.rés. S.II.8952
 95 x 132 mm
Provenance: Prior to 1844, in the collection of the engraver Franz Gawet (Vienna) (on the
verso collection mark Lugt 1070). Prior to 1865, in the collection of the sculptor Joseph
Daniel Böhm (Vienna) (on the verso collection marks Lugt 271 (2 x), 272, and 1442).
Acquired in an exchange with M. Clément, Paris on 5 January 1866. See introduction
p. 17.
Literature: Hind V.213.13; Washington 1973.418.151; TIB, vol. 25 Commentary, n° 2519.010;
Lambert 1999.395.726 a and b.

567 LANDSCAPE WITH ST JEROME (state II) plano rés. S.I.12360
 285 x 416 mm
Woodcut.
Provenance: Unknown.
Literature: TIB, vol. 25 Commentary, n° 2519.017; Lambert 1999.401.737 (with bibliography).

ATTRIBUTED TO DOMENICO CAMPAGNOLA

568 THE ADORATION OF THE MAGI; and fol.rés.S.II.62805
 THE ADORATION OF THE SHEPHERDS
 185 x 265 mm (plate)
Two prints on one plate. This belonged to a lot of two prints purchased for the total sum of
14 BEF, 28 centimes.
Provenance: Prior to 1895 in the Collection of Luigi Angiolini (Milan); purchased from this
collection during the sale held between 8 and 22 May 1895 (Sale Gutekunst, Stuttgart: Lugt,
Ventes 53517).
Literature: Hind V.214.15 and 16.

JACOPO FRANCIA
(Italian engraver. Bologna, before 1486 - Bologna 1557)

569 BACCHUS AND HIS ATTENDANTS fol.rés. S.II.17793
253 x 310 mm
Provenance: Prior to 1872, d'Albanas Collection; purchased from this collection (Sale Olivier). Entered in the inventory on 23 April 1872 (13 BEF).
Literature: Hind V.232.7; Washington 1973.494.179; Lambert 1999.406.748.

570 CHRIST IN THE HOUSE OF SIMON (state I) fol.rés. S.I.42525
218 x 338 mm
After Marcantonio Raimondi.
Provenance: Unknown.
Literature: Hind V.234.13.

LORENZO COSTA
(Italian painter and engraver. Ferrara, c.1460 - Mantua, 1535)

571 THE PRESENTATION OF CHRIST fol.rés. S.II.62830
155 x 133 mm
See also n° 572
Provenance: Prior to 1895 in the Collection of Luigi Angiolini (Milan); purchased from this collection during the sale held between 8 and 22 May 1895 (Sale Gutekunst, Stuttgart: Lugt, *Ventes* 53517). (45 BEF, 94 centimes).
Literature: Hind V.237.1; Washington 1973.490.178; TIB, vol. 24.3 Commentary, n° 2409.030; Lambert 1999.409.752.

572 THE PRESENTATION OF CHRIST fol.rés. S.II.22143
145 x 133 mm
Counter proof of n° 571.
Provenance: Purchased from the sculptor Starké. Entered in the inventory on 25 July 1875 (60 BEF).
Literature: Not in Hind (cf. Hind V.237.1)

MASTER NA. DAT (WITH THE MOUSE TRAP)
(Italian engraver. North Italy, active c.1500-20)

573 THE VIRGIN AND CHILD ENTHRONED
WITH ST ANNE fol.rés. S.II.649
143 x 214 mm (= S.I.25793)
Provenance: Purchased from Van Marck, Liège, in January 1856 (200 BEF).
Literature: Hind V.266.1; Washington 1973.504.183; TIB, vol. 25 Commentary n° 2516.001; Lambert 1999.426.781.

ANONYMOUS

574 ST AMBROSE AND THE EMPEROR THEODOSIUS fol.rés. S.II.63271
>232 x >195 mm (trimmed)

In Gere 1969 and in the Washington 1973 catalogue, the image is identified as Alexander and the High Priest of Jerusalem.

Provenance: Prior to 1895 in the Collection of Luigi Angiolini (Milan); purchased from this collection during the sale held between 8 and 22 May 1895 (Sale Gutekunst, Stuttgart: Lugt, *Ventes* 53517).

Literature: Hind V.299.27; Gere 1969, p. 97, n.1; Washington 1973.512.186; Lambert 1999.435.795.

BIBLIOGRAPHY

Aldana Fernandez 1970
S. Aldana Fernandez, *Guia abreviada de artistas valencianos*, Valencia 1970.

Alvin 1857(a)
L. Alvin, *Les nielles de la bibliothèque royale de Belgique. Notice lue à la Classe des Beaux-Arts de l'Académie royale de Belgique, séance du 13 mai 1857*, Brussels 1857.

Alvin 1857(b)
[L. Alvin], 'Sur quelques nielles italiens retrouvés dans un cahier d'institutes du droit romain, dicté en l'annee 1600, à l'université de Louvain et faisant partie de la bibliothèque royale de Bruxelles (Extrait d'une communication faite à la classe des beaux-arts de l'Académie de Belgique, le 13 mai 1857, par M. Alvin, conservateur de la Bibliothèque royale, et membre de la classe)' *Bulletin du Bibliophile Belge*, 13, 2 (1857), pp.185-88.

Alvin 1859(a)
L. Alvin, 'Les grandes armoiries du duc Charles de Bourgogne, gravées vers 1467' *Bulletins de l'Académie royale des sciences, des lettres et des beaux-arts de Belgique*, 28 (2. series, vol. VI) (1859), pp. 122-44.

Alvin 1859(b)
L. Alvin, 'Les grandes armoiries du duc Charles de Bourgogne, gravées vers 1467' *Revue universelle des arts*, 9 (1859), pp. 5-21.

Alvin 1876
L. Alvin, 'La plus ancienne gravure en taille-douce exécutée aux Pays-Bas' *Bulletin des commissions royales d'art et d'archéologie*, 15 (1876), pp. 333-48.

Alvin 1877
L. Alvin, 'Communications et lectures' *Bulletins de l'Académie royale des Sciences, des Lettres et des Beaux-Arts de Belgique*, 46 (2. series, vol. XLIII) (1877), pp. 754-57.

Ampe 1962
A. Ampe, 'Aantekeningen bij een zestiendeeuws handschrift uit Dendermonde (Hs. 4407-08 de K.B. te Brussel)' *Handelingen der Koninklijke Nederlandse Maatschappij voor Taal- en Letterkunden en Geschiedenis*, 16 (1962), pp. 9-54.

Ampe 1964
A. Ampe, 'Nieuwe belichting van de persoon en het werk van Jan Pascha' *Handelingen der Koninklijke Zuidnederlandse Maatschappeij voor Taal- en Letterkunde en Geschiedenis*, 18 (1964), pp. 5-105.

Angerman 1972
N. Angerman, 'Einwirkungen des frühen deutschen Kupferstichs auf den russischen Buchschmuck', in *Israhel van Meckenem und der deutsche Kupferstich des 15. Jahrhunderts*, Bocholt 1972, pp. 123-29.

Van Anrooij 1997
W. van Anrooij, *Helden van weleer. De Negen Besten in de Nederlanden (1300-1700)*, Amsterdam 1997.

Antwerp 1930
[L. Lebeer] in *Exposition internationale coloniale, maritime et d'art flamand. Section d'art flamand ancien*, vol. IV: *Manuscrits, incunables, impressions du XVIe et XVIIe siècles, gravures* (exhibition cat.), Antwerp 1930, pp. 65-208.

Arnould 1993
A. Arnould, 'Monastic Libraries and the Introduction of Humanism in Flanders', in A. Arnould and J.M. Massing (eds.), *Splendours of Flanders* (exhibition cat.), Cambridge 1993, pp. 204-20.

Bartsch
A. von Bartsch, *Le Peintre-Graveur*, 21 vols., Vienna 1803-21.

Van Bastelaer 1903
R. van Bastelaer, 'La gravure primitive et les peintres de l'école Tournaisienne', *Revue des bibliothèques & archives de Belgique*, 1, 1903 (offprint).

Bauman 1989
G. C. Bauman, 'A Rosary Picture with a View of the Park of the Ducal Palace in Brussels, Possibly by Goswijn van der Weyden', *Metropolitan Museum Journal*, 24 (1989), pp. 135-51.

Behling 1972
L. Behling, Israhel van Meckenem als Kopist, inbesondere in seiner Beziehung zum Hausbuchmeister, in *Israhel van Meckenem und der deutsche Kupferstich des 15. Jahrhunderts*, Bocholt 1972, pp. 2-20.

Bevers 1986-87
H. Bevers, *Meister E.S.. Ein Oberrheinischer Kupferstecher der Spätgotik* (exhibition cat.), München-Berlin 1986-87.

Biemans 1984
J. Biemans, 'Middelnederlandse bijbelhandschriften', in *Verzameling van Middelnederlandse bijbelteksten. Catalogus*, Leiden 1984.

Blum 1950
A. Blum, *Les nielles du quattrocento. Musée du Louvre, cabinet d'estampes Edmond de Rotschild*, Paris 1950.

Bradshaw 1889
H. Bradshaw, 'On two Engravings on Copper by G.M., a Wandering Flemish Artist of the 15-16th Century', in *Collected Papers... comprising Memoranda and Communications*, Cambridge 1889, pp. 248-52.

De Brou 1846
C. D[e] B[rou], *Quelques mots sur la gravure au millésime de 1418*, Brussels 1846.

De Brou 1859
C. De Brou, 'Le graveur de l'an 1466 et les grandes armoiries de Bourgogne' *La revue universelle des arts*, 9 (1859), pp.426-35.

Brussels 1930
Exposition de reliures. I: du XIIe siècle a la fin du XVIe (exhibition cat.), Brussels 1930.

Brussels 1961
Het prentenkabinet. Dertig jaar aanwinsten 1930-1960 (exhibition cat.), Brussels 1961 (exists also in a French edition).

Brussels 1967
G. Colin and M.-T. Lenger, *Vingt livres de la bibliothèque de feu monsieur Fernand J. Nyssen. Don de Madame Fernand J. Nyssen* (exhibition cat.), Brussels 1967.

Brussels 1969
Vijftien jaar aanwinsten sedert de eerste steenlegging tot de plechtige inwijding van de Bibliotheek (exhibition cat.), Brussels 1969 (exists also in a French edition).

Brussels 1973
De vijfhonderdste verjaring van de boekdrukkunst in de Nederlanden (exhibition cat.), Brussels 1973 (exists also in a French edition).

Carderera 1864
V. Carderera, 'Una estampa española del siglo XV' *El Arte en España*, 3 (1864), pp. 41-6.

Carrete Parrondo 1996
J. Carrete Parrondo, F. Checa Cremades and V. Bozal, *El Grabado en España (Siglos XV al XVII)*, (*Summa Artis. Historia General del Arte*, vol. XXXI), 5th ed., Madrid 1996.

Cockx-Indestege 1990
E. Cockx-Indestege, 'De Passie Delbecq-Schreiber. Houtsneden in drukken 1500-1550' *Ons geestelijk erf*, 63 (1990), pp. 245-78.

Cordemans de Bruyne 1895
H. Cordemans de Bruyne, 'Bibliographie malinoise. Histoire de l'art typographique à Malines et bibliographie raisonnée de ses productions. Première partie. Quinzième siècle' *Bulletin du Cercle Archéologique, Littéraire et Artistique de Malines*, 6 (1895), pp. 1-111.

Delen 1924
A.J.J. Delen, *Histoire de la gravure dans les anciens Pays-Bas et dans les provinces Belges des origines jusqu'à la fin du 18ème siècle. I: des origines à 1500*, Paris and Brussels 1924.

Delen 1932
A.J.J. Delen, 'Livres' [review of: Heitz 77 (1932)] *De Gulden Passer*, 10 (1932), pp. 131-36.

Delen 1933
A.J.J. Delen, 'Aanteekeningen over Nederlandsche plaatsnijders en boekillustraties der XVIe eeuw' *Oud Holland* (1933), pp. 145-58

Delen 1943
A.J.J. Delen, 'De Meester der Passie Delbecq-Schreiber', in Idem, *Oude Vlaamsche graphiek. Studies en aanteekeningen*, Antwerp and Amsterdam 1943, pp. 5-21.

Deschamps & Mulder 1998
J. Deschamps & H. Mulder, *Inventaris van de Middelnederlandse handschriften van de Koninklijke Bibliotheek van België*, vol. 1, Brussels 1998.

Deschamps & Mulder 2000
J. Deschamps & H. Mulder, *Inventaris van de Middelnederlandse handschriften van de Koninklijke Bibliotheek van België*, vol. 3, Brussels 2000.

Dodgson 1903
C. Dodgson, *Catalogue of Early German and Flemish Woodcuts preserved in the Department of Prints and Drawings in the British Museum*, vol. 1, London 1903.

Dodgson 1911
C. Dodgson, *Catalogue of Early German and Flemish Woodcuts preserved in the Department of Prints and Drawings in the British Museum*, vol. 2, London 1911.

Dodgson 1929
C. Dodgson, *Woodcuts of the Fifteenth Century in the Ashmolean Museum*, Oxford 1929.

Dodgson 1935
C. Dodgson, *Woodcuts of the XV Century in the British Museum*, 2 vols., London 1935.

Donati 1962
L. Donati, *Il Botticelli e le prime illustrazioni della Divina Commedia*, Florence 1962.

Dreyer 1984
P. Dreyer, 'Botticelli's Series of Engravings of 1481' *Print Quarterly*, 1 (1984), pp. 111-15.

Duchesne 1826
J. Duchesne, *Essai sur les nielles, gravures des orfévres Florentins du XVe siècle*, Paris 1826.

Duchesne 1834
J. Duchesne, *Voyage d'un iconophile. Revue des principaux cabinets d'estampes, bibliothèques et musées d'Allemagne, de Hollande et d'Angleterre*, Paris 1834.

Dutuit 1888
E. Dutuit, *Manuel de l'amateur d'estampes*, vol. I/2: *Introduction générale. Nielles*, Paris and London 1888.

Van Even 1870
E. van Even, *L'ancienne école de peinture de Louvain*, Brussels and Leuven 1870.

Eysen 1904
E. Eyssen, *Daniel Hopfer* (dissertation), Heidelberg 1904.

Fétis 1877
E. Fétis, 'Nouveaux documents pour la tradition iconographique des Neuf Preux', in *Documents iconographiques et typographyques de la Bibliothèque Royale de Belgique*, Brussels-Amsterdam 1877, pp. 67-73.

Field 1995
R.S. Field, *A Census of Fifteenth-Century Prints in Public Collections of the United States and Canada*, New Haven (Connecticut) 1995.

Filedt Kok 1990
J.P. Filedt Kok, 'Een gravure van Israhel van Meckenem, de Kerkgangers' *Bulletin van het Rijksmuseum*, 38, 1990, n° 4, pp. 288-299.

Fleischmann 1998
I. Fleischmann, *Metallschnitt und Teigdruck. Technik und Entstehung zur Zeit des frühen Buchdrucks*, Mains 1998.

Geisberg
M. Geisberg, *The German Single-Leaf Woodcut: 1500-1550*, W. Strauss (ed.), 4 vols., New York 1974.

Geisberg 1909
M. Geisberg, *Die Anfänge des deutschen Kupferstiches und der Meister E.S.* (*Meister der Graphik*, vol. 2), Leipzig 1909.

Gere 1969
J. Gere, *Taddeo Zuccaro*, London 1969.

Van den Gheyn (=VDG)
J. Van den Gheyn, *Catalogue des manuscrits de la Bibliothèque royale de Belgique*, 13 vols., Brussels 1901-48.

Godenne 1956
W. Godenne, 'Deux gravures anciennes du couvent de Béthanie, fondé en 1421 à Malines' *Handelingen van de Koninklijke Kring voor Oudheidkunde, Letteren en Kunst van Mechelen*, 60 (1956), pp. 61-73.

GW
Gesamtkatalog der Wiegendrucke, 8 vol., Leipzig 1925-40.

H. *Dutch*
F.W.H. Hollstein, *Dutch and Flemish Etchings, Engravings and Woodcuts, ca. 1450-1700*, Amsterdam 1949-87; Roosendaal 1988-94; Rotterdam 1995-

H.*German*
F.W.H. Hollstein, *German Engravings, Etchings and Woodcuts, ca. 1400-1700*, Amsterdam 1954-87; Roosendaal 1988-94; Rotterdam 1995-

Harzen 1859(a)
E. Harzen, 'Einige Worte über den sogenannten "Meister von 1466"' in R. Naumann and R. Weigel (eds.), *Archiv für die Zeichnenden Künst, mit besonderer Beziehung auf Kupferstecher- und Holzschneidekunst und ihre Geschichte*, 5, Leizig 1859, pp. 1-8.

Harzen 1859(b)
E. Harzen, 'Quelques mots sur le Maitre de 1466' *La revue universelle des arts*, 9 (1859), pp. 193-206 [with some notes from L. Alvin on p. 193 and on pp. 202-06].

Hébert
M. Hébert, *Inventaire des gravures des Écoles du Nord. 1440-1550*, 2 vols., Paris 1982-83.

Heireman 1973
K. Heireman, 'Het zogenaamde Mechelse atelier' in Brussels 1973, pp. 538-42 and pl. 147.

Heitz 1 (1909)
P. Heitz, *Neujahrswünsche des XV. Jahrhunderts* (P. Heitz (ed.), *Einblattdrucke des fünfzehnten Jahrhunderts*, 1) 3th. ed., Strassburg 1909.

Heitz 2 (1901)
W.L. Schreiber, *Pestblätter des XV. Jahrhunderts* (P. Heitz (ed.), *Einblattdrucke des fünfzehnten Jahrhunderts*, 2) Strassburg 1901.

Heitz 3 (1906)
A. Fäh, *Kolorierte Früdrucke aus der Stiftsbibliothek in St. Gallen* (P. Heitz (ed.), *Einblattdrucke des fünfzehnten Jahrhunderts*, 3) Strassburg 1906.

Heitz 12 (1908)
W. Molsdorf, *Die Niederländische Holzschnitt-Passion Delbecq-Schreiber* (P. Heitz (ed.), *Einblattdrucke des fünfzehnten Jahrhunderts*, 12) Strassburg 1908.

Heitz 14 (1908)
W. Molsdorf, *Formschnitte des Fünfzehnten Jahrhunderts aus der Sammlung Schreiber* (P. Heitz (ed.), *Einblattdrucke des fünfzehnten Jahrhunderts*, 14) Strassburg 1908.

Heitz 22 (1911)
M. Geisberg, *Die Formschnitte des fünfzehnten Jahrhunderts im Kgl. Kupferstichkabinet zu Dresden* (P. Heitz (ed.), *Einblattdrucke des fünfzehnten Jahrhunderts*, 22) Strassburg 1911.

Heitz 29 (1912)
G. Gugenbauer, *Die Niederländische Holzschnitt-Passion Delbecq-Schreiber* (Teil II) (P. Heitz (ed.), *Einblattdrucke des fünfzehnten Jahrhunderts*, 29) Strassburg 1912.

Heitz 43 (1916)
Meisterwerke der Metallschneidekunst (vol. 2) *Ausgewälte Schrotblätter aus öffentliche Sammlungen und Bibliotheken* (P. Heitz (ed.), *Einblattdrucke des fünfzehnten Jahrhunderts*, 43) Strassburg 1916.

Heitz 49 (1918)
M.D. Henkel, *Holzschnitte, Metallschnitte, Kupferstiche in Holländische Sammlungen. Amsterdam, Kupferstichkabinett des Rijksmuseums; Den Haag, Museum Meermanno-Westreenianum und Kgl. Bibliothek; Haarlem, Frans Halsmuseum und Sammlung Enschedé* (P. Heitz (ed.), *Einblattdrucke des Fünfzehnten Jahrhunderts*, 49) Strassburg 1918.

Heitz 51 (1920)
E. Baumeister, *Formschnitte des XV. Jahrhunderts in der Universitätsbibliothek zu München* (P. Heitz (ed.), *Einblattdrucke des Fünfzehnten Jahrhunderts*, 51) Strassburg 1920.

Heitz 66 (1928)
W.L. Schreiber, *Holz-, Metallschnitte und Kupferstiche aus der Kunsthalle, dem Museum für Kunst und Gewerbe in Hamburg und der Stadtbibliothek in Lübeck* (P. Heitz (ed.), *Einblattdrucke des fünfzehnten Jahrhunderts*, 66) Strassburg 1928.

Heitz 77 (1932)
P. Heitz, Vervolständigte Holzschnittfolge der Passion Delbecq-Schreiber nach dem ersten Antwerpener Drucke des Adriaen van Berghen von 1500 (P. Heitz (ed.), *Einblattdrucke des fünfzehnten Jahrhunderts*, 77) Strassburg 1932.

Heitz 80 (1933)
P. Heitz, *Italienische Einblattdrucke in den Sammlungen Bremen, Düsseldorf, Hamburg, London, Modena*, vol.2, (P. Heitz (ed.), *Einblattdrucke des fünfzehnten Jahrhunderts*, 80) Strassburg 1933.

Heitz 84 (1934)
W. Cohn, *Holz- und Metallschnitten einer Süddeutschen Sammlung* (P. Heitz (ed.), *Einblattdrucke des fünfzehnten Jahrhunderts*, 84) Strassburg 1934.

Heitz 99 (1940)
T.O. Mabbott, *Reliefprints in American Private and Public Collections in New York, Cambridge, Cincinnati, Kansas City* (P. Heitz (ed.), *Einblattdrucke des fünfzehnten Jahrhunderts*, 99) Strassburg 1940.

Hind
A.M. Hind, *Early Italian Engravings. A critical catalogue with complete Reproduction of All the Prints Described*, vols. I-IV, London 1938; vols. V-VII, London 1948.

Hind 1935
A.M. Hind, *An Introduction to a History of Woodcut with a detailed Survey of Work done in the Fifteenth Century*, 2 vols., London 1935.

Hind 1936
A.M. Hind, *Nielli, Chiefly Italian of the XVth Century, Plates, Sulphur Casts and Prints, prserved in the British Museum*, London 1936.

Hisette 1914
L. Hisette, 'Notes sur les premiers imprimeurs anversois et les gravures de la Passion Delbecq-Schreiber' in *Mélanges d'histoire offert à Charles Moeller*, vol. 2, Leuven-Paris (1914) pp. 13-20.

Hollstein
See: H. *Dutch*
See: H.*German*

Husband 1995
T. Husband, *The Luminous Image. Painted Glass Roundels in the Lowlands, 1480-1560* (exhibition cat.), New York 1995.

Hymans 1877(a)
H. Hymans, 'Gravure criblée, Sainte Barbe (XVe siècle). Impressions négatives, Sainte Dorothée – Saint Benoit (XVe siècle)', in *Documents iconographiques et typographyques de la Bibliothèque Royale de Belgique*, Brussels-Amsterdam 1877, pp. 13-22.

Hymans 1877(b)
H. Hymans, 'La planche des armoiries de Bourgogne' *L'Art. Revue hebdomadaire illustrée*, 3 (1877), pp. 233-37.

Hymans 1903
H. Hymans, 'L'estampe de 1418 et la validité de sa date', *Académie Royale de Belgique. Bulletin de la Classe des Lettres et des Sciences morales et politiques et de la Classe des Beaux-Arts*, 1 (1903), pp. 93-139.

Hymans 1907
H. Hymans, *Catalogue des estampes d'ornement faisant partie des collections de la Bibliothèque Royale de Belgique classé par nature d'objets, suivi d'un index alphabétique des noms d'auteurs et accompagné de planches*, Brussels 1907.

James 1913
M.R. James, *A descriptive Catalogue of the Manuscripts in the Library of St. John's College, Cambridge*, Cambridge 1913.

Körner 1979
H. Körner, *Der früheste deutsche Einbladholzschnitt (Münchener Universitätsschriften. Philosophische Fakultät für Geschichts- und Kunstwissenschaften. Studia Iconologica*, vol. 3), Mittenwald 1979.

Koreny 1972
F. Koreny, '"Das Marienleben" des Israhel van Meckenem. Israhel van Meckenem und Hans Holbein d. Ä' in *Israhel van Meckenem und der deutsche Kupferstich des 15. Jahrhunderts*, Bocholt 1972, pp. 51-70.

De Kreek 1986
M.L. de Kreek, 'Geprent te Mariënwater'. Onderzoek naar —en voorlopige inventarisatie van— mogelijke 'Mariënwater-prentjes', in *Birgitta van Zweden 1303-1373. 600 jaar kunst en cultuur van haar kloosterorde* (exhibition cat.), Uden 1986.

Kruitwagen 1924
B. Kruitwagen, 'Nederlandsche prenten uit de 15e-16e eeuw (II)' *Het Boek* 13 (1924), pp. 39-62.

L.
See: Lehrs

Lambert 1999
G. Lambert, *Les premières gravures Italiennes: quattrocento - début du cinquecento. Inventaire de la collection du département des Estampes et de la Photographie*, Paris 1999.

Landau & Parshall 1994
D. Landau & P. Parshall, *The Renaissance Print 1470-1550*, New Haven - London 1994.

Lebeer 1931
L. Lebeer, 'Une suite de gravures du "Maitre du Martyre des dix mille,"' in *Mélanges Hulin de Loo*, Brussels-Paris 1931, pp. 231-36.

Lebeer 1935
L. Lebeer, 'Le Brabant et l'art de la gravure 1400-1800', in J. Willems (ed.), *Le livre, l'estampe, l'édition en Brabant du Xve au XIXe siècle*, Gembloux 1935, pp. 189-247.

Lebeer 1936
L. Lebeer, 'Un graveur de la cour de Charles le Téméraire' *Les Beaux-Arts*, 6, 205 (15 mai 1936), pp. 14-15.

Lebeer 1938
L. Lebeer, *Spirituale Pomerium. Étude critique*, Brussels 1938.

Lebeer 1947
L. Lebeer, 'De gaveerkunst te Mechelen', in R. Foncke; L. Lebeer and K. Goossens (eds.), *Mechelen de heerlijke*, Mechelen [1947], pp. 453 - 77.

Lebeer 1953
L. Lebeer, 'Le dessin, la gravure, le livre xylographique et typographique', in *Bruxelles au XVme siècle*, Brussels 1953, pp. 187-217.

Lebeer 1981
L. Lebeer, 'Nabeschouwingen betreffende de oudstgedateerde West-Europese houtsnede, de zgn. "H. Maagd van 1418"', in M. Smeyers (ed.), *Archivium Artis Lovaniense. Bijdragen tot de geschiedenis van de kunst der Nederlanden. Opgedragen aan Prof. Em. Dr. J.K. Steppe*, Leuven 1981, pp. 67-78

Lecluyse 1845
P.C. Lecluyse, 'Explication de deux anciennes gravures provenant de la Société de Rhétorique à Nieuport', *Annales de la Société d'Emulation de Bruges*, vol. III, 2e série (1845), pp. 222-24.

Lehrs
M. Lehrs, *Geschichte und kritischer Katalog des deutschen, niederländischen und französischen Kupferstichs im XV. Jahrhundert*, 9 vols., Vienna 1908-34.

Lehrs 1892
M. Lehrs, 'Der deutsche und niederländische Kupferstich des fünszehnten Jahrhunderts in den kleineren Sammlungen. XXVI. Brüssel', *Repertorium für Kunstwissenschaft* 15 (1892), pp. 479-504.

Lehrs 1895
M. Lehrs, *Der Meister W.A. Ein Kupferstecher der Zeit Carls des Kühnen*, Dresden 1895.

Leuven 1971
Aspekten van de Laatgotiek in Brabant (exhibition cat.), Leuven 1971.

Van der Linden 1908
J. Van der Linden, 'Le pèlerinage de Notre-Dame (Manuscrit avec Enluminures). Le graveur GM', *Annales de la Société d'Archéologie de Bruxelles*, 22 (1908), pp. 403-23.

Van Lokeren 1846
A. V[an] L[okeren], 'Gravure de la Bibliothèque Royale à Bruxelles, au millésime de 1418', *Messager des sciences historiques et archives des arts* (1846), pp. 446-51.

London 1987
S. Lambert, *The Image Multiplied. Five Centuries of Printed Reproductions of Paintings and Drawings* (exhibition cat.), London 1987.

London - New York 1992
S. Boorsch, K. Chritiansen, D. Ekserdjian, C. Hope and D. Landau, *Andrea Mantegna* (exhibition cat.), London-New York 1992.

Lugt
F. Lugt, *Les marques de collection de dessin et d'estampes*, Amsterdam 1921; *Supplément*, La Haye 1956.

Lugt, *Ventes*
F. Lugt, *Répertoire des catalogues de ventes publiques intéressant l'art ou la curiosité*, vols. 1-4, The Hague 1938-64 and vol. 5, Paris 1987.

Luterau 1846
J. A. L[uterau], *Opinion d'un bibliophile sur l'estampe de 1418 conservée à la Bibliothèque royale de Bruxelles*, Brussels 1846.

Lyna 1921
F. Lyna, *Ex-libris des manuscrits de la Bibliothèque Royale de Belgique*, Brussels 1921.

Lyna 1923
F. Lyna, 'Een zeer oud ex-libris' *Het Boek* 12 (1923), pp. 321-27.

Marrow 1979
J.H. Marrow, *Passion Iconography in Northern European Art of the Late Middle Ages and Early Renaissance. A Study of the Transformation of Sacred Metaphor into Descriptive Narrative* (*Ars Neerlandica*, 1), Kortrijk 1979.

Matile 1998
M. Matile, *Frühe italienische Druckgraphik 1460-1530. Bestandeskatalog der Graphischen Sammlung der ETH Zürich*, Basel 1998.

Mauquoy-Hendrickx 1975
M. Mauquoy-Hendrickx, 'Une dernière hypothèse (?) au sujet de l' ecce panis angelorum du couvent de Béthanie (Malines) portant le millésime 1467' *Gulden Passer* 52 (1974) (*Bijdragen tot de geschiedenis van de grafische kunst, opgedragen aan Prof. Dr. Louis Lebeer ter gelegenheid van zijn tachtigste verjaardag*, Antwerp 1975), pp. 177- 90.

Mauquoy-Hendrickx 1978-83
M. Mauquoy-Hendrickx, *Les estampes des Wierix conservees au cabinet des estampes de la Bibliothèque Royale Albert Ier. Catalogue raisonné enrichi de notes prises dans diverses autres collections*, 3 parts in 4 vol., Brussels 1978-83.

Meertens 1934
M. Meertens, *De godsvrucht in de Nederlanden. Naar handschriften van gebedenboeken der XVe eeuw*, vol. VI, [Brussels-Antwerp] 1934.

De Meyer 1970
M. De Meyer, *Volksprenten in de Nederlanden. 1400-1900. Religieuze, allegorische, satirische en verhalende prenten, speelkaarten, ganzen- en uilenborden, driekoningenbriefjes, nieuwjaarsprenten*, Amsterdam-Antwerp 1970.

Miedema 1996
N.R. Miedema, *Die "Mirabilia Romae". Untersuchungen zu ihrer Überlieferung mit Edition der deutschen und niederländischen Texte*, Tübingen 1996.

Milan 1984
C. Alberici and M. Chirico De Biasi, *Leonardo et l'incisione. Stampe derivata da Leonardo e Bramante dal XV al XIX secolo* (exhibition cat.), Milan 1984.

Möller 1981
L.L. Möller, 'Der Indianische Hahn in Europa', in M. Barasch and L. Freeman Sandler (eds.), *Art the Ape of Nature. Studies in Honore of H.W. Janson*, New York 1981, pp. 313-40.

Nagler
G.K. Nagler, *Die Monogrammisten und diejenigen bekannten und unbekannten Künstler aller Schulen, welche sich zur Bezeichnung ihrer Werke eines figurlichen Zeichens, der Initialen des Namens, der Abbreviatur desselben etc. bedient haben*, 5 vols., Munich 1858-79.

Nijhoff
W. Nijhoff, *Nederlandsche houtsneden 1500-1550. Reproducties van oude Noord- en Zuid Nederlandsche houtsneden op losse bladen met en zonder tekst in de oorspronkelijke grootte*, 4 vols., The Hague 1933-36.

Nijhoff - Kronenberg
W. Nijhoff & M.E. Kronenberg, *Nederlandsche Bibliographie van 1500 tot 1540*, 3 parts in 8 vols., The Hague 1923-71.

NK
See: Nijhoff-Kronenberg

Paris 1991
J.-R. Pierrette (ed.), *Graveurs allemands du XVe siècle dans la Collection Edmond de Rothschild* (exhibition cat.), Paris 1991-92.

Paris 1997
J.-R. Pierrette, *Graveurs en taille-douce des Anciens Pays-Bas. 1430/1440-1555 dans la Collection Edmond de Rothchild* (exhibition cat.) Paris 1997.

Passavant
J.D. Passavant, *Le peintre-graveur. Contenant l'histoire de la gravure sur bois, sur métal et au burin jusque vers la fin du 16ème siècle. L'histoire du nielle avec complément de la partie descriptive de l'essai sur les nielles de Duchesne Ainé et un catalogue supplémentaire aux estampes du 15ème et 16ème siècle du peintre-graveur de Adam Bartsch*, 6 parts in 4 vols., Leipzig 1860-64.

Pinchart 1876
A. Pinchart, 'La plus ancienne gravure sur cuivre faite dans les Pays-Bas (Les grandes armoires du duc Charles de Bourgogne)' *Bulletin des commissions royales d'art et d'archéologie*, 15 (1876), pp. 228-36.

Polain
M.-L. Polain, *Catalogue des livres imprimés au quinzième siècle des bibliothèques de Belgique*, 4 vols, Brussels 1932 and *Supplement*, Brussels 1978.

De Raadt 1898
J.Th. de Raadt, 'Une découverte sensationelle pour l'histoire des origines de l'imprimerie en Belgique' *Jadis. Recueil archéologique et historique*, 2 (1898), pp. 36-42.

Reiffenberg 1845(a)
F. de Reiffenberg, *Annuaire de la Bibliothèque royale de Belgique*, 6, Brussels and Leipzig 1845 [pp. 155-63: *Curiosités nouvellement acquises. Gravure antérieure à la plus ancienne connue jusqu'ici, et qui vient d'être achetée en Belgique pour la Bibliothèque royale*].

Reiffenberg 1845(b)
F. de Reiffenberg, 'Gravure antérieure à la plus ancienne connue jusqu'ici et qui vient d'être acquise en Belgique' *Bulletin du Bibliophile Belge*, 1 (1845), pp. 435-38.

Reiffenberg 1845(c)
F. de Reiffenberg, *La plus ancienne gravure connue avec une date* (*Mémoires de l'Académie Royale des Sciences de Bruxelles*, vol.XIX), Brussels 1845.

Reiffenberg 1846(a)
F. de Reiffenberg, *Annuaire de la Bibliothèque royale de Belgique*, 7, Brussels and Leipzig 1846.

Reiffenberg 1846(b)
F. de Reiffenberg, [Review of 'de Brou 1846'], *Bulletin du Bibliophile Belge*, 3 (1846), pp. 219-22.

Reiffenberg 1847(a)
F. de Reiffenberg, *Annuaire de la Bibliothèque royale de Belgique*, 8, Brussels and Leipzig 1847.

Reiffenberg 1847(b)
F. de Reiffenberg, [Review of 'Van Lokeren 1846'], *Bulletin du Bibliophile Belge*, 4 (1847), pp. 130-31.

Reiffenberg 1848
F. de Reiffenberg, *Annuaire de la Bibliothèque royale de Belgique*, 9, Brussels and Leipzig 1848.

Renouvier 1859
J. Renouvier, *Histoire de l'origine et des progès de la gravure dans les Pays-Bas, jusqu'a la fin du quinzième siècle* (*Mémoire couronné le 23 septembre 1859*) (*Mémoires couronnés et autres mémoires publié par l'Académie royale des Sciènces, des Lettres et des Beaux-Arts de Belgique*, 10), Brussels, 1860.

Rhodes 1958
D.E. Rhodes, 'An Unidentified 'Incunable' printed at Augsburg not before 1502' *The Library*, March 1958, pp. 54-6.

Robels 1972
H. Robels, 'Israhel van Meckenem und Martin Schongauer', in *Israhel van Meckenem und der deutsche Kupferstich des 15. Jahrhunderts*, Bocholt 1972, pp. 31-50.

Rosell y Tores 1873
I. Rosell y Tores, 'Estampa española del siglo XV grabada por Fr. Francisco Domenec' *Museo Español de Antigüedades*, 2 (1873), pp. 442-64.

Ruelens 1877
Ch. Ruelens, 'La Vierge de 1418', in *Documents iconographiques et typographyques de la Bibliothèque Royale de Belgique*, Brussels-Amsterdam 1877, pp. 23-46

Schleuter 1935
E. Schleuter, *Der Meister PW* (*Studien zur deutschen Kunstgeschichte*, vol. 305), Strassburg-Leipzig 1935.

Schmidt 1998
P. Schmidt, 'Rhin supérieur ou Bavière ? Localisation et mobilité des gravures au milieu du Xve siècle' *Revue de l'Art*, n° 120 (1998-1), pp. 68-88.

Schr.
See: Schreiber

Schreiber
W.L. Schreiber, *Handbuch der Holz- und Metalschnitte des XV. Jahrhunderts. Stark vermehrte und bis zu den neuesten Funden ergänste Umarbeitung des manuel de l'amateur de la gravure sur bois et sur métal au XVe siècle*, 8 vols., Leipzig 1926-30.

Schreiber-Heitz 1908
W.L. Schreiber and P. Heitz, *Die deutschen Accipies und Magister cum Discippulis-Holzschnitte* (*Studien zur deutschen Kunstgeschichte*, 100) Strassburg 1908.

Schroeder 1971
H. Schroeder, *Der Topos der Nine Worthies in Literatur und bildender Kunst*, Göttingen 1971.

Schuppisser 1991
F.O. Schuppisser, 'Copper Engraving of the "Mass Production" Illustrating Netherlandish Prayer Manuscripts', in K. van der Horst and J.-C. Klamt (eds.), *Masters and Miniatures. Proceedings of the Congress on Medieval Manuscript Illumination in the Northern Netherlands (Utrecht, 10-13 December 1989)*, Doornspijk 1991, pp. 389-400.

Serra y Boldú 1925
V. Serra y Boldú, *Libre d'or del rosari a Catalunya*, Barcelona 1925, pp. 256-59.

Spamer 1930
A. Spamer, *Das kleine Andachtsbild vom XIV. bis zum XX. Jahrhundert*, München 1930.

Van der Stock 1998
J. Van der Stock, *Printing Images in Antwerp. The Introduction of Printmaking in a City. Fifteenth Century to 1585* (*Studies in Prints and Printmaking*, 2), Rotterdam 1998.

Van der Stock 2000
J. Van der Stock, 'Iconographie' in *Bruxelles et le livre. Sept siècles de bibliophilie* (exhibition cat.), Brussels 2000, pp. 147-151 (n° 248-249).

Theele 1927
J. Theele, 'Schrotdruckplatten auf Kölner Einbänden' *Gutenberg Jahrbuch* (1927), pp. 256-62.

TIB, vol. 8.1 Commentary
J. C. Hutchison, *The Illustrated Bartsch*, 8 Commentary Part 1 (*Le Peintre-Graveur* 6 [Part 1]): *Early German Artists. Martin Schongauer, Ludwig Schongauer, and Copyists*, New York 1996.

TIB, vol. 9.2 Commentary
J. C. Hutchison, *The Illustrated Bartsch*, 9 Commentary Part 2 (*Le Peintre-Graveur* 6 [Part 2]): *Early German Artists*, New York 1991.

TIB, vol. 24.1 Commentary
M.J. Zucker, *The Illustrated Bartsch*, 24 Commentary Part 1 (*Le Peintre-Graveur* 13 [Part 1]: *Early Italian Masters*, New York 1993.

TIB, vol. 24.2 Commentary
M.J. Zucker, *The Illustrated Bartsch*, 24 Commentary Part 2 (*Le Peintre-Graveur* 13 [Part 1]: *Early Italian Masters*, New York 1994.

TIB, vol. 24.3 Commentary
M.J. Zucker, *The Illustrated Bartsch*, 24 Commentary Part 3 (*Le Peintre-Graveur* 13 [Part 1]: *Early Italian Masters*, New York 2000.

TIB, vol. 24.4 Commentary
M.J. Zucker, *The Illustrated Bartsch*, 24 Commentary Part 4 (*Le Peintre-Graveur* 13 [Part 1]: *Early Italian Masters*, New York 1999.

TIB, vol. 25 Commentary
M.J. Zucker, *The Illustrated Bartsch*, 25 Commentary (*Le Peintre-Graveur* 13 [Part 2]: *Early Italian Masters*, New York 1984.

VD 16
Irmgard Bezzel, *Verzeichnis der im deutschen Sprachbereichs erschienenen Drucke des XVI. Jahrhunderts. Herausgegeben von der Bayerischen Staatsbibliothek*, Stuttgart 1983.

VDG
See: Van den Gheyn

Verheyden 1943
P. Verheyden, 'De boekbinderij van Groenendaal' *Ons Geestelijk Erf*, 11 (1943), pp. 82-111.

Vervliet 1962
H.D.L. Vervliet, 'Een onderzoek naar de vermoedelijke datum van de planodruk 'Ecce panis angelorum' uit het klooster Bethanië nabij Mechelen (1467?)' *Handelingen XVI der Koninklijke nederlandse Maatschappij voor Taal-, Letterkunde en geschiedenis* (1962), pp. 433-41.

Washington 1965
R.S. Field, *Fifteenth Century Woodcuts and Metalcuts from the National Gallery of Art Washington, D.C.* (exhibition cat.), Washington [1965].

Washington 1967-68
A. Shestack, *Fifteenth Century Engravings of Northern Europe from the National Gallery of Arts Washington, D.C.* (exhibition cat.), Washington 1967-68.

Washington 1973
J.A. Levenson, K. Oberhuber and J.L. Sheehan, *Early Italian Engravings from the National Gallery of Art* (exhibition cat.), Washington 1973.

Willshire 1883
W.H. Willshire, *Catalogue of Early Prints in the British Museum. German and Flemish Schools*, vol. II, London 1883.

Winston-Allen 1997
A. Winston-Allen, *Stories of the Rose. The Making of the Rosary in the Middle Ages*, University Park (PA) 1997.

Winther 1972
A. Winther, 'Zu einigen Ornamentblättern und den Darstellungen des Moriskentanzes im Werk des Israhel van Meckenem', in *Israhel van Meckenem und der deutsche Kupferstich des 15. Jahrhunderts*, Bocholt 1972, pp. 81-100.

Wittert 1877
[Wittert], *Les gravures de 1468. Les armoiries de Charles le Téméraire gravées pour son Mariage avec Marguerite d'York*, Liège 1877.

Zahn 1864
A. von Zahn, 'Ein spanischer Kupferstich des XV. Jahrhunderts' in R. Naumann and R. Weigel (eds.), *Archiv für die Zeichnenden Künst, mit besonderer Beziehung auf Kupferstecher- und Holzschneidekunst und ihre Geschichte*, 10, Leizig 1864, pp. 278-82.

CONCORDANCES

Chalcography

0679 C	[478]
2029 A	[134]

Manuscript Department

Ms.222	348
Ms.1810	105
Ms.2310-23	139, 140
Ms.2945	053, 074
Ms.2992-93	136
Ms.3059	071, 090, 094
Ms. 4086	479 - 499
Ms.4210	106
Ms.4249-50	102
Ms.4583	060
Ms.4604	003, 011, 065, 111
Ms.4660-61	004, 059, 063
Ms.4919	021
Ms.5106	040
Ms.5237	096
Ms.8587-89	095
Ms.10758	348bis, 476
Ms.11059	196, 197, 198, 199, 200, 201, 202
Ms.11237	002, 006, 075, 088
Ms.15960-62	331
Ms.18982	058, 064, 067
Ms.21056	024, 025
Ms.22012	049, 047, 210, 437
Ms.II.433	349
Ms.II.1035	170, 171, 194, 195
Ms.II.1561	097, 438
Ms.II.2098	007, 062
Ms.II.2934	092
Ms.II.3688	466, 467, 468, 469, 470, 471
Ms.II.4398	085
Ms.II.4557	052
Ms.II.7265	475
Ms.IV.4	005
Ms.IV.317	472
Ms.IV.433	204
Ms.IV.480	473, 474
Ms.IV.511	050, 051

Print Room

S.I.17	350
S.I.2354	035
S.I.2355	036
S.I.2356	037
S.I.2357	038
S.I.2358	039
S.I.9367	560
S.I.10385	323
S.I.12359	559
S.I.12360	567
S.I.12361	563
S.I.12362	562
S.I.12363	564
S.I.14005	ill. 5
S.I.16888	309
S.I.22813	555
S.I.22815	530
S.I.22816	539
S.I.22818	382
S.I.22819	375
S.I.22820	392
S.I.22821	439
S.I.23042	066
S.I.23097	331
S.I.23177	163
S.I.23186	069
S.I.23188	076
S.I.23189	080
S.I.23190	082
S.I.23191	055
S.I.23249	108
S.I.23250	045
S.I.23251	099
S.I.23252	101
S.I.23253	089
S.I.23261	100
S.I.23262	110
S.I.23263	081
S.I.23264	044
S.I.23265	093
S.I.23266	107
S.I.23267	144
S.I.23280	343
S.I.23291	134
S.I.23293	127
S.I.23294	128
S.I.23295	129
S.I.23297	130
S.I.23299	048
S.I.23359	322
S.I.23361	122
S.I.23362	123
S.I.23363	124
S.I.23364	125
S.I.25675	327
S.I.25676	326
S.I.25792	547
S.I.25793	573
S.I.25795	423
S.I.30214	518
S.I.30215	519
S.I.30962	346
S.I.31344	244
S.I.31590	296
S.I.31591	293
S.I.31592	295
S.I.31593	294
S.I.31945	223
S.I.31946	222
S.I.31947	402
S.I.31948	278
S.I.31949	303
S.I.42404	205
S.I.42405	175
S.I.42406	193

S.I.42407	173	S.II.1941	397
S.I.42408	192	S.II.1942	398
S.I.42409	169	S.II.1943	422
S.I.42410	168	S.II.1944	424
S.I.42411	166	S.II.1983	219
S.I.42412	167	S.II.1984	232
S.I.42413	162	S.II.1985	299
S.I.42414	352	S.II.1986	261
S.I.42415	353	S.II.1987	272
S.I.42416	156	S.II.1988	343
S.I.42417	158	S.II.2072	541
S.I.42418	157	S.II.2083	517
S.I.42419	159	S.II.2084	520
S.I.42420	161	S.II.2371	214
S.I.42421	160	S.II.2372	215
S.I.42422	154	S.II.2373	218
S.I.42423	152	S.II.2374	236
S.I.42424	334	S.II.2375	237
S.I.42425	070	S.II.2376	239
S.I.42428	113	S.II.2377	242
S.I.42432	540	S.II.2378	224
S.I.42433	151	S.II.2379	252
S.I.42434	206	S.II.2380	250
S.I.42437	212	S.II.2381	249
S.I.42446	385	S.II.2382	251
S.I.42447	291	S.II.2383	253
S.I.42448	305	S.II.2384	255
S.I.42449	324	S.II.2385	256
S.I.42450	344	S.II.2386	257
S.I.42451	355	S.II.2387	260
S.I.42525	570	S.II.2388	321
S.I.42529	085	S.II.2389	264
S.I.42652	091	S.II.2390	262
S.I.42653	105	S.II.2391	259
S.I.42980	292	S.II.2392	263
S.I.44150	266	S.II.2393	258
S.I.44153	477	S.II.2394	254
S.I.45399	[478]	S.II.2395	265
S.II.22	524	S.II.2396	268
S.II.23	523	S.II.2397	271
S.II.36	383	S.II.2398	273
S.II.37	431	S.II.2399	274
S.II.182	327	S.II.2400	245
S.II.183	ill. 3	S.II.2401	230
S.II.225	163	S.II.2402	276
S.II.326	371	S.II.2403	277
S.II.328	356	S.II.2404	280
S.II.359	521	S.II.2405	284
S.II.411	296	S.II.2406	282
S.II.649	573	S.II.2407	287
S.II.677	511	S.II.2408	373
S.II.679	513	S.II.2409	376
S.II.1053	331	S.II.2410	377
S.II.1211	374	S.II.2411	386
S.II.1222	304	S.II.2412	399
S.II.1231	478	S.II.2413	341
S.II.1847	308	S.II.2414	403
S.II.1930	328	S.II.2415	407
S.II.1937	393	S.II.2416	409
S.II.1938	394	S.II.2417	411
S.II.1939	395	S.II.2418	426
S.II.1940	396	S.II.2419	428

S.II.2420	425		S.II.5029	443
S.II.2421	421		S.II.5030	444
S.II.2422	435		S.II.5033	446
S.II.2424	336		S.II.5086	086
S.II.2425	338		S.II.5398	534
S.II.2426	339		S.II.5399	529
S.II.2427	337		S.II.5400	542
S.II.2428	358		S.II.5401	533
S.II.2429	362		S.II.5402	532
S.II.2430	360		S.II.5403	531
S.II.2431	366		S.II.5662	ill. 4
S.II.2506	153		S.II.5709	508
S.II.2507	234		S.II.5711	150
S.II.2508	226		S.II.5778	148
S.II.2522	082		S.II.5781	174
S.II.4637	354		S.II.6026	138
S.II.4638	342		S.II.6136	413
S.II.4639	217		S.II.6779	047
S.II.4640	216		S.II.6784	437
S.II.4641	241		S.II.6785	210
S.II.4642	225		S.II.6796	079
S.II.4643	227		S.II.7786	416
S.II.4644	248		S.II.7787-90	415
S.II.4645	228		S.II.7791	056
S.II.4646	267		S.II.7792	061
S.II.4647	269		S.II.7793	042
S.II.4648	246		S.II.7824	516
S.II.4649	229		S.II.7838	551
S.II.4650	[276]		S.II.7839	554
S.II.4651	306		S.II.8306	190
S.II.4652	279		S.II.8307	191
S.II.4653	283		S.II.8308	329
S.II.4654	288		S.II.8311	142
S.II.4655	289		S.II.8314	176
S.II.4656	290		S.II.8322	203
S.II.4657	384		S.II.8324	ill. 1
S.II.4658	207		S.II.8333	320
S.II.4659	378		S.II.8533	509
S.II.4660	388		S.II.8535	325
S.II.4661	390		S.II.8652	247
S.II.4662	405		S.II.8653	285
S.II.4663	401		S.II.8874	369
S.II.4664	404		S.II.8952	566
S.II.4665	408		S.II.8954	546
S.II.4666	410		S.II.8956	238
S.II.4667	412		S.II.10280	433
S.II.4668	429		S.II.10281	427
S.II.4669	434		S.II.10283	538
S.II.4670	436		S.II.10284	556
S.II.4671	359		S.II.10381	510
S.II.4672	361		S.II.10718	391
S.II.4673	363		S.II.10719	240
S.II.4856	310		S.II.10930	315
S.II.5016	452		S.II.10965	235
S.II.5017	445		S.II.10968	231
S.II.5022	451		S.II.11404	213
S.II.5023	450		S.II.11637	057
S.II.5024	447		S.II.11638	031
S.II.5025	448		S.II.13009	527
S.II.5026	442		S.II.15965	281
S.II.5027	441		S.II.16204	149
S.II.5028	449		S.II.17257	528

S.II.17287	558	S.II.62902	312
S.II.17793	569	S.II.62903	313
S.II.18646	522	S.II.62904	314
S.II.20960	286	S.II.62905	316
S.II.21235	145	S.II.62906	317
S.II.21244	143	S.II.62907	318
S.II.21245	172	S.II.62915	302
S.II.21257	381	S.II.62961	372
S.II.22085	512	S.II.62962	379
S.II.22135	221	S.II.62963-68	420
S.II.22143	572	S.II.62969-74	419
S.II.22886	118	S.II.62975-80	418
S.II.23205	132	S.II.62981-86	417
S.II.24193	301	S.II.62987	155
S.II.24195	351	S.II.62992	330
S.II.24196	165	S.II.63028	557
S.II.24197	164	S.II.63121	244
S.II.24204	209	S.II.63148	357
S.II.26157	121	S.II.63149	365
S.II.26258	535	S.II.63150	370
S.II.26329	220	S.II.63151	380
S.II.26362	565	S.II.63265	550
S.II.26461	333	S.II.63271	574
S.II.26535	072	S.II.63272	549
S.II.26547	133	S.II.63970	332
S.II.29535	349	S.II.85301	561
S.II.29788	211	S.II.86244	177
S.II.30151	389	S.II.86245	178
S.II.30153	275	S.II.86246	179
S.II.31165	319	S.II.86247	180
S.II.31262	347	S.II.86248	182
S.II.31284	233	S.II.86249	181
S.II.32133-38	440	S.II.86250	183
S.II.34579	278	S.II.86251	184
S.II.34580	387	S.II.86252	185
S.II.36007	208	S.II.86253	186
S.II.36008	026	S.II.86254	187
S.II.36028	270	S.II.86255	188
S.II.40484	526	S.II.86256	189
S.II.41478	545	S.II.87485	243
S.II.42911	544	S.II.87486	364
S.II.45438	134	S.II.93381	129
S.II.45439	134	S.II.110809	507
S.II.45692	525	S.II.112123	[536]
S.II.54030	367	S.II.112124	543
S.II.54890	117	S.II.131109	297
S.II.54891	115	S.II.132778	368
S.II.62759	400	S.II.137459	008
S.II.62764	119	S.II.137460	009
S.II.62765	116	S.II.137461	010
S.II.62766	114	S.II.137462	012
S.II.62770	552	S.II.137463	013
S.II.62771	553	S.II.142145	146
S.II.62776	345	S.II.142463	018
S.II.62779	548	S.II.142464	017
S.II.62782	537	S.II.142465	046
S.II.62804	[565]	S.II.142466	016
S.II.62805	568	S.II.142467	014
S.II.62830	571	S.II.142506	043
S.II.62899	307	S.II.142507	033
S.II.62900	309	S.II.142508	029
S.II.62901	311	S.II.142509	041

S.II.142510	023	S.V.70813	135
S.II.142511	034	S.V.71313	127
S.II.146707	087	S.V.71314	128
S.II.152770	028	S.V.81636	453
S.II.152771	015	S.V.81637	454
S.II.152772	019	S.V.81638	455
S.II.152773	020	S.V.81639	456
S.II.152774	022	S.V.81640	457
S.III.24591	414	S.V.81641	458
S.III.25542	126	S.V.81642	459
S.III.30076	084	S.V.81643	460
S.III.37341	083	S.V.81644	461
S.III.37342	109	S.V.81645	462
S.III.47282	120	S.V.81646	463
S.III.58603	147	S.V.81647	464
S.IV.367	054	S.V.81648	465
S.IV.368	078	S.V.84422	340
S.IV.3963	299	S.V.96769	335
S.IV.3964	300	S.VI.28914	077
S.IV.14846	101		
S.IV.14847	068		
S.IV.14848	030	**Rare Books Division**	
S.IV.16642	032		
S.IV.22817	432	Inc. 1385bis	211
S.IV.86327	430	Inc. A 1017	066
S.V.27484	406	Inc. A 1212	001
S.V.63312	098	Inc. B 25	138
S.V.63313	104	Inc. B191	066
S.V.63314	073	Inc. B 449	137, 141
S.V.63315	103	Inc. B 1017	066
S.V.63316	ill. 2	FS.XI.1 RP	514, 515
S.V.70810	112	VB 2268 A RP	122, 123, 124, 125
S.V.70811	131		

INDICES

Index I:
Origins, sales and previous collections

Aachen, cathedral library 347, 348
d'Albanas (<1872) 569
Alexander VI Borgia (pope) 473, 474
Amsterdam (1860) 082
Angiolini, Luigi (Milan, 1894) 114, 116, 119, 155, 244, 302, 307, 309, 311-314, 316-318, 330, 345, 357, 365, 370, 372, 379, 380, 400, 417-420, 537, 548-550, 552, 553, 557, [565], 568, 571, 574
Antwerp, Bolandists 095
Antwerp, Jesuits 040, 102
De Arozarena, D.G. (South America and Paris, ca. 1860) 368
B.v.G. (unknown collection) 386, 407
Backer, Frans (Leuven, 1552/53) 210
Baer & co. (Frankfurt/M, 1909-14) 008-010, 012-020, 022, 023, 028, 029, 033, 041, 043, 046
Baer & co. (Frankfurt/M, 1913) 034
Baer & co. (Frankfurt/M, 1922) 083, 109
Baex (1644) 095
Balmanno, Robert (1829) 377
Barnard, John (London, <1784) 425
De Bassompierre, A. (Brussels, 1921) 084
De Bast (Brussels, 1853) 356, 371
De Becker (Brussels, 1909) 052
Van der Beelen (1863) 047, 049, 210, 437
Berlin, Kupferstichkabinett der Staatlichen Museen (<1878) 164, 165
Bermann, J. Sigmund (Vienna, 1834) 307
Best (Brussels, 1907) 466-471
Bethanië, canonesses of St. Augustine (Mechelen) 030, 031, 066, 067, 131
Bethlehem, convent of the Gray Sisters (Brussels) 097
Bilzen, Walter von (Aachen, 15th. C.) 347, 348
Birmann & Söhne (Basle) 285
Blokhuysen (Rotterdam, 1871) 281
Blücher, C.W. von (Brunswick, 1755-1826) 239
Bluff (Brussels, 1876) 118
Bluff (Brussels, 1888) 526
Bluff (Brussels, 1893) 115, 117
Bluff (Brussels, 1895) 332
Bodmer, Martin (Cologny-Genève) 473-474
Boerner (Leipzig, 1909) 368
Böhm, Joseph Daniel (Vienna, <1865) 566
Bonnivert (Antwerp, 1950) 406
Borluut de Noortdonck (Gent, 1858) 219, 232, 261, 272, 298, 308, 328, 343, 393-398, 424, 517, 520, 541
Van den Brande, Willem (Mechelen, 1566) 092
Brassinne, Joseph (Liège) 073, 098, 103, 104
De Bray-Cordemans (Brussels, 1957) 112, 131, 135
Van Brigille, Lodowijca (Brussels 1549) 071, 090, 094
Brisard (Gent, 1849) 393-398, 500-506
Vanden Brugge, Catharina (Brussels, 1552) 049
Bruges, Jesuits 004, 059, 063.

Brussels, convent of the Gray Sisters 097
Brussels, Carmelite monastery 137, 141
Brussels, State Archives of Belgium 093
Brussels, St. Elisabeth convent 071, 090, 094
De Bruyne, Auguste (Mechelen, <1862) 131
De Bruyne, Auguste (Mechelen, 1874) 145
De Bruyne, Auguste (Mechelen, 1890) 134, 525
Buffa (Amsterdam, 1854) 296
Buttstaedt (Berlin, 1878) 164, 165, 209, 301, 351
Buttstaedt (Berlin, 1880) 220
Buttstaedt (Berlin, 1885) 440
Camberlyn d'Amougies, J. (Brussels, <1865) 142, 176, 190, 191, 203, 247, 285, 325, 329, 369, 509, 516, 551, 554
Cels (1862) 413
Chalon, R. (1864) 110
Chalon, R (1868-90) 206, 212
Claessens, Laurent (Brussels, 1880) 072, 133
Clément (Paris, 1865) 320
Clément (Paris, 1866) 238, 546, 566
Clément (Paris, 1872) 528, 558
Clough, G.J. (London, 1889) 544
Colnaghi (London, 1961) 340
Cologne, Benedictine abbey of Brauweiler (S. Nicolaus) 139
Cologne, Brethren of the Common Life in Weidenbach 204
Coppieters (Nieuwpoort, 1868) 206, 212
Cordemans de Bruyne, H. (Mechelen) 112, 131, 134
Coster, Auguste (<1907) 131, 536, 543
Couret, Alphonse (Orleans, 19th Century) 473, 474
Cuvelier (Lille, <1889) 545
C(?).V.D. (unknown collection) 531
Danlos & Delisle (Paris, 1867) 240, 391
Danlos (Paris, 1884) 319
Danz (Leipzig 1874) 286
Dauloz (Paris, 1880) 535
Debois, François (Paris, 1833) 251, 376
Delbecq, Jean-Baptiste (1833-1845) 008-010, 012-020, 022, 023, 028, 029, 033, 041, 043, 046
Delhez, Armand (Liège, 1955) 073, 098, 103, 104
Dietrich (Brussels, 1886) 278, 387
Dietrich (Brussels, 1887) 270
Drugulin (Leipzig) 380
Drugulin (Leipzig, 1859) 214, 215, 218, 224, 230, 236, 227, 239, 242, 245, 249-260, 262-265, 268, 271, 273, 274, 276, 277, 280, 282, 284, 287, 321, 336-339, 341, 358, 360, 362, 366, 373, 376, 377, 386, 399, 403, 407, 409, 411, 421, 425, 426, 428, 435
Drugulin (Leipzig, 1879) 333
Drugulin (Leipzig, 1880) 565
Drugulin (Leipzig, <1895) 380
Durand, E. (Paris, <1835) 546
Eke, village in Oost-Vlaanderen (Belgium) 106
EKL (unknown mark) 108, 133, 220, 226, 228, 235, 238, 242, 325, 351, 382, 429, 431, 477, 531
Van Elderen, Lysbeth (Brussels 1549) 071, 090, 094
Emmerson, Thomas (Crawhall, 1857) 249
Esdaile, William (London, <1838) 276, 282, 377, 403, 409
Van den Eynden (1898) 007, 062

Felix, Eugeen (1885) 387
De Férol, Ch. (1859) 153, 226, 234
Fétis, Edouard 066
Fiévez (Brussels, 1907) 131, 536, 543
Fiévez (Brussels, 1921) 126
Fiévez (Brussels, 1924) 120
Fountaine Walker (Ness Castle, Inverness, Scotland, <1880) 220
Füssli, Heinrich (Zürich, ca.1826/28) 239
G.W. (unknown collection, <1895) 317
Gawet, Franz (Vienna, <1844) 566
Gembloux (Belgium), Benedictine abbey of (ca. 1535) 096
Geraardsbergen (Belgium) abbey 086
Goewaerts, Josijnken (Mechelen, 1566) 092
Van Gogh (Brussels, 1869) 213
Van Gogh (Brussels, 1872) 149
Van Gogh (Brussels, 1873) 522
Van Gogh (Brussels, 1875) 221, 512
Goupil (Brussels, 1867) 315, 427, 433, 538, 556
Goupil (Brussels, 1868) 231, 235
Groenendaal, canons regular of St. Augustine 136
Grootebroeck (prov. Noord-Holland, Northern Netherlands) St. Elisabeth convent 021
Grünling, Joseph (Vienna, <1845) 273
Guichardot (Paris, 1859) 153, 226, 234
Guichardot (Paris, 1865), see: Camberlyn d'Amougies, J. (Brussels, <1865)
Gumpeltzheym (Ratisbonne) 149
Gutekunst (Stuttgart, 1868) 209
Gutekunst (Stuttgart, 1883) 275
Gutekunst (Stuttgart, 1884) 233
Gutekunst (Stuttgart, 1887) 026, 208
Gutekunst (Stuttgart, 1890) 008-010, 012-020, 022, 023, 028, 029, 033, 041, 043, 046
Gutekunst (Stuttgart, 1893) 367
Gutekunst (Stuttgart, 1895), see: Angiolini, Luigi (Milan, <1895)
Gutekunst (Stuttgart, 1900) 243, 364
Gutekunst (Stuttgart, 1909) 297
Van der Haeghen, F. (Gent, 1865) 042, 056, 061, 415, 416
Van der Haeghen, F. (Gent, 1869) 031, 057
Hasselt (Belgium), Sint-Catharinadal 475
Havenith (Brussels, 1932) 299, 300
Heussner (Brussels, 1860), see: Paelinck, Jozef (Brussels, 1860)
Hippert, Th. (Brussels, <1870) 527
Hippert, Th. (Brussels, <1919) 126
De Hondt (Uytkerke near Blankenberge, Belgium, 1898) 561
Hukeshoven, Petrus (Cologne, 1514) 137, 141
Van Hulthem, Charles (1837) 001
Jadot, M. [127]
Kempynck (Nieuwpoort, Belgium 1890) [206, 212]
Kesteloot (1845) [212]
Van der Kolk (1853) 163
Kornfeld & Klipstein (Bern, 1966) 335
Krug (Antwerp, 1885) 147
Lanna, A. Freiherr von (1909) 297
Leblanc (1865) 320

Lebrun, G. (Brussels, 1932) 054, 078
Lecluyse, P.C. (Nieuwpoort, Belgium, 1868) 212
Lefèvre (Cherain, Luxembourg, 1881) 349
Lehrs, Max (Dresden, 1890) 334
Lemoine, P. (Brussels) 131
Leppel, W.H.F.K. von (<1826) 165
Leuven, Discalced Carmelites 137, 141
Leuven, Franciscans of (1552/53) 210
Liphart, Carl Eduard (Florence, 1876) 333
London, British Museum, Printroom 243, 432
Van Loock, A. (Brussels, 1966) 204
Lugt, Frits (Paris, 1960) 453-465
Luxemburg, Jesuits of 476
Maaseik (Belgium), St. Augustinessen (St. Agnes) of 472
Mabbott, T.O. (New York, >1938) 077
Macoir (Brussels, 1934) 032
Magnier (Brussels, 1907) 507
Van Marck (Liège, 1851) 383, 431, 523, 524
Van Marck (Liège, 1856) 511, 513, 573
Mariënwater (prov. Noord-Brabant, Northern Netherlands) 084
Mechelen, Canonesses of St. Augustine of 030, 031, 066, 067, 131
Mechelen, city of (1844) 085
Mechelen, Groot Begijnhof of (1566) 092
Meulhausen, see: Mulhausen
Morandius, Horatius 514, 515
Morona, Alessandro da [511-513]
Mueleneers, Agnes 472
Mulhausen (1857) 304, 374, 478
Van Myellen, Agnes 475
Nagler, K.F.F. von (Berlin <1848) 164
Négron, marquis de, see: Sevilla, don Fréderic de
Nieuwpoort (Belgium), Rhetoricians' Chamber De Doorne Kroone, 206, 212
Nijhoff (Amsterdam, < 15 July 1902) 092
Van Noort (Amsterdam?, 1860?) 082
De Noter, Jan Frans (Mechelen, 1844/45) 085
Nyssen, Fernand, J. (1965) 514, 515
Oettingen-Wallerstein, Fürst zu (Maihingen, Bavière, <1935/37) 430
Olemaert, Philip (Brussels) 137, 141
Olivier (1872) 569
Onze-Lieve-Vrouw ten Troost, see: Vilvoorde
Van Overloop, J. (Antwerp, 1933) 030, 068, 101
Van Overloop, J. (Antwerp, 1935) 432
Paelinck, Jozef (Brussels, 1860) 086, 207, 216, 217, 225, 227-229, 241, 246, 248, 267, 269, [276], 279, 283, 288-290, 306, 310, 342, 354, 359, 361, 363, 378, 384, 388, 390, 401, 404, 405, 408, 410, 412, 429, 434, 436, 441-452, 529, 531-534, 542
Le Paige, Constantin (Liège) 073, 098, 103, 104
Papillon (Brussels, 1861) 150, 508
Papillon (Brussels, 1883) 389
Papillon (Brussels, 1889) 545
Paris, Bibliothèque nationale 002, 053, 058, 060, 064, 071, 074, 090, 094, 136, 139, 140, 196-202, 347, 348, 476
Petit, J. (1867) 510
Peutie, see: Vilvoorde

Philips, Thomas (Cheltenham, <1888) 170, 171, 194, 195
Pinchart, Alexandre (Brussels, 1861) 148, 174
Piot, Eugène (1890) [511-513]
Pons d'Aix (1872) 528, 558
Poor Clares (1516-19) 002, 006, 075, 088
Postle Hesseltine, John (London, 1920) 432
PR or RR (unknown collection, <1892) 375
Rechberger, Frans (1800) 408
De Ridder, Louis (Brussels, 1913) 087
Rosenthal, L. (München) 109
RR or PR (unknown collection, <1892) 375
Ruhneu (1909) 368
Ryckbos (Mechelen, 1844) 085
Sauboua (Brussels, 1924) 147
Schmidt (Brussels (1875) 221, 512
Schreiber, W. L.(1890) 008-010, 012-020, 022, 023, 028, 029, 034, 033, 041, 043, 046
Sestich, Johannes van (Leuven, 1600) 479-499
Sevilla, don Fréderic de (Brussels 1893) 115
Simonson, R., (Brussels, 1943) 475
Smit, Henricus (Leuven, 1616) 137, 141
Soloani firm (Modena, 1640 - 1870) 054, 078, 114-120
Somers, Anna 053, 074
Sotheby's (London, 1966) 473, 474
Speeckardt, Marie. (Mechelen ?) 066
Staeckebrans, Helle 196-202
Starké (1875) 572
Storck, Guiseppe (Milan, 1798) 253
Storck, Giuseppe (Milan, 1805) 155
Van der Straeten-Ponthoz, F. (1879) 121
Van Sulpen, Raoul (Brussels, 1899) 177-189
Tavernier (Gent, 1904) 129
Tavernier (Antwerp, 1921) 414
Tenner, H. (Heidelberg, 1979) 077
Thibaudeau (London, 1877) 132
Thomas, Allan G. (London, 1968) 050, 051
Van Trigt (Brussels, 1894) 097, 438
Vallardi, Giuseppe (1790-1810) [518, 519]
Van de Velde, Jan Frans (Gent, 1743-1823) 008-010, 012-020, 022, 023, 028, 029, 033, 041, 043, 046
Vande Velde, Maria (16th C.) 170, 171, 194, 195
Verachter (Antwerp, 1852) 327
Vilvoorde (Belgium), Carmelite convent Onze-Lieve-Vrouw ten Troost in Peutie 003, 034, 064, 065, 071, 074, 076, 090, 092, 094, 111
De Vreese 472
Walsingham Martin, Robert 514, 515
Weber (1855) 153
Weber, J. (1851) 048, 130
Wiesböck, C. (Vienna, <1869) 545
Zinser, Richard (Brussels, 1939) 430
Van Zurpele, Maria Isab. (Diest, Belgium, 18th.C.) 177-189
Zweibrücken (Malmédy, Belgium, 1874) 143, 172, 381

Index II:
Artists, authors, designers, engravers, woodcutters, copyists and publishers

Aelst, Nicolas van 549
Aert [...] 073
Alart du Hameel, see: Hameel, Alart du
Alvin, Louis 105, 122, 331
Andreani, Andrea <534
Ascensius, Jodocus Badius 137, 141
Augustinus de Ratisbona 137, 141
Backer, Frans 210
Badius Ascensius, Jodocus 137, 141
Baldini, Baccio 512, 513
Barbari, Jacopo de' 551-554
Beham, Hans Sebald and Bartel 504
Berjeau, J. Ph. 144
Birago, Giovanni Pietro da, see: Giovanni Pietro da Birago
Bomberg, Cornelius de 001
Bosch, Hieronymus 345
Bramante, Donato 548-550
Brande, Willem van den 092
Brantheghem, Willem van 113
Breda, Jacob van 211
Brigille, Lodowijca van 071
Campagnola, Domenico 562-568
Campagnola, Giulio 536, 538, 559-561
Canitia, Guilllielmus de 139, 140
Cesariano, Cesare 548
Cool, Henricus 007, 062
Cosins, Tanneke 004
Costa, Lorenzo 571, 572
Dante 514-516
Darmont, Lambertus 024
Doménech, Francisco 478
Dürer, Albrecht 432, 520
Elderen, Lijsbeth van 071
Fétis, Edouard 121
Fierlants Edmond 331
Folkard, M. 85
Francesco Francia, see: Francia, Francesco
Francia, Francesco 490, 493, 494, 498-500
Francia, Jacopo 569, 570
Gerson, Johannes 087, 097
Giovanni Antonio da Brescia 537, 544, 545, 546
Giovanni Pietro da Birago 547
Graf, Urs 302
Guisi, Guido 348
Hameel, Alart du 333, 345
Hamman, Johannes 001
Herolt, Johannes 138
Hoffmann, W. 162, 175, 324, 352-353
Holbein, Hans the Elder 373-379
Hopfer, Daniel 150
Housebook Master, see: Master of the Housebook

Huberti, see: Huybrechts
Huss, Johannes 122, 123, 124, 125
Huybrechts, Adrian 292, 293, 294, 295, 297, 298
Isidorus of Sevilla 106
Jacopo de Bologne 506
Krug, Ludwig 054
Landino, Cristoforo 514-516
Landshut, see: Mair von Landshut
Leonardo da Vinci 547
Lippi, Filippino 518
Mair von Landshut 354-356
Mantegna, Andrea 521-523, 528-544
Marcantonio Raimondi 570
—

Monogrammists:
Master A G 307-320
Master B R with the Anchor 328
Master E S 144, 153-165, 190, 201, 387, 415, 416
Master F I 349
Master FVB 335- 341
Master GM (1) 114, 115, 117, 120
Master GM (2) 131
Master I A M of Zwolle 342-344, 381
Master I C 322, 323
Master I E 305-306
Master J C 090
Master M Z 357-371
Master Na.Dat (with the mousetrap) 573
Master P W of Cologne 346- 348
Master R (or RI) 118
Master S 176
Master W A 097, 329-333
Master W H 321
– – –

Anonymous masters:
Master of the Amsterdam Cabinet, see: Master of the Housebook
Master with the Banderoles 205
Master of the Berlin Passion 166-169, 199-202
Master of the Boccacio Illustrations 350-351
Master of the Calvary 147
Master of the Dutuit Mount of Olives 176, 203
Master of St. Erasmus 197, 174-175
Master with the Flower Borders 196, 170-173
Master of the Gardens of Love 152
Master of the Housebook 352, 353, 422, 423
Master of the Martyrdom of the 10.000 177-193
Master of the Nuremberg Passion 151
Master of the Sforza Book of Hours 547
——

Meckenem, Israel van 203, 207, 341, 372-440

Mijnnesten, Johan van den, see: Master I A M of Zwolle
Montagna, Benedetto 555-558
Nicoleta da Modena 484, 485, 492, 499, 505
Nicolò di Lorenzo della Magna 514-516
Ockham, Guilielmus 137, 141
Olmütz, Wenzel von, see: Wenzel von Olmütz
Olomuscz, Wenceslaus de, see: Wenzel von Olmütz
Otmar, Johann 150

Pelbartus de Themswar, see: Themswar, Pelbartus de
Peregrino da Cesena 482, 483, 486-491, 493, 494-498, 500, 502, 507, 509
Petit, Jean 097
Philippe, Gaspar 097
Pinder, Ulrich 070
Piombino, Sebastian del 478
Prüss, Johannes 066
Quentell, Heinrich 087
Raibolini, Francesco, see, Francia, Francesco
Ratisbona, Augustinus de, see: Augustinus de Ratisbona
Reyser, Georg 320
Robetta, Cristofano 517-520
Ruelens, Charles 347
Schongauer, Martin 213-306, 319-323, 325-326, 340, 341, 386, 390-392, 402, 404, 406, 411- 414
Severeyns, G. 085
Soloani firm 054, 078, 114-120
Spechtshart, Hugo 066
Speeckardt, Marie 066
Suso, Heinrich 008, 204
Süss, Hans von Kulmbach 148
Tedeschi, Nicolaus 347
Themswar, Pelbartus de 150
Trechsel, Johannes 137, 141
Vinci, Leonardo da, see: Leonardo da Vinci
Visscher, Cornelisz. 300
Vorsterman, Willem 113
Wenzel von Olmütz 324, 325, 326, 327
Wierix, Hieronymus 299, 300
Wissekercke, Marcus 292, 295
Wolfgang Aurifaber (Wolfgang the Goldsmith) 163-165
Zaisinger, Mathias, see: Master M Z
Zanetti, Antonio Maria 554
Zasinger, Mathias, see: Master M Z
Zell, Ulrich 138
Zoan Andrea 534, 535, 536, 538, 544

Index III: Iconography

Old Testament

Adam and Eve with the infants Cain and Abel 517
Joshua (as one of the Nine Worthies) 114, 115, 121
Samson and the lion 491
King David (as one of the Nine Worthies) 121, 123
King Salomon 045
 – The idolatry of Salomon 357
Judith with the head of Holofernes 372, 551

New Testament (This division includes New Testament, Apocrypha and Legends)

Anna Selbdritt (i.e. Anna, the Vigin and Christ-child close together), see: St. Anna
Wurzel Emerantiana, see: St. Emerantia
The presentation of the Virgin in the temple 373
The Virgin making garments for the poor and the priests 373
Joseph is chosen as husband because his rod is flowering 374
The marriage of the Virgin 374
The annunciation to the Virgin 001, 002, 078, 213, 214, 215, 375, 455, 478, 525, 526
The annunciation to Joseph 573
The visitation 177, 375, 456, 478, 525, 526
The nativity 003, 151, 216, 217, 303, 380, 457, 478, 525, 526
The annunciation to the shepherds 003, 217, 573
The adoration of the sheperds 217, 568
The circumcision of the Christ-child 178, 478, 525, 526
The presentation of the Christ-child in the temple 180, 478, 571, 572
The magi on their way to Betlehem 003
The adoration of the magi 179, 218, 342, 354, 458, 518, 568
The massacre of innocents 182, 376
The flight into Egypt 181, 376
 – Miracle of the bending palmtree 219
The holy family in Egypt 034
Christ among the doctors 377, 441, 464, 478, 525, 526
The Virgin and Joseph searching for their Child 377
Christ found by his parents 377
The baptism of Christ in the river Jordan 004, 220
St. John the Baptist in prison
 – Two disciples of St. John are sent to Christ 442
The beheading of St. John the Baptist 359
The head of St. John the Baptist on a platter (*Johannes in Disco*) 100, 359
Christ in the wilderness attended by angels (Christ Blessing the Angels) 305
Christ healing the man born blind 443
Christ healing the paralytic man (The man is let down through the roof) 444, 445

Christ healing a leper, who kneels before him 446
Christ healing the son of the widow of Nain 447
The raising of Lazarus 184
The calling of St. Peter and St Andrew 448
The transfiguration 005, 449, 525, 526
Christ and the woman of Samaria 006, 559
Christ and the Virgin in the house of Lazarus, Martha and Mary in Bethany 131
Christ in the house of Simon 007, 008, 183, 570
Christ preaching in the open 450
The wise and the foolish virgins (Parable of) 276, 277, 278, 302, 306, 411, 412, 413, 414
The entry into Jerusalem 174, 175
Christ driving out the money-lenders from the temple 185
The last supper 009, 307, 308, 547
The agony in the garden 010, 011, 194, 231, 309, 310, 478
The betrayal of Christ 012, 170, 232, 233, 292, 311, 415
Christ before Annas 013, [234], [293]
Christ before Caiaphas 014, 234, 293, 451
The mocking of Christ 015, 019, 478
Christ before Pontius Pilate 016, 312, 415
Pontius Pilate washing his hands 017, 237, 294, 323, 382, 466
The denial of St. Peter 382
The flagellation of Christ 018, 235, 313, 415, 478, 534
The crowning with thorns 019, 236, 314, 315, 350, 415, 524
Ecce Homo 020; 238, 295 (see also infra: Christ as Man of Sorrows)
The making of the cross 382
Christ bearing the cross 021, 022, 171, 221, 222, 223, 316, 467, 478
 – Christ's falls 035, 036, 037, 038, 039, 040, 065, 221, 222, 223
 – Christ meets Veronica (with the *Sudarium*) 239
Christ stripped of his raiment (with the Virgin and St. John the Evangelist) 023, 186
Soldiers quarreling over the seamless garment 383
The preparation for the crucifixion (Christ waiting to be crucified) 041, 060, 061, 062, 063, 187, 383, 420
Christ is offered a benumbing drink, but he refuses it 041
Christ nailed to the cross 042, 043
The crucifixion
 – The crucifixion (alone, without bystanders. Blood spouting from his wounds) 066; 067; 068; 069
 – The crucifixion (with the Virgin and St. John the Evangelist) 024, 025, 026, 132, 224, 226, 291, [304], 335, 349, 381, 478 (see also: The Crucifixion (Calvary))
 – The Virgin [standing under the cross] 304
 – The crucifixion (with the Virgin, St. John and Franciscan Saints) 136
 – The crucifixion (with the two thieves and a monk) 070
 – The crucifixion (*Calvary*) 028, 147, 167, 225, 226, 240, 317, 343, 351, 383, 462

The descent from the cross 029, [130]
The lamentation (and *Mater Dolorosa*) 030, 031, 032, 044, 045, 071, [130], 206, 207, 324, 344, 461
Christ as Man of Sorrows (cf. *Ecce Homo*) 054, 055, 056, 058, 059, 060, 061, 062, 063, 383, 437, 438, 468
 – Christ as Man of Sorrows standing in the tomb 057, 437, 438, 470, 472, 473
 – Christ as Man of Sorrows with the Virgin 064
 – Christ as Man of Sorrows with the Virgin and St. John 247
The entombment 033, 188, 241, 296, 297, 298, 318, 465, 529
The arms of Christ (*Arma Christi*) 057; 060, 061, 062, 063, 098, 155, 210, 292, 295, 388, 437, 473
Christ in limbo 046, 189, 207, 242, 535
The resurrection 207, 243, 244, 325, 478, 525, 526
Christ appears to Mary Magdalene (*Noli Me Tangere*) 195, 227, 384
Christ as gardener 195, 384
Christ appears to the Virgin 047, 454
Christ at Emmaus 384, 452
The assumption of Christ 478, 525, 526
Pentecost 459, 478, 525, 526, 562
The creed of the apostles 107, 393, 394, 395, 396, 397, 398
The death of the Virgin (*Dormition*) 228, 378, 379, 478
The funeral procession of the Virgin 378, 379
The assumption of the Virgin (*Assumptio Corporis*) 045, 072, 416, 460, 525, 526, 564
The blessing of the Virgin by Christ 230
The crowning of the Virgin
 – by the Trinity 048, 478
 – by God the Father and Christ 525, 526
 – by Christ 229, 322
 – by two angels 463, 525, 526
The apostles, see: Saints
The Last Judgement 133, 196, 345

Other religious subjects

The Trinity 048, 090, 107, 134, 135, 220
The sacred monogram IHS 108, 109, 110, 111, 126, 211, 469
The Lamb of God (*Agnus Dei*) 101, 419
The infant Jezus
 – blessing (*Salvator Mundi*) 417
 – with a bird 050, 051
 – with the instruments of the passion 202
Vera Icon (St. Veronica with St. Peter and St. Paul) 419
Christ as Savior 052, 245, 246
The sacred heart 469
 – The sacred heart and the wounds of Christ 108, 211, 388
Holy Spirit (The Holy Ghost Represented as a Dove) 049, 050, 109

Virgin and Child
 – alone 073, 074, 075, 076, 077, 082, 172, 173, 208, 248, 249, 250, 251, 252, 358, 385, 386, 436, 528
 – in mandorla, on the crescent 079, 080, 137, 388, 402, 453, 471, 475, 477
 – in a glory 387, 476, 478 (see also: Virgin and Child on the Crescent)
 – in a Glory with Saint Catherine and St. Barbara 084
 – on a rosary (*Marianum*) 388, 478
 – enthroned, adored by a pope and an emperor 525, 526
 – with St. Anne 087, 088, 204, 348bis, 389, 417, 573
 – with the family of St. Anne 190
 – with St. Bernard 092
 – with abbot Ludwig 163, 164, 165
 – on the ship of St. Ursula 105
 – with four Saints 085
 – with the annunciation and four saints 078
 – with an angel 081
 – with two angels 289
Mater Dolorosa, see: The lamentation
The Virgin with Christ 155
The Fifteen Mysteries of the Rosary [044, 045], 148v, 388, 478, [525, 526 (?)]
Ecce Panis Angelorum 112
Two puti 484, 485, 505
The miracle of the knights 478

Saints

St. Adrian with a monk 086
St. Agate 203, 418
St. Agnes 199, 418
St. Ambrose 574
St. Andrew 255, 393, 448
St. Anne, the family of St. Anne 190
St. Anne, the Virgin and Child 087, 088, 204, 348bis, 389, 417, 573
St. Anthony 078, 168, 265, 299, 300, 399
St. Antony tormented by demons 266, 340, 341, 399
St. Appollonia 418
St. Aubert of Cambrai 089
St. Augustine with the Child and the Trinity 090
St. Barbara 084, 085, 091, 138, 139, 200, 205, 406, 407
St. Bartholomew 261, 321, 396
St. Bernard of Siena 136
St. Bernard with the Virgin and Child (*Lactatio*) 092
St. Catherine of Alexandria 078, 083, 084, 085, 140, 141, 201, 274, 355, 360, 361, 409, 478, 554, 563(?)
St. Catherine of Siena 093, 417, 478, 525, 526
St. Christopher 153, 169, 267, 439
St. Clara 136, 417
St. Cosmas and St. Damian 417
St. Dominic 417, 478, 525, 526
St. Dorothy 085, 142, 148, 418

St. Elisabeth 094, 095, 408, 418
St. Emerantia 096
St. Erasmus 197
St. Eulalia of Barcelona, see: St. Eulalia of Mérida
St. Eulalia of Mérida 478
St. Francis 136, 329, 417
 – St. Francis with a Nun 097
St. George 268, 268v; 319, 555
St. Gregory (the mass of) 098, 143, 198, 400, 401
St. Hubert 099, 154
St. James the Greater 134, 135, 256, 394
St. James the Lesser 264, 337, 395
St. Jerome 003, 102, 134, 135, 474, 511, 527, 556, 567
St. John the Baptist 078, 101, [176], 269, 359, 442
 – The Head of St. John the Baptist on a
 Platter (*Johannes in Disco*)100, 359
St. John the Evangelist 257, 270, 394, 402 (see also:
 Crucifixion)
 – Symbol of St. John (Eagle) 150, 155, 419
St. Judas Thaddaeus 107, 259, 398
St. Lawrence 176, 301, 403
St. Lazarus Cedonius 131
St. Louis (king Louis IX of France) 034, 524
St. Luke
 – Symbol of St. Luke (Ox) 150, 155, 419
St. Lucia 078
St. Marcella 131
St. Mark
 – Symbol of St. Mark (Lion) 150, 155, 275, 419
St. Margaret 085, 410
St. Maria Magdalene 418 (see also: New Testament)
St. Martha 131
St. Martin 271
St. Matthew 262, 338, 397
 – Symbol of St. Matthew (angel) 150, 155, 419
St. Matthias 107, 398
St. Michael 144, 193, 209, 272
St. Ontcommer, see St. Wilgefortis
St. Orathea, see: St. Dorothy
St. Paul 254, 326, 419
St. Peter 191, 192, 253, 336, 393, 419, 448
St. Peter Martyr 149, 478, 525, 526
St. Philip 260, 391, 396
St. Sebastian 273, 327, 404
St. Severus 103
St. Simon 263, 339
St. Stephen 405
St. Thomas 258, 390, 395
St. Thomas Aquinas 478, 525, 526
St. Trudo 104
St. Uncumber, see: St. Wilgefortis
St. Ursula 362, 371, 417
 – The ship of St. Ursula 105
St. Veronica with St. Peter and St. Paul 419
St. Vincent Ferrer 478
St. Wilgefortis 106

Abstract ideas (see also: Mythology)

Abundance 496, 497
Adversity (?) 495
Arbor Porphiriana 145, 146
Death 113, 432, 504(?)
Dance of Death 420
Envy 520
Fall of Ignorant Humanity (*Virtus Combusta*) 544
Love 498, 507, 519
Peace 496, 497
Rhetoric 522
Woman with the owl (The light of Truth, the end of
 Darkness ?) 367, 368

Mythology

Amor 498, 507, 519
Bacchus (and bachanal) 490, 493, 494, 530, 531, 569
Hercules 546
 – Hercules and Antaeus 542, 545
Mars 492, 506(?), 507
Medusa 502
Mercury 489, 490, 523
Neptune 488, 489, 532, 533
Rhetoric 522
Satyr 558
 – Combat between men and satyrs 553
 – Landscape with sheperd and satyr 560
Sea gods 532, 533
Terpsichore 521
Venus 500, 508, 566
Battle of naked men 565
Allegory with an old woman 501
Women dancing 482, 483, 543
Panel of ornament with mythological caracters 502,
 509

Literature, history and legend

Aristotle and Phyllis 328, 370
Lucrecia 433
Nine Worthies 114-120, 121, 122-125
Alexander and the high priest of Jerusalem 574
Triumphs of Caesar 536-541
St. Ambrose and the emperor Theodosius 574
Gesta Romanorum (13th.-century) (The dead king
 and his three sons) 369
Dante 512-516
King Louis IX of France (St. Louis) presenting a
 thorn to Bartolomeo de Bragantiis, bishop of
 Vicenza 524
The war of Switzerland 346
The lifting of the siege of Neuss 372

Rhetoricians' chamber of Nieuport (1491) 206, 212
The ball (Festive occasion in the Munich palace of
 Albrecht IV of Bavaria, 1500) 365
The tournament (Festive occasion in the Munich
 palace of Albrecht IV of Bavaria, 1500) 366
Two (unidentified) philosophers 552

"Portraits" (see also: Liteature, history and legend)

Arthur (king) 124
Bartolomeo de Bragantiis (bishop) 524
Charlemagne (emperor) 116, 117
Godfried of Bouillon (crusader) 125
Hector of Troy (Trojan hero) 118, 119, 120, 122
Innocent VIII (pope) 478
Ludwig (abbot) 163, 164, 165
Louis IX (king), see: Saints
Mary of Burgundy (duchess and countess) 510
Pelbartus of Themswar (franciscan) 150
Portrait (?) of a man (bust of a warrior) 506
Portrait (?) of a woman 481

"Genre" (see also: Literature, history and legend)

Men:
 – Bust of a warrior 506
 – A miller with two donkeys 279
 – A man seated on a stump 499
 – A man seated by a palm tree 557
 – The young shepherd 561
 – Two old men reading 552
 – Two Moors (or Turks) in conversation 280
 – Four soldiers 363
Women:
 – The woman with the owl (German folksong ?)
 367, 368
 – Two women and a skull 504
 – Women dancing 482, 483, 543
Men and Women:
 – Couples: 126, 356, 364, 422, 425-430, 432, 434
 – The morris dance 431
Children:
 – Two children (Puti) 484, 485, 505
 – Children's bath 421
 – Children dancing 486, 487, 503
 – Children playing with a dog 479, 480
Family:
 – Peasants going to market 281
 – Children's bath 421

Animals (see also: nativity, saints, heraldry, ornament, symbols of the evangelists)

ape 126, 305, 424
camel 124, 127
cock 523
deer 099, 127, 305
dog 323, 479, 480, 547, 563, 565
 – dog eating a snake 569
donkey 089, 279
dove, see: Holy Spirit
dromedary, see: Camel
elephant 127, 129, 284, 536, 537
falcon 126
fox 305
griffin 283
heron (?) 129
horse 099, 114-123, 128, 281, 343, 366, 369, 423, 488,
 489, 532, 555, 565
leopard, see: panther
lion 127, 275, 491, 511, 527
ostrich 127
owl 305, 367, 368
ox 536, 537
panther 127, 558
parot 050, 051, 250
peacock 127
pig 282
rabit 050, 051, 085, 090, 305
turkey 129
unicorn 127, 129

Objects and architecture

Alphabet 440
Bisshop's crosier 289, 436
Censer 290
Gothic house and a standing couple 356
Interior of a gothic church 163, 165
Lemmet of a knife 503
Monstrance 333, 334
Ship 105, 330, 511
Street with buildings 548-550

Heraldry

073, 155, 206; 210v, 212, 285, 286, 287, 320, 331, 347,
348, 434, 435

ILLUSTRATIONS

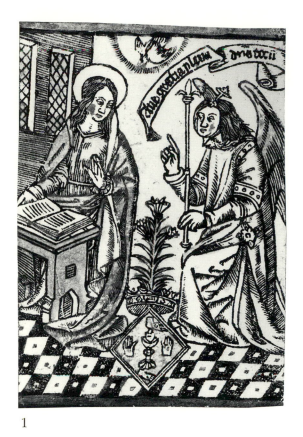

2

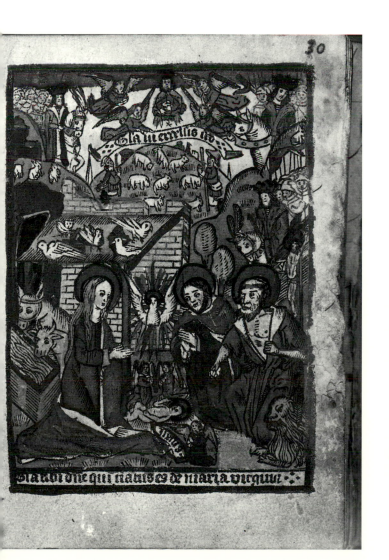

1

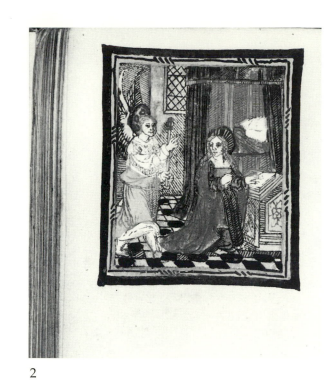

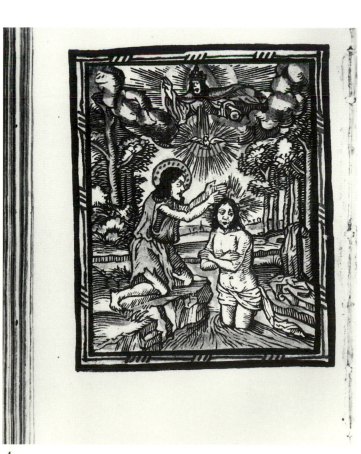

4

5

6

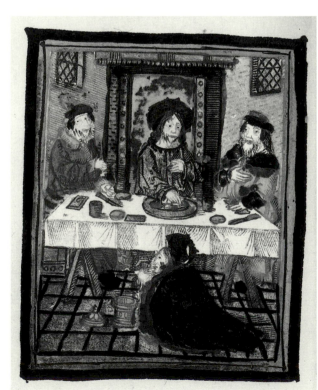

7

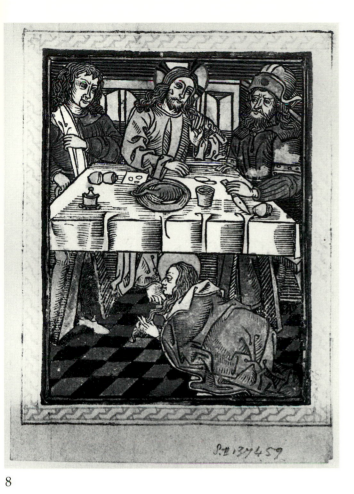

8

ñ noteat hoshũ gua̅ꝑ ⸫ ſꝫ ſoꝯeam̃ reꝗꝫ te
li teꝗm̃ ameꞃ.

9r

9v

10r

fleam. tu maria magdalena te per
fecte diligam. tu latrone pendente i
crucis patibulo te etñaliter videre
valeam. Amen. Vrban9 pp dedit ad
pscriptã œoz tu deuo tione dicti
bz ïdulgẽtias. xv ãnoz. Xde morta
libz. 7 v̈ rïïi. de venialibz. tu e̊
carenis.

[seal]

Jncipiut tentũ meditationes paſſi
onis dñi ihu xpĩ ꝗ b quilibet deuotᵒ
triſti diſcipulus quottidie debet deuo
ta mente pſoluere. at in eisdem dño
suo se ꝛformare.
 Dũtis diebus.

 3

10v

ghe v̈dientẽ dat yhn mynder
ontfermt eñ my alle myn son
den goedtierelyc v̈gheeſt Amẽ

11

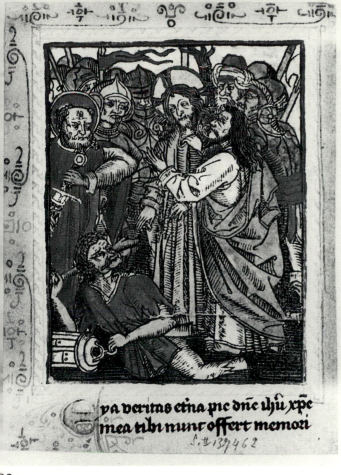

va veritas etna pie dñe ihu xpe
mea tibi nunt offert memori

S. # 139462

matina cõpacietia pietate dolet ꝑ pectoꝛ
lugubriter te aspexit Aue benigniſſie.
O mea vnica Dõ exaudi oroez oro
ſingulaꝛis fiducia pyſſie ihu xpe
hoꝛ hodie bonitati tue miecia repíto.
vt in oi tbulacioe ꞇ ãgꝰ. pena in pieta
te ſuceꝛas. a pectoꝛ viculis me abſolua.
ꞇ ab occultis delictis ꞇ manifeſtꝰ vicioꝛ
ſcũdalis me cuſtodias. ab iſidioſis dy
aboli ſuggeſtioibꝫ cũ etiſꝫ crimino
ſis occaſionibꝫ liberes ꞇ defenſes. ꞇ tuu
matriſꝫ tue doloꝛibꝫ intima py amo
ris affectione me facias adolere. pyſ
ſie dõ ihu xpe qui cũ pre ꞇ ſpu ſcõ viu
es deus oĩs in ſecula benedictus. .V.

.VI.

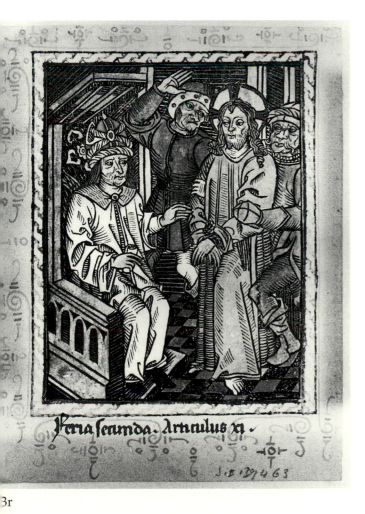

Feria secunda. Articulus xi.

S. # 139463

maiſſie. ſudoꝛ tuu ꝓcioſiſſim. atꝫ glo
ſiſſia paſſio tua. vulnea ꞇ moes tua. ꞇ
bñdis ſaguis vulneꝛ tuoꝛ .V. Dõ ex
audi oroez mea. Et da graio
Õ ſpes ꞇ aſolaⁿ mei coꝛdis pyſſie
theſu xpiſte ꝑ horribile tue crucifixi
onis ſententia ſiupliciter te exoꝛo. vt
in hõ moꝛtis mee mite iudiciũ meũ
agas. Doce me mũdi honoꝛes cõtẽp
nere. ꞇ tibi fideliter. prudenterꝫ ſer
uire. Pctoꝛ meoꝛ vulnea. tuis me
doꞇeas aſolidae vulneibꝫ. Non me
ihu bõ itenta ois tpe delinꝗꝫ. qui me
cauſa crꝯ tuu ſaꞇimũ tot ſpinaꝛu
pũctionibꝫ obierꝛiſti. da aute in dñe
doloꝛ tuoꝛ amatoꝛia ſp recoꝛdai ꞇ pro
meo modulo crucifoꝛmẽ vite tue re
pendere paſſioni pyſſime theſu xe.
Qui cũ pre et ſpiritu ſancto vnus
es deꝫ in ſecula benedictus. Amen

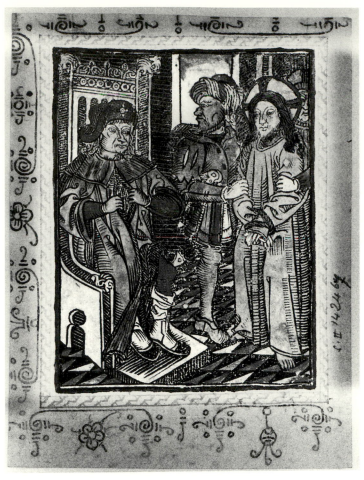

14r

spiritus amoris z timoris tui ne audi
re cupiant linguam nequã. verba
vana maledica seu detractoria pro
ferentem. odoris illecebram et inordi
natum carnalium suauitatũ in me
extingue penitus. appetitum fac
me quoq domine de oblectamentis
ciborũ z potuũ non curare. sed da
michi obedientem et humilem in
tuo sancto seruicio voluntatem. vt
mea propria voluntas sub tua sanc
tissima voluntate humiliata dign
habear tuorũ annumerari deuotoꝝ
collegio famulorum. et in hac vi
ta tibi humiliter seruientiũ. et in
aula glorie eternaliter benedicenti
um et laudantium deum in secula
gloriosum. Amen.

Articulus xvij

14v

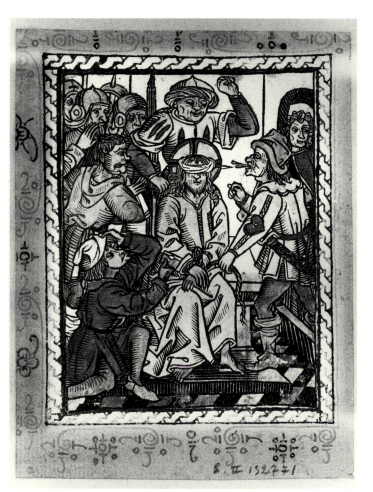

15r

effuescere. et ob tue crucifixionis
reuerenciam has amare. da et michi
t domine prauorum mores et in
solencias pacienter et humiliter
tollerare. contēptus et contumeli
as pro tui nominis gloria non me
tuere sed potius affectare. omnes
animi mei amaritudines et tristi
cias in tue pietatis dulcedine dul
corare. et carnales concupiscencias
et omnes in me corporales illecebꝭ
ob tui amorem mortificare. qui me
t gratia mortem crucis subire mini
me dubitasti. benedictissime ihesu
xpriste deus verus laudabilis et
gloriosus et super exaltatus in se
cula seculorum. Amen.

Articulus xxi.

15v

6r

opto domine totum corpoeis et anime
mee posse truti tue inseparabiliter
affigere. et omnes affectiones meas
inte amoris anchora quietare. fac me
queso pie ihesu impotentem meas
malas contupiscentias exequendi.
fortem at vegetii promendi. cogita
tatus meos in tuos amarissimos
cruciatus aduersus potentiam mo
lientium me separare a te meo diui
nissimo salutari in secula benedic
to Amen.

Feria tertia. Articulus xxvi.

16v

7r

Eya agnus innocens demetissie ihu xp
o silis apparuisti. dum me scelem
tos crucifoemiter pependisti. Aue xxxij.
A sinistro maligno se et explante latrone
iuste blasphemy fuisti. Aue b xxxiij.
A dexte aut penitete latine excusaty voca
ter. et excoraty huile cetristi. Aue xxxiiij
Qu veo pyssie ihu oia illi trimia remi
sisti. Aue benignissie. art xxxv.
Qu illi ramui padrsi misericorditer a
periusti. Aue b Do exaudi Oratio.
O rex amirabilis bonor otiu largitu
do diuinissie ihu xp. hodie moete
tuu mocente per mea nocetissia vita
pys celestis pris espectibs reputo. no
li me obsecro dne ob mea multa et gndia
trimia edepnare. clamo pettator petes
cu latrone deuotissie penitete. meme
to mei dne in regno tuo. oia itaqs ni pi
e ihesu pettata dimitte et tuu celestem
aperi paradisu. vbi te beati omes lau
dant et gloeificant metinu. Amen. xxxvi

17v

18r

meditacione tue benedictissime pas
sionis compuctozie adinare. et truci
formiter octupare et vt nullum sit
cozpozis mei membrum quod non a
liqua exe parte parte passioni tue sen
sibiliter confoemetur. concede michi
quo eß bone ihesu vt in laude tua. tu
oeß diuinissimo famulatui nuuqz in
tedium subzepat. sed in hoc michi
pax et requies suma consistat. da et
michi domine delectabilem appetitu
in tuis sacris sanguinolentis vulne
neribus demozandi. vbi in omni t
bulacione et tedio cozdis mei recreaci
onem accipiam salutarem. Qui cu
patre et spiritu sancto vnus es deu
in secula benedictus. Amen.

Articulus xxxi.

18v

19r

Heu ihu piissime flozidu cozp tuu istipi
te cruc pedes p cruciatibz nimijs marte
tebat. Aueb. O iesu tuu ten
met lassu du xx
ro cruc redinato incubebat. Aue xxxii.
O cozp tuu satri penosa lassitudie pode
rosu peduli nimia ad vma vgebat. Aue
Carne tua dulcissiaz vulni inumer do
lose ledebat. Aue Heu oia pie ihu coe tu
u diuina caritate plenissi amatissie pfe
rebat. vt sit tui inotescet nob amoe imesb.
Oscreani sapia Aue. Do exau. oracio
ihu x tui itruce pendes p cruciatu
nimio cozpis marte. sit m obser intua
gra flozes viroz. tua iimitiad truc stipite
cozpal rediacl. sit m ite spiual qeta. tu
eß pode osi cozpis declinatio dolosa. sit m
btute apice exalta grandiosa. carnis tue
vulnea q doloes ptox i me sanet vlcem
roeß aie mee sedet merces. coe eß tuu ama
tissi meu ihu bone diuio iertinguibili
arcendat amoze flamescente in vitam
eternam Amen. Articulus. xxxvi.

19v

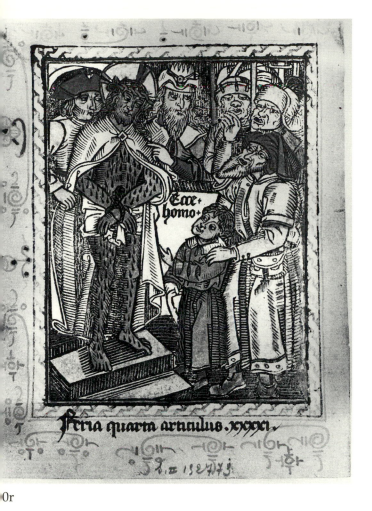

22r

hominum ĩ prudencia . da michi mã
suetudinem taciturnam ob tue reue
renciam et amaritudinem dire mor
tis que michi per iugem meditatio
nem in corde in eradicabiliter sit plã
tata . in ore per frequentem oratoñe
in fatigabiliter recitata . in toto corpe
per sanctam operationem indelebi
liter figurata . Amen .

quãq̃ gesim artis

I 4

23r

Elargitatẽ dõ cordz tui dũ in cruce pen
des . solus tue dilaissie mũs cor mestissi
ãgztebas . Aue benig . Articul . lij .
Tristissiã ex aĩa ꝯ gestz nimiũ lugu
būdz tuiĩ t dõ martiriũ duplicabiũt .
Verba ipsi ĩgrula ꝯ Aue . articul . liiij
miserã dissi lamẽtatz cor tuũ tenerri
disserebãt . Aue arᷓ luj Cz ihõ nĩ
t extine ꝯ separaiois itollerade ꝯsolatoẽ
ei dilctĩ dist ĩ idz idiuisti vgiẽz v gi sb mir
fide cõmedãs Aue arᷓ lv Iassim
q̃ dist ĩ vgiẽz mir . vgi sb filiali fide stiᷓ
cõmedasti . Aue . Dõ exau . oratio
Dultissie ihu xᵖ me letalit truasix
e . cõmedo me hõ tue sãssie fidei ꝯ securis
sie custodie pissie tue mũs sᷓ illꝰ dist
tu pdilũ q̃s vtroᷓ ĩ cruce pedes ob ꝓga
tiᷓ castio cœpis ꝯ aĩe sigulare tᷓẏ inter
ꝯ filiũ idissolubilᷓ fedẽasti vt tu cõmis
sioẽ me ꝯ ī hac vita fideles cõmissarij
tueãt . ꝯ ihõ mortᷓ sĩs pribᷓ recõsili
ent . et ad vitã eternã pducẽt . Amen

I 3

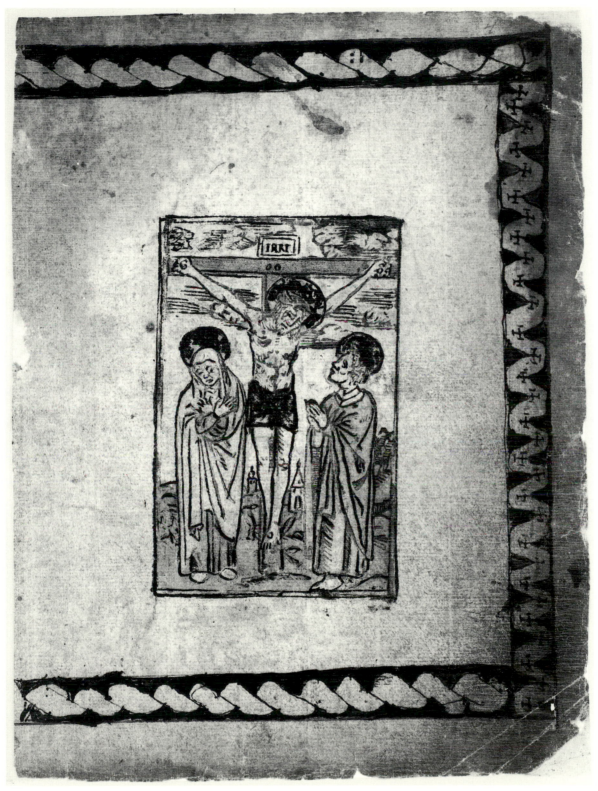

24

26

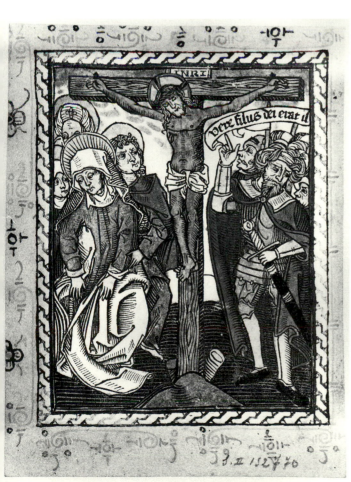

28r

amaritudines passionu̅ virtutu̅
tranquillitate dulcoret. da michi do
mine ut in sensu recto et bonis actib;
usq; ad mortem stabilis p̅ seuerem. a
a tue obedientie semita nu̅q̅ disceda̅
in manus tuas pie ihe̅su meu̅ sp̅m
nu̅c comendo. ut post hanc uitam
a te letanter suscipi merear. ama
ram mortem tua̅ dn̅e pro patris tui
conspectu represento pro p̅c̅is meis
dignissimu̅ placamentu̅. infinitu̅
meritu̅ tuu̅ ihe̅su bone meas p̅ ce
exiguas operunculas patrie mate-
stati tam delectabiles faciat et accep
tas. ut in ip̅so diuorcio corpis et ani-
me mee ita michi reatus ois. et o̅ne
debitu̅ dimittatur quo instar dile-
tissimo̅r tuor̅ a morte ad uitam tra̅
seam sine mora. Amen.

lxxvi. articulus.

28v

29r

o auisa durus labor quem mei cm
ihesu pyssime pertulisti. suaui me
soueat resrigerario raritaris que nes
tit laborem. et quia tibi domine tan
torum extiti tmisa labor. obseruo vt
dulri amoris vnione tibi me facias
adherere. vt vnus effici terum spiri
tus ineternum Amen.

18

29v

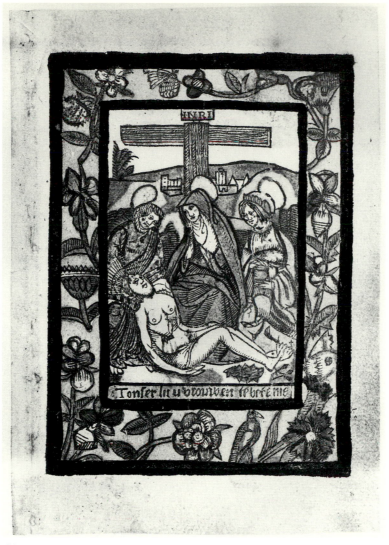

30

32

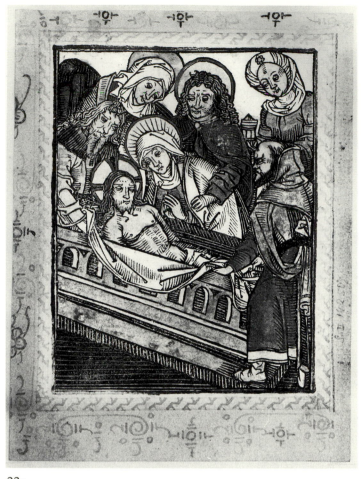

33r

tissime ihesu xpriste tue benedicte hu
manitatis vellere peccatorum meorum ob
secro maculas deleas. debitaque psoluer
ne sictis oculis de tua inocua morte
pensare me sinas sed tibi compati et om
bus in neccib: constitutis pie condole
me doceas. O deus ompotens discer
ne deprecor mentem meam ab homib: munda
nis et vanis terrena oblectamenta que
rentib: externam pulchritudinem magni
pendentib: et seculares honores dilige
tib: huicque misello vermiculo ad eter
num illum honorem tribue venire quo
te cum electis tuis in celi regno laudem
et glorificem in eternum. Amen.

33v

34

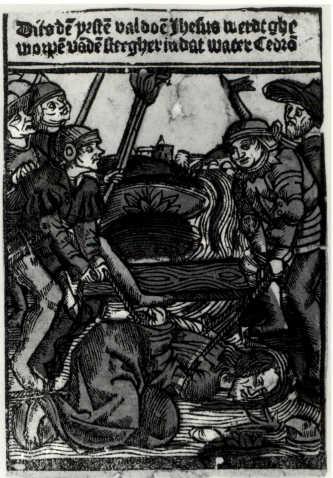

Dits dē yrstē val doē Jhesus werdt ghe worpē vādē stergher iudat water Cedrō

35

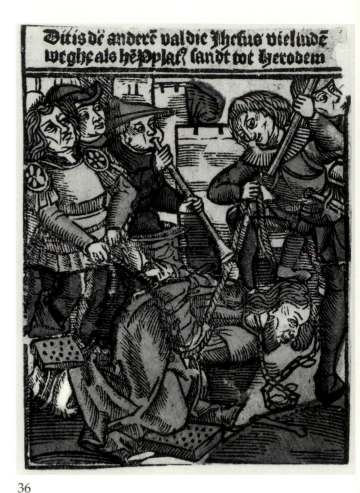

Dits dē anderē val die Jhesus viel indē weghe als hē Pplaks sandt tot Herodem

36

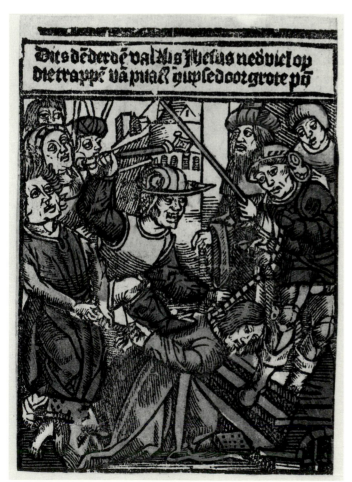

Dits dē derdē val Als Jhesus nedviel op die trappē vā piaks gupsed oor grote pȳ

37

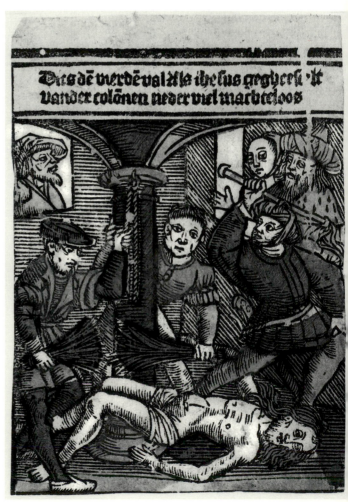

Dits dē werdē val Als ihesus gegyerst vander colōnen neder viel macrteloos

38

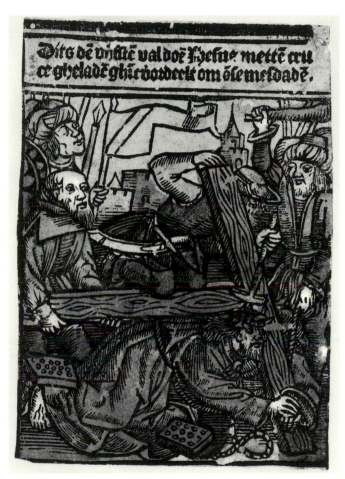

39

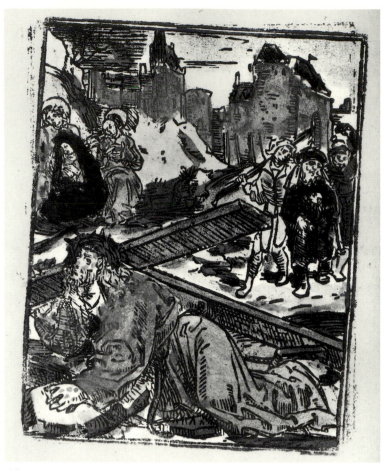

40

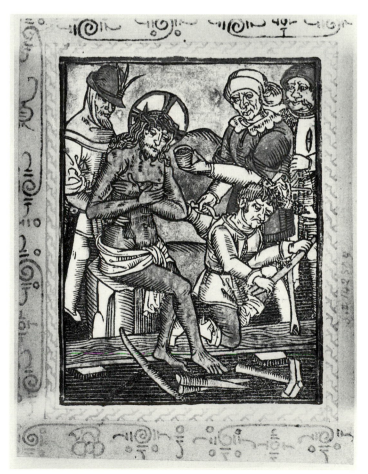

41r

mͤſedͤ; dulcediͤs ſupplicit´ exozcā. vt ī ſ
letali hozrula tua letantı pͤnͥcıa pͤſtruͥ
digͥnͤ͞ ſͥtıā. Nͣ uıd ıs tımere qͣ ıllı nocere
potͤrıt vͤgo mͤr pzo qͤ tu ꝓͥtͥcedere. qͤ tue
famılıe ānoͣtae dıgnāͥs. Dͣ mͤeͣ ıgͥtur
ſıngulāͥs ꝛ ſolacıo. clemͤēs regͥna ımpͤe
rıcͤlıtantſ meı ſuccurſu benıgnı͞t tunc
feſtına contra laruales demonıu facıes
me ꝛ ſıgna. a malıgnoꝛ hoſtıu͞ manͥ
bus me defenſa. ꝛ pterrıtu͞ dulcı ꝛ ſo
lacıone ꝛ fecta et mıſcͣbıles meos ge
mıtꝛ clemͤētͤr auſculta. tunc m̄ o dͤnͤā
manus tue largıſſıme mıͤecdıf erten
dant. tunc mea mıſera aͤıa a te be
nıgne ſuſcepta ſu͞mo ıudıcı vͥultu tu
o ro ſco pzeſentetur. ꝛ eterna ın celo
beatıtudıne munͤeretur vbı dılectı ſı
lıᷓ tuı glͤoͤrͥoſam facıem deͤtatſꝛ tue
ercellentıſſıme gloͤrͥā dıgnıtatıs vıdͤe
valeat ın eternum Amen.

Cartıculus. lrrrvı.

18 15

41v

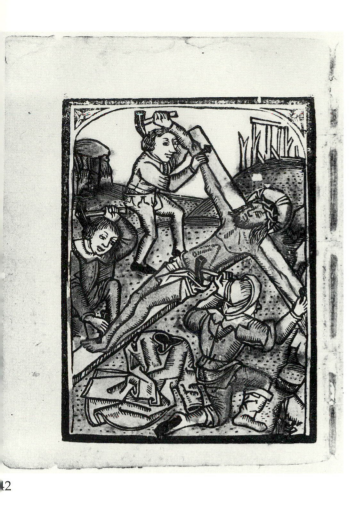

42

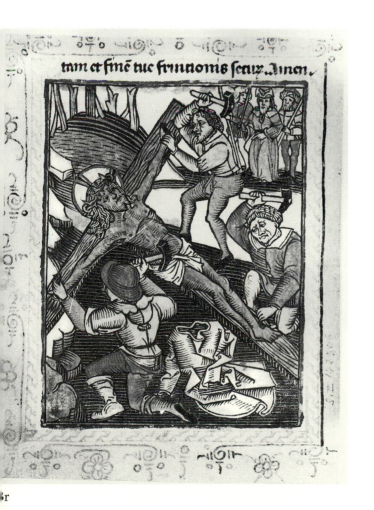

tam et finē tuc frantōis secuł Amen.

3r

43v

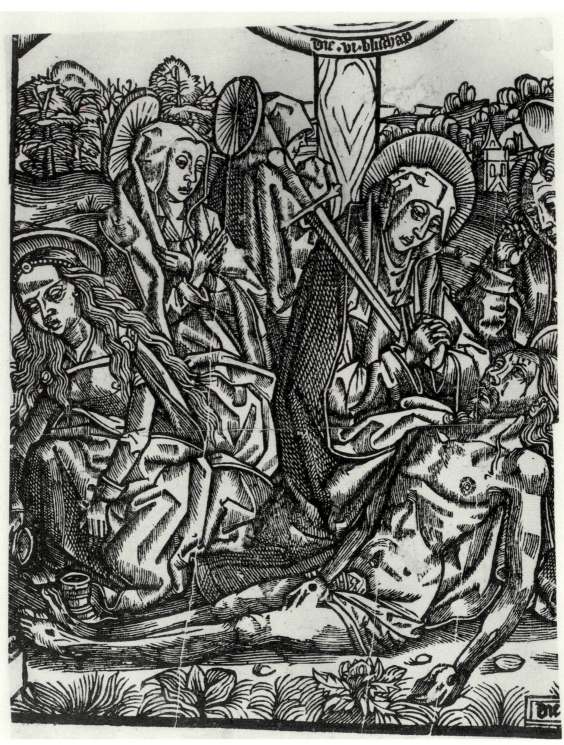

44

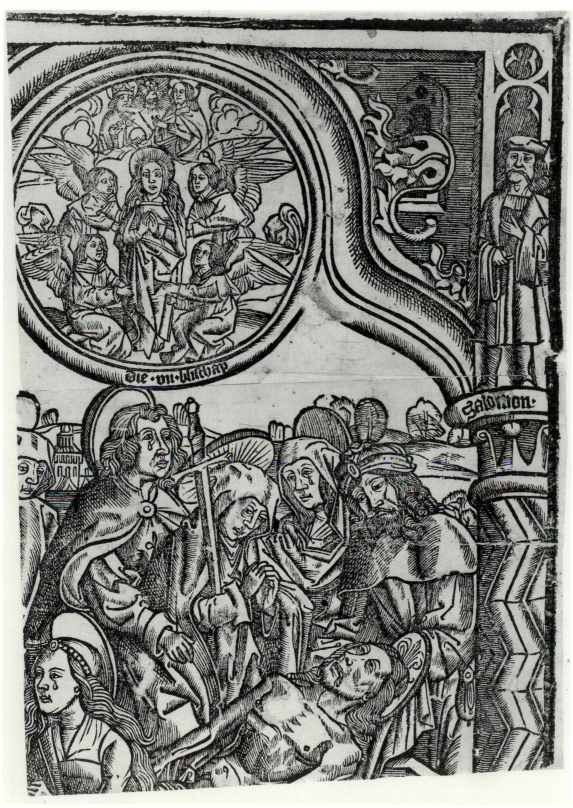

45

q̄ expectabam viatoribus vt educes hīt nocte

46r

te domis spo sc̄u illumines. vt tuā scissi
mā voluntatē impleā omībz diebz vite
mee. Amen.
Chabeř inquodā ex q̄ scūs calixty ꝫꝑ h̄
tria pater noster docuit que sequitur et
ex speciali pīate tōcessit vniuīcꝫ deuo
te dicēti. De pīmo pater noster lxxx.
ānos ꝫ dulgentiaꝝ venialuī pctoꝝ et
tpm pdītoꝝ. De secō similiter. lxxx.
ānos moztaluī delictoꝝuī ꝫ tpm pdītoꝝ
De terzio habentur mille carene.
Quotiens q̄ aluī docuerit ceoꝝ. ꝫdul
genc̄ie duplicabuntur. Insuꝑ est scien̄
dū qd sanctus iohānes euāgelista
reuelauit hanc ocōīonē tante esse ef
ficacie et veritatis sicut suī euāgeluī
scilicet In pīncipio erat verbū. aū
Dū rex glē xpͤs infernū debellaturꝰ
isseť ꝫ choꝝ āgeloꝝ an faciē eꝰ por
tas pīncipū tolli pīciperet scōꝝ ppͬls q̄ tī
batur īmoete captiuus voce lacryma
bili clamaueaͭ. aduenisti desideabilı

20 IL

46v

REGINA CELI LETARE

davide mr Vandebel I. 1779

47

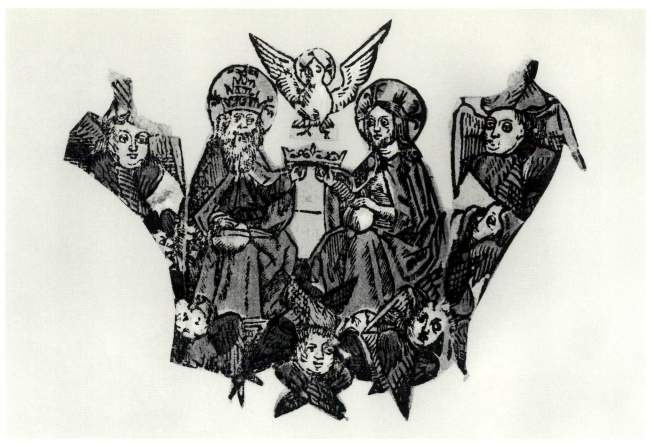

48

49

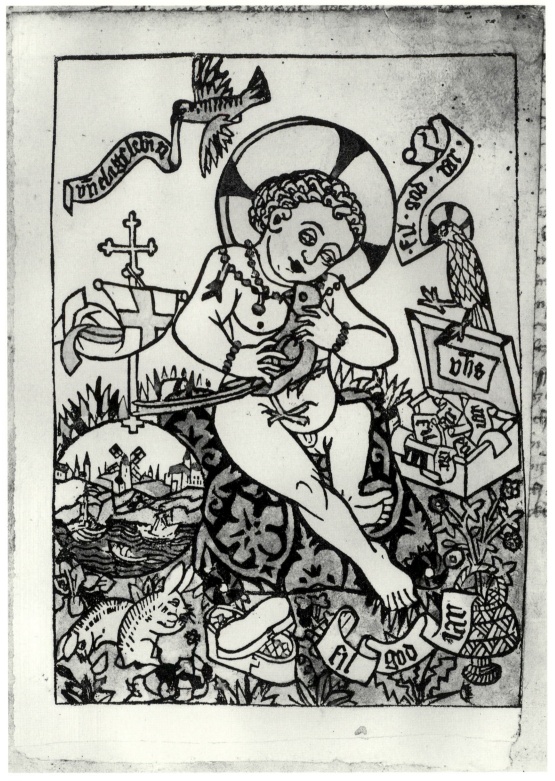

50

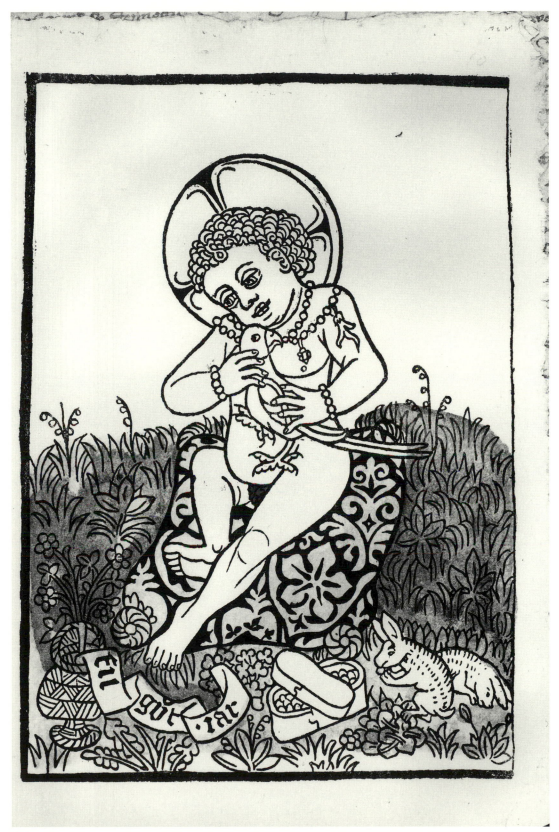

51

52

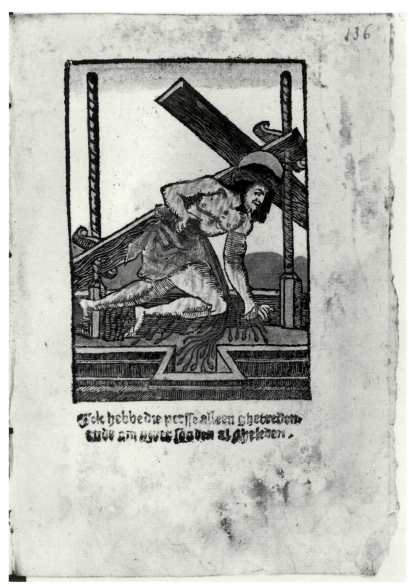

53

54

55

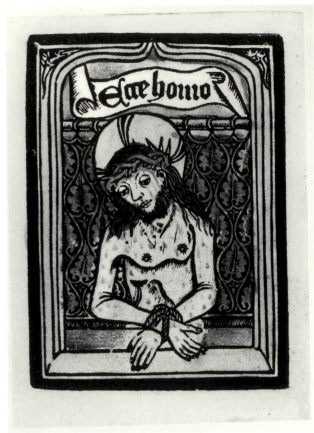

56

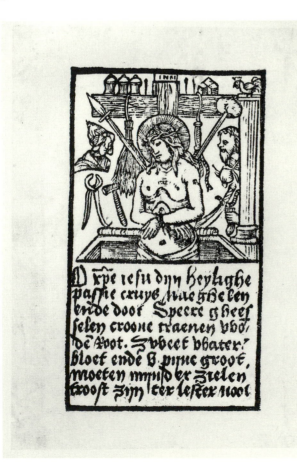

O xpe iesu dyn heylighe
paſſie cruys nue ghebelen
ende door Speere gheef
ſelen croone traenen vbo/
dē Root. Svbeet vhater
bloet ende b.pyne groot.
moeten mynd er Zielen
troost Zyn ter leſter noot

57

58

59

61

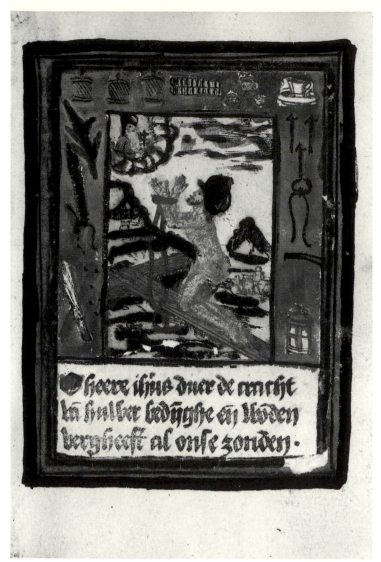

62

63

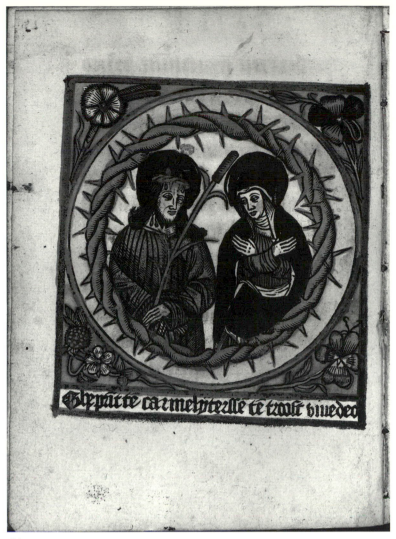

64

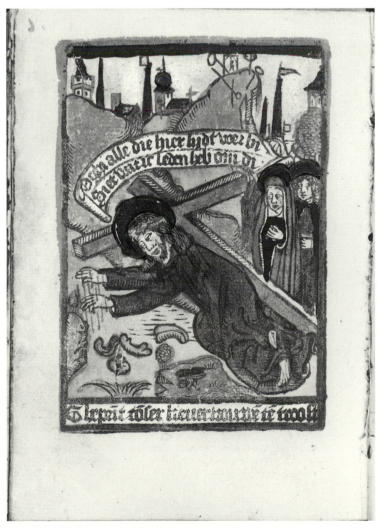

65

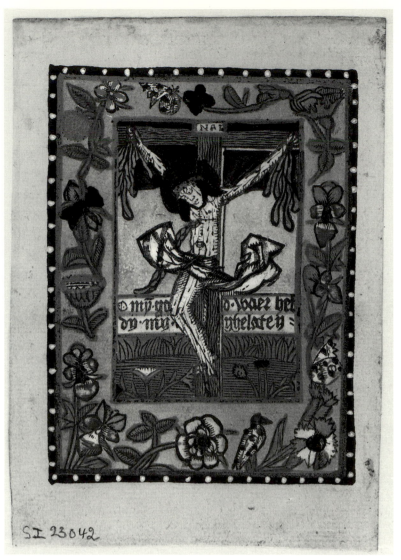

66

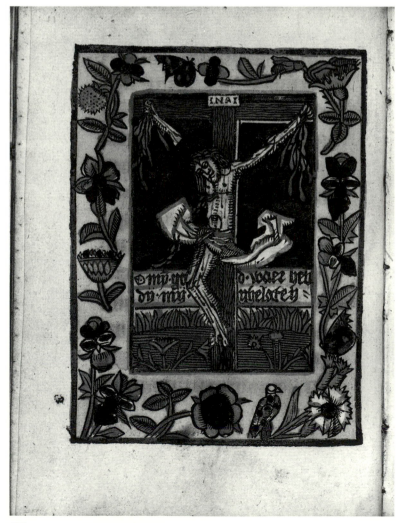

67

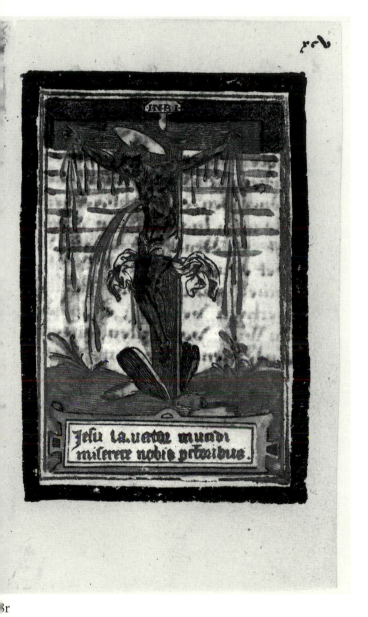

pr̄ n̄r doe rechter̄ voeth̄xpi

Ulder goedertierenst
heere Jhesu christi · Ich
dancke v voer die wonde dīs
rechteren voetk̄· Daer in
verberghe ich alle mijn sonde
ondueghden ondanckbaerheijt
Alle mijn luostheijt en̄ crauch
heijt · biddende v doer alle die
bloet druppen die daer vut ghe
ronnen quamen dat ghij mij
voertaen verlossen en̄ behoe
den wilt van allen sonden
Ende nemet van mij wat
v mishaghet · ende gheeft
mij wat v behaechlijch is
Amen v·· pater n̄r Aue o̔ā

Jesu la·vetor mundi
miserere nobis precibus·

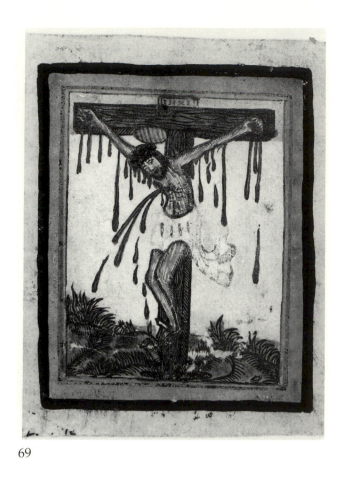

69

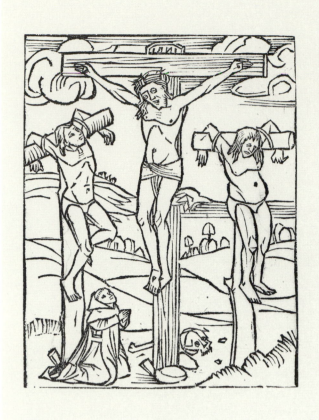

70

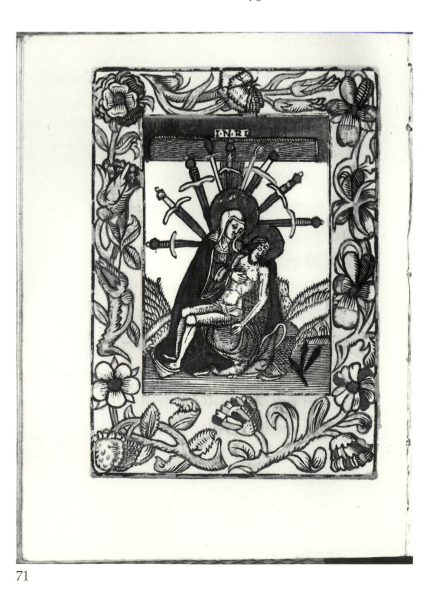

71

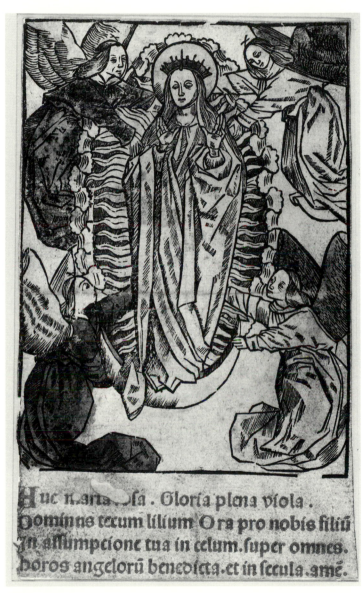

Huc maria osa. Gloria plena viola.
Dominus tecum lilium. Ora pro nobis filiu
Jn assumpcione tua in celum. super omnes.
horos angeloru benedicta. et in secula. ame.

72

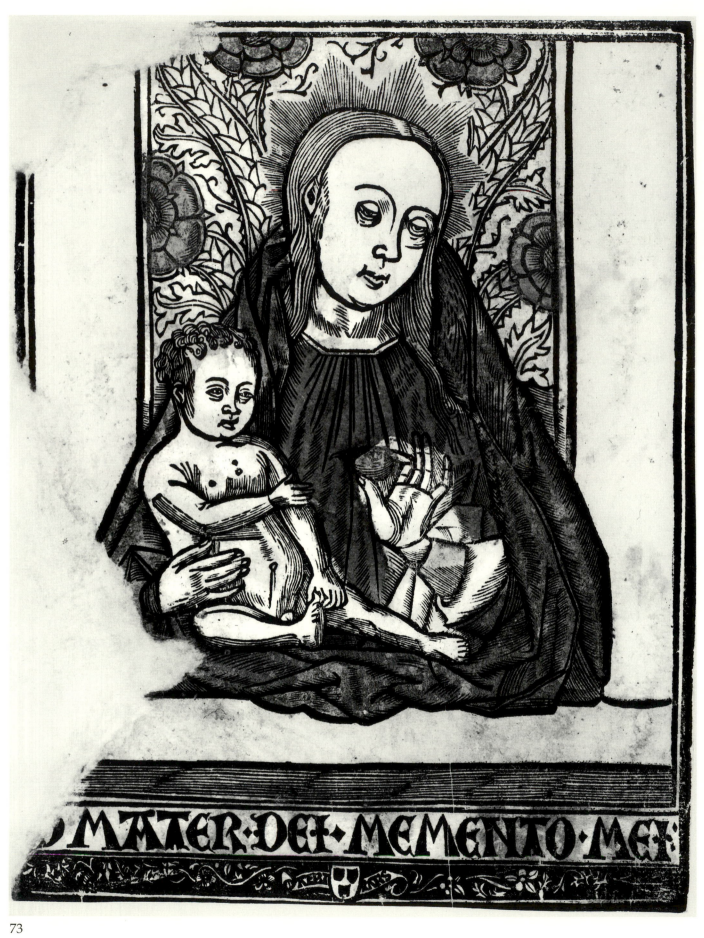

73

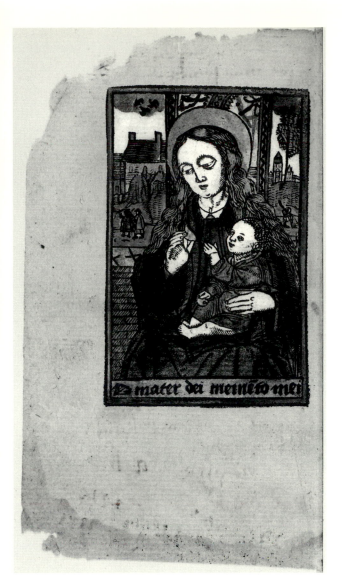

74

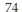

75

76

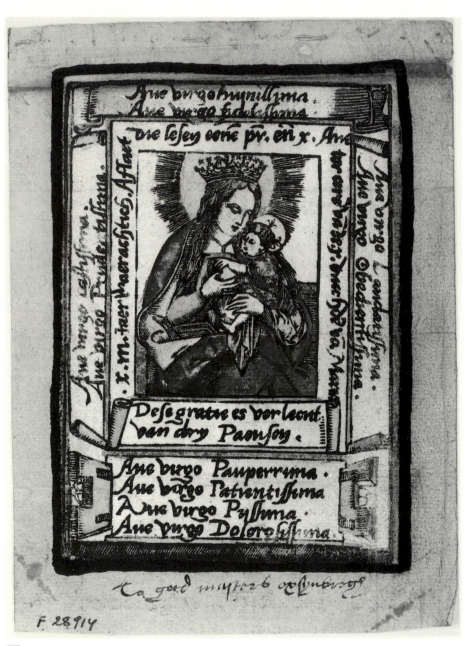

F. 28914

77

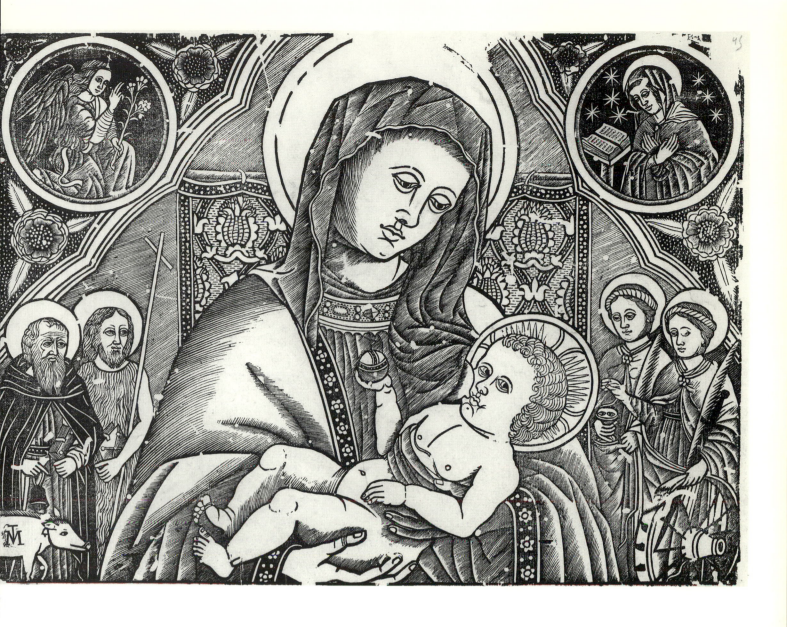

79

80

81

82

83

84

85

86

87

88

Sanctus oubertus ora pronobis ·

89

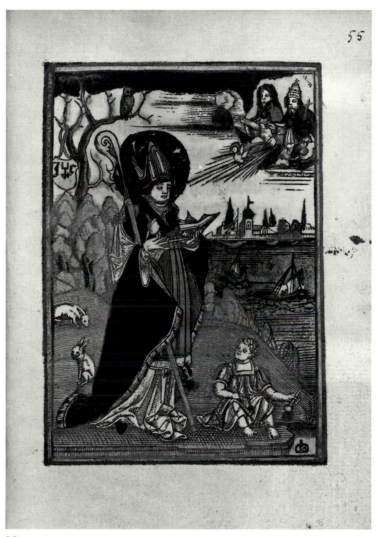

90

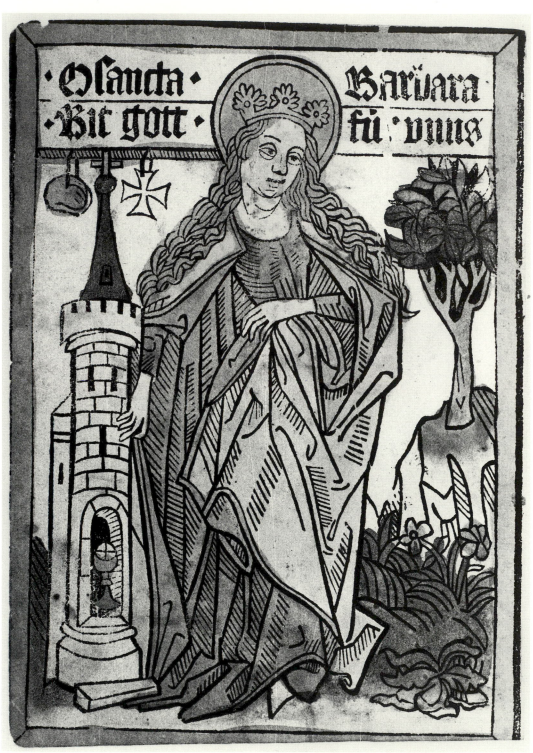

91

Confer uel vrouwe ten troost

S. Catharine de Sena, Ora pro nobis.
S. Cathalijne vander Senen / bidt

93

94

95

96

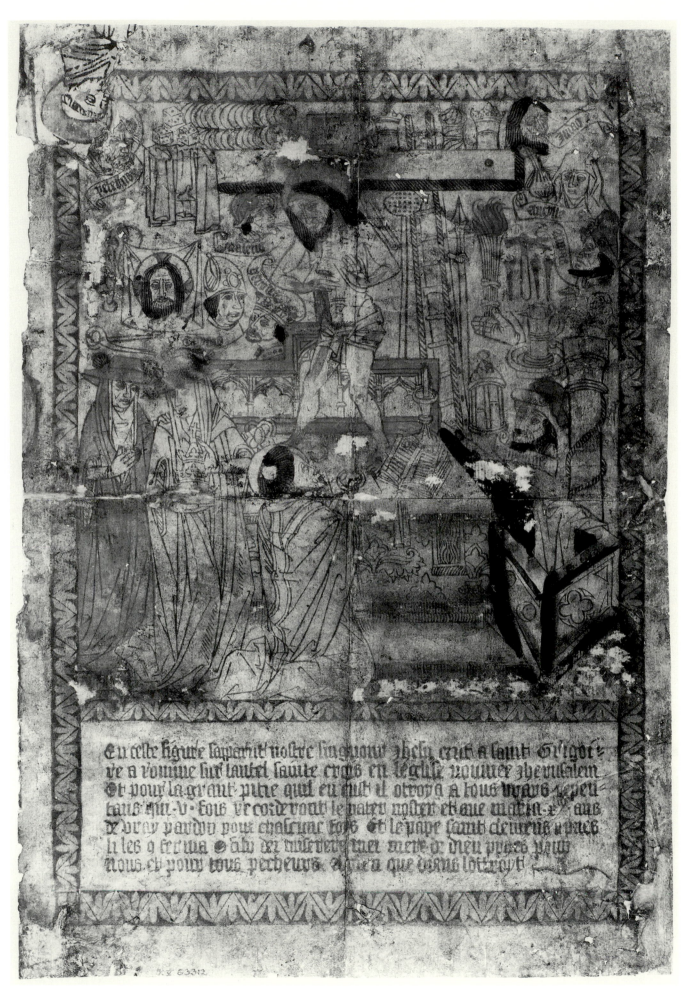

En celle figure sapperut noftre fingnour Jhelu crist a faint Gregoi=
re a romme fur lautel faute croys en leglise nomier iherusalem
Et pour la graunt pitie quil en eult il otroya a tous wrays repen=
tans xiiii.V. fois ve corde vout le pater noster et aue maria .x. ans
de vray pardon pour chascune fois Et le pape faint clemens apres
li les q fcriua . Ab dei misereris vuel mere de dieu prics pour
nous et pour tous pecheurs . Amen que dieus lotroyt

O heiligic iufroic s̄ hubert vn̄ andriē
beserrut al onse schone vnf sinnē.
voer die popelsi rasen m̄ plagr grot
en̄ voer die haastighē ouerlidē tōt.

99

100

101

102

103

104

105

Desen boeck heeft oerghefet Ibten Ibalsche in duytsche die
eersameghe en godurnchtighe Religieuse vrouwe Mar-
gareta bnillemöt ·saligher memorie die Ibelcke sterf
int jaer ons herre· a, cccc· en lbj·

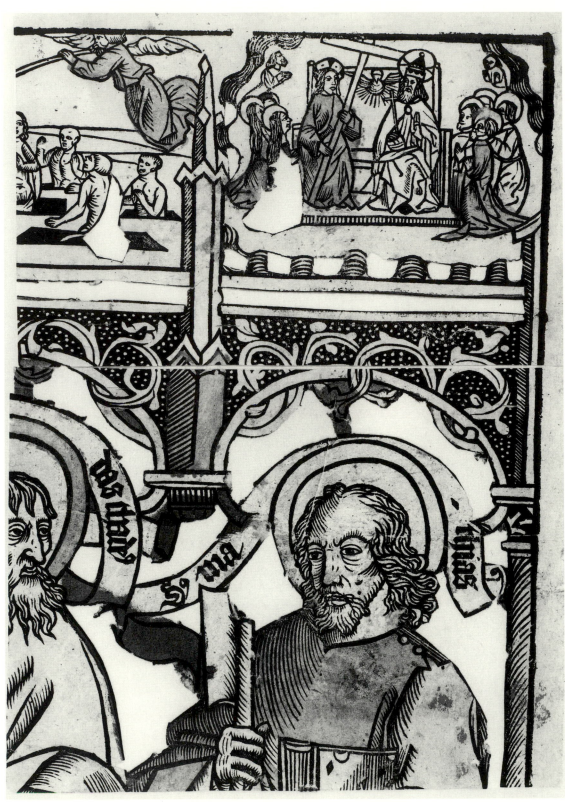

107

108

109

110

111

Och christen menschen hier in deser Cyborien
Is God ende mensch die coninck der glorien
Het leuende broot / neder ghedaelt warachtich
Wt den schoot zijns Vaders God almachtich
Daer doude Vaders naer hadden verlanghen
Dwelck die suuer maecht Maria heeft ontfanghen
Duer den heyligē Gheest / en is van haer gheboren
Die om te versoenene zijns vaders toren
Is voor v ghestoruen die bitterste doot
En waert dan niet ondancbaerheyt groot
Dat ghi den soone gods den heere der heeren
Die uwen pays gemaect heeft niet en soudt eeren
En hoomo·dich clappende soudt voorbi gaen
Met bedeckten hoofde / oft hertneckich staen
Sonder v knien eens voor hem te boogene:
Al schijnt hijt nv saechtmoedich te gedoogene
Als een lam / datmen zijn sacramēten veracht /
Hi salt soo zwaerlijck strauen sijt dies bedacht
Jnt laetste oordeel / daer hi hem sal vertoonen
Als een leuwe / en elcken nae sijn wercken loonen.

Dat ghi bidde voer die vanberghe wer hepusberch epswpch chaboch
nassouwe grobbendonch glimis zutsenboch Amen

IoAN:6:

Nicia muros castell marthe bethania ype wechliniam imstawue

EGO SVM PANIS VITÆ

año dm̄ mcccc lxxij

113

114

115

116

117

118

119

120

Hector van troien ·

Bij mij hector des conincx ... naem eerste gheborene sone de vrool...
ouder egeslachtde van troien w ... ren xviij · comminghe voor troien
te om paris mijns broeders wille de scone helene bescudde en w...
recht en de scoftierichede die de griecke mijnre moepe deden · maer...
ic hadde begonnen verradelic van Achilles verwonnen ·

124

125

126

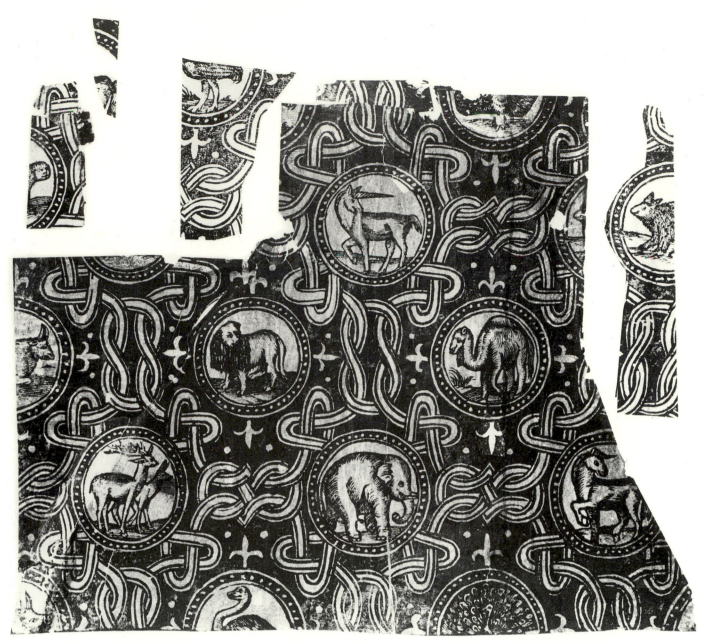

127

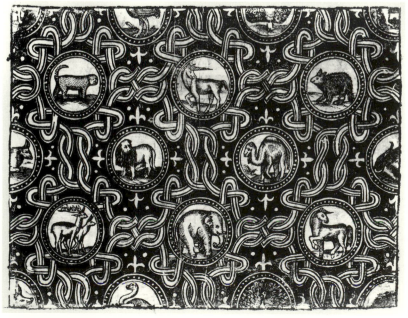

Decorative paper with animals: complete copy in the Collection of M. Jadot

128

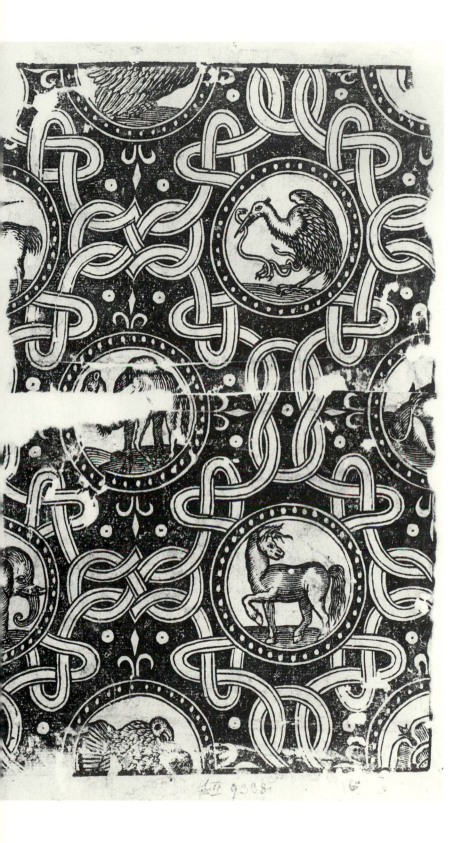

F 23297

130

132

131

133

134

135

134-135 copperplate recto

134-135 copperplate verso

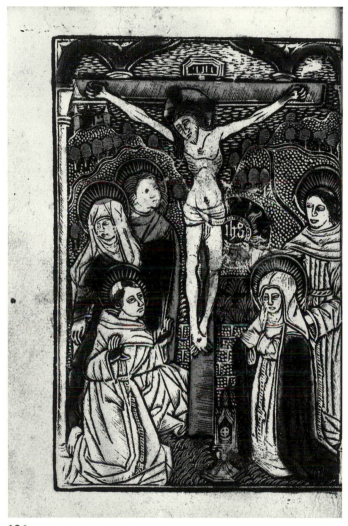

136

137

138

140

141

142

143

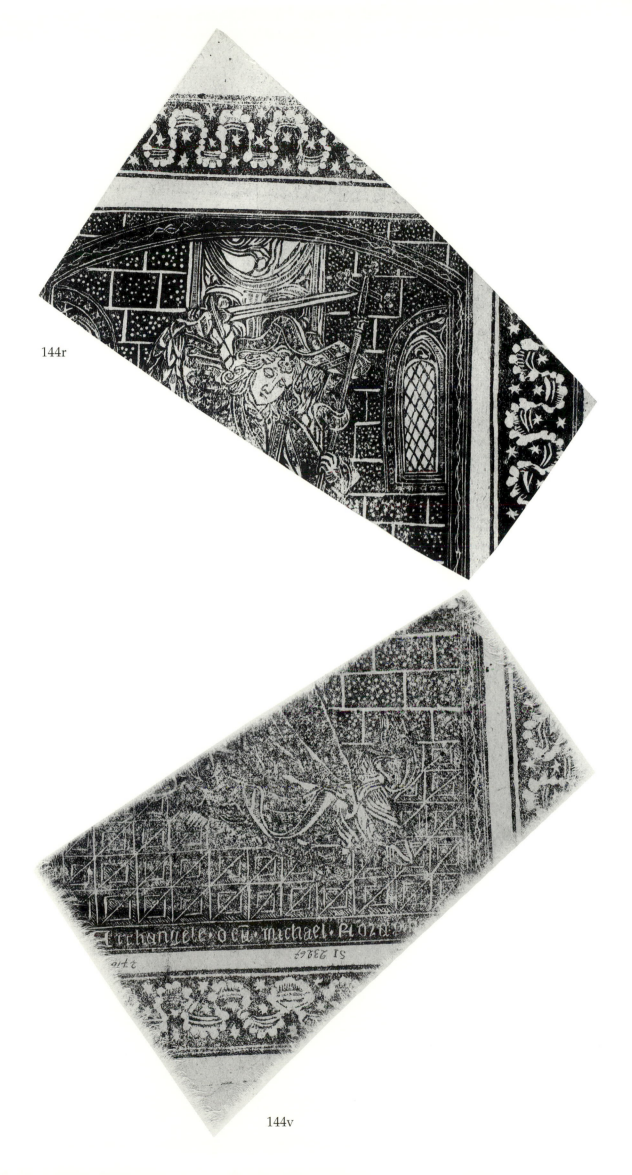

144r

144v

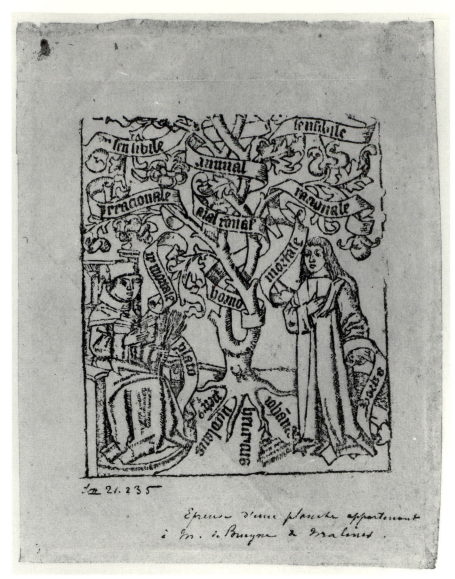

145

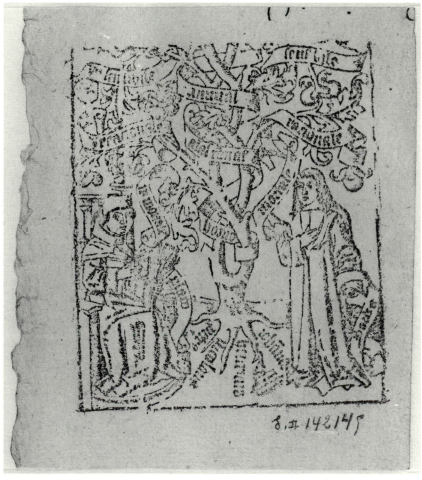

146

147

148r

148v

149

150

153

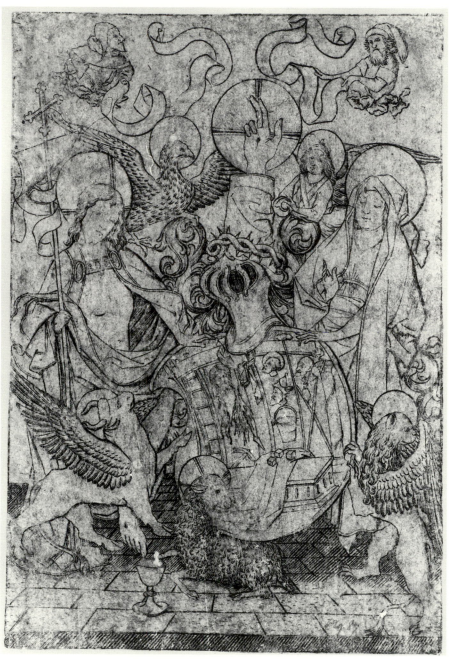

155

163

164

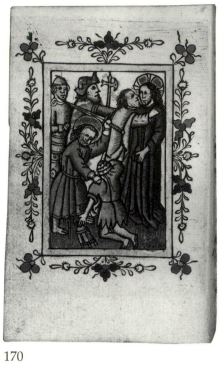

170

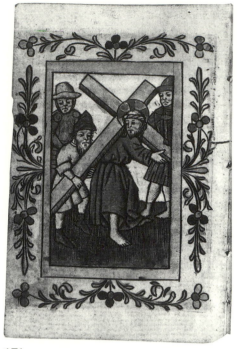

171

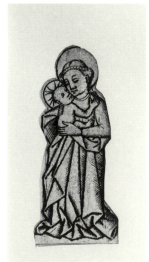

172

174

176

177

178

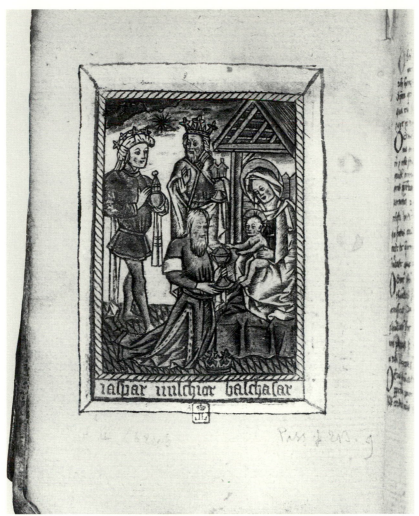

179

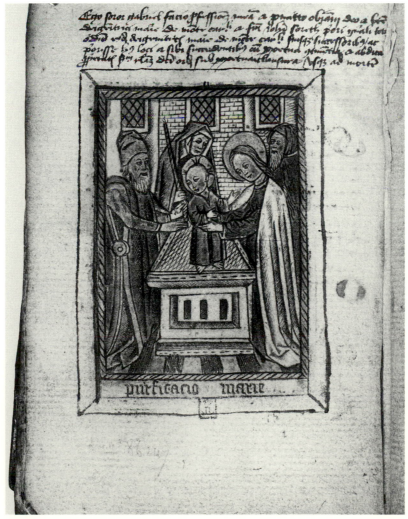

180

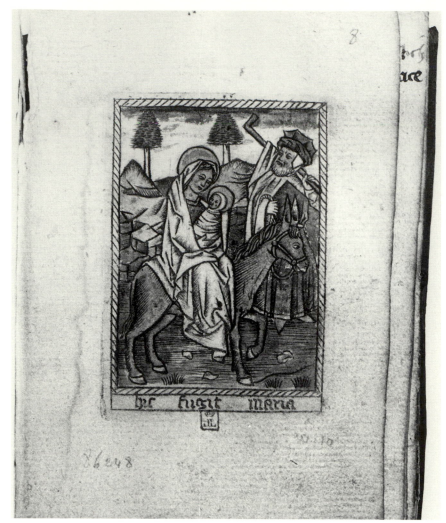

181

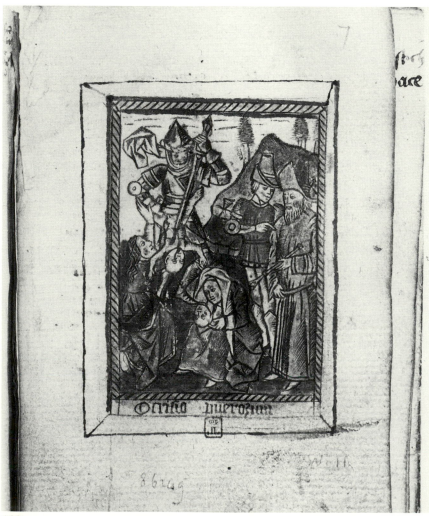

182

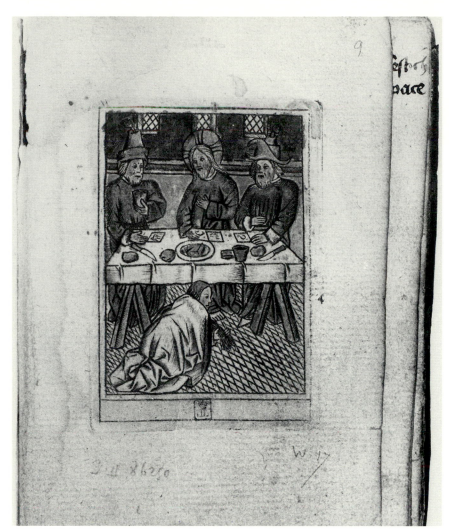

183

ytheđmelte đer zielen ban sust'
Inmihē rols ēñ bāsust' nellehe bā rfestoch
onse benīde mede sisters Riefstat m pace

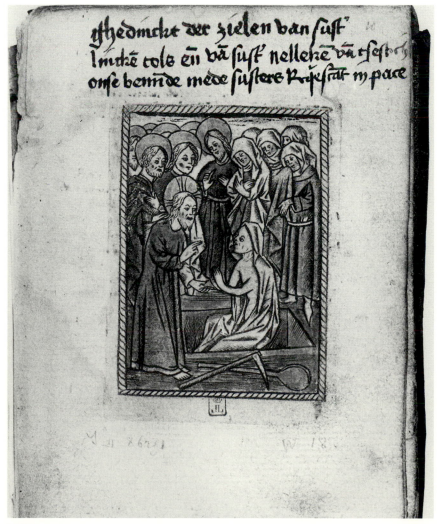

184

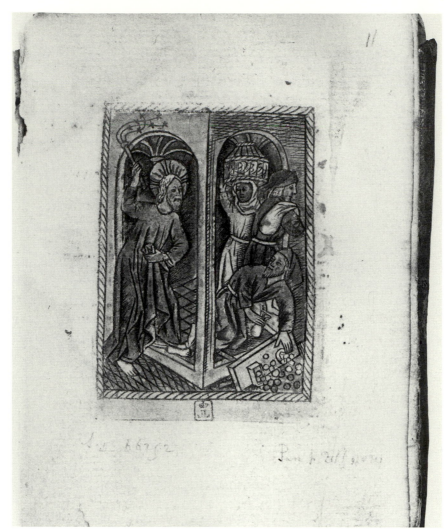

185

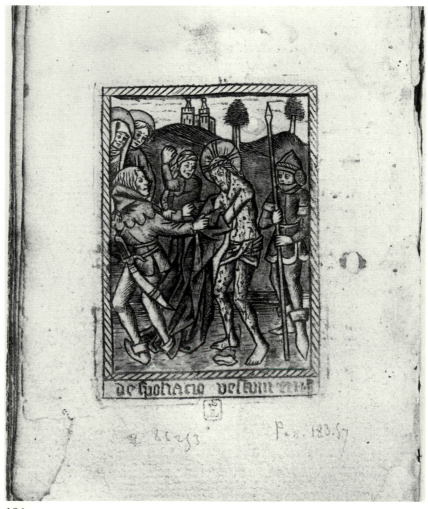

186

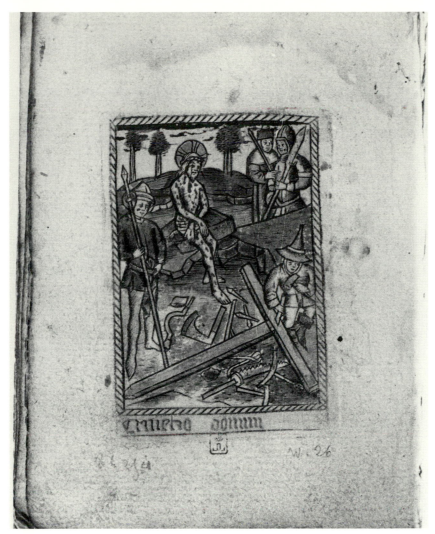

187

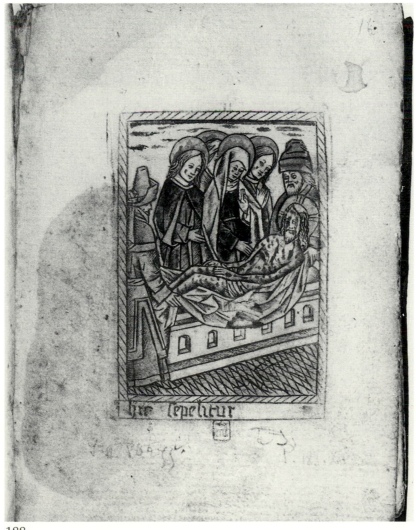

188

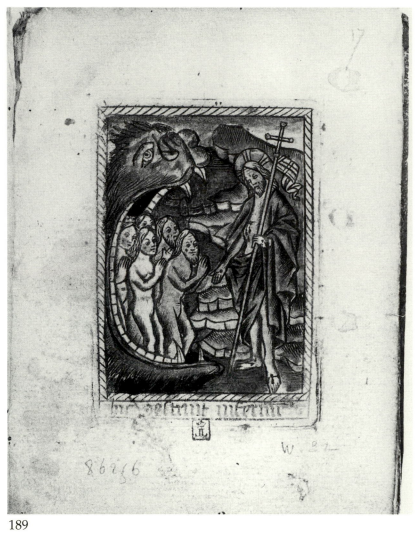

189

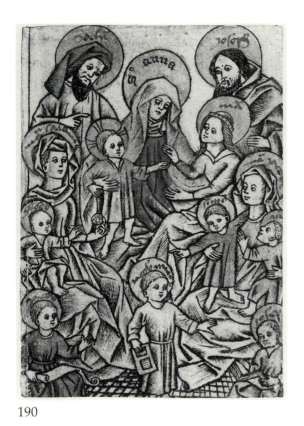

190

191

194

195

196

197

198

199

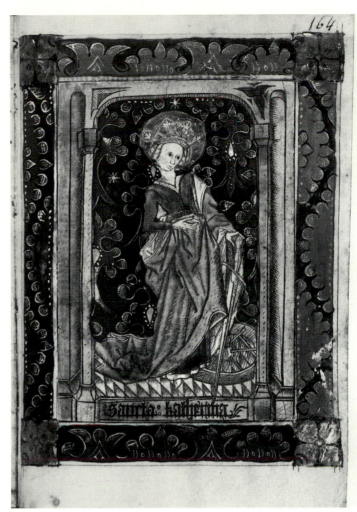

200

201

202

203

204

206

207

208

209

210r

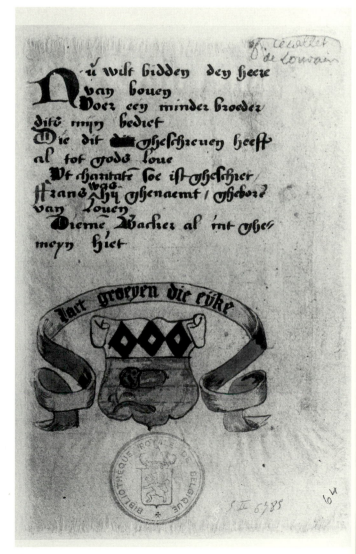

210v

211

212

213

214

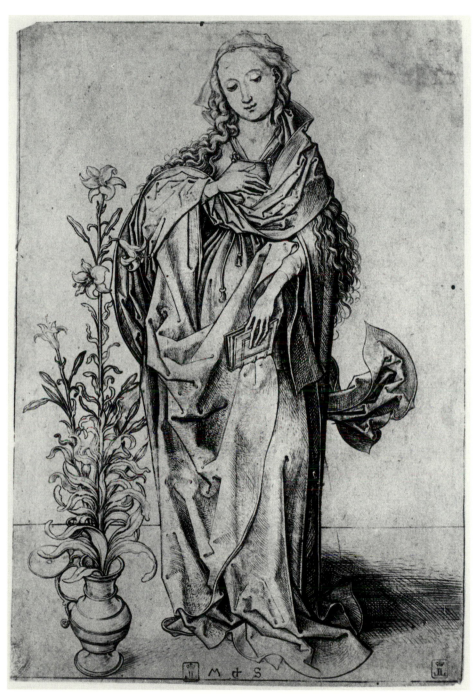

215

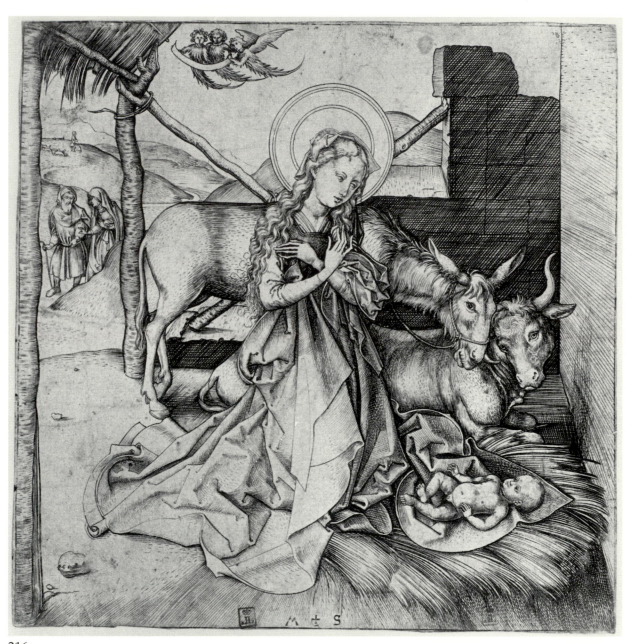

216

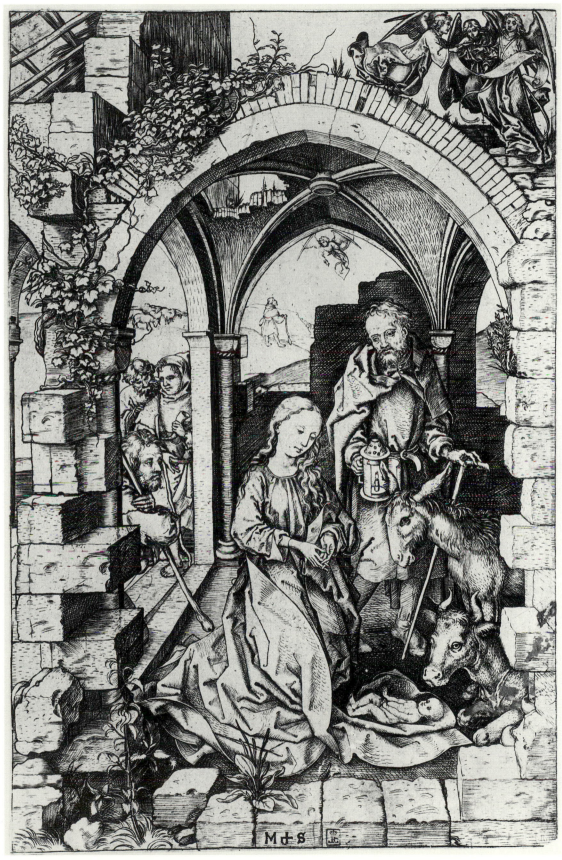

217

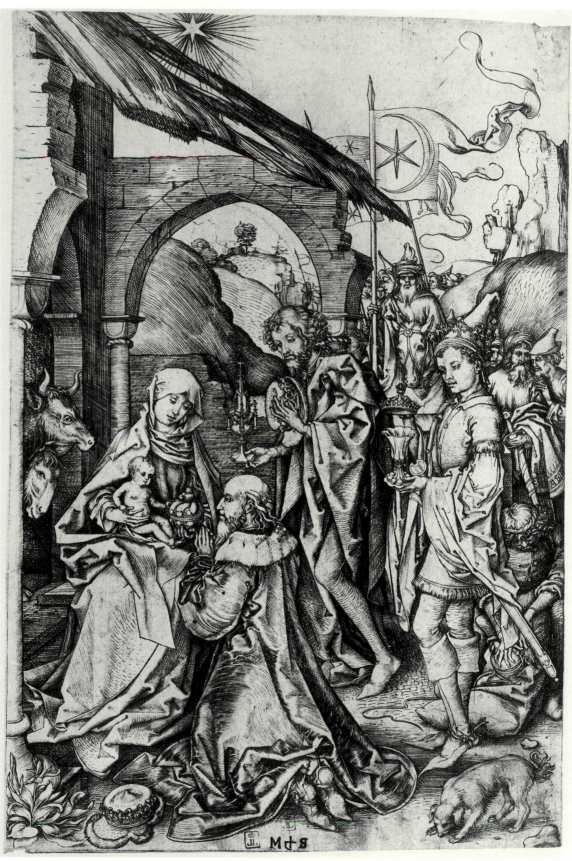

218

219

220

221

222

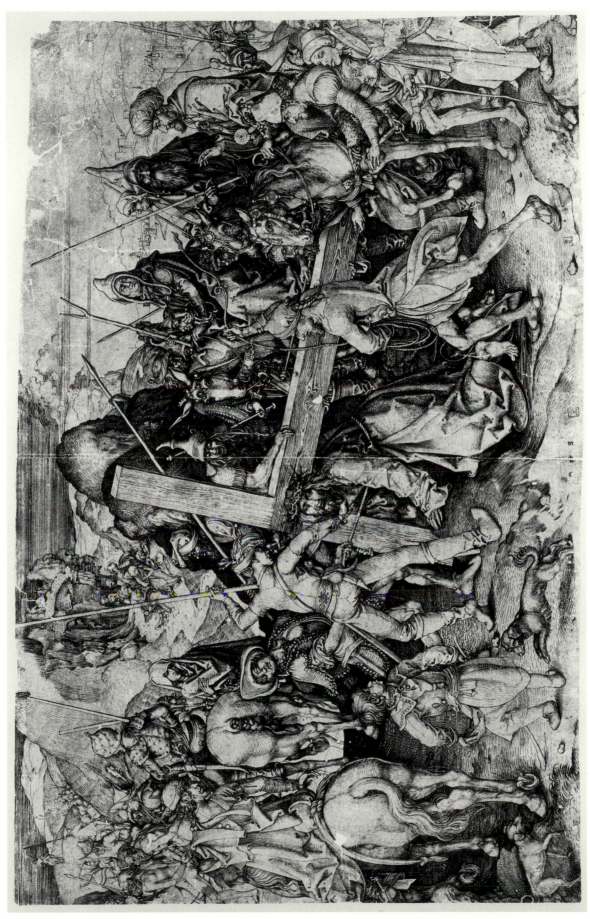

223

224

226

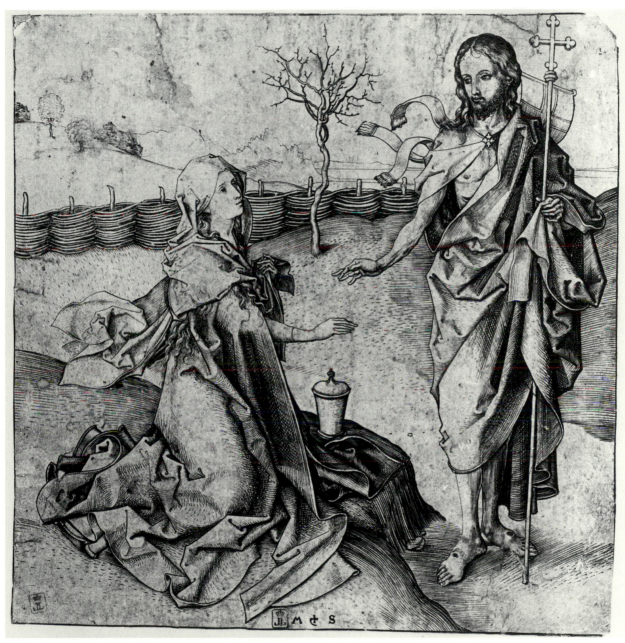

227

229

230

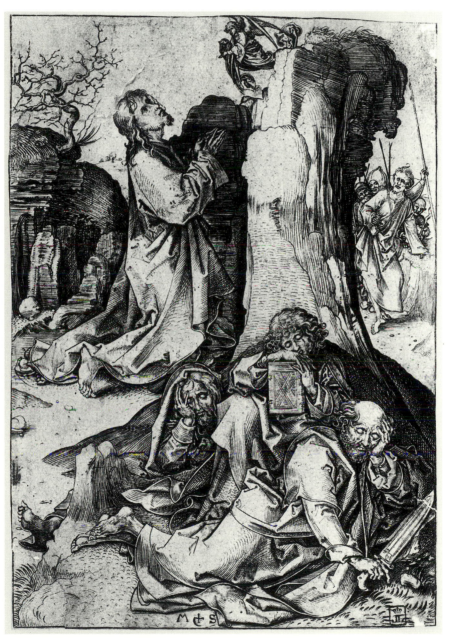

231

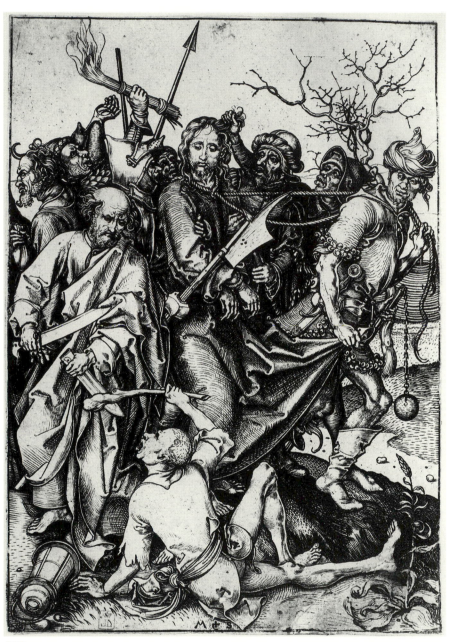

232

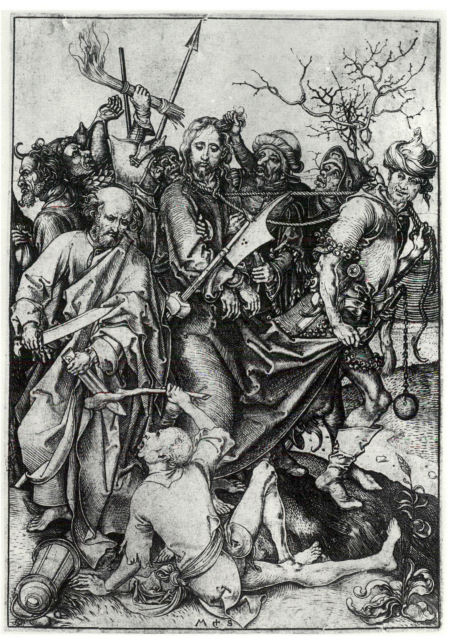

233

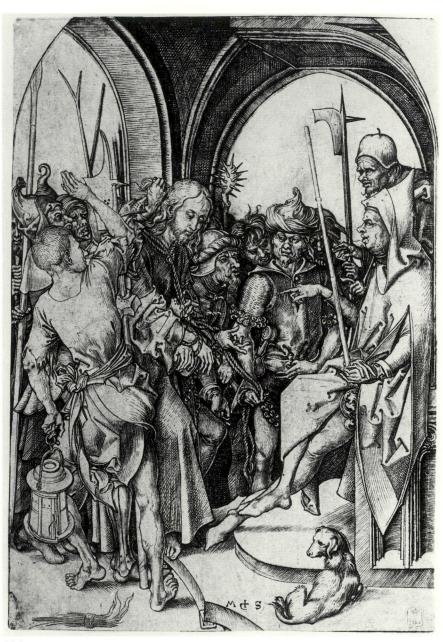

234

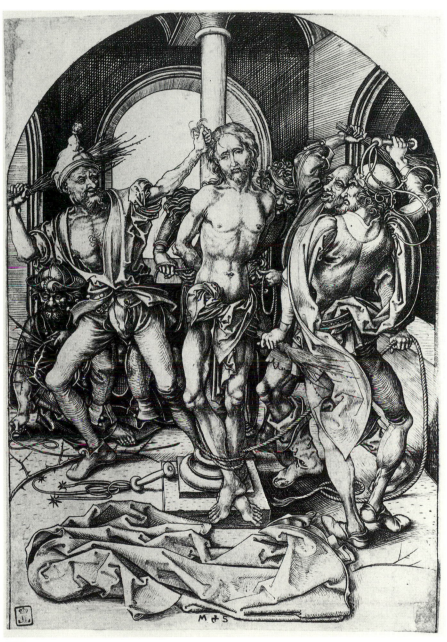

235

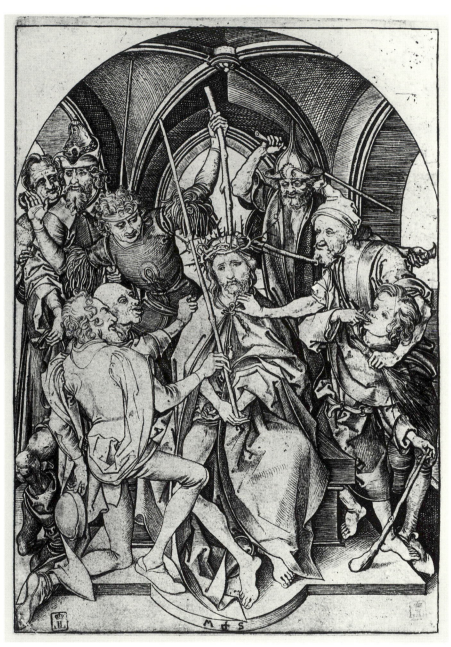

236

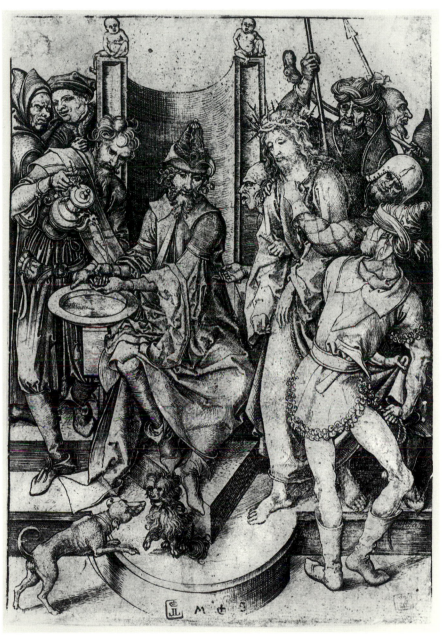

237

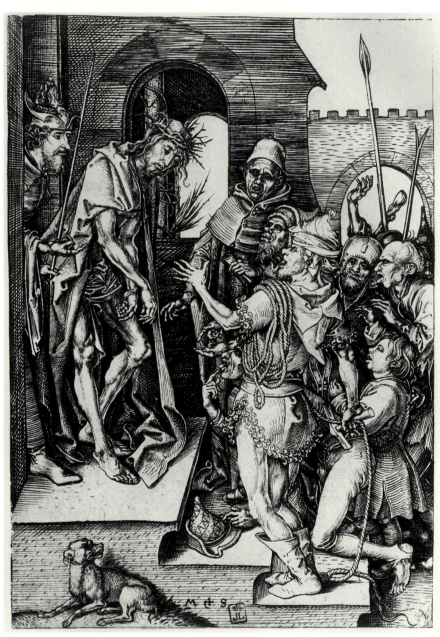

238

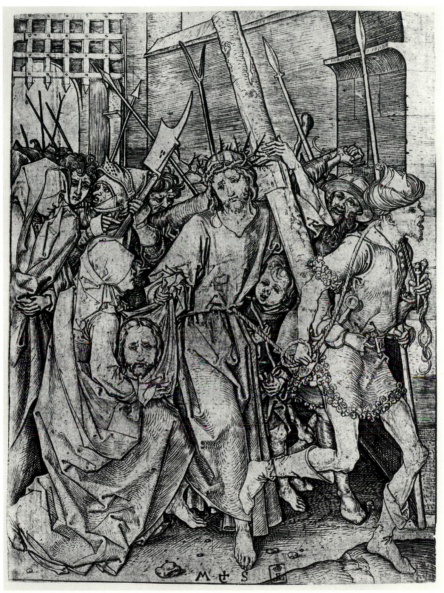

239

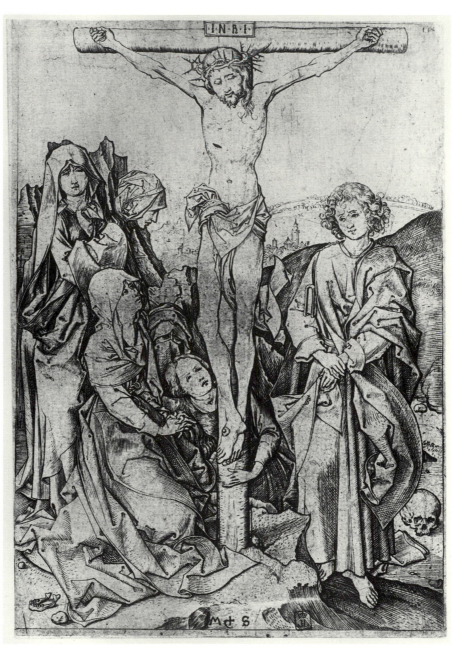

240

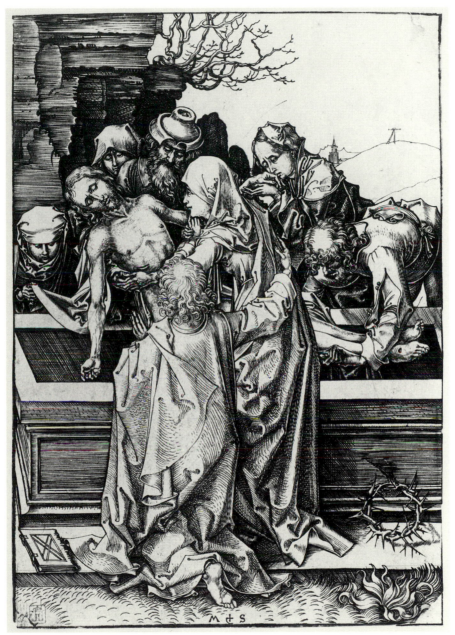

241

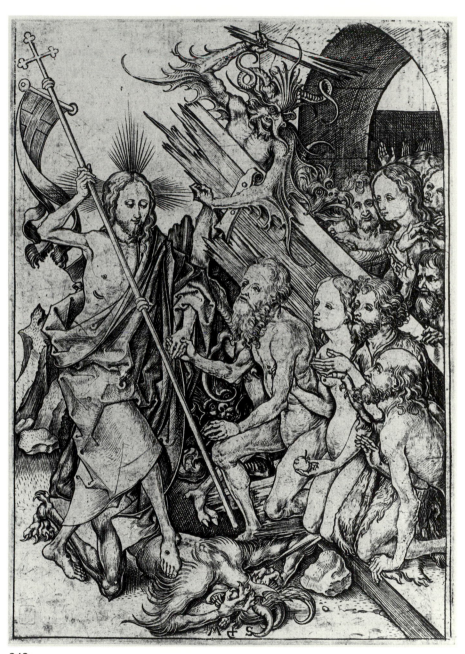

242

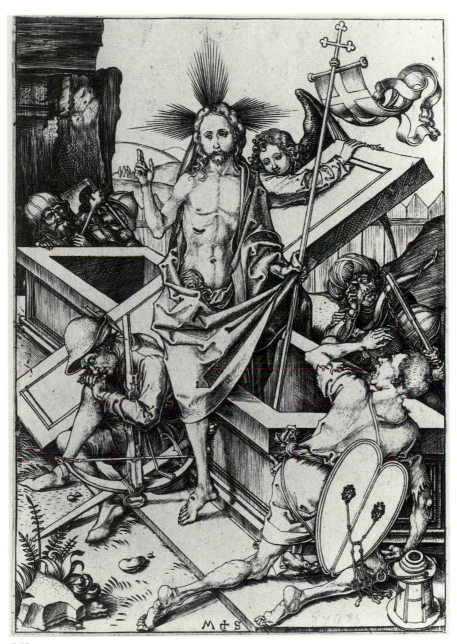

243

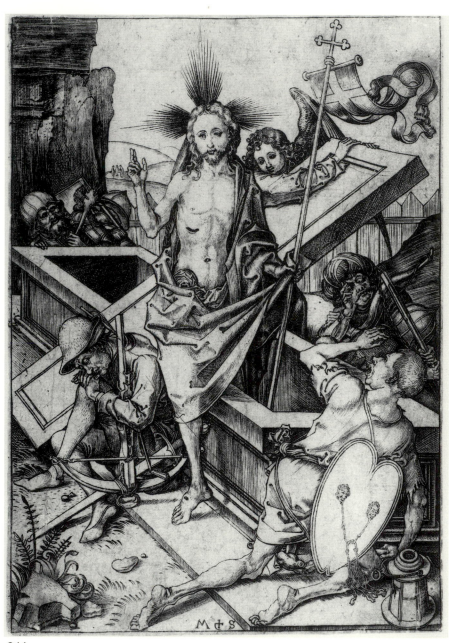

244

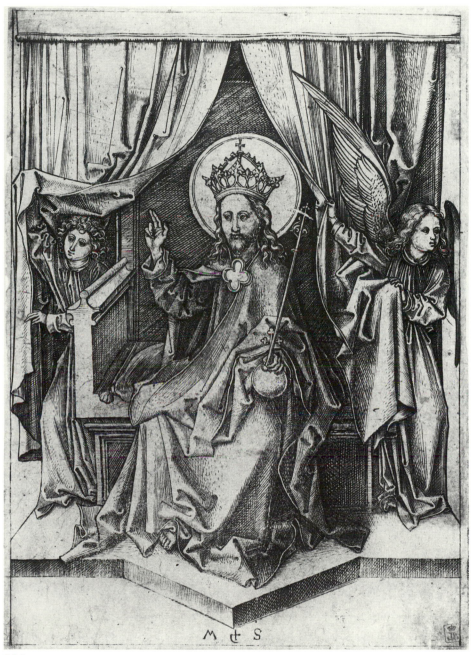

246

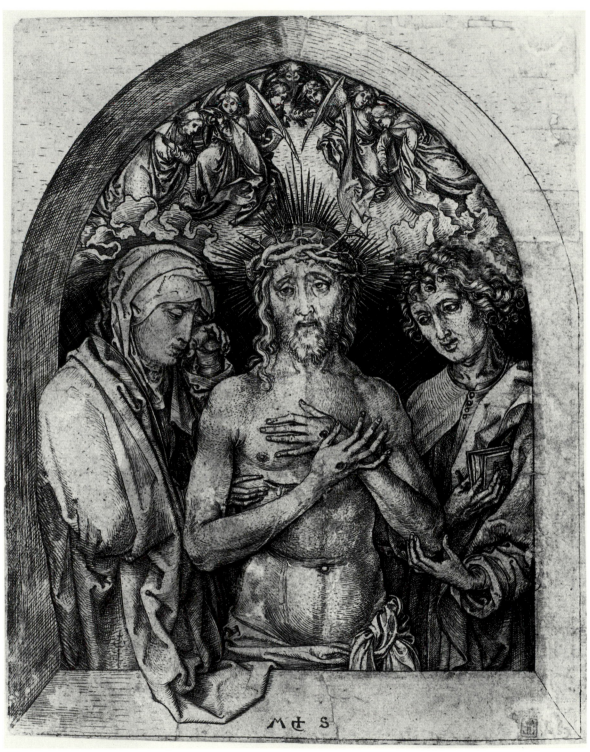

247

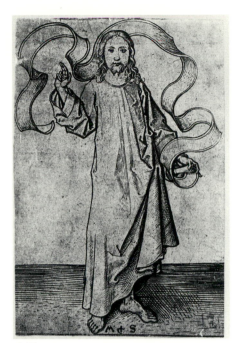

245

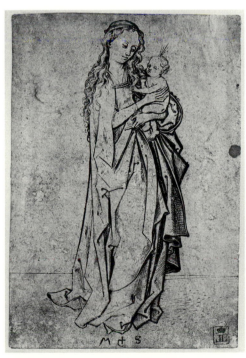

248

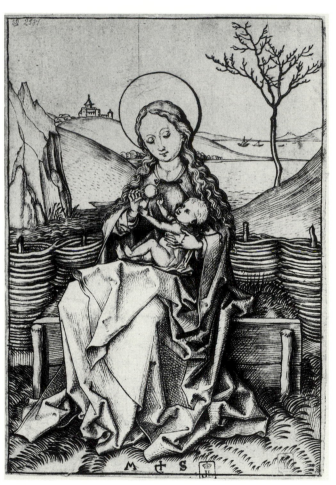

249

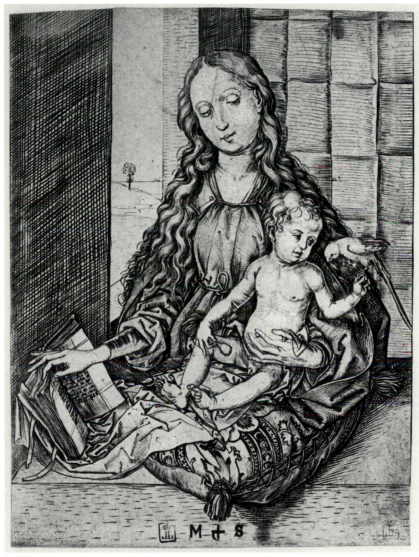

250

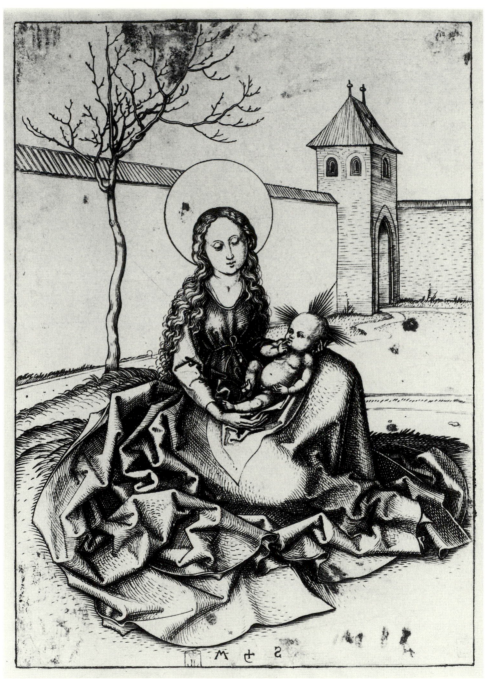

251

252

253

254

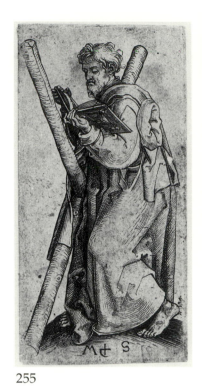

255

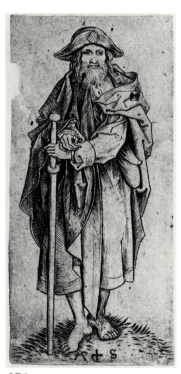

256

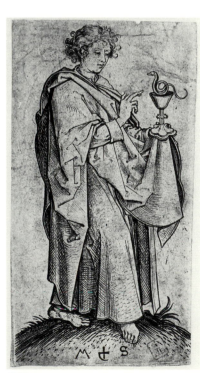

257

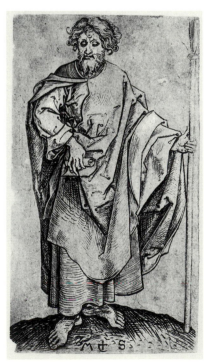

258

259

260

261

262

263

264

265

266

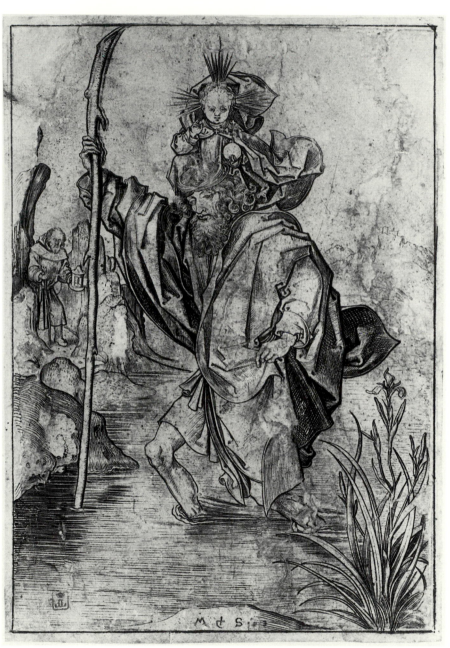

267

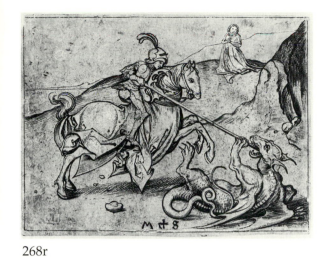

268r

268v

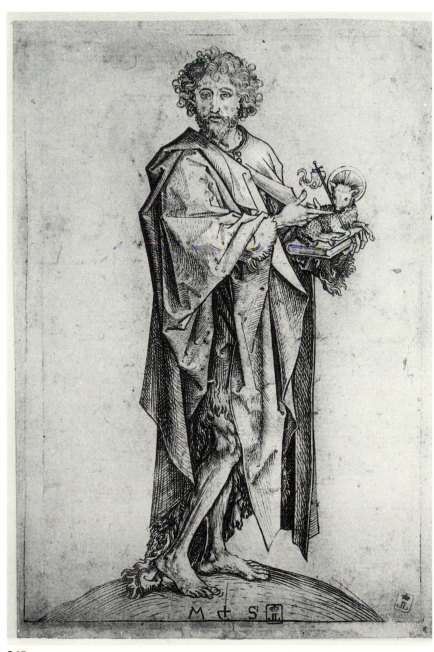

269

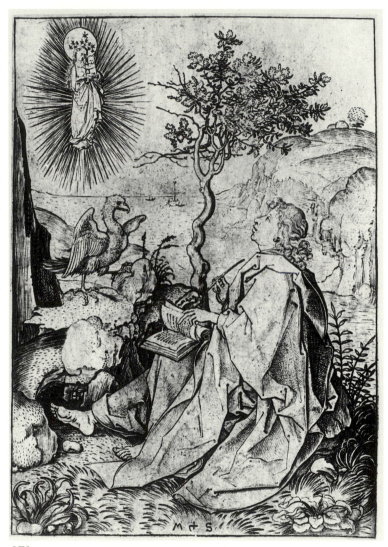

270

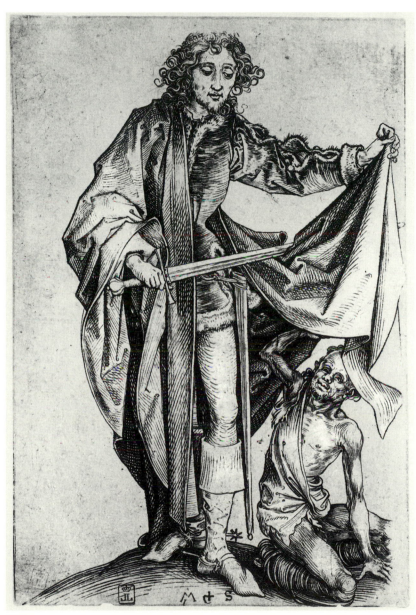

271

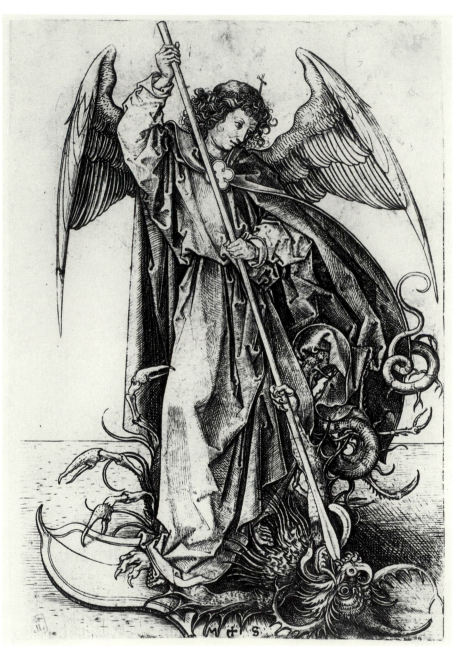

272

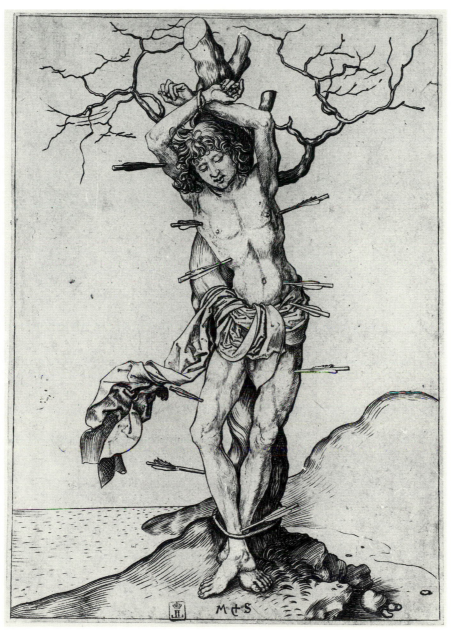

273

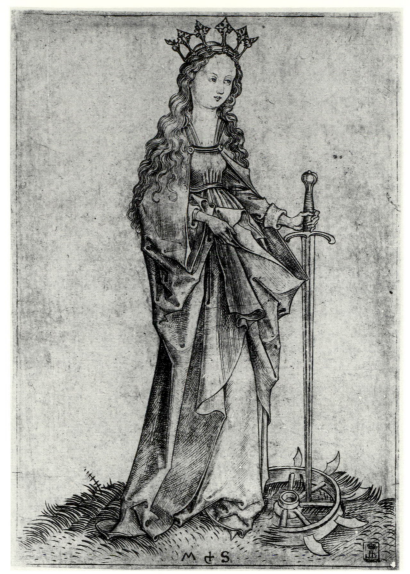

274

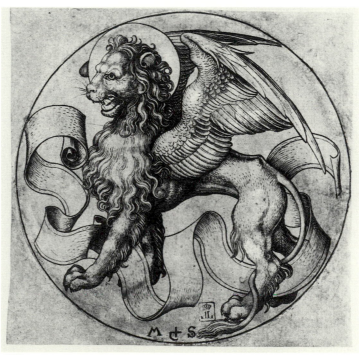

275

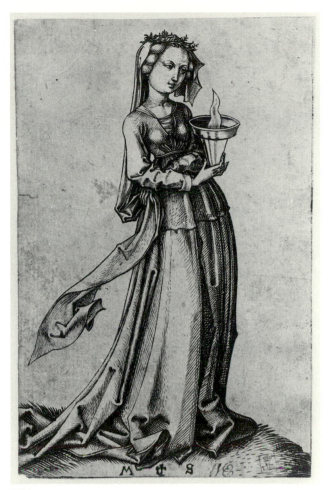

276

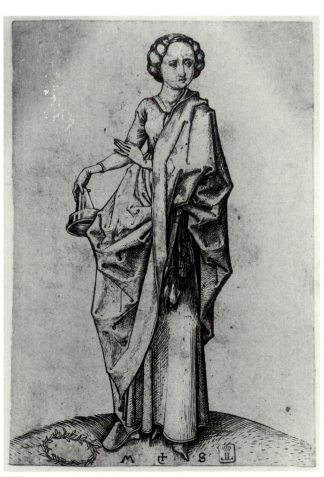

277

278

279

280

281

282

283

284

285

286

287

288

289

290

291

Plus. Dñe JESV iniurijs tuis debeo, quod redemptus
sum, quam opibus quod creatus ego quidem sum. non
prodesset nasci, nisi redimi profuisset. Ambr. lib. 2. in Luca.

Docto Pioq. Viro Marco van Steelant Signifer Peditu a Domino van
Wissekercke. Adrianus de S. Huberto D.D.

293

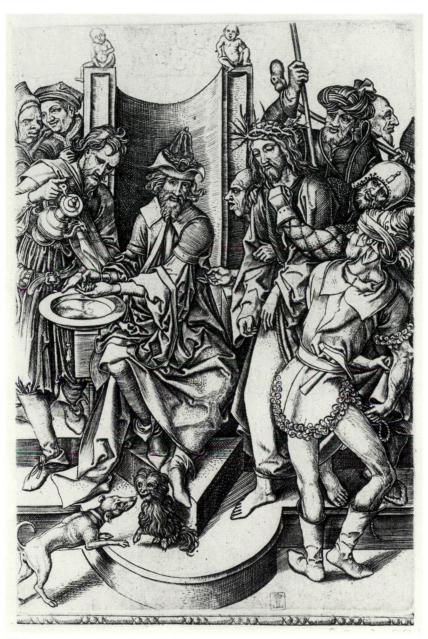

294

295

296

297

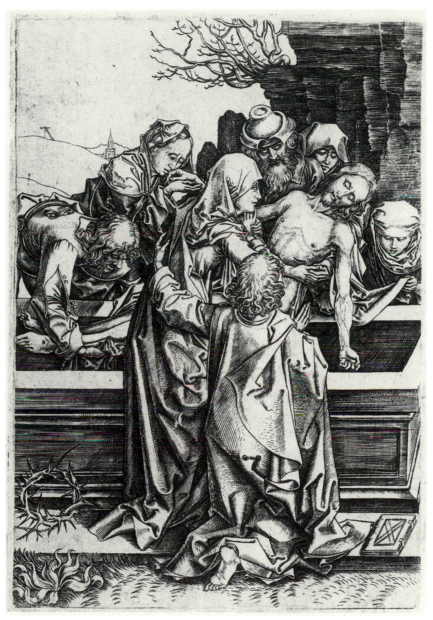

298

299

300

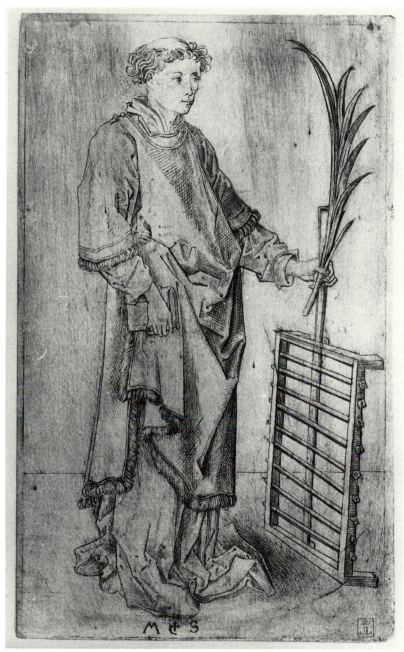

301

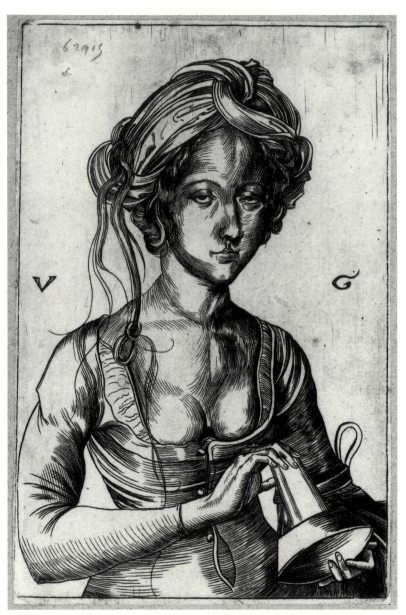

302

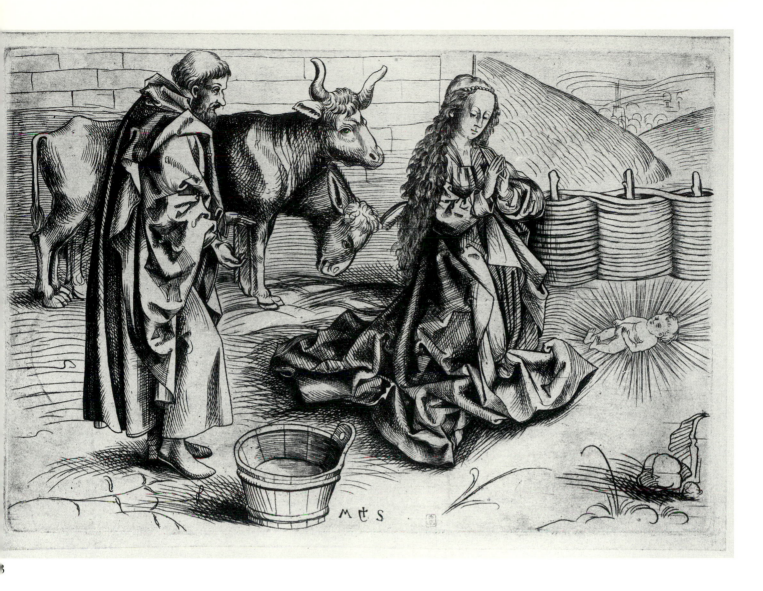

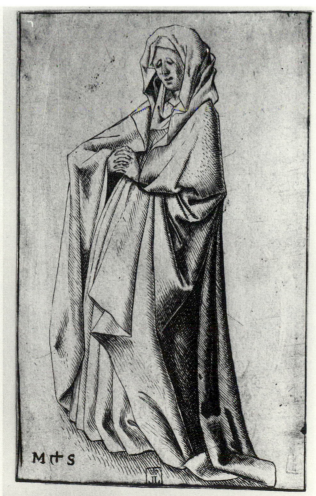

304

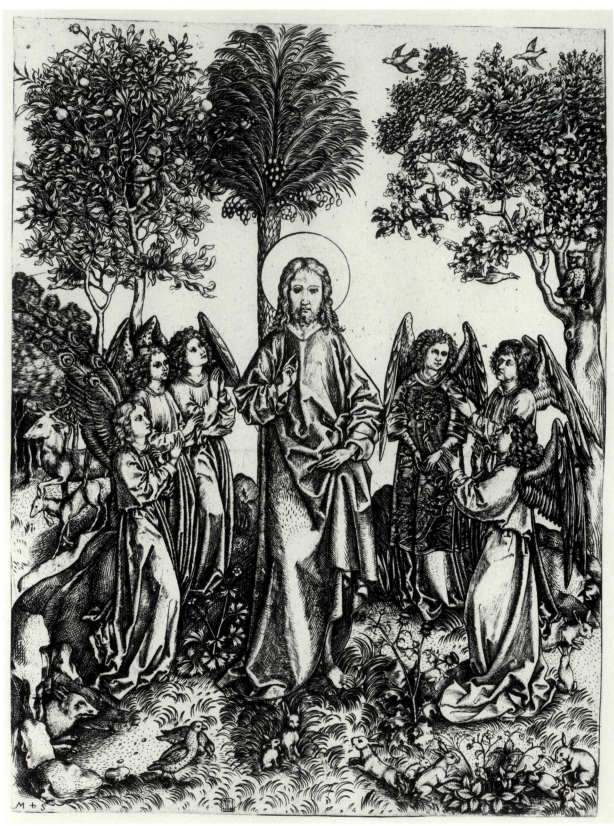

305

306

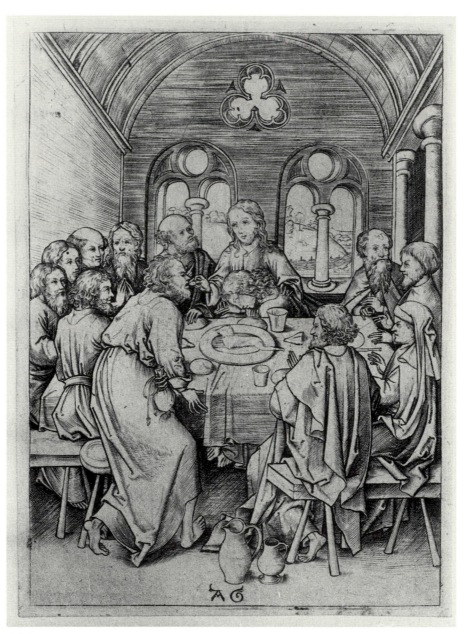

307

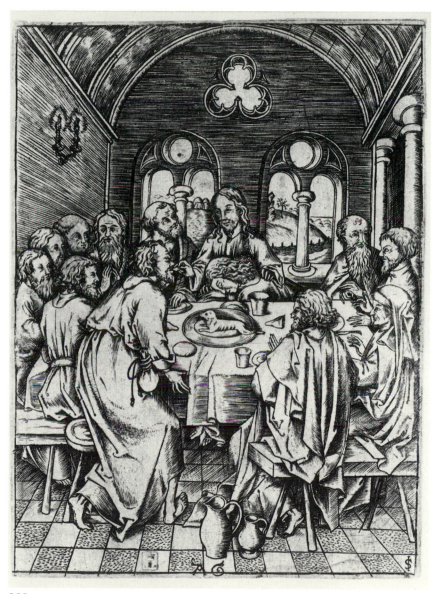

308

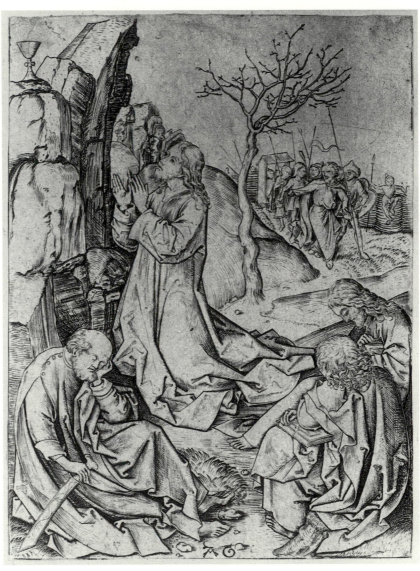

309

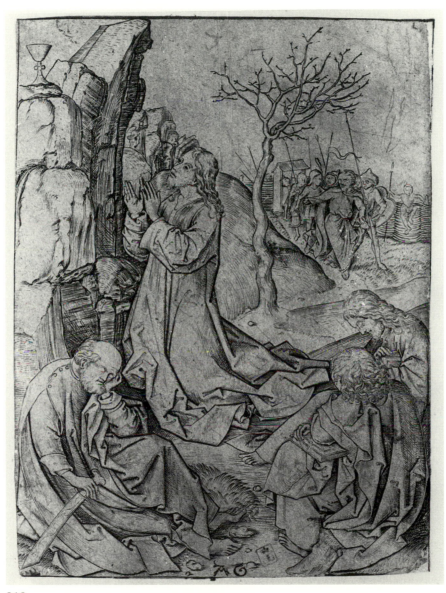

310

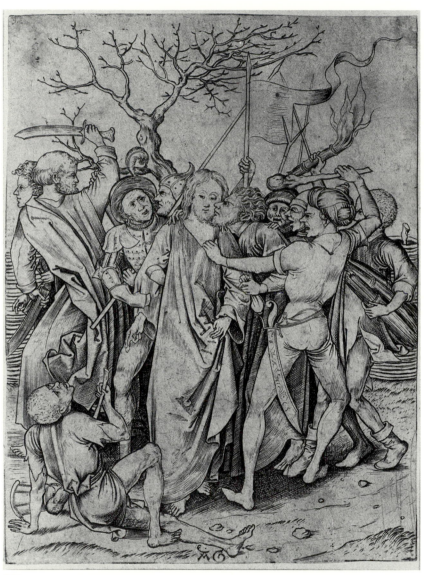

311

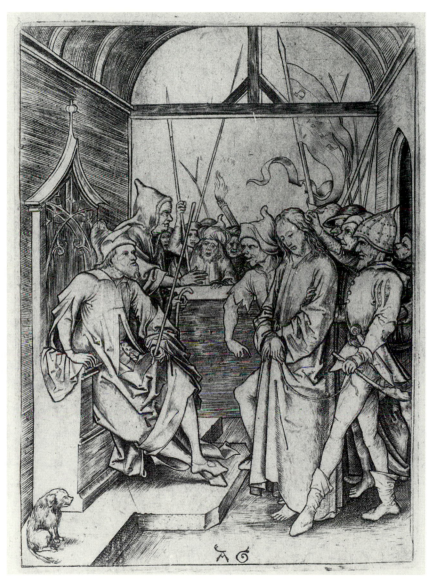

312

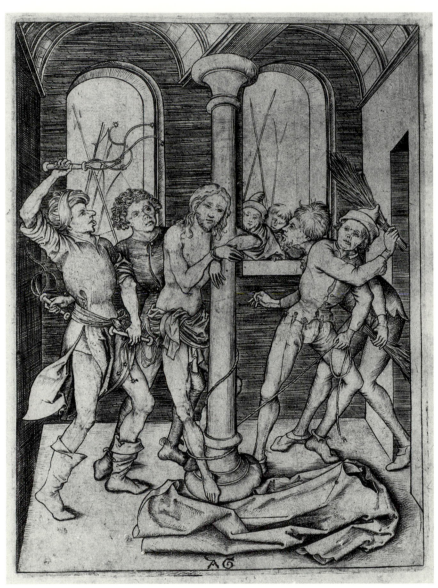

313

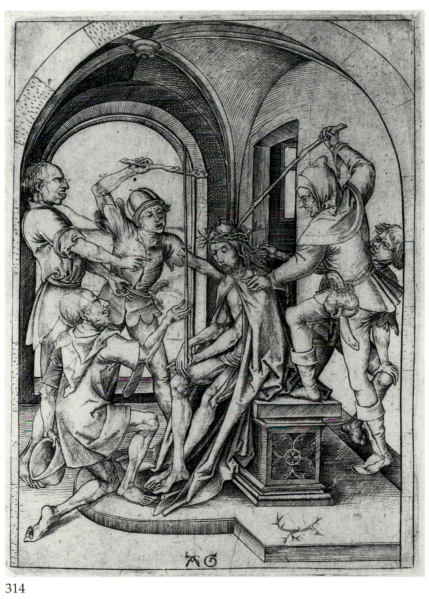

314

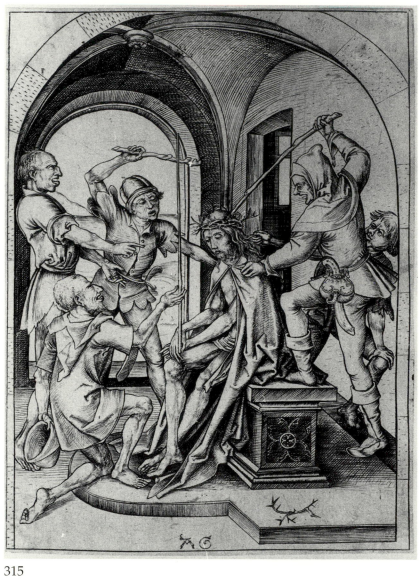

315

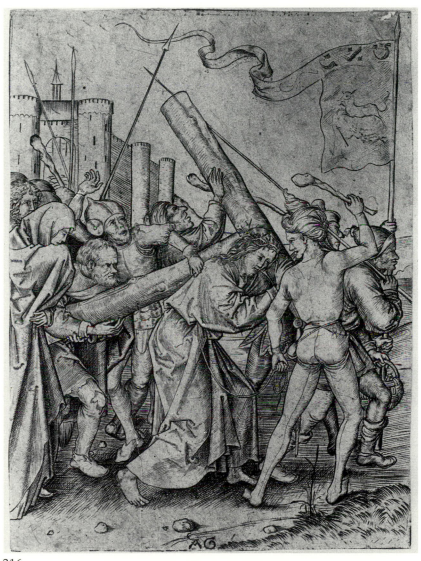

316

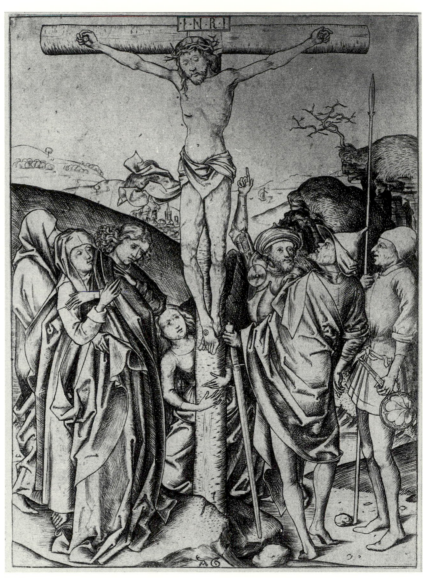

317

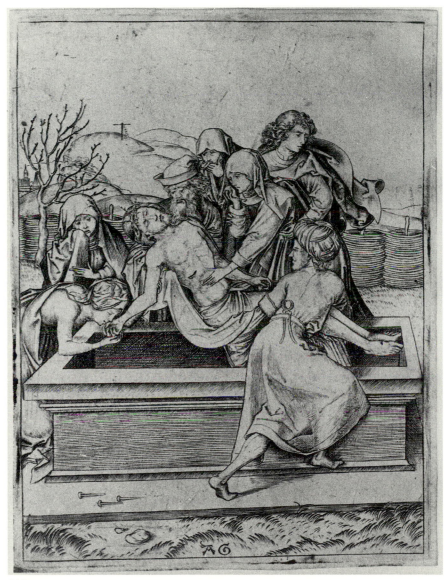

318

319

miſſa ex eo quidē opere p eoꝛ debita deuotōe vnigenitū dei filium in altaris officio re
ueréter ptractare ac eius virtute augmētū conſequi grāꝫ. Nos quoꝗ Rudolfus herbñ
eccleſie Epūs et Dux pfatus platos ecchaſticoſꝗ et bñficiatos ſubditos nōs ceteroſꝗ
xpifideles ad fruendū vtendūꝗ tanti opis donis volentes ſpūalibus animare. omïbus
vere penitētibus ꝛ cōfeſſis qui ad huiuſmōi libꝛoꝛ miſſaliū opus conſilium ꝛ auxiliū con
tulerit vel libꝛos ipos imṕſerint coꝛꝛexerint emēdauerint ꝛ qui libꝛū ſeu libꝛos emerint
taliſmodi vel ex eis miſſas celebꝛauerint ac illis qui huiuſmōi miſſis interfuerint quadꝛa
ginta dies ſingulis miſſaꝛ celebꝛatōibus de omïpotentis dei miſericoꝛdia et bōꝛ apo
ſtoloꝛ petri ꝛ pauli ac pcioſiſſimoꝛ martirū kiliani eiuſꝗ ſocioꝛ patronoꝛ nſoꝛ aucto
ritate ꝛ interceſſione confiſi de iniunctis ſibi penitētijs in dño relaxamus Et vt igitur de
huiuſmōi libꝛoꝛ impꝛeſſura indulgentijſꝗ nſis Epiſcopalibus vt ṕfertur per nos datis
cunctis plenioꝛ pateat fides iuſſimus annuimus vt cōmemoꝛatus Jeoꝛius Kyſer artis
impꝛeſſoꝛie magiſter huiuſmōi miſſales libꝛos vt ṕdicitur impꝛimēdos nꝛoꝛum pōtifica
tus et Capituli inſignijs decoꝛaret. Datū in Ciuitate nꝛa herbñ. Anno dñi milleſimoqua
dꝛingenteſimoocctogeſimoquarto vndecimo kl̃s marcij.

321

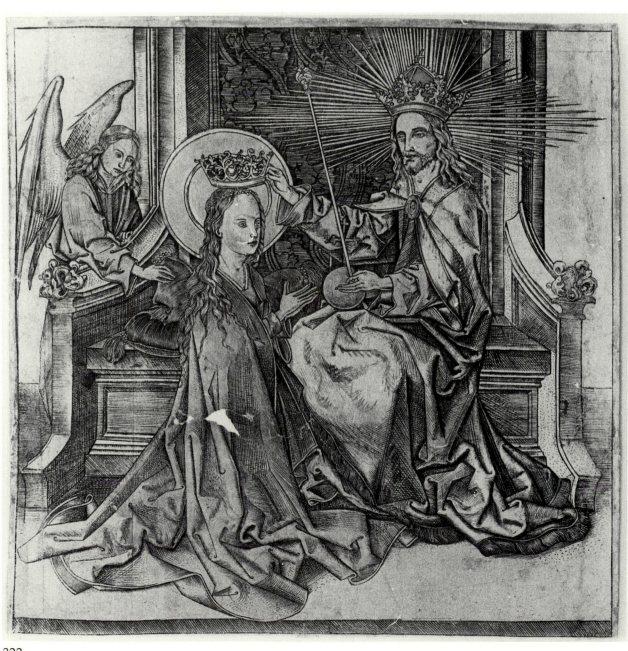

322

323

325

326

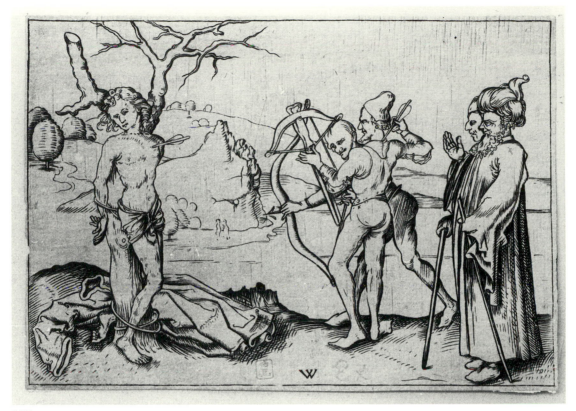

327

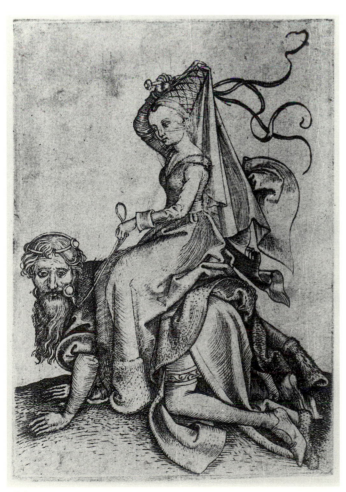

328

329

330

332

333

335

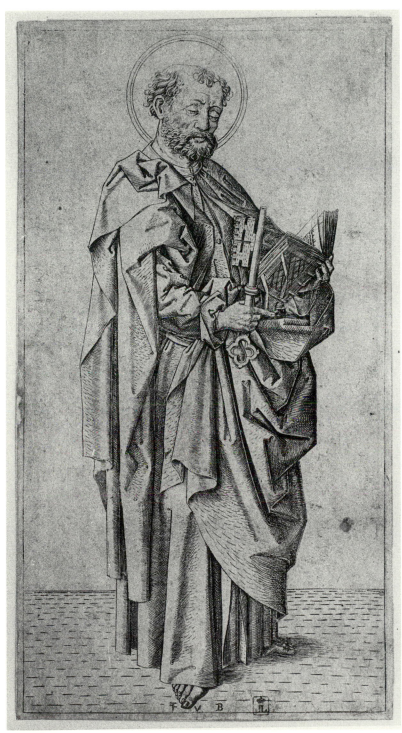

336

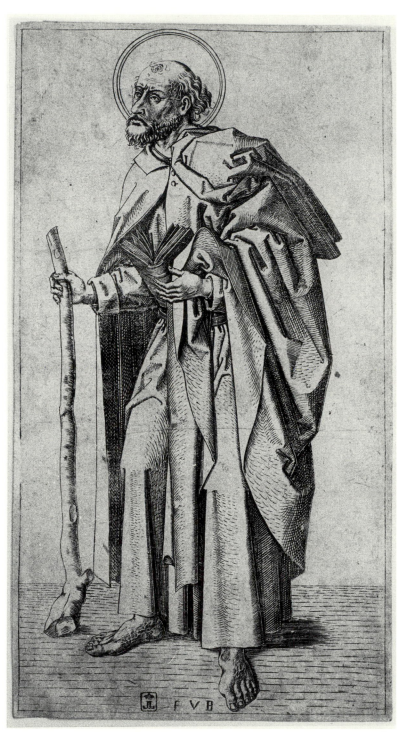

337

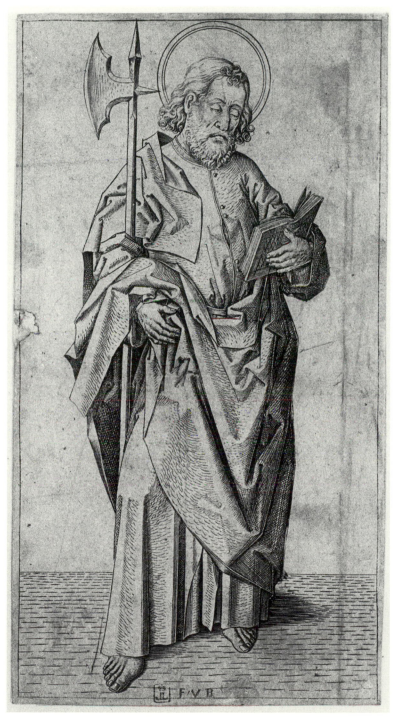

338

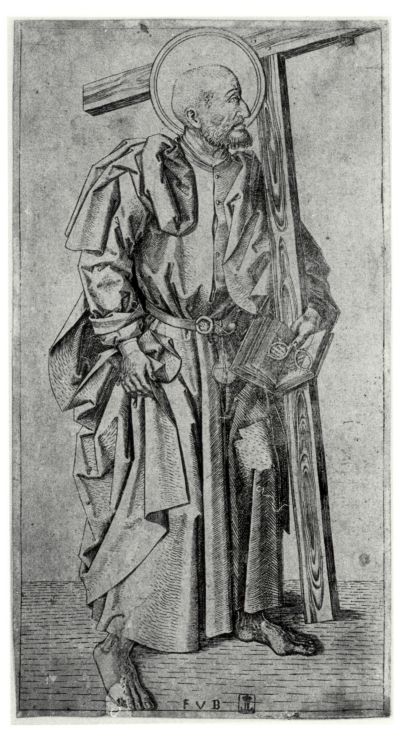

339

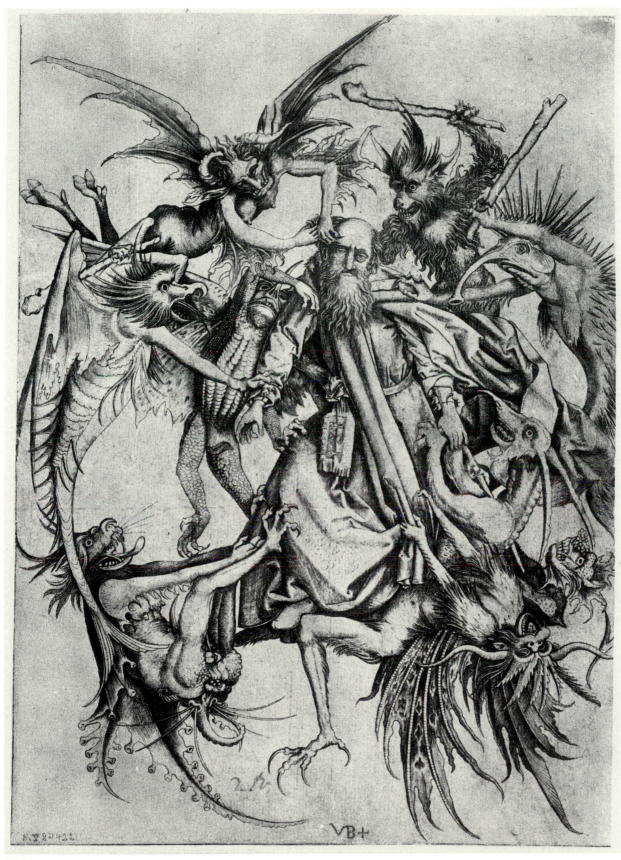

340

341

343

344

345

346

347

348

Gegrut systu ma
ria woll gena
den der herre
yst mit dir Dyne ge
nade sy mit mir Du
byst gebenedyt vn der de
frauwen vnnd gebe
nedyt sy anna dyne
hillige moder van wel
cher sonder sun de vn
flecken du byst ge vor
kommen O Jonfraw
maria vß dir yst gebor
ren ihesus christus

des leuendichen godes sohn Amen
Frenwe dich selige Anna die entfangen
haist eyne dochter die gebe zen solde den
erloeßer der werrelt Frenwe dich selige An
na geberersche marien die gott haut gebereit
vnnd yst eyn moder des warhafftichen messie
Frenwe dich selithe Anna die alleyne haist
verdient daß du werest eyn moder der Jonfra
wen der moder ihesu Frenwe dich selithe
Anna eyn moder der großer dochter vß der
yst vortgangen der schynende sterne der hoech
ster sonnen Frenwe dich selithe Anna fren
we dich ane ende zeich vur vnß die gebedde

349

350

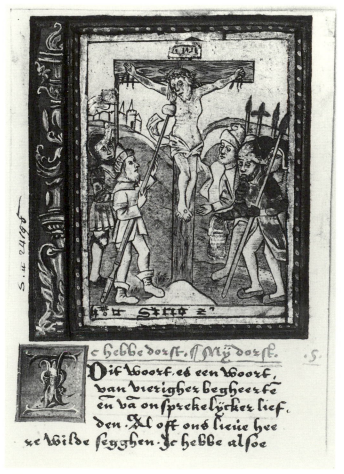

351r

351v

354

356

357

358

359

360

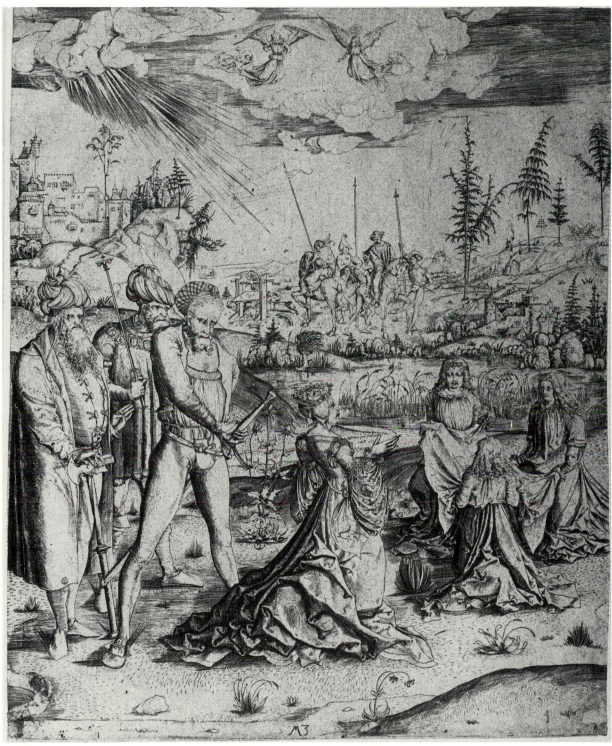

361

362

363

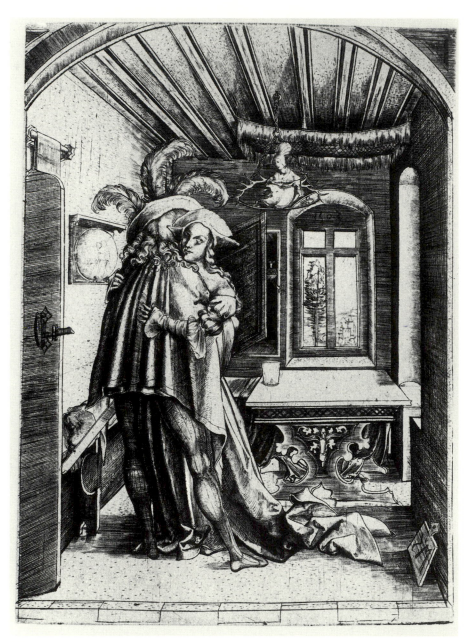

364

365

366

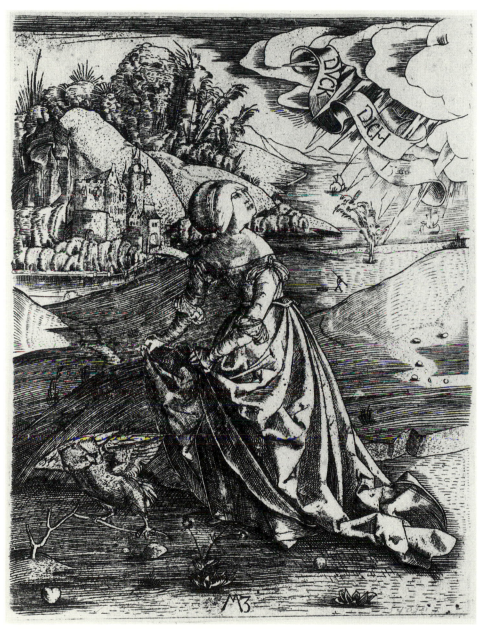

367

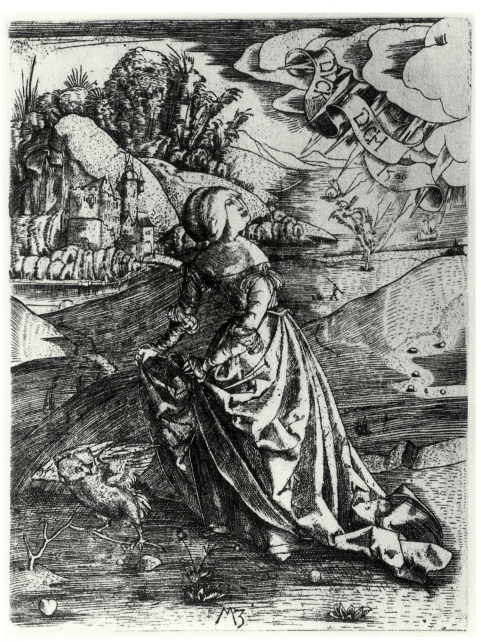

368

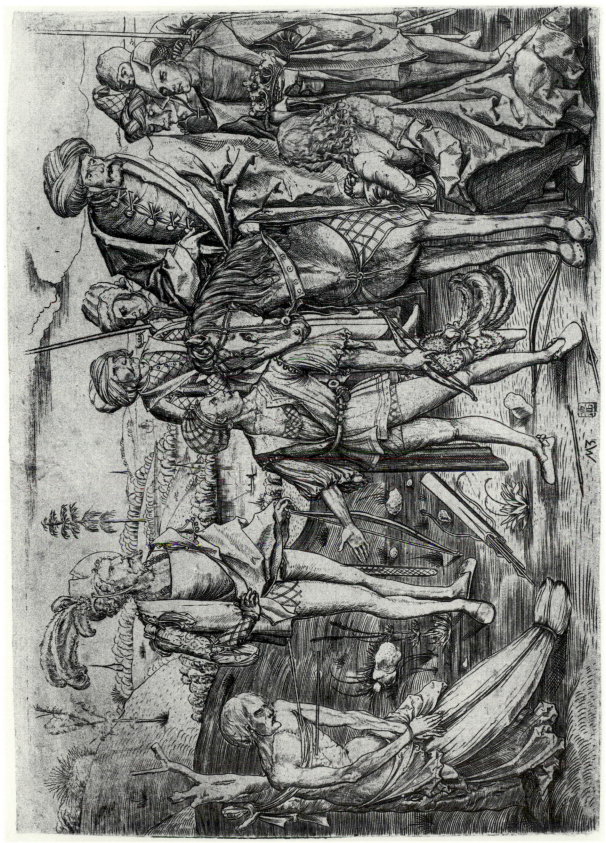

369

370

371

372

374

375

376

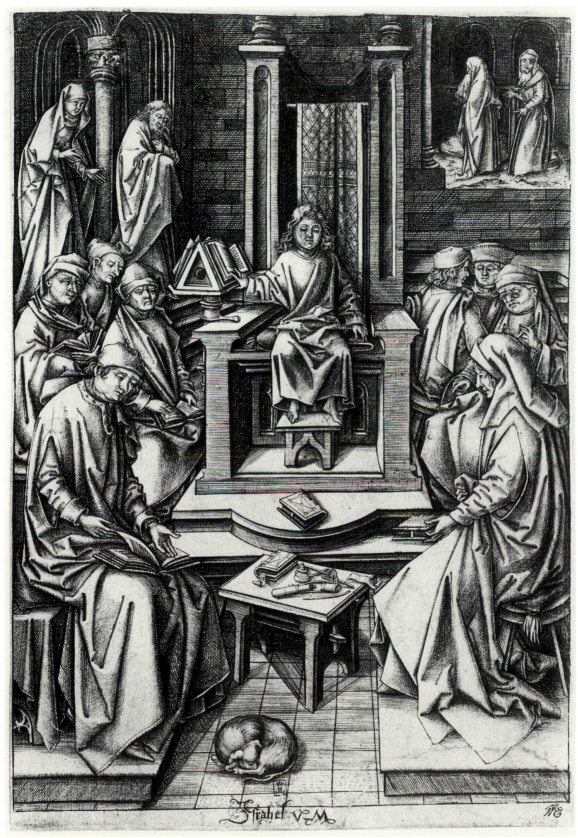

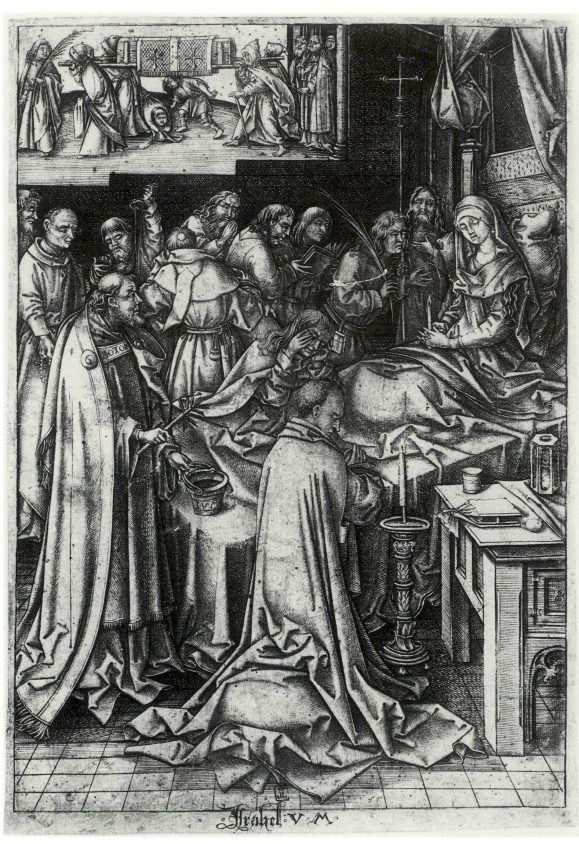

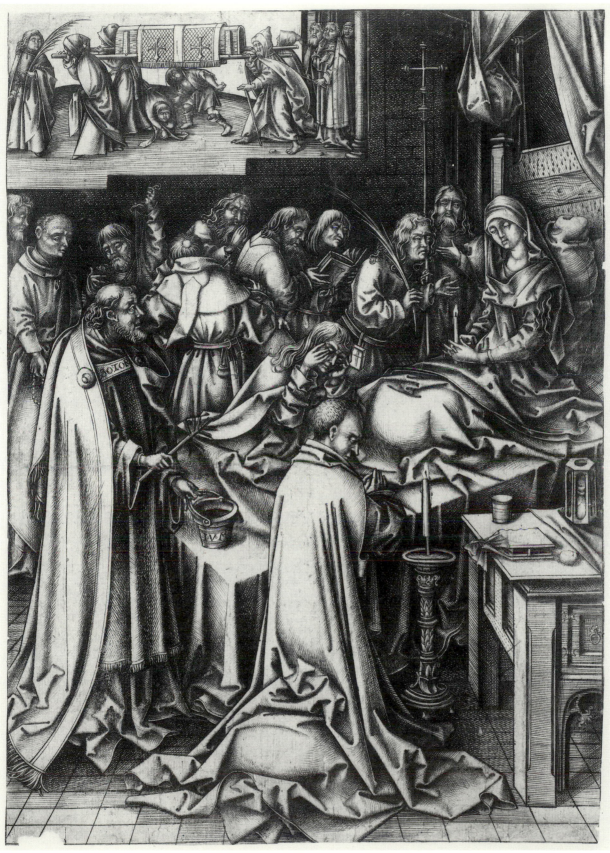

379

380

381

382

383

384

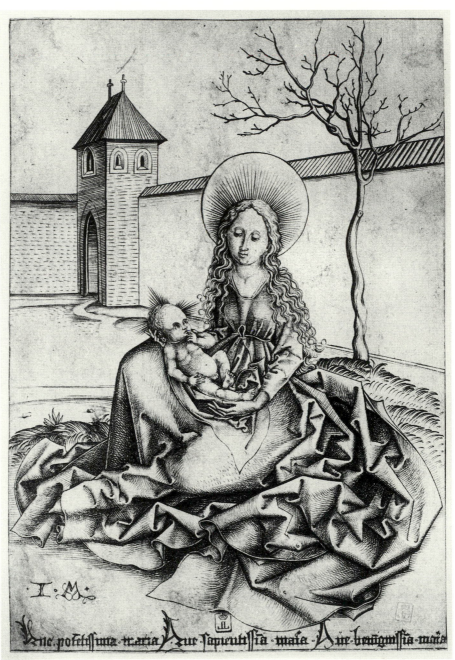

386

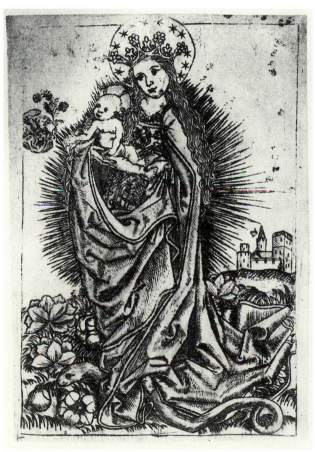

387

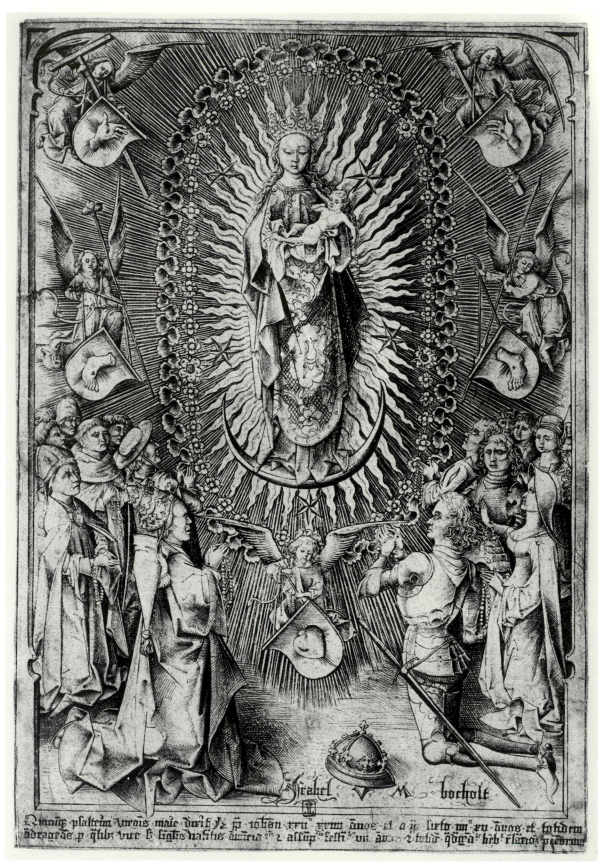

Jfrabel V M bocholt

Onunctp pfaltrim turois maie doift j̃z sp iohan trũ prim ãnge it a ip luese m° ru ãuas et sohdem
oðragrae p qhlz vure ß ßigtes naßtus ãutris m° z aßup̃ sesti bo mi ãu z solũ qðgia heb claetos pterum

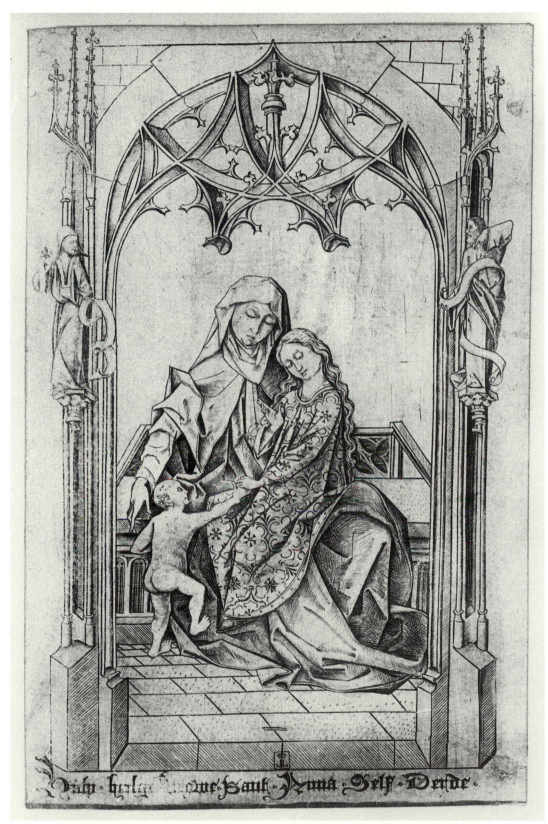

389

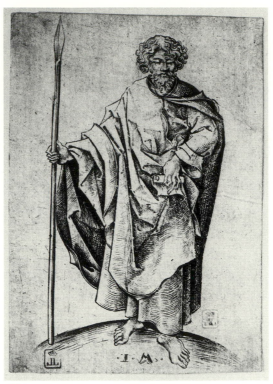

390

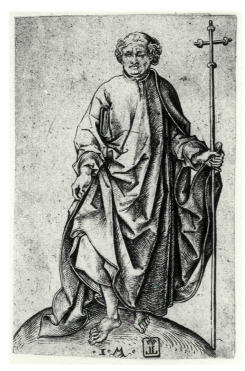

391

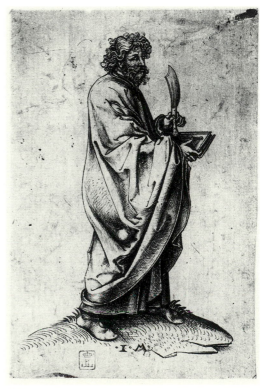

392

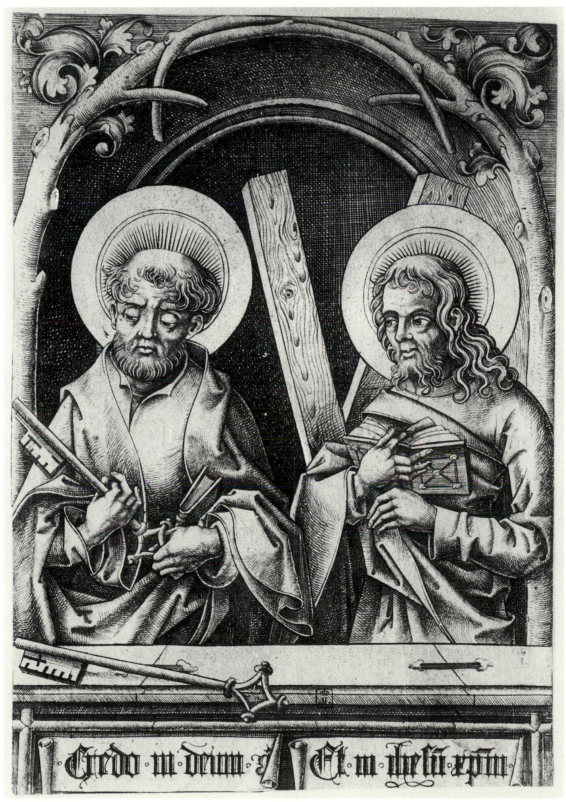

Paſſus ſub põio Qui conrephs eſt

394

Descēdit ad ínferna· Aſcēdit ad cclos·

395

396

Remissione peccatorum. Sancta ecclesiam catholicam.

397

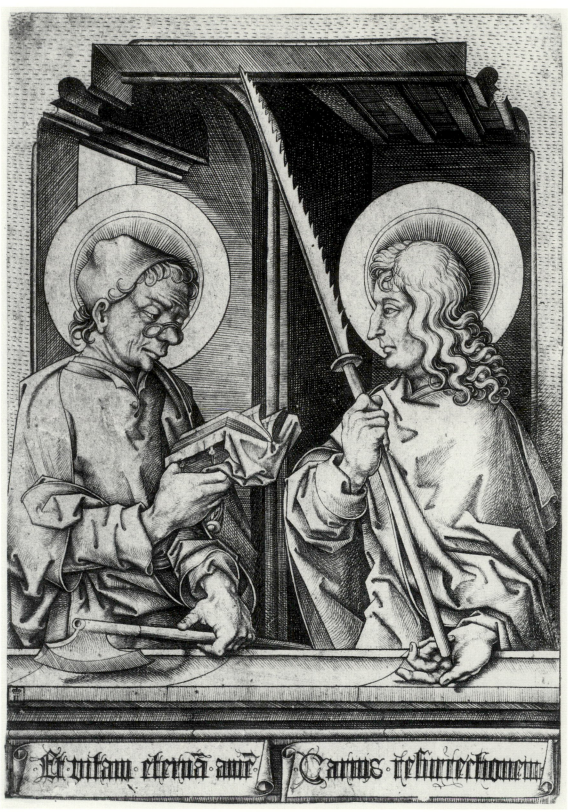

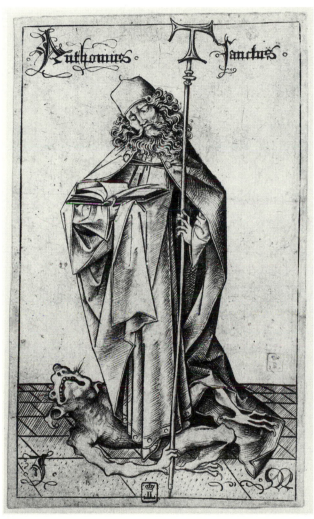

399

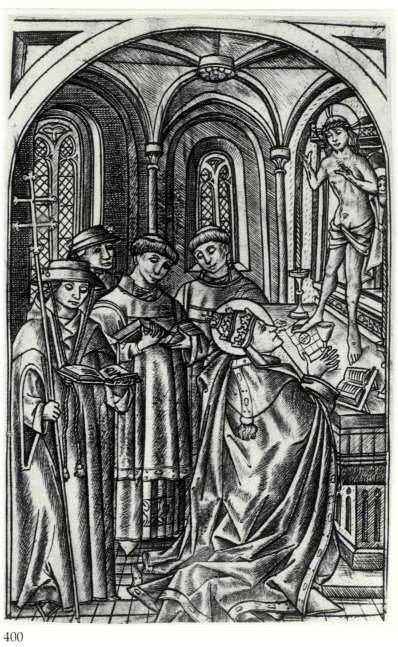

400

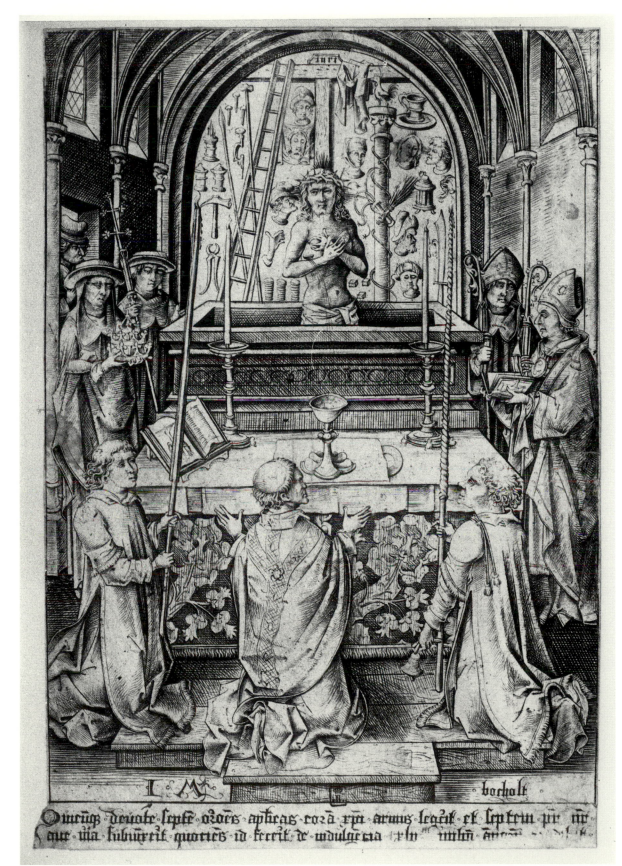

L&M bocholt

Quicūꝗ deuote septē ozoes apticas cozā ɼm aɼmis legeɪt et septem ɡr ūr
saɼe ɪlla ɪubuerɪt quories ɪd feceɪt ᵭ ɪndulgēɪa ɼln̄ m̄ m̄bn̄ āɪcōɪ · l ʰ ·

401

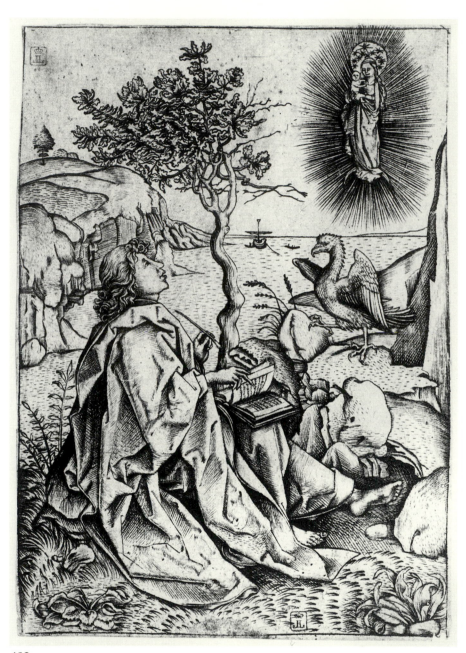

402

403

404

405

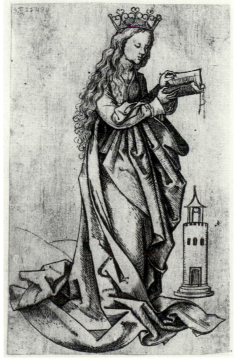

406

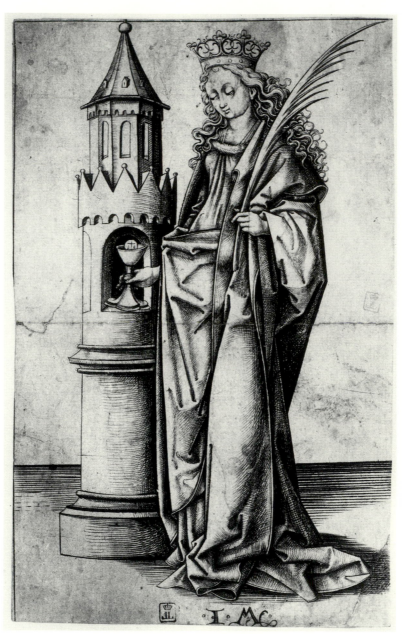

407

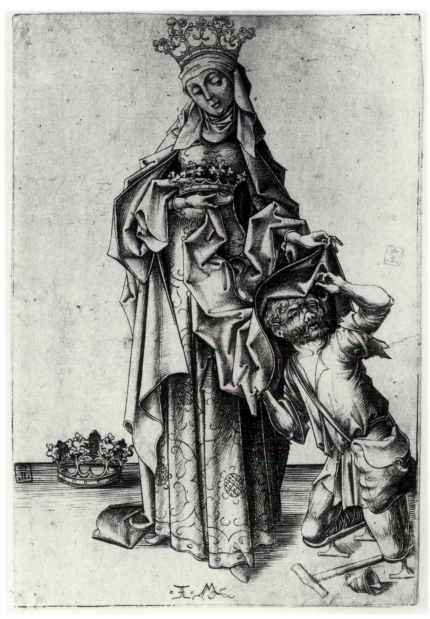

408

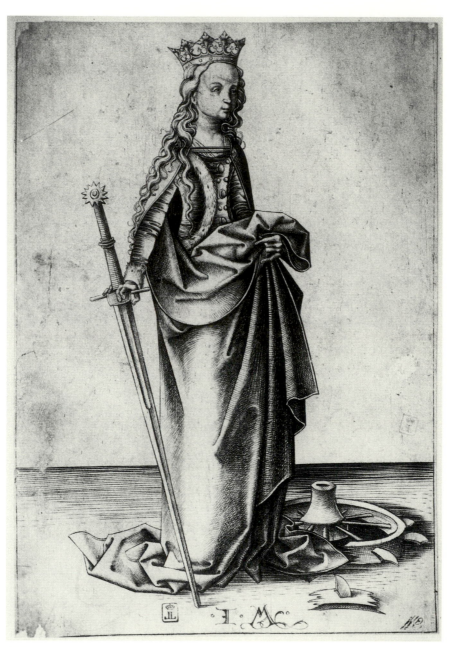

409

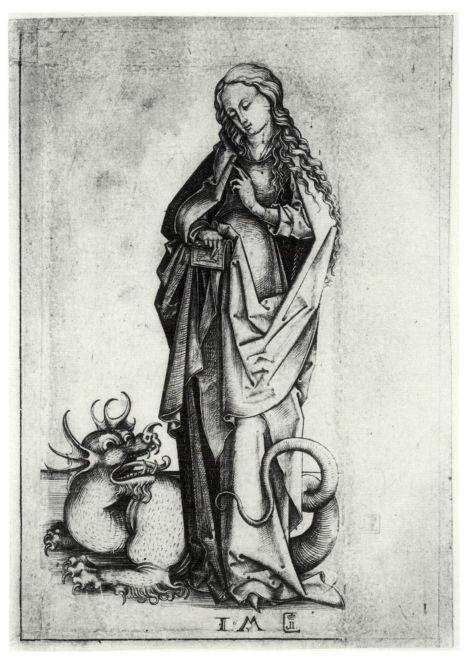

410

411

412

414

416

415

417

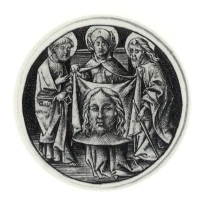

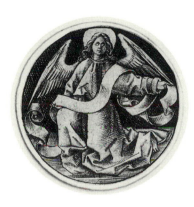

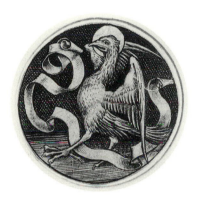

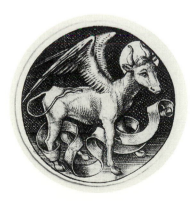

419

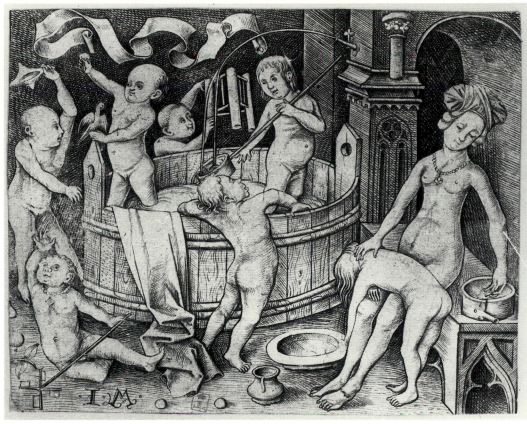

421

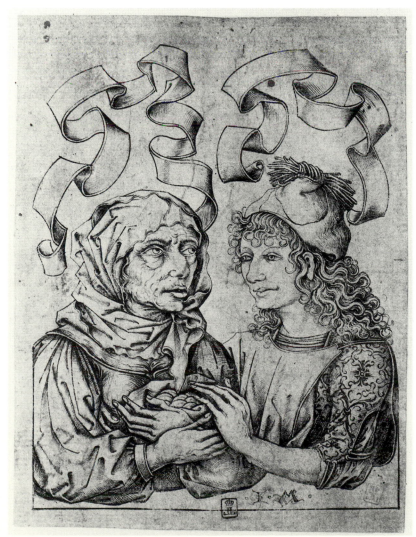

422

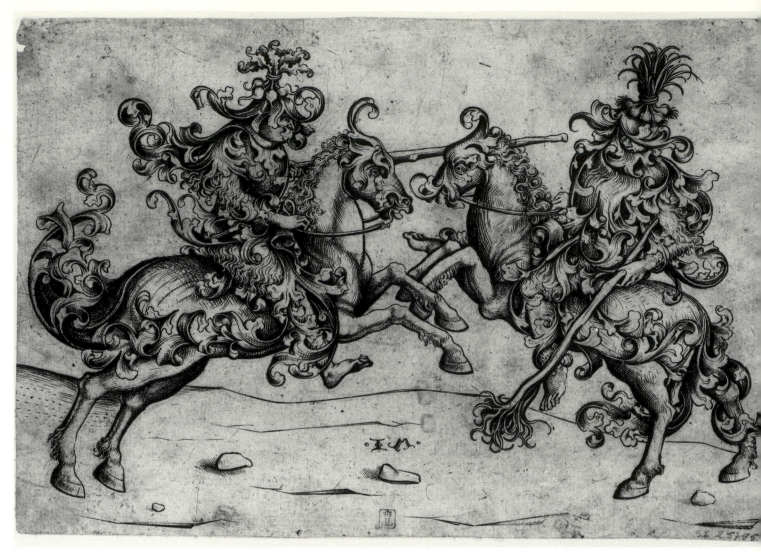

423

424

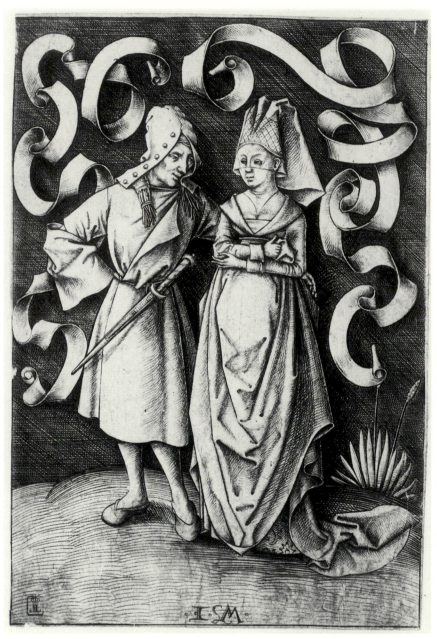

426

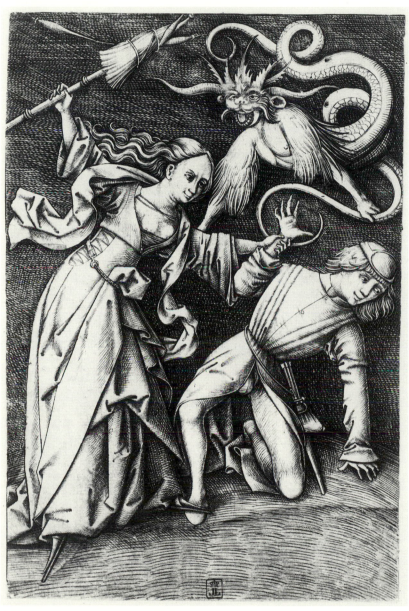

427

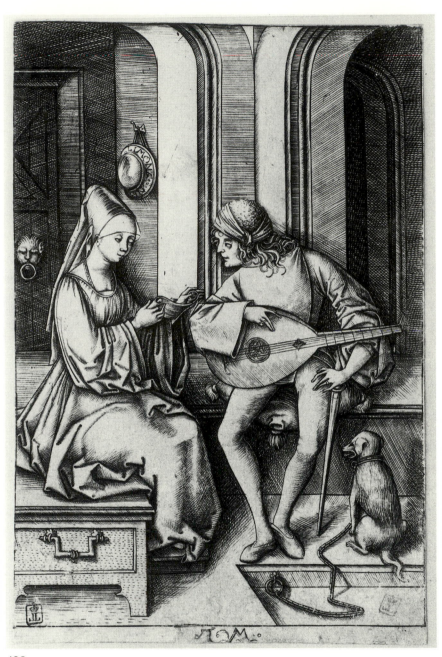

428

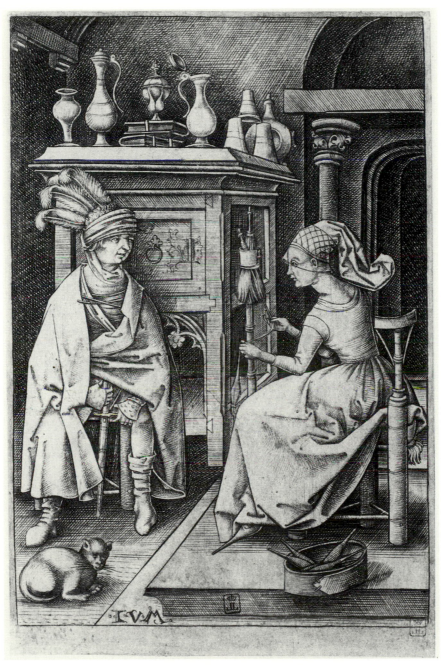

429

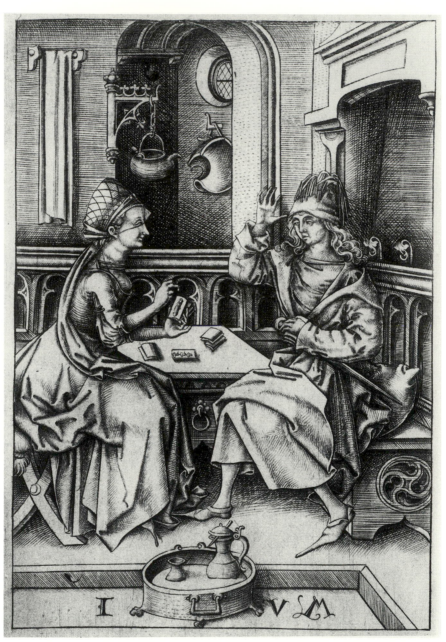

430

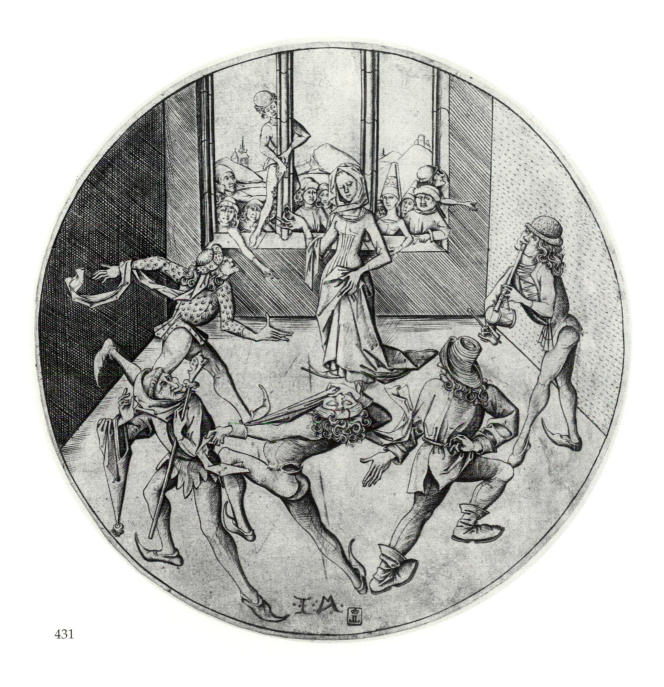

431

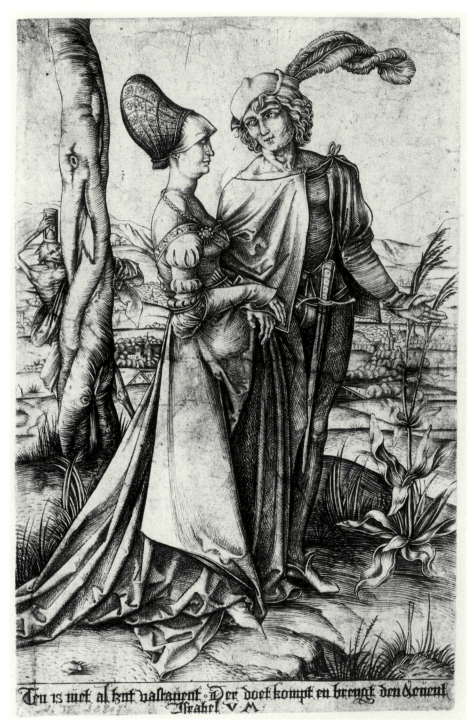

Teu is met al kut vastauent · Der doet kompt en brengt den deuent
Israhel · V M ·

432

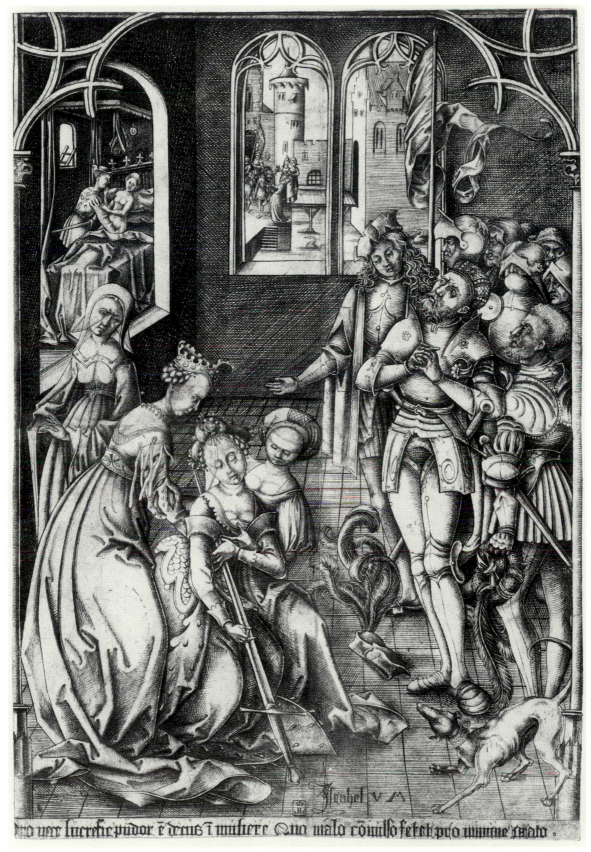

to vere lucrecie pudor e decus i muliere Quo malo comullo fetet pro muliere malo.

433

434

435

436

437

siti·Purgabo me p̃ tria sc̃ p̃ gemitũ orationis: per
ignem tue compassionis per ardorem tue caritatis·
Et r̃t latius hec via purgatiua appareat· videatur
hec tabula secũdũ ordinem alphabeti·

Salue benigne ih̃u̅ saluet tua
passio vi̅os defuncti r̃z labor sit
tuis eua quies

Peccator̃z debet dolere·

De

Amicicia dei amissa·
Bonitate dei contempta
Consensu r̃ culpabili vita
Dilapsu temporis r̃ virium
corporis et anime
Excessu preceptorum dei
ecclesie et superiorum
fragilitate resistendi peni
tendi et proficiendi·
Graui negligentia laborãdi:
vrandi:meditandi:legẽdi.r̃c.
Dabitu r̃ cõsuetudine ex fre
queti intentione peccandi
Jngratitudine qua iterum et
iterũ sibi dimissa renouauit·
karitatis extinctione per
quecunq̃ peccata·
Laxatione timoris dei q̃ cõ
tra tam magnum dominum
tam magna et horribilia pec
cata committere presumpsit·

438

439

441

442

443

444

445

446

447

448

449

450

451

452

ere du salste op doen mijn
lippen. Ende mijn mont sal
voertkundigen dijn lof. G
od wilt denckē in mijn hul
pe. Here tot mi te helpen haest

453

heb ic gehaept. laet mi niet
confuus staen inder ewich
heit. Vuide is ghestort die gra
cie in dine lippen. Daer om
heuet di god ghebenedijt in
der ewicheit. Die laudes
God
wilt
mijn
hulpe
Here
tot mi
te helpen haeste. Glorie si.
Alst was inden. ps.
Die heer heeft gereg
niert. en heft aenge

454

Gode seggen wi dāt. Alle gelo
uige sielē moetē rustē in vrede
Amen. Die prime

Ghegruet sistu maget
maria vol vā gracie en ghena
den die heer is mitti. gebūdijt
bistu bouē allē vrouwen en
gebūdijt is die vruchte buchs
ihs xps. Amē. Jest dese Aue
maria ī duytsch of ī latijn
voer allē getidē ōser vrouwe.

Od wilt
denckē
in mijn
hulpe.
H se tot

Od
wilt
denckē
in mijn
hulpe.
Here

tot mij te helpē haeste. Glo
riste coninc ymen
alre goedertiereucste
besutte onse harte opdat wi
tot alre tijt di behoerlike loue
mogē ghenē. Ghedencke
meister der salich dattu hier
te voren aen names een ghe
daente ons lichaem is en gebo
wordes vader onbeuleckter ma

sonder eynde. Ame. Die ver
hoer. ⁊ En mij ro. Biidien
wi. Gode seg. ⁊. Alle gelou
ge sielē moetē. ⁊ die serte
 OD
 wilt
 dedkē
 tmij
 hulpe
 bie tot
 mi te
helpē haeste. Glorie si. ⁊
Oriste conic Vmmeu
alre goedertierensr
besitte onse hartē op dat wi
tot alre tijt di behoerlike lo

457

Alle gelouige sielē moetē
rusten in vrede. Amen.
 dienoen
 OD
 wilt
 dethē
 tmij
 hulp
bie tot mi te helpē haeste.
Glorie si. Alt. Vme
Oriste conic alre
goedtiereste. besit
te onse lsitē op dat wi tot al
retijt di behoerlike loue
mogē thenē. Gyedēe
ke meister der salich dat

458

459

460

461

463

464

Jhebben obenägē die such
ten des doots die droeuige
seer der helle hebbē mi obe
uangen. Venite
Oenit laet os seer

465

466

467
100

468

469

At ierste pā m eñ
aue maria sprect
ter eere d bloetspor
tinge ons here hēn
als hi opte achten
dach besnede wart isā dan eē aue
mā t eere dē herte hdē dat maria
had Woe hō symeon toe sprac dz dat
sweert des rouwē solde dō snyde ō
herte X aue mā Die ierste tē
aue mā t ere d grot woude die
maria had Woe si ontmits dē heili
ge geest dē soen gads ontfynck iā
nu mdē hemel d halyter drienoldich
alre naeste syt pā m aue
At ander pā m t ere d bloetspor
tinge doe hi mdē gaerdē wat
eñ bloet sweete dattet van syne ele
derē m die eerde vloet Eē aue
maria ter ere des herte lydens dat
mā had doe si mit ihū vloe m egyp
ten voer herodes tern X aue

een barnende kerse eñ tusschē
elc gebet tien aue maria staen
de eñ die gebede knyelende eñ
hoedē hem voer doot sinde als
hi best mach eñ sand trouuel hi
sal sond trouuel vtroert werden
m alle syne noede leest ierst tē
Marr aue mā
suete maget Jck
vermaen di der
groter ere die di
die almechtige
god gedaen heest bouē alle geschapē
creatuerē m hemel eñ m eerde d
grot onbegripelijker mynē Daer
hi di vō alle tyt m vōsien had des
wonderlike genoechlike raets eñ
oit drachts die mdē raet d heilig
drienoldichz ouerdragē was dat
die ander persoen d godhz Dat is dz
woert dat mitē vaderlike herten
geulatē is hi mdē tyt ayū dynen

472

473+474

477

478

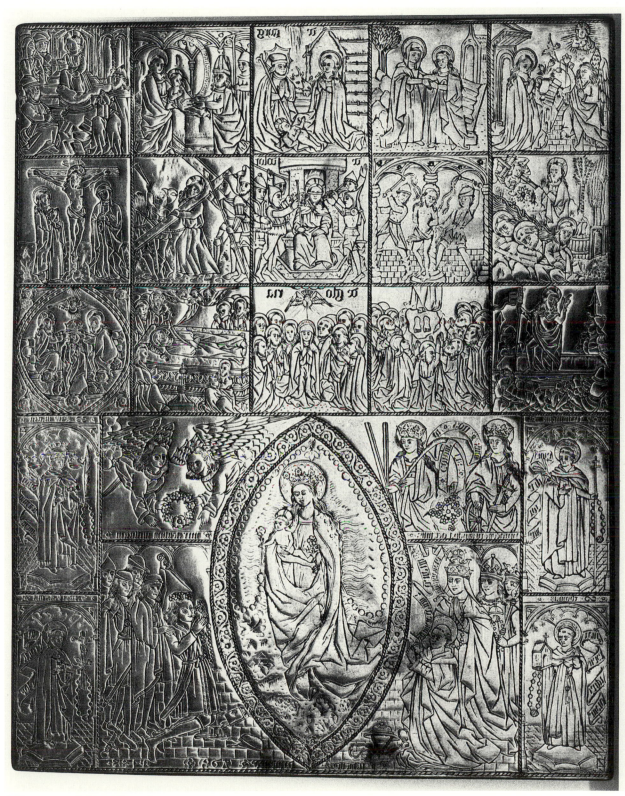

478 copperplate recto

478 copperplate verso

479

480

481

482

483

484

485

486

487

488

490

491

489

492

493

494

495

496

497

498

499

500

501

502

503

504

505

506

507

508

509

510

511

513

della nostra eta: per che diuersi scriptori diuersamente sentono. Aristotile nel suo de republica

514

ge alla contemplatione et Danthe cioe epso appetito gli tien drieto perche gli diuenta obbediente

515

516

517

518

519

520

.D. .TERPSICORE . XIII. .13.

521

C | RHETORICA XXIII | 23

522

MERCVRIO XXXXII

A 4z

523

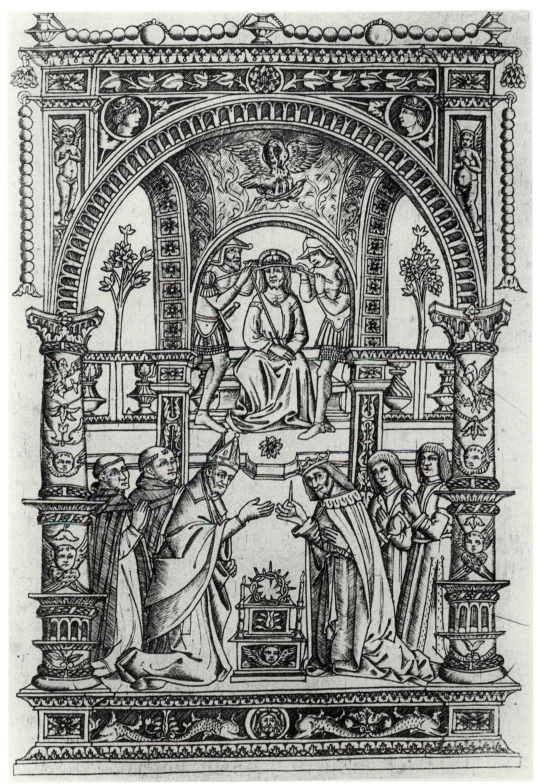

524

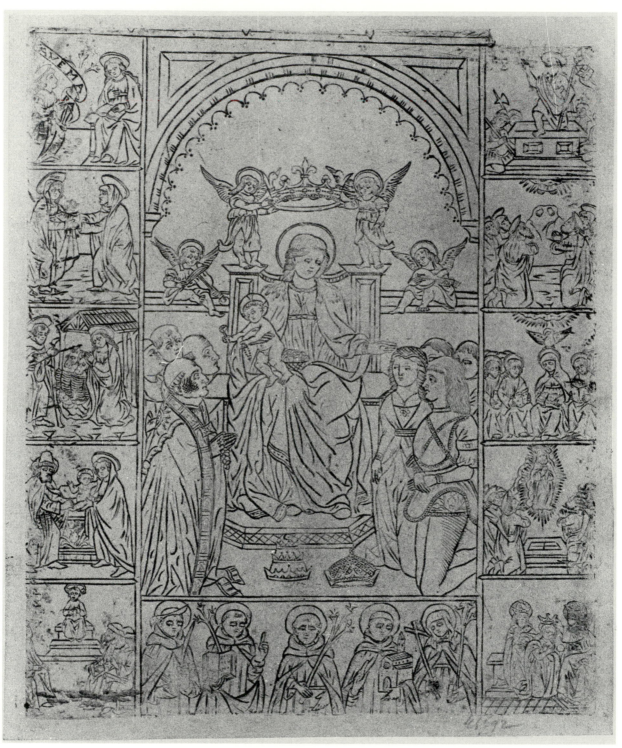

525

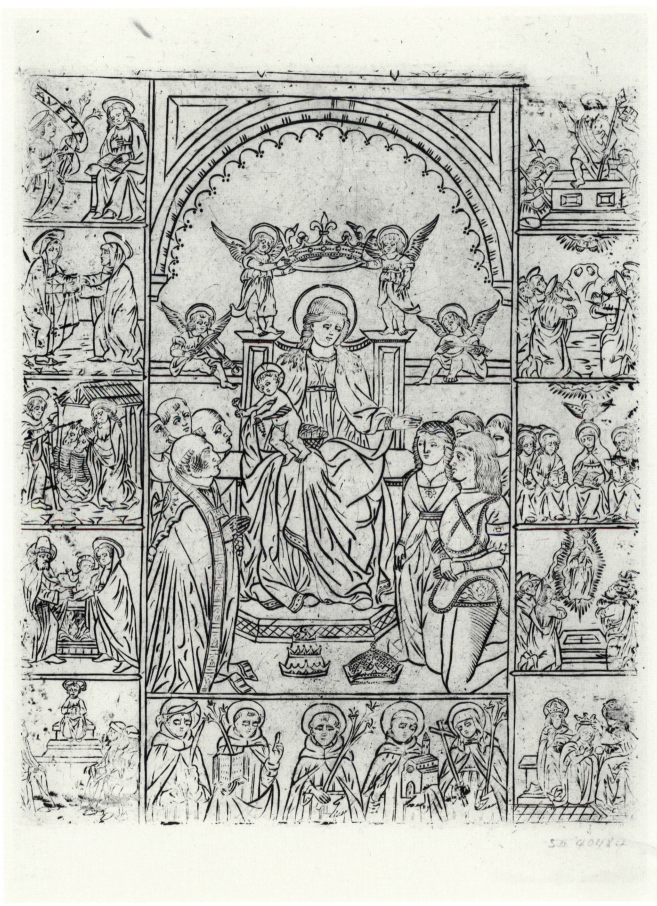

526

527

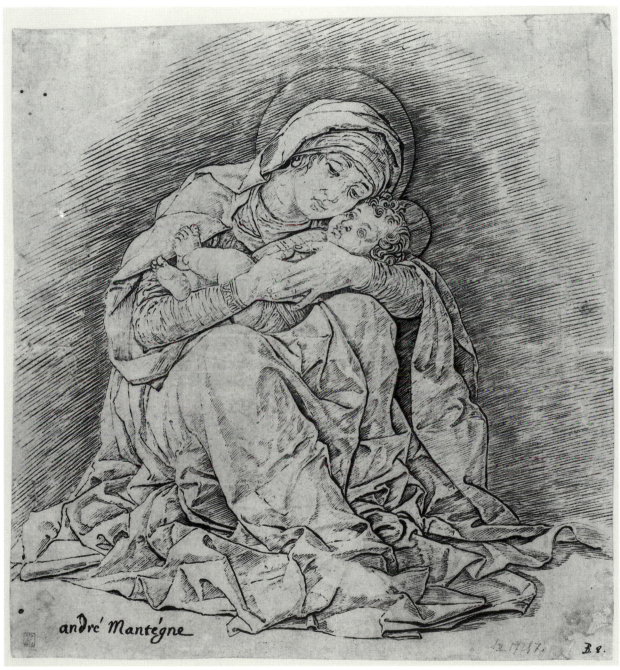

andré Mantegne

528r

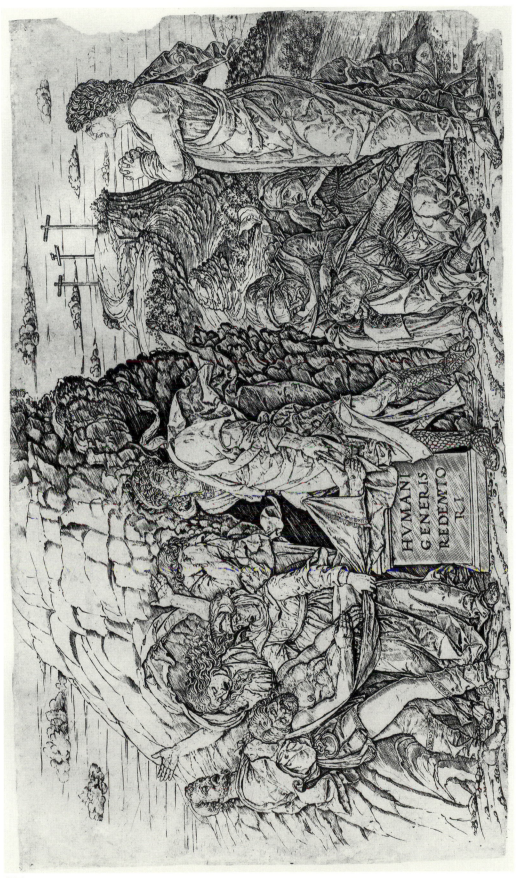

529

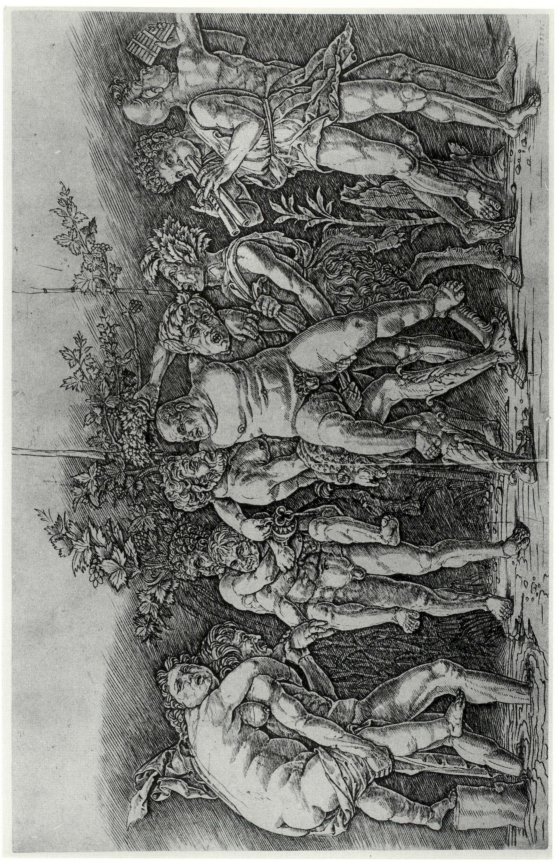

530

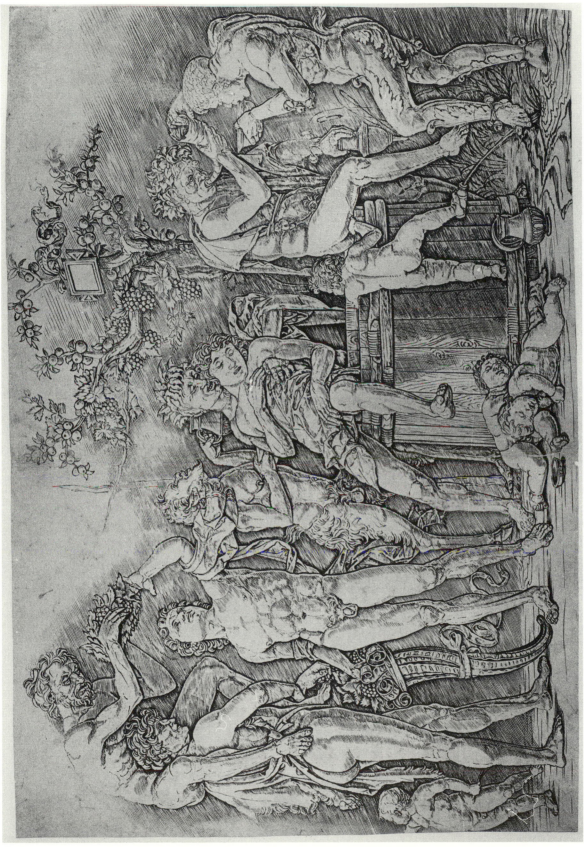

531

533

534

535

536

537

538

539

540

541

542

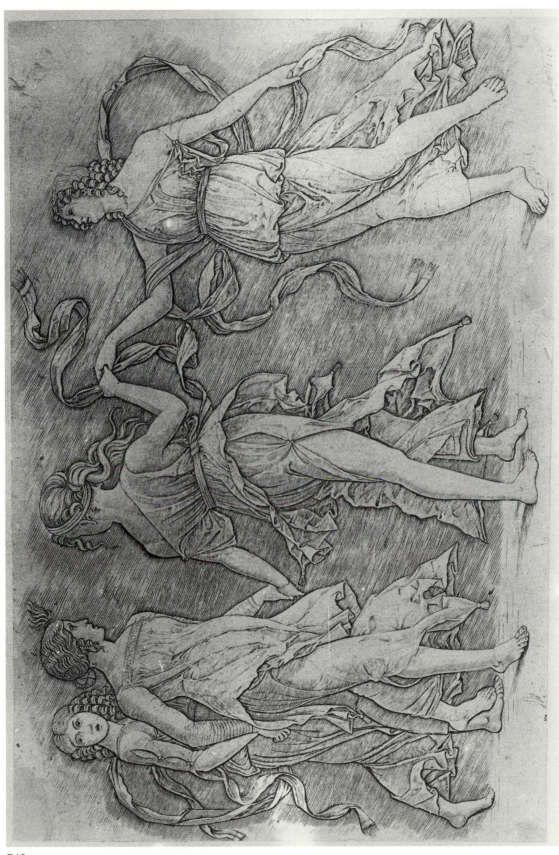

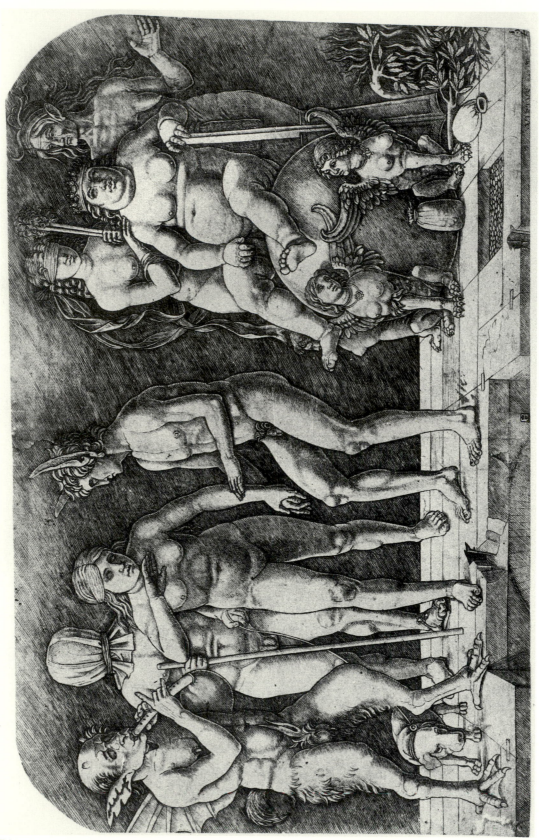

544

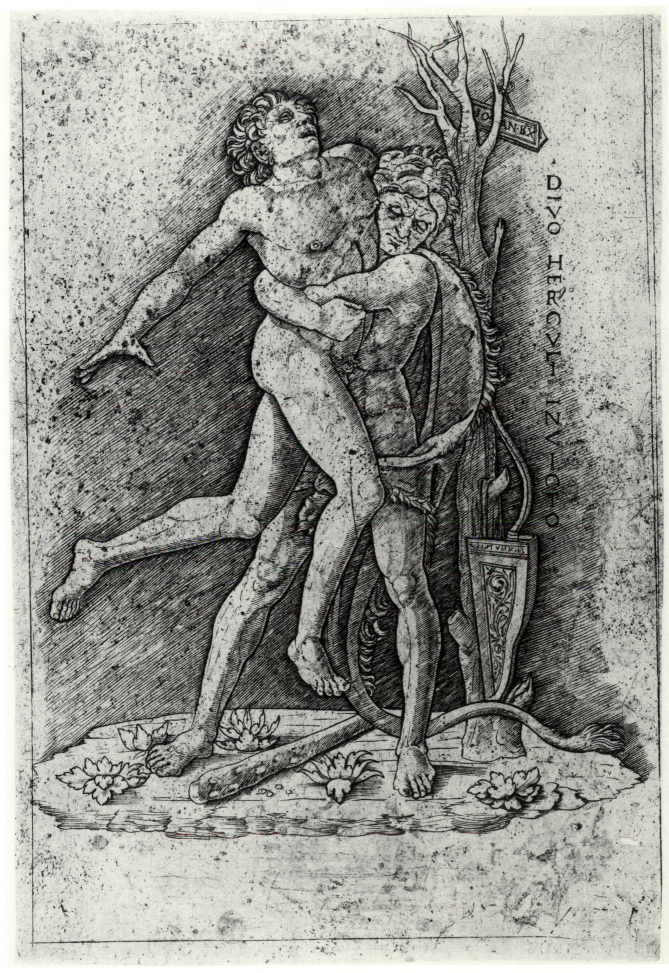

546

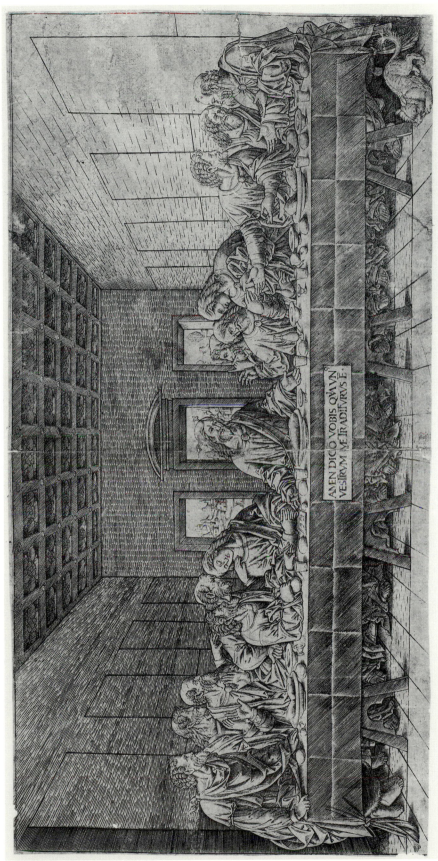

547

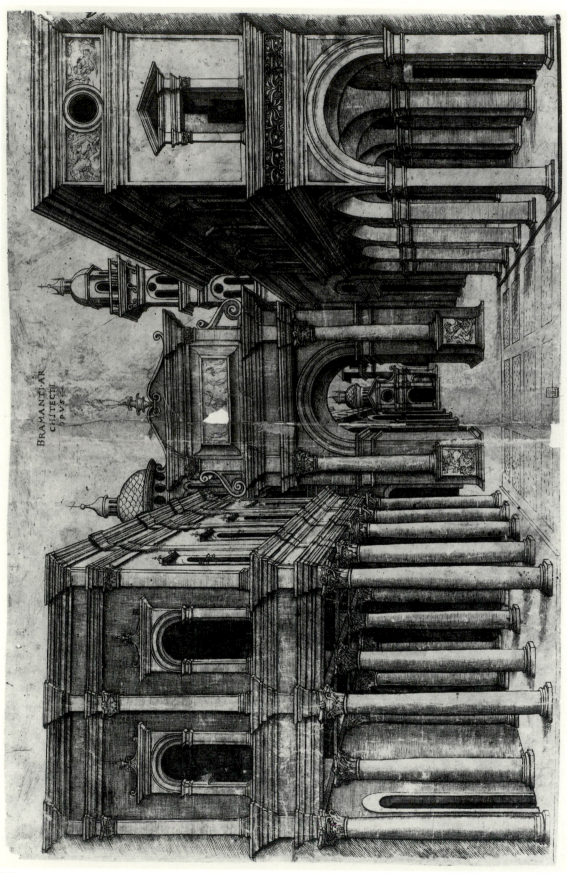

548

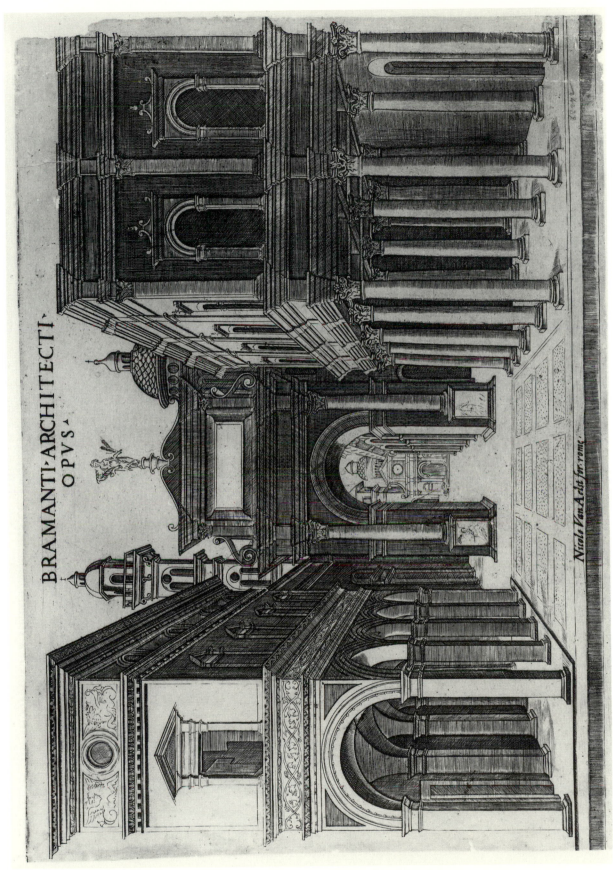

BRAMANTI·ARCHITECTI·
OPVS·

Nicola Van Aelst for. rom.

549

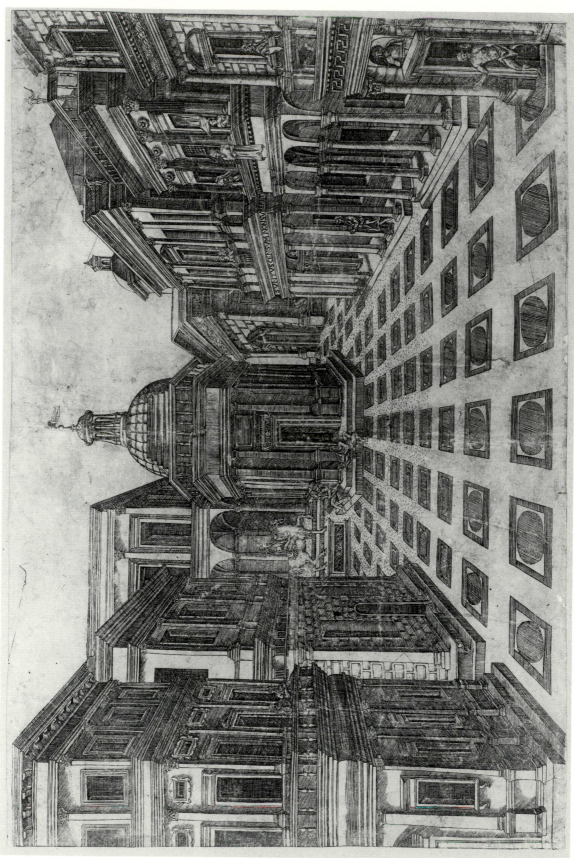

550

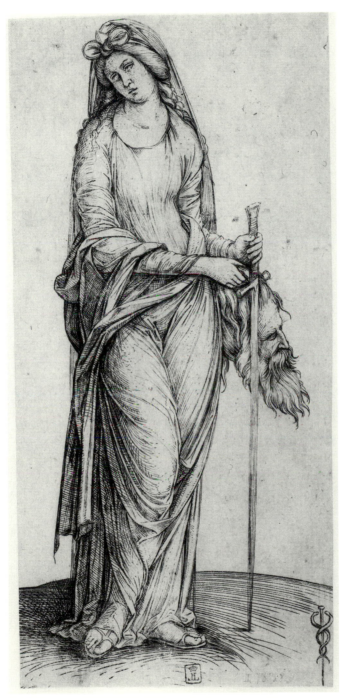

551

552

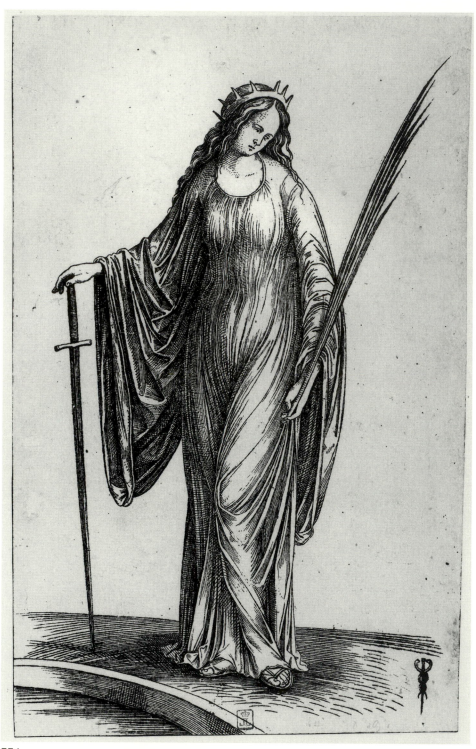

554

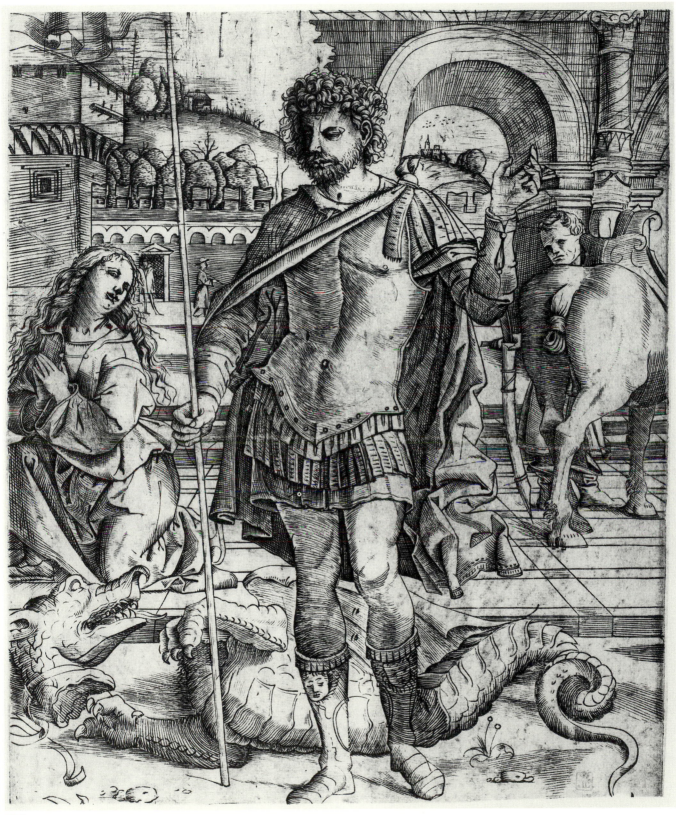

555

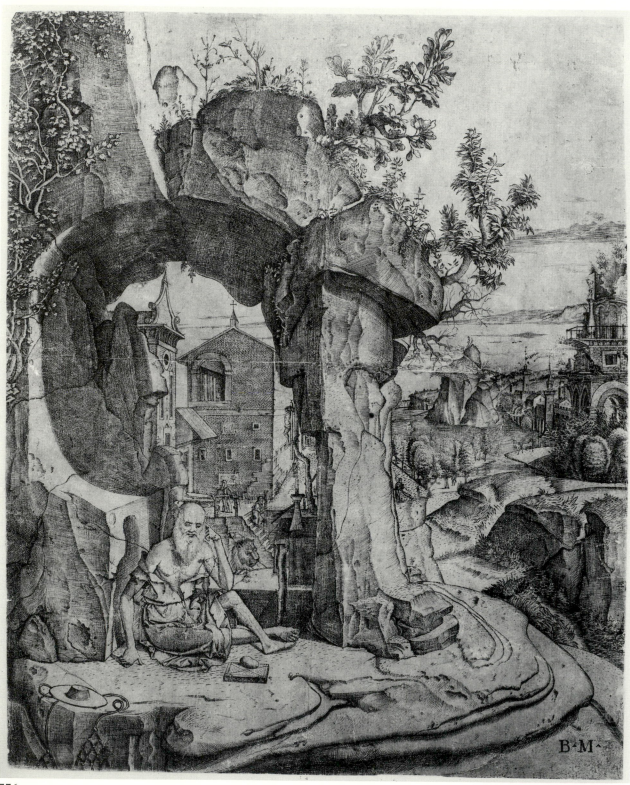

556

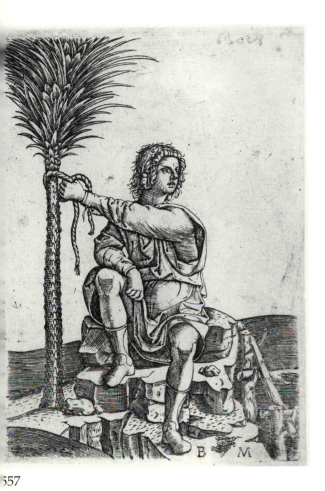

557

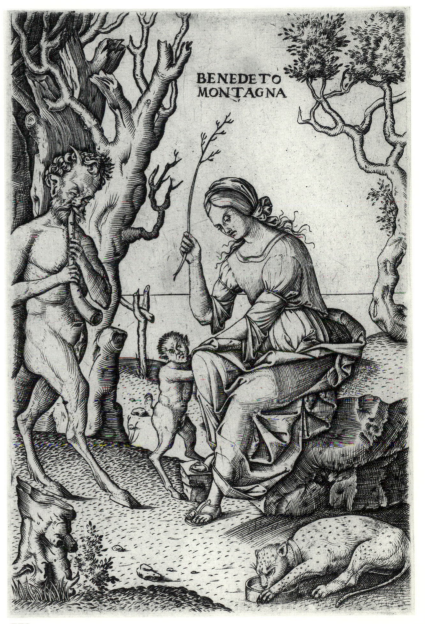

558

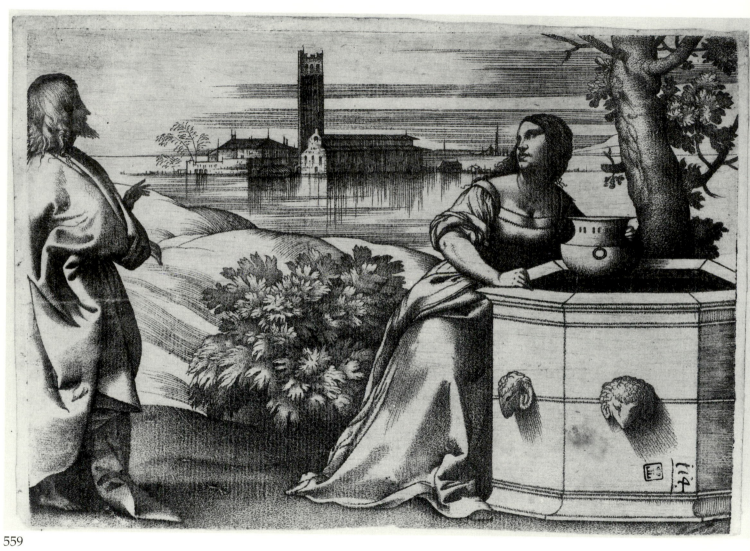

559

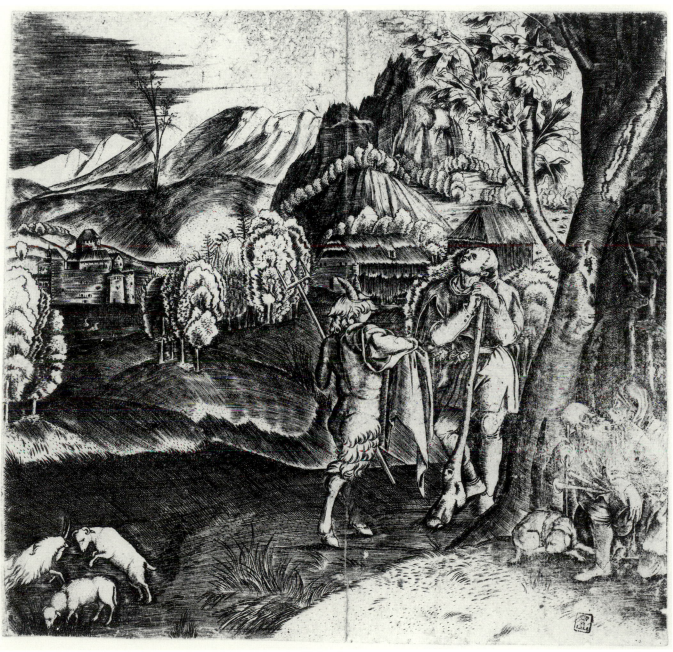

560

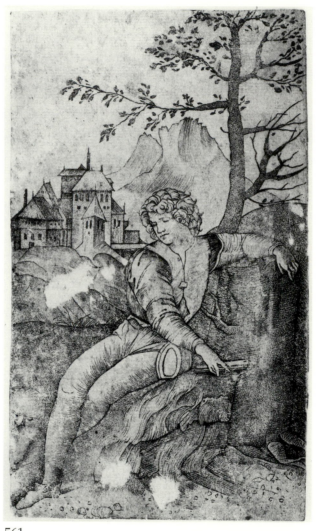

561

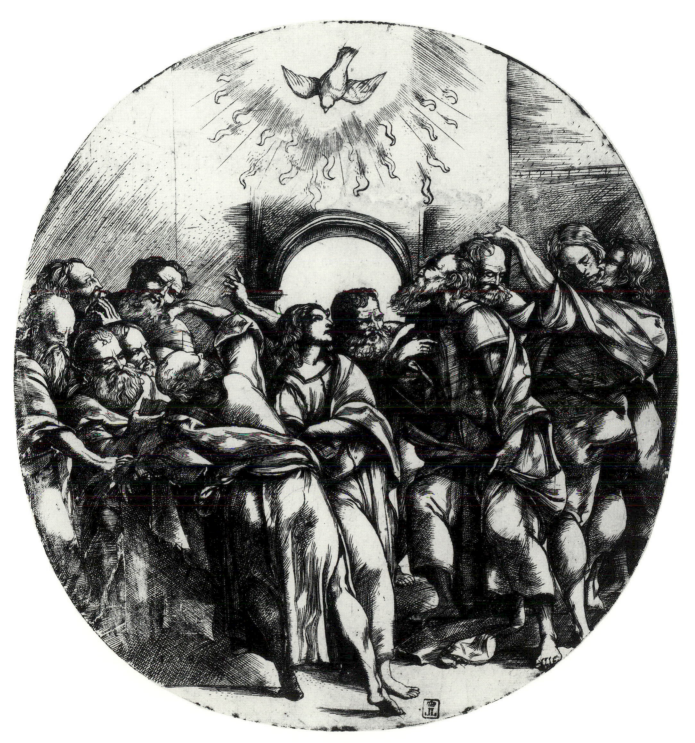

562

DOMINICVS CAMPA GNO LA

.MDXVII.

563

565

566

568

570

571

572

573

574

PLATES

PLATE I

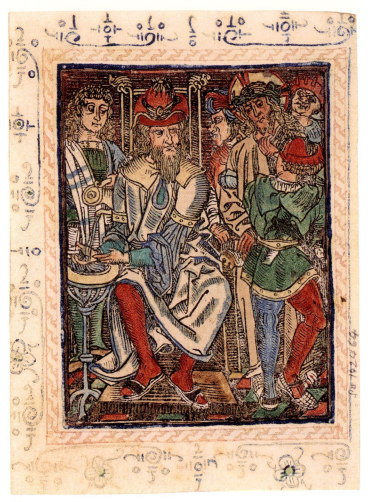

17

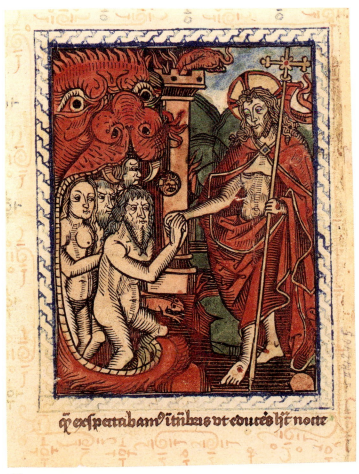

46

PLATE II

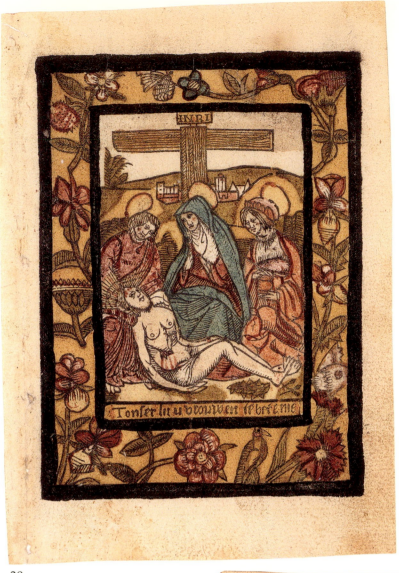

30

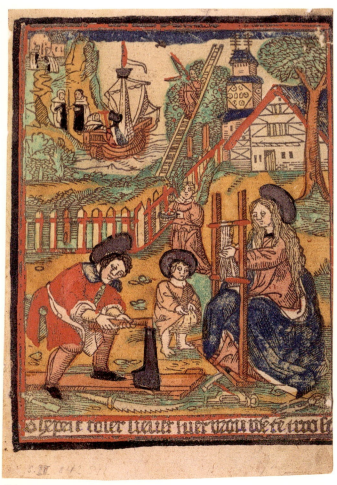

34

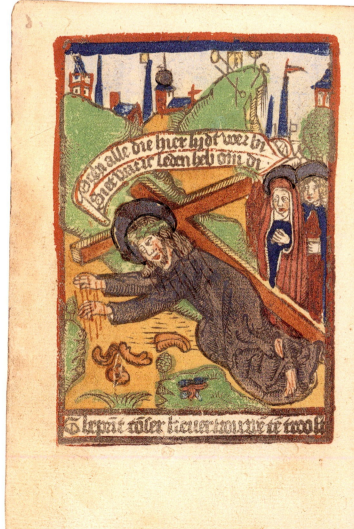

65

PLATE III

71

55

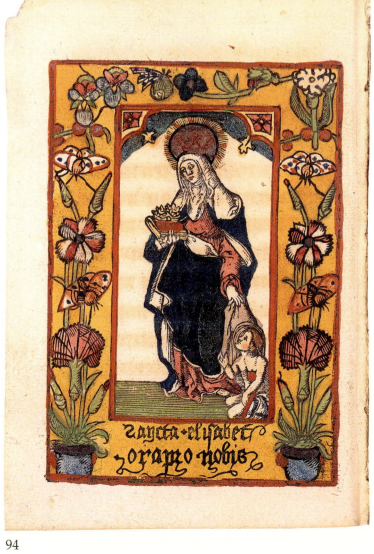

94

PLATE IV

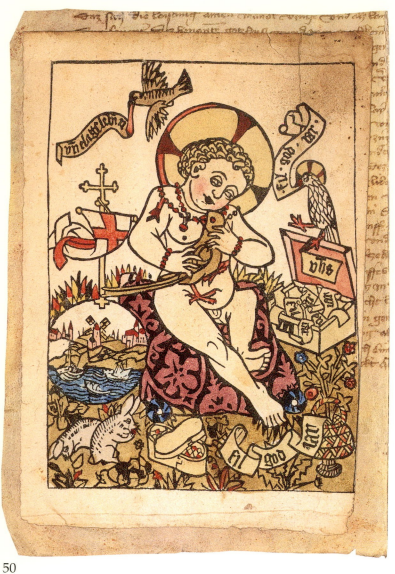

50

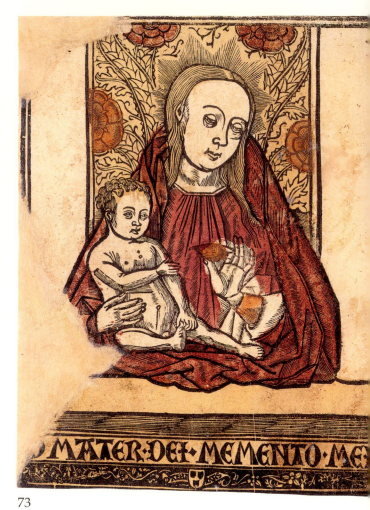

73

99

103

PLATE V

125

138

PLATE VI

170

171

190

PLATE VII

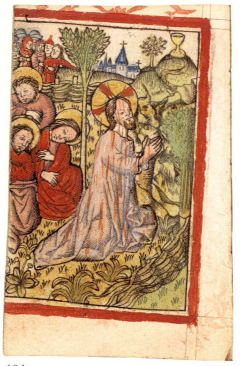

194

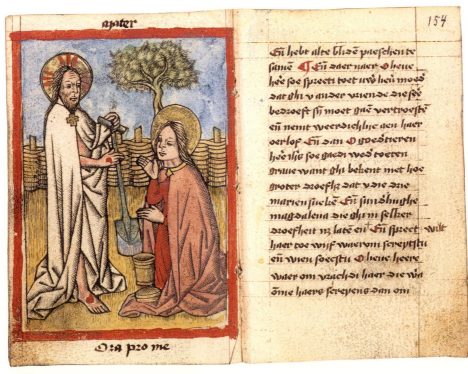

195

PLATE VIII

113

196

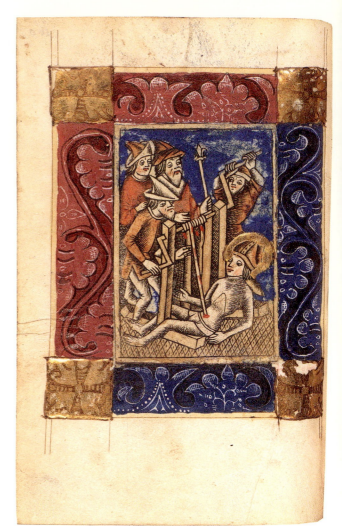

197

198

165

199

PLATE IX

166

164

201

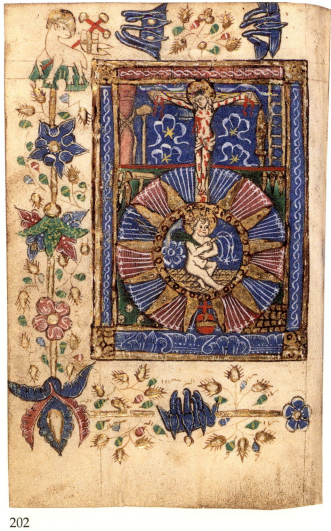

202

PLATE X

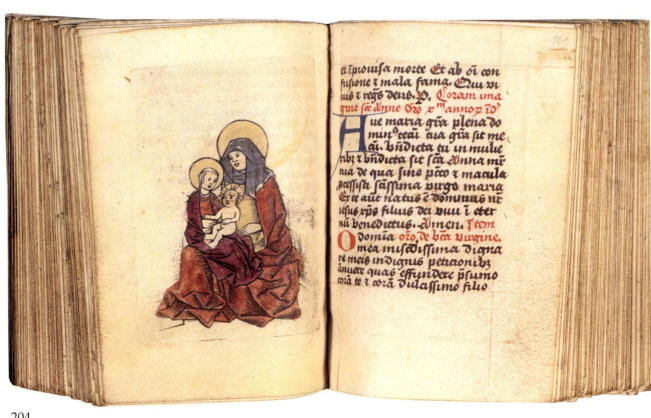

204

PLATE XI

.7

228

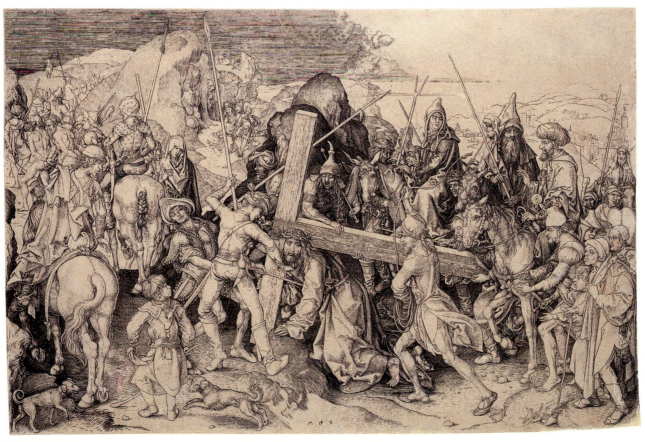

221

PLATE XII

319

329

PLATE XIII

351

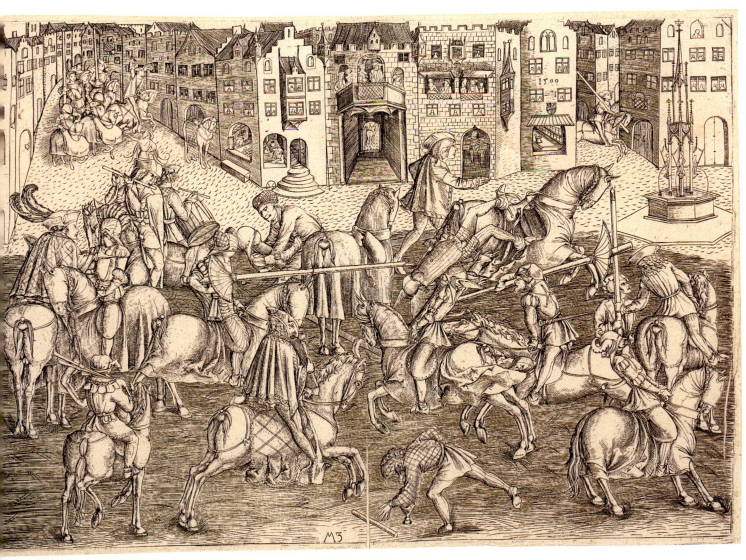

PLATE XIV

375

453

473-474

PLATE XV

RHETORICA XXIII

522

PLATE XVI

559